ICONS

ICONS

KURT WEITZMANN MANOLIS CHATZIDAKIS SVETOZAR RADOJCIC

PUBLISHERS OF FINE ARTS BOOKS

NEW YORK, NEW YORK

Published by: The Alpine Fine Arts Collection, Ltd.
527 Madison Avenue, New York, New York 10022

ISBN: 0-933516-07-X

This book was conceived and coordinated by Ivan Ninić

English text edited by Brian Comerford
English text designed by Laszlo Matulay
This book was produced in Yugoslavia.

INTRODUCTION

Religious object and work of art, the icon has always been at the core of religious life in the Orthodox world and has never ceased to be treated with particular fervor by the best of Byzantine artists. This collection of works offers an opportunity to witness some of the most remarkable creations of the past thousand years. Accompanied by commentary that clarifies and defines each illustration, this handsome book enables one to appreciate at a glance the problems of this aspect of Byzantine culture.

Far from being a simple esthetic presentation, this means of artistic expression is closely related to the ideological structure of the society which produced it; some of the artistic movements here represented catalyzed crises that shook the Empire.

It is not the purpose of this collection to stress the ideological issues which existed in Byzantine society, but rather to underline the profound unity that governed icon painting through the centuries. Here we attempt to pinpoint the reasons for this oneness, and to describe the conditions which allowed the development of the icon.

Despite the separation into chapters based on geography, the book illustrates the unity of this mode of expression through space and time. The chapter on Sinai, for example, which discusses works of the sixth to eighth centuries, reveals as much about the early development of all icons as about the idiosyncrasies of the region's art. Similarly, the chapters about Greece and Yugoslavia highlight the evolution of icon painting in later centuries.

The thousand years during which this art form developed and sustained its preeminent position could appear as an inconceivably long period for an artistic phenomenon to endure. One must realize, however, that in such an institution as the Orthodox Church, whose ceremony of the Mass in some areas dates from the fourth century, change occurs only very slowly. Once the icon did manage to gain a place in the practice of the religion, its future was secure for a considerable time.

Until the fifth century the cult of holy relics had been the object of extraordinary fervor, while during the same century the icon played only a modest role — a portrait of a saint or.the depiction of an episode in his life. As such, they came before the portraits of kings (it is in honoring the portrait that one honors the original), according to Saint Basil. But an icon could be more than a relic when it was touched directly by a holy person, such as, for example, the one supposedly touched by Veronica, or the six hundred icons attributed to Saint Luke, or the rare "acheiropoietes", which are said to have been painted by other than the human hand. These icons became the object of a particular veneration, its value as a relic carrying over into the subject of the composition. And so the people, looking for a way to give form to their hopes and wishes, attributed magical powers to certain pious images who were supposed to perform miracles or to have the power to communicate their wishes to God. The authorities attributed to certain icons the power to protect the city or Empire. The cult of religious images became more generalized and dispersed in the sixth and seventh centuries, accompanied by certain

sporadic reactions. These culminated in the crisis of the Iconoclast movement, which after a century of persecution and looting ended with the victory of the advocates of icons in 843.

The political turmoil which surrounded the practical use of icons was linked with theological questions about their nature. During the course of the long and bloody confrontation, defenders of religious images took the position, inspired by neo-Platonic theories, that the icon was but a reflection of a higher, purely intellectual form. It served a valid purpose insofar as it resembled the celestial prototype. Only through this resemblance did divine grace pass into the work of art, the tangible object which has form and substance. From the time of the image's creation, the grace bestowed on the original icon could be transferred to another only if it was a faithful copy.

These elements of belief, summarily mentioned here, are profoundly rooted in the conscience of the Orthodox (indeed, the cult of religious artworks has been called the triumph of Orthodoxy); they account for the conservation of themes found in the art of icon painting — the episodes of the lives of the saints or stylized portraits that are perpetuated in work after work.

One understands then why the personality of the artist became submerged beneath the simple requirement of imitating the models that were suggested to him. It can also be stated that there was a certain latitude in the choice of models, appropriated according to the era, and also in the application of principles. But the art of icon painting did not become less regulated through the centuries and, in the Orthodox countries as a whole, retained certain constants which can clearly be seen in the reproductions of this book.

Practical means of creating the artworks could only have been borrowed from the traditions of antiquity, from which came the technical procedures, inspirational themes, and stylistic models — symbolic or representative, chromatic or linear — lasting through the Middle Ages. In addition, the best copies were produced in the larger cities — Constantinople and Thessalonica — because it was in these sanctuaries that the miraculous images were transported, venerated and preserved.

The limited number of these icon producing centers, at least for the period properly called Byzantine, constitutes another factor in the unity (but not uniformity) of this art. Constantinople was a receptacle of the classic traditions, such as the latent echo of Hellenistic art, which one finds in works of high quality. The heart of the Empire was thus a unifying center and at the same time a place of creation and propagation of new artistic developments, alterations of style, and renewal of art trends. The most beautiful icons were painted in the center of the city or else in the great monasteries by artists whose talents were doubled by their religious fervor. The productions from the capital, from which Orthodox dogma, technical skill, and esthetic quality were incontestable, were researched by all of the great Christian sanctuaries: Mount Athos, Patmos, and Sinai, to cite only the most famous of them. These icons in turn became models for those which were created in the provinces of the Empire and in neighboring countries, and the prestige which these masterpieces enjoyed favored the spreading of the Byzantine style of art. One finds influences among Russian icons and in examples from the Greek Church as well.

This fundamental oneness of icon art is therefore explained by religious doctrine, the underlying Orthodox thought; and practical concerns, the conditions of the production and diffusion of the sacred images. To these are added another factor, their use.

The format and workmanship of the icon were influenced by its use in a similar way

in the various Orthodox churches and populations. The mobile icons had diverse destinations and their importance only increased after the victory over the Iconoclasts. Each hearth had its private iconostasis, and the gifts that were sent by the emperor to important dignitaries, governors of the provinces, and foreign nobility consisted obligatorily of icons. The individuals of a certain rank, in presenting their gifts to the churches and monasteries in order to obtain forgiveness for their sins, often had small portraits of themselves included near the bottoms of these offerings. 70,108 118,189 188

The icons that were created for private use, generally smaller in size, took on a 104,105 format that adapted itself to particular needs, such as the diptychs, triptychs, tetraptychs, or hexaptychs. The most common was the easily transported triptych, which was created in a fairly liberal style of workmanship usually inspired by the images adorning the iconostases of the churches.

During the tenth and eleventh centuries, the progressive transformation of the sanctuary and the appearance of an iconostasis within the church itself played a decisive role in the development of the icon. From the eleventh century on, there was an enrichment of the themes and an augmentation of production to correspond to new needs. Leaving aside the hypotheses about the stages of this evolution, which range from a simple decoration of the architrave to the introduction of tri-level icons of various dimensions, we will describe the iconostasis according to its standard format.

On the wall separating the sanctuary from the rest of the church (a wall which was at first typically marble, later wood) the first level was composed of the large icons of proskynesis. These were hung at about the height of a man under arches carved in relief, in position for the adoration of the faithful. Of special import on this tier were 143, 178, 179 the three icons forming the Deësis, arranged according to strict religious dictates: the figure of Christ was always flanked by images of the Virgin and John the Baptist.

These most venerated icons of the first level were involved in the rite of 76, 77, 81, 101 proskynesis. Oil lamps and candelabras were lit before them, and the worshipers 102, 103, 115, 124 kissed the images and addressed their prayers to them. This, in fact, was the only 131, 141, 147, 163 point at which the believer was in direct physical contact with that held most sacred. 178, 181, 184, 187

The proskynesis icons were often encased in silver or gold. They were created with the most elaborate and painstaking workmanship, sometimes being painted on both sides for use in processional ceremonies.

Above the architrave was a second row of icons, which followed one of two formats. The first type consisted of a series of tall, narrow portraits mounted within arches similar to those on the first tier, but smaller. This arrangement, called an epistyle, once enjoyed a wide popularity throughout the Byzantine world. In the second format, there was a line of icons which could either represent individuals or separate parts of a larger composition.

The subject of the second level varied. It could reinforce the theme of the Deësis--the three central figures would be repeated, supported by archangels, apostles, or scenes from the cycle of feasts; in this case the Dodecaorton sometimes formed yet a third level of icons. Other possibilities for themes were those dealing with the dedication of the chapel--scenes from the life of the Virgin or some saint could be shown, depending on who was especially revered at the given location.

Along with the various levels of icons, the iconostasis held a large cross painted with the crucified Christ, and also a folding door, upon which an Annunciation was 198,199 painted.

The positioning of the iconostasis in front of the sanctuary not only heightened the visual effect of the sacred images, but suggested their symbolic connection with the

religious notions involved in the celebration of the Mass. For instance, the Virgin and Child could be seen as a representation of the Incarnation. Similarly, the Deëesis evoked concepts of the Intercession and Last Judgement and the Dodecaorton had traits which would identify it with the Eucharist. In all of these examples, the same concept underlay the material objects as underlay the rites concealed behind them.

But icons were destined not only for display on the iconostasis. The most honored were placed on the proskynitarias situated in various parts of the church. Some of them adorned the sanctuary, which became like a small museum where the oldest and most precious works were preserved. Within the monasteries, the icons of saints' days were displayed on special proskynitaria in the center of the church or in the chapel.

Monasteries, in fact, have proven to be the most fruitful areas for discovery in icon research. As the number of icons proliferated during the eleventh and twelfth centuries, many found their way into these places of meditation and prayer much the same way as writings of the time did. A most notable location is the Monastery of Saint Catherine at Sinai, which, due to some thirteen centuries of uninterrupted production, had in its possession two thousand icons dating up to the nineteenth century. This collection has permitted us to follow the principal stages in the production of holy images.

In doing so we consider the icon not simply as an object of devotion and piety, but as a work of art. This is because Byzantine painting, in spite of the restrictions previously stated, was a living art that reflected the cultural values of the place and time in which it was created. Admittedly all icons were copies of earlier prototypes. But since it was not known how to reproduce all the aspects of a painting with perfect precision, exact duplication was practically inconceivable. The artist, careful to correctly execute his "copies", contented himself with a paper reproduction of the image to be copied, which was marked off in pinholes. He was not able to give vent to his natural sensitivity because it was necessary to observe the rules of tradition. The coloring, prototypes of the figures, the style of workmanship in the composition, and its moral content were confined within norms, which allowed little room for an artistic interpretation.

Nevertheless, if we examine several works on a given theme, say the Virgin and Child, variances in style do suggest that there was a personal contribution from the painter. A comparison of common elements shows that various trends did exist in icon painting, producing very different works which all still remained true to Orthodox dictates. The depiction of facial features is one such telltale element. In some representations of Mary and Christ, the regular, stylized features reflect 18,59,147 classical notions of beauty. Other works are drawn with a more realistic touch--the 186,76,77 faces are carefully painted to display all the imperfections of human nature. 184,187 Differences like this show clearly that in spite of the requirements placed on the creation of icons, there was an individual input which made this art anything but stagnant.

The changes that occurred through time can be well appreciated by looking at three renditions of the Descent into Limbo, all from different periods: an epistyle 47,177,123 from Sinai of the second half of the twelfth century, an icon from the Dodecaorton at Ohrid dating somewhere from 1315 to 1320, and a work in the Benaki Museum signed by the best Cretan artist of the sixteenth century, Michael Damaskinos. The decor and personages are the same, the gestures and poses are hardly different, yet the three are fundamentally dissimilar. In the first icon, one can perceive the painting 47 style of the era in the dramatic movement of Christ — the authority and unattractive

lack of elegance with which he seizes Adam's hand — and also in the rather crude, ignoble faces. Characteristic too is the mural-like quality of the work, a monumentality achieved by the arrangement of the short, massive figures. In the icon of 1315 - 1320, there is a significant change in the depiction of Christ. His motion 177 has acquired a fullness and grace — the wide spread of His robes swirling above Him gives the impression that the Savior has just descended from heaven. The other individuals are of reduced stature as before, but more refined, having an air of thoughtful melancholy. The grouping, which develops other secondary scenes within the depths of the composition, is classified as "romantic" by Radojcic. Finally, the icon of the sixteenth century, while greatly concerned with preserving the elegance 123 of the poses and gestures as well as the delicacy of the colors, is situated nearly on one single plane. Underlined by a somewhat geometric arabesque, this work imparts a classic majesty to the individuals involved, who exchange courtesies befitting their rank while the central scene develops with the deliberateness of a coronation. These three icons illustrate separate and unique moments of a millenniun-long art.

The evolution of icon painting is also dependent upon the kind of icon in question. The large proskynesis icons decorating the iconostasis have a strong resemblance to their celebrated models. One sees this, for example, in the icons from Ohrid in Macedonia, based upon a particularly venerated icon from Constantinople called the Peribleptos. Also, these icons distinguish themselves by their unique and somewhat constant form, which makes them rather difficult to date. The scenes from the Dodecaorton, on the other hand, were treated more liberally, provided that certain elements remained recognizable. This is why it is easier to discern in this type of composition the innovations that are typical of each century, as well as the style of each artist. The icon of the Ascension can be cited as an example in which one can see the decidedly different painting techniques of two different artists. This is a fairly rare occurrence in the painting of holy images.

Before ending, we would like to say a few words about the time after the fall of Constantinople, an event which we have distinguished as the end of the true Byzantine period. Culture continued to live and evolve after the Turkish victory, but it is evident that the material conditions of artistic production suffered important changes due to the grave economic crisis that followed. In addition, the purity of the tradition was destroyed by the broadening influence of naturalistic art from the West in the regions under Venetian dominance, and by the gradual transformation of the traditional models under the brushes of artists who descended from the common class. The numbers of these painters who turned their art into a trade did not cease to grow. An inventory comprised only of Greek artists of this period consisted of more than two thousand names, which testifies at least to the vitality of production of icons.

There was little or no change in the structure of religious life, but, the large centers of cultural expansion having disappeared, the artists from the Byzantine diaspora looked for another creative center in which to continue their artistic production. Some fled to the villages on the island of Crete, where they perpetuated the classic traditions of Constantinople. In continental Greece and the Balkans, there was a definite diffusion of "anti-classical" tradition. But it was Mount Athos, because of its prestige, which replaced the great capital in the dissemination of artistic ideas. Only through the influence of this center did Cretan art of the sixteenth century and northern Greek art up to the eighteenth century spread throughout the Orthodox world.

Manolis Chatzidakis

SINAI

Kurt Weitzmann
Icon Painting from the Sixth to the Eighth Century

SINAI

From the writings of the early Fathers of the Church it appears that the type of picture we call an icon only very gradually took on the specific meaning that the Orthodox Church attributed to it during and after the Iconoclast movement. The way for its veneration was prepared by that of relics, especially those of the Holy Cross, in the fourth century. But it is not until the fifth century that we find the cult of holy images mentioned by Augustine, Epiphanius of Salamis, and others, and not until the first half of the sixth century that there is a reference, by Hypatius of Ephesus, to a proskynesis, an act of prostration before an icon. By a half-century later, in the period following the reign of Justinian, accounts of icons and their miraculous powers became more numerous. From then on, though iconoclasts and apologists continued to dispute the question, the veneration of holy images gained ground steadily until 726. It was then that the Iconoclast movement, which objected to any kind of depiction of the divine, put a temporary halt to any further development.[1] Between the sixth and early eighth centuries there was a change from the old concept of the icon as no more than a religious object of immediate utility to a new attitude of greater spirituality stressing the transcendental relationship between the image and the holy personage depicted. This provided the basis for the clear formulations, written by John of Damascus and Theodore the Studite, concerning the significance of icons.

Until recently only four icons of any importance were known from this earliest phase. These were icons from the Monastery of Saint Catherine on Mount Sinai, which were brought to Kiev by the Russian archimandrite Porphyrius Uspensky in the middle of the nineteenth century.[2] But a few years ago our knowledge was significantly increased when George and Maria Sotiriou made known further material from the pre-Iconoclast period which had survived in Saint Catherine's monastery.[3] Among those icons are two of such outstanding quality that we are inclined to attribute them to one of the workshops in Constantinople, although all attempts to localize and date these and other early icons must still be considered hypothetical.

One of the icons depicts the Virgin enthroned with the Child and flanked, as if by 16, 18, 19 two pylons, by the warrior-saints Theodore and George. In a second picture plane, two angels gaze up toward the hand of God, from which a ray of light streams down upon the head of Mary. In contrast to the stiff frontal poses of the two saints, who are dressed in the garments of the Imperial Bodyguard, the artist permitted the Virgin a limited freedom of movement: her eyes turn to the right, her knees to the left. This freedom is accentuated by the diagonal pose of the Christ Child. His legs are drawn up in typical baby fashion, although the head is that of an adult, with emphasis on the high forehead to bring out the spirituality and divinity He represents. From the artistic standpoint, it is above all in the heads that expressive power is concentrated.

The dark olive-colored shadows on Mary's face underline her remoteness from reality, her divinity; in contrast, the sun-tanned face of Theodore and the pallor of the youthful George are more true to life. Moreover, the thicker and broader use of paint for the angels' heads, which are still very much in the antique tradition, is an attempt to convey pictorially the ethereal quality of such creatures of heaven and represents a third mode of expression. In view of the soft, well-modeled plastic treatment of the figures, we are inclined to date this icon as early as the sixth century, although others opt for a century later. In either case, it goes back to a period in which the icon style proper had only just begun to crystallize.

The generally accepted notion that religious cult in classical antiquity found its essential expression in statues of its gods while Christianity preferred the painted image is true only in part. Antiquity was not unacquainted with painted images of the gods, as is known from certain panels, depicting enthroned gods, which have been found in Fayum;[4] a few painted wings from triptychs also show gods standing upright, and these presumably once flanked central panels of other gods seated on thrones.[5] Although the diffusion of this form of panel painting in the ancient world and its influence on Christian art cannot be demonstrated in detail, the examples quoted above are proof that there was a pagan antecedent for both the form and the content of icons.

Our second masterpiece of early icon painting[6] is an almost life-size half-figure of Saint Peter with the cross-staff in one hand and a bundle of keys in the other. His penetrating gaze squarely meets the viewer, while his inner emotion, expressed pictorially by the sweep of his hair and his slightly curved beard, is counteracted by the firm grip of his hands, creating an impression of concentrated energy. The three medallion busts above the niche, which in itself serves to give the picture a solid structure, include Christ in the central position, turned slightly toward one side, and the Virgin and a youthful saint (most probably John the Evangelist) on either side. The versatile artist applied here the same principle as that used by the painter of the icon of the Virgin: a somewhat animated central figure placed between two immobile figures. Closely associated with this is the use of an abstract style for the flanking medallion busts. These, in fact, are reminiscent of certain portraits in encaustic from the Fayum.[7] Their abstract style contrasts with the more naturalistic one; the latter recalls the older classical tradition merely suggested in the head of Christ but brought out fully in the head of Saint Peter. Further evidence of this link with antique painting is the impressionistic technique used for the draperies of Peter. On the other hand, the highlights are already subjected to a process of ornamental stylization which was to become the rule in the later development of Byzantine painting. This in itself suggests a later date for this icon than that of the Virgin, possibly already the seventh century.

Portrait icons also have their roots in pre-Christian art, notably in the official portrait of the emperor, the "lauraton." Even after Christianity had become the state religion, this form continued to be venerated for some time. The sixth century historian Malalas tells us that the Imperial portrait of Constantine the Great was still carried about in processions and worshiped by the current emperor.[8] A panel painting, now in Berlin, of the portraits of Septimius Severus and his family appears to be such a "lauraton."[9] It is in the form of a disc, and this form also survived for a long time in icons.[10] In the icon of Saint Peter under discussion, the arrangement of

the three medallions is an obvious parallel to that of the Emperor, Empress, and Second Consul found on certain ivory consular diptychs.[11] This makes it clear that there was a direct link between icons and imperial images.

Besides those portraits derived from the worship of gods and emperors, icon painting at an early period developed other formats that were new creations of Christian art, in particular, narrative scenes from the Old and New Testaments. A 21, 36 characteristic example is the icon of the Three Hebrews in the Fiery Furnace. Like the two icons already discussed, this one was done in encaustic, a technique familiar to us from Egyptian mummy portraits. As far as this limited material permits any general conclusions, it may be said that encaustic was the principal, though not the only, medium used for icons in the pre-Iconoclast period, and that it was discontinued in the post-Iconoclast period. Dressed in Persian costume, the three youths stand praying in the midst of a sea of spiral-shaped flames. An angel lays one hand comfortingly on the shoulder of the youth nearest him and in the other he holds, proleptically in this Old Testament scene, a cross-staff signifying that the Hebrew youths would soon be saved by the Cross of Christ.[12] The style here is highly expressive but not as refined as in the icons discussed earlier. The figures are somewhat thickset and have simplified outlines, the highlights are more ornamentalized, and the cloaks are decorated with a pattern of dotted circles. The Sinai collection includes several other icons of the same stylistic trend, for which we propose Palestine as the place of origin;[13] to all intents and purposes, this means Jerusalem — the center with which the Sinai monastery has been most closely connected from earliest times to the present.

In the same stylistic group belongs an icon of the Crucifixion in which Christ, 34, 35 following the Palestinian tradition, is depicted wearing a colobium, a tunic decorated with a pattern similar to that on the mantles of the Three Hebrews in the Fiery Furnace. As is usual, Christ is flanked by Mary[14] and John, and, in addition, by the two thieves, who are here given the apocryphal names of Gestas and Dimas. In terms of iconography this Crucifixion has a special significance; it is, as far as we know now, the earliest example of Christ that shows His eyes closed and the crown of thorns,[15] although highly stylized. These features initiate the development of the type that predominates in the later Middle Ages, the suffering Christ on the Cross.

According to its style, this Crucifixion must be dated a little later than the icon of the Three Hebrews. Comparatively speaking, its closest parallel is a fresco of the Crucifixion in Santa Maria Antiqua in Rome, which was executed shortly before the middle of the eighth century.[16] Assuming that our icon was also done about the mid-eighth century, it must stem from the period when icons were banned in the Empire. This, in fact, appears highly probable, for precisely the reason we assumed that it originated in Palestine, a region then under Islamic control and in which the Iconoclastic decrees of the Byzantine emperors had no power. It must be remembered that it was in the Monastery of Saint Saba close to Jerusalem that John of Damascus wrote his *Apology in Defense of the Holy Images,* by which means he must certainly have hoped to ensure the continuing production of icons in Palestine. The Monastery of Saint Catherine on Mount Sinai, always dependent on Jerusalem, possesses more icons from this critical period, thus supporting the idea that there was no interruption in the production of icons in that region.

The period after the termination of the Iconoclast Controversy has been rightly

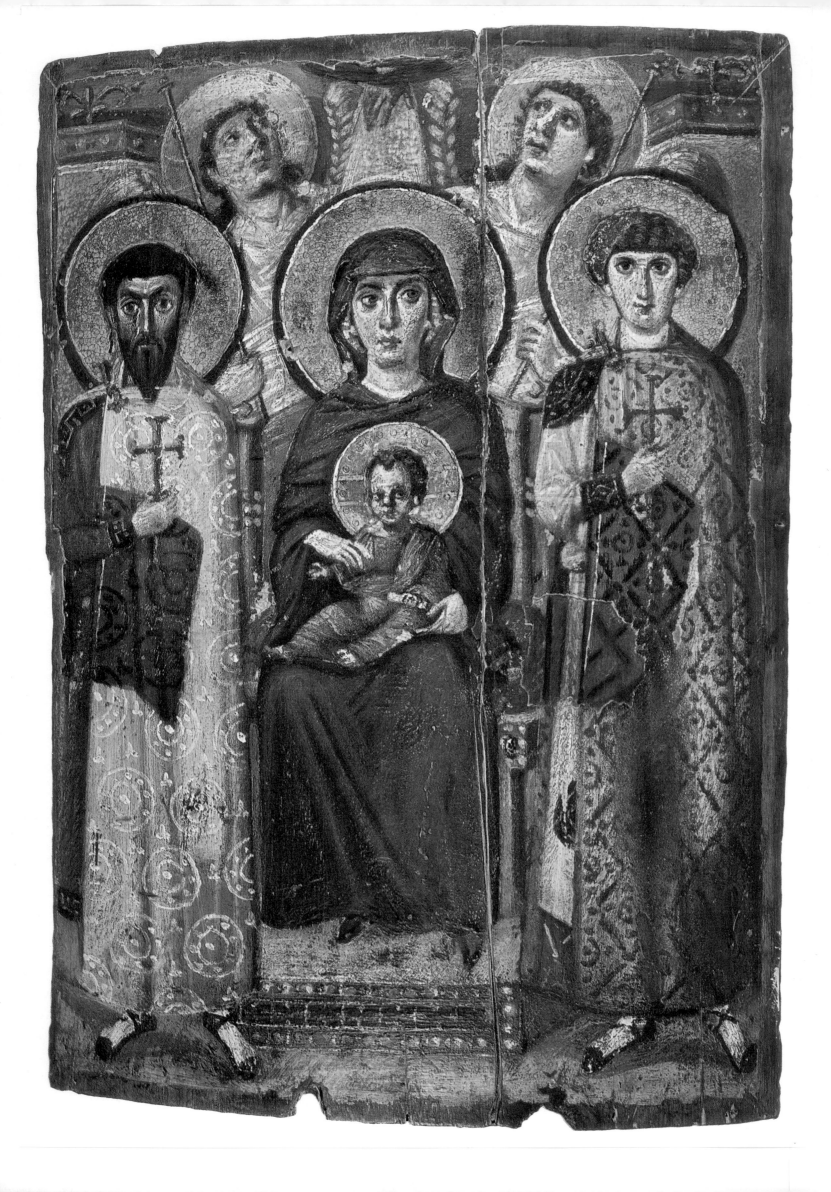

described as the second Golden Age of Byzantium. In the tenth century especially, Constantinople produced manuscript illuminations of the highest quality, along with works in gold and silver, carved ivory, and cloisonné enamel. The reawakened feeling for antique forms was at times so marked as to justify calling this period the Macedonian Renaissance.[17] But no icons from this flourishing period were known until the recent discovery of a few examples in Sinai. While these do not suffice to fill the deplorable gap in our knowledge of the artistic monuments of that epoch, they do help us to reconstruct the history of icon painting in this important century. The seated figure of the Apostle Thaddeus, which occupies the upper half of a wing of a 31 triptych, bears eloquent testimony to the new renaissance spirit. The new feeling is expressed, among other ways, by the gentle billowing-out of the draperies, through which is created a stronger plasticity, although the artist only rarely achieves a convincing impression of a solid body beneath the drapery. Especially striking are the light pastel-like colors,[18] so much like those used in miniature painting at the end of the ninth and the beginning of the tenth century. They recall those of a well-known manuscript, now in the Bibliothèque Nationale in Paris, the Homilies of Gregory of Nazianzus. In fact, our dating of icons of the middle Byzantine period must generally depend on stylistic comparisons with manuscripts, for which dates can more easily be determined.

Yet this relatively more plastic style did not predominate in the tenth century. A rather more dematerialized human body was preferred, especially for depictions of saints, Fathers of the Church, and monks — more in keeping with the ascetic ideal of monasticism. A characteristic example is an icon of Saints Zosimus and Nicholas. 37 Although it has in common with the icon of Thaddeus a very free and painterly brush technique, it is derived ultimately from the study of late antique or early Christian models.

In the second half of the tenth century appears a hardening of the painterly style; this goes hand in hand with an often enamel-like brilliance in the treatment of surfaces. It seems very likely that the subtle technique of cloisonné enamel, then at its highest point of development, must have exercised a profound influence on both icon and miniature painting. An icon of the youthful Apostle Philip shows clearly this 38, 39 change of style. Instead of indicating the folds of the drapery by lightly brushed-in highlights in the impressionistic manner, the folds are rendered here by sharp lines. Especially characteristic is the treatment of the folds over the apostle's upper thigh, which imitates the channeled effects of drilled marble in late antique sculpture. This technique, however, was not derived directly from the ancient source but from a particular group of contemporary ivory carvings in which the surfaces were treated in the same way.[19]

The tenth century was a formative period during which iconography and, to a certain extent at least, style itself tended toward standardized conventions. By the end of the century variants were beginning to disappear. Icons for the cycle of the great church feasts became crystallized into forms that can be termed canonical. Depictions of saints were so rigidly characterized that the slightest variation in the treatment of hair or beards was enough to make clear which particular saint was intended. A half-length figure of Saint Nicholas, the most popular of all saints, as is 40 shown by the large number of icons devoted to him in the Sinai monastery, still represents the phase before standardization; and for that reason this icon, the earliest

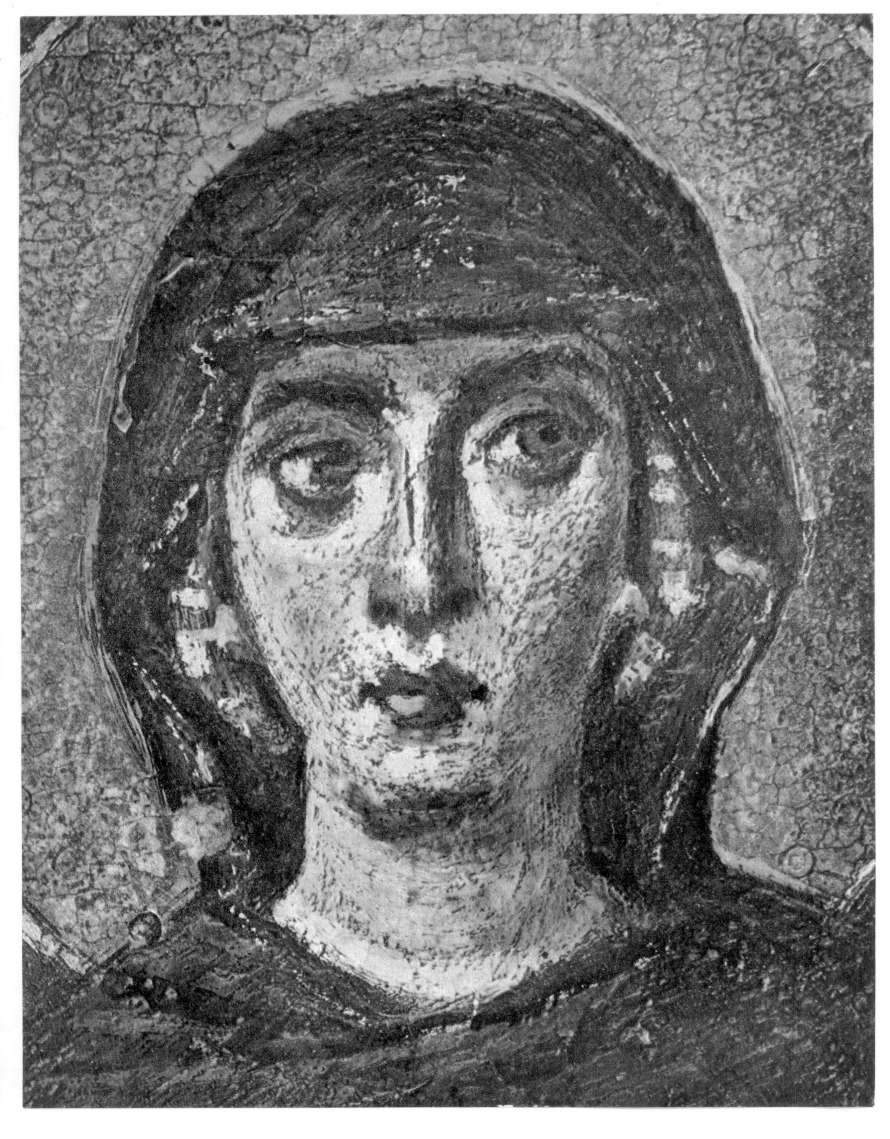

18

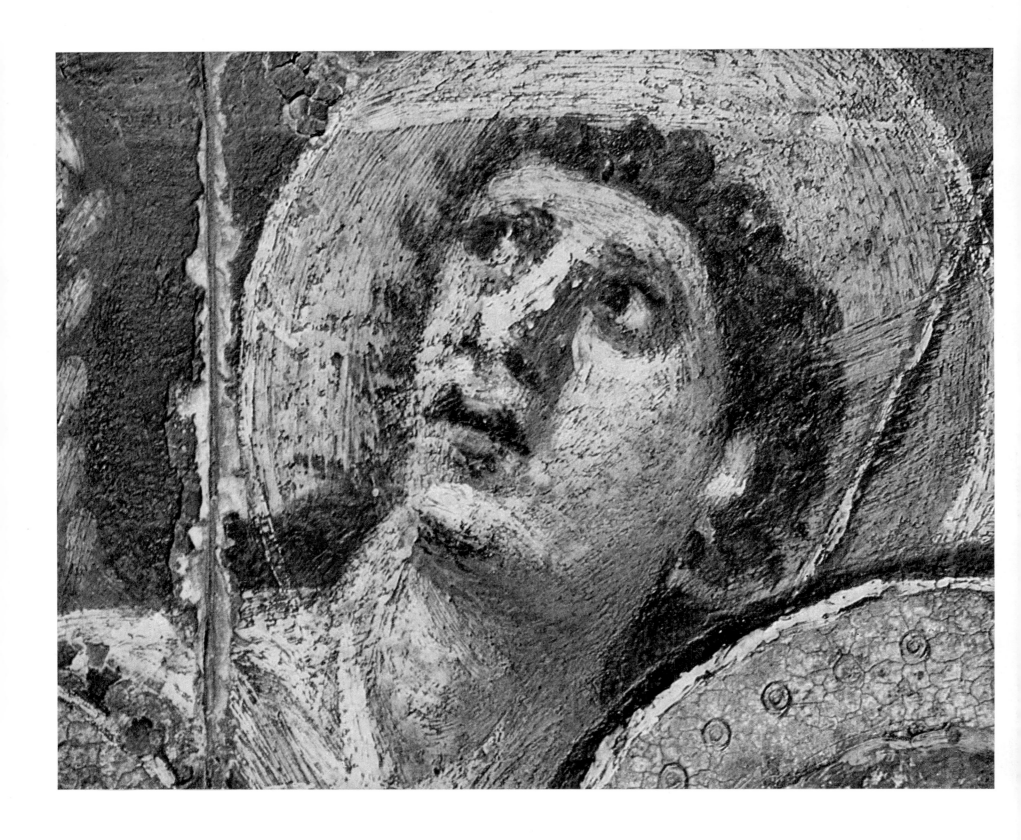

of Saint Nicholas known to us, can still be ascribed to the end of the tenth century. The face is treated in a very subtle and painterly manner. Its organic structure is clear and as yet free of the exaggerations — the overly high forehead and the ornamental treatment of hair — which characterize later icons of this saint. On the other hand, what is typical of later development is the series of medallions with busts of saints which decorates the frame and occupies the place filled by cloisonné enamels in the more lavish icons of the tenth and eleventh centuries.[20] These small busts already show the tendency toward the precious and miniature-like style which was to become the rule in the eleventh century.

The slenderness of the figures on an icon of the Crucifixion strikes us almost as a [43] reaction against the physical solidity of Thaddeus. The figure of Christ, draped in a [31] transparent loincloth, has an organic structure which reveals an understanding of the human body, but the body is at once so elongated as to give the impression of being weightless. John is still depicted with a certain degree of physical reality, convincing mostly through its use of antique-style motifs for the folds of the drapery; while the Virgin is so enveloped in a maphorion that the body beneath it is almost completely hidden. Typical of a great many icons of the eleventh to thirteenth centuries is the effect of a rotating nimbus around the heads, which is achieved by a circular roughening of the gold background. These haloes, imitating a highly refined goldsmith's technique, work together with the brilliant enamel-like surfaces of the painted areas to create the sense of preciousness we associate with reliquaries, especially those containing particles of the Holy Cross.

This effect is even stronger in the nimbi around the medallion busts painted on the frame. These are set in a fixed hierarchical order. John the Baptist is in the center, flanked on either side by an archangel, and each archangel has in turn an apostle at one side; then follow various saints, beginning with the Fathers of the Church as the most important. The hierarchy is that of the liturgical prayer for intercession, and it is an excellent example of how the liturgical element itself dominated the art of the middle Byzantine period, and in particular icon painting. On the central axis, directly beneath the Cross, is the bust of Saint Catherine; this may be taken as a hint that the icon was made for the monastery dedicated to her on Mount Sinai, although it is not necessarily proved that the icon was itself executed there. Constantinople should be taken into consideration first as a place that could have produced an icon of such high technical perfection.

The tendency toward refinement in the icon painting of this period often creates an effect of minuteness that is closely related to manuscript illumination — to such an extent that from time to time one has the impression that the icon painter and the miniaturist may have been the same artist. Direct borrowings from the miniature art, not only in technique but also in content, are seen most clearly when the icon painter enters the special province of the miniaturist and adopts its narrative cycles. Excerpts, for example, were made from the lives of saints, and the separate scenes were either arranged around the raised frame of the icon,[21] as was to become the most customary practice, or else painted on the panel itself; in the case of triptychs, these scenes were placed on the wings. Thus, on a panel fragment we find beneath a Virgin of the Annunciation two scenes from the life of Saint Nicholas — his [25] ordination as a priest and, later, a bishop — done in a remarkably delicate miniature-like style, which to all intents and purposes cannot be distinguished from

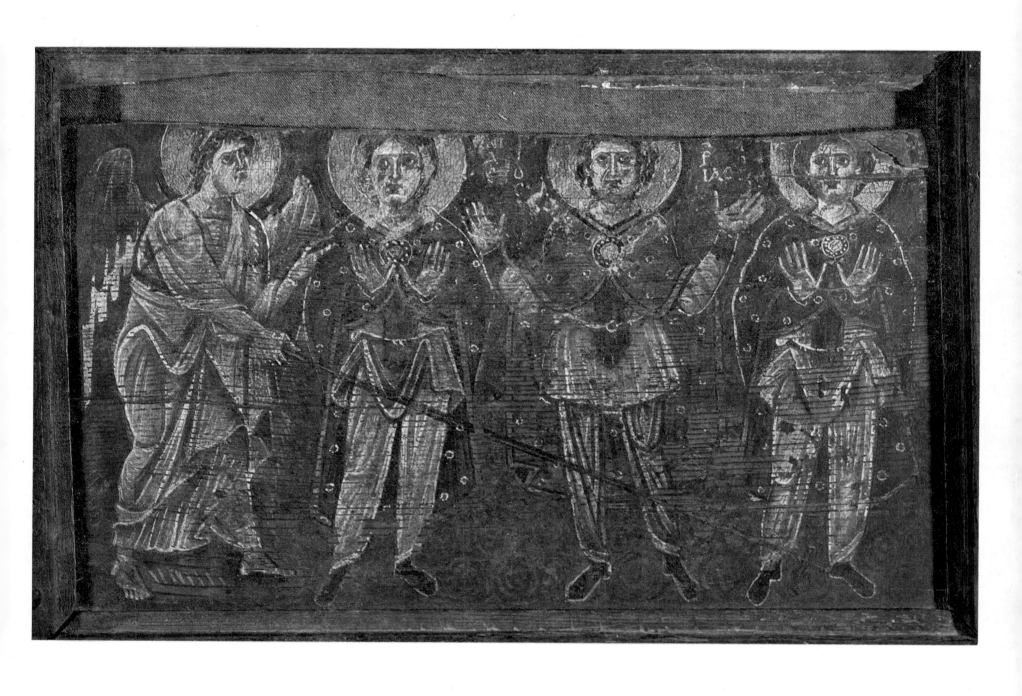

the style in use at the time for manuscript illumination. The fragment is the upper half of a triptych wing, whose lower half, still extant, contains four later scenes from the Saint's life; the lost left-hand wing must have had the Angel of Annunciation along with six more scenes, while still others must have appeared on the lost central panel.

In a similar, miniature-like style that again reveals its origin in manuscript illumination is an icon of the Nativity. The many related episodes in it are disposed in 44, 45 such a way that most of the individual scenes maintain the isolation they would have had if they were still intercalated into the columns of text in a Gospel or Lectionary. The icon painter did not line up the individual scenes according to any scheme, but inserted them between overlapping ranges of mountains. These, however, resemble *coulisses,* theatrical scenery, and remain ornamental, with no apparent spatial depth, the latter being a notion which would not have occurred to the painter. The Nativity is presented as taking place in a cave and is framed by scenes illustrating the Annunciation to the Shepherds and the Arrival, Adoration, and Departure of the Magi: these accessory scenes were common in other feast icons of Christmas. To these, however, were here added the Dream of Joseph, the Flight into Egypt (with a welcoming personification of the city), the Concealment of Elisabeth and the young John, and the Massacre of the Innocents. For all of these episodes parallels can easily be found in the extensive cycles of eleventh century depictions of the Gospel stories,[22] whereas the charming episode of the midwives carrying vessels to the place of the Nativity to bathe the newborn Child is a genre scene otherwise unknown to us. The source must have been a manuscript with numerous illustrations of the sacred event.

One cannot avoid the impression that the icon of the Scala Paradisi, the Ladder to 41 Heaven, must have been copied directly from the title-page miniature in one of the many manuscripts of John Climacus' treatise on that subject.[23] The monks clamber zealously up the thirty rungs of the ladder, corresponding to the thirty virtues treated by John in an equal number of chapters. Their ascent is impeded by the temptations of vices, personified by tiny devils who try to cause the stumbling monks to fall. Only one has virtually succeeded in reaching the goal of heaven; this is John Climacus himself, the author of the treatise and the abbot of the monastery on Mount Sinai. Directly behind him follows a certain Archbishop Anthony, who most likely was another abbot of Sinai, presumably at the period when the icon was made, which means sometime during the eleventh to twelfth centuries. The quality of this icon as a work of art is revealed in the animated rhythm of the climbing monks, in the mixture of typified and individual characterization in the heads, and, not least, in the subtle color range of the monks' garments. This range is rich in nuances and at the same time subdued, in contrast to the gay, light colors of the angels' robes. The broad expanse of gold background, against which the devils stand out sharply in silhouette, is itself a daring feat. The subject matter of the icon suggests that it may have been made, not at, but for Mount Sinai; the icons that we can be fairly certain were executed there are all rougher in style. Thus it seems likely that this icon was made as a gift for the Sinai monastery, and it again seems likely that Constantinople was the place of origin.

In the twelfth century there was another change in style, this time to more solid, more monumental forms; eloquent evidence of this is an icon of Saint Euthymius in 46 prayer. The monk stands his ground immovably, his figure delineated in simple, even

harsh outlines. Nothing distracts our eyes from the powerful head, all of whose details — the contracted brows, the long hooked nose, the tight lips — are keenly noted and full of character, but at the same time are abstractly impersonal. The saint's gaze is directed at a small bust of the Virgin, which resembles an icon and was in all likelihood conceived as such.

The further course of stylistic development in the twelfth century can be demonstrated very well by a type of icon which, at least until now, has not been found elsewhere than at Sinai. These are the beams of an iconostasis that were — and in part still are — placed like a frieze above the architrave; as a rule, they show beneath an arcade the representations of the twelve great feasts. In some instances the cycle of feasts is interrupted in the middle by a Deësis, [24] thereby repeating the theme of the large principal icons of the iconostasis; or it may be expanded by adding some scenes from the life of the Virgin at the beginning of the beam. [25] There are also beams showing scenes from the life of a saint, such as Saint Eustratius, one of the five martyrs of Sebaste; [26] a separate chapel is dedicated to this saint in the Sinai monastery and this work must certainly have been commissioned for that chapel. The earliest surviving beam depicts the twelve feasts along with the Raising of Lazarus. It 49, 50, 51 is in a style that tends toward monumentality, much like that of the icon of Saint Euthymius. Also typical are the almost rectangular contours which flatten the bodies but at the same time serve to integrate the individual figures firmly into the total compositional structure. Movement is confined within fixed limits and does not seem to arise out of any inner necessity; instead, it seems to be imposed from without. This is particularly noticeable in the head of Christ, which cranes far forward, and in the head of Peter, which inclines to one side: both movements are there for no other purpose than to conform to the curve of the framing arch above them. The color scale is strikingly light, almost pastel-like, which is peculiar to this beam, distinguishing it from all the others.

The change of style in the latter half of the twelfth century can be seen in another beam on which it is apparent that more than one artist worked. To the first of those artists can be attributed the Anastasis, or Descent into Limbo, which, in marked 47 contrast to the measured calm of the Raising of Lazarus, is keyed to a high dramatic pitch. Christ strides ahead stormily to seize Adam by the wrist, while Adam leans forward to meet the Saviour with equal energy. The faces reveal a similar intensification of expression: Christ sharply scrutinizes Adam and Eve, whose eyes meet His in supplication. The change in the use of color is also typical: instead of luminous light colors, these are more saturated colors which radiate an inner glow and thereby add to the drama of the scene.

This emphasis on emotion began in the late Comnenian period, and it was accompanied by another new element: the observation of human relationships, which had previously been excluded from Byzantine art as alien to its essentially hieratic character. The earliest datable example of this change of style, which was of such moment for the future development of Byzantine art, comes from 1164, or shortly after; it is the frescoes in Nerezi, in which the depiction of the Lamentation over the Dead Christ [27] has proved to be a key point in the study of this trend toward a more emotional expression. From that time on, the abundant material of fresco paintings, which are relatively easier to date, serves more and more to help us in dating icons, which, by their very nature, lack historical points of reference. Thus,

fresco painting serves a similar function in our investigations of this period to that of miniature painting in the preceding phases of Middle Byzantine art.

The artist who painted the Descent into Limbo also began the Ascension, and completed the left-side group of apostles headed by Saint Paul. Although the Saint Paul with his hand shading his eyes is traditional in type, the figure has been rendered dramatic, above all by the pleated mass of draperies whose agitated folds emphasize the exaggerated motion of the figure. Here the late Comnenian style takes a turn which has certain features in common with the Mannerist style of the sixteenth century.

The Virgin and the group of apostles on the right are attributed to a second artist, for the figures are conceived on a somewhat smaller scale and are much more slender. This is especially evident in the strikingly small heads, a detail which makes the parallel with sixteenth century Mannerism even more obvious. The agitated drapery no longer follows the organic structure of the bodies, underlining their physical reality — as was still very much the case with Saint Paul — but instead it begins to have a life of its own. This is very noticeable in the swirl of drapery over the shoulder of the apostle seen from the rear. In a similar way the motions expressed in the faces are exaggerated: the almost caricature-like sharpness of the profile of the apostle seen from behind, the disheveled hair of Saint Andrew, and the disproportionately high forehead of the apostle behind Peter (presumably Saint John) are characteristic. The ultimate phase, which carries all these elements to even more excess, is known to us from the frescoes in Kurbinovo in Macedonia, dated 1191,[28] and from those in the church of Laghoudera on Cyprus, from 1192.[29] Thus our beam can be dated about the seventh or eighth decade of the twelfth century.

However, the activity of this second artist was no more than an interlude. A third artist did the ascending Christ and the angels who bear aloft the circular mandorla, executed in the rotating technique used for nimbi; his style was more painterly than linear. This third painter also did the final scenes of the cycle of feasts: the Pentecost, and the Dormition of the Virgin. Outwardly the general impression is of greater calm. The turbulent treatment of the draperies is abandoned in favor of a much more simplified approach. However, the emotional element is not only retained, but has, in fact, been intensified through the coloristic means of a freer brush technique. One need only compare the Peter at the head of the bed in the Dormition with the same saint in the earlier Raising of Lazarus: the burning look with piercing eyes in the former is quite different from the fully formed but almost impassive expression in the latter, earlier work. Instead of the traditional emphasis on strong local colors, the painter of the Dormition preferred subdued colors such as olive green in sensitive nuances and tones; these, by means of the symbolic values associated with colors, help bring out the funereal significance of the scene.

With this third, and latest, style of the beam (which today still forms part of an iconostasis, although it is much later in date) we have perhaps passed beyond the time limit proposed. The origin of the artists who painted this cycle of feasts cannot even be guessed at given the present inadequacy of our knowledge of icon painting from that period. On the one hand, there can hardly be any doubt that each one of the stylistic phases of Middle Byzantine art that we have discussed had its origin in Constantinople. On the other hand, the style of the capital, beginning with the eleventh century, was disseminated throughout the provinces to such a degree that

56

57

49, 50

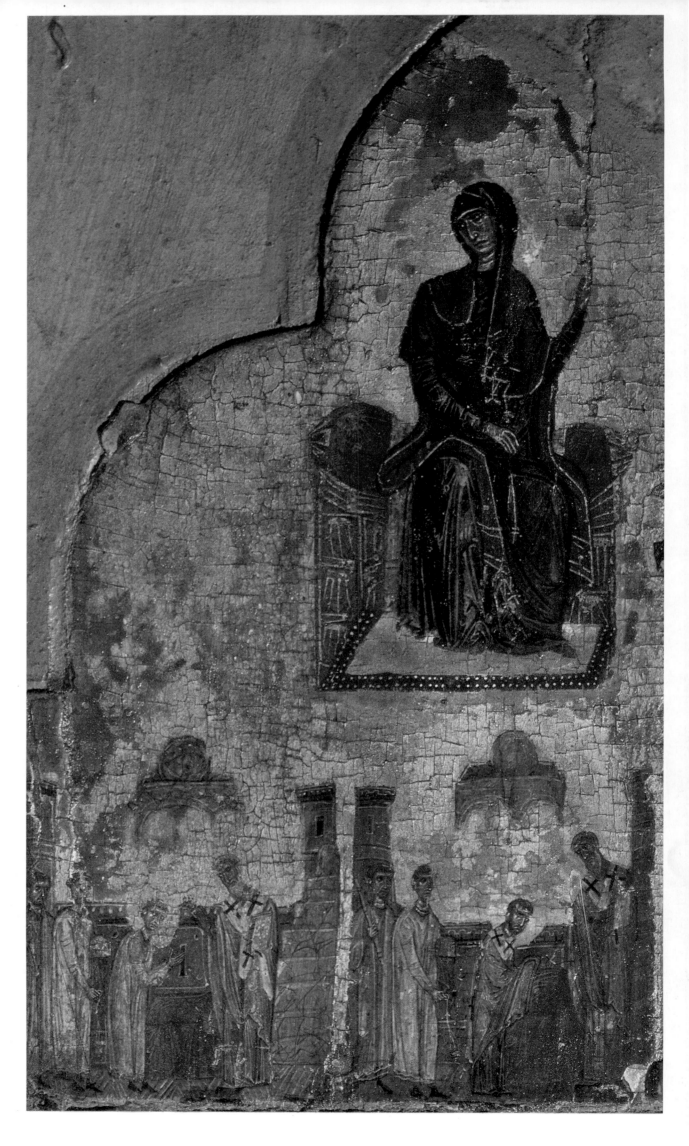

local differences either were absorbed or were suppressed. Today, historians of Byzantine art generally tend to ascribe to Constantinople all works of the highest quality and to hold the provincial centers responsible for anything of lesser quality. Indeed, there are good grounds for assuming that Constantinople attracted the most talented artists, who set new artistic standards. However, in all times and places, the great metropolitan centers have also produced art of a lower level, and for this reason we dare not go so far as to propose any more precise place of origin in the case of the beam from Sinai.

The stylistic phase of the second artist of this beam is found in another icon at Sinai, of such high quality that we cannot hesitate to attribute it to Constantinople. 54 This is an Annunciation, whose almost monochromatic technique, imitating grisaille, is most unusual. Likewise uncommon is its iconography; in the foreground runs a river which we might take to be the symbolic form of one of the epithets of the Virgin, that of the "grace-giving stream." The approaching angel stops and turns round, creating with his double movement a "figura serpentinata." His searching look is directed at Mary and he seems to be struck by the thought that his sudden apparition may have alarmed her. Mary herself is not depicted as the stately matron of the traditional Byzantine Annunciation but rather as a frail maiden who meets the angel's glance with inner agitation and mild apprehension. The more subtle psychological observation, together with the elegant and sensitive drawing of the figures, renders this icon one of the most meaningful examples of late Comnenian art. Both of the fresco cycles mentioned earlier in connection with this particular stylistic phase (those of Kurbinovo and of Laghoudera) include an Annunciation which, in each case, is remarkably similar to that of our icon, but does not at all match it in quality. What is more, the figures on the icon (especially the angel) show a much more marked feeling for the organic form of the human body than do those of the frescoes, which tend toward more ornamentalized forms. All this suggests that the icon must have been painted in the capital. This gives us a clearer insight into the dependency of both Macedonian and Cypriot art upon the art of Constantinople, as well as the possibility of determining more sharply the peculiarities in the style of these peripheral centers.

The late Comnenian style exerted a profound influence not only on the Balkans and the countries east of Constantinople but also on the Latin West. It was correctly recognized long ago that the "maniera greca" of Guido da Siena and other Italian painters of the thirteenth century was derived from Byzantine models. However, all too rarely have Byzantine works been placed for comparison side by side with their contemporary Italian imitations. For this reason, our survey can best be concluded with two icons of the Virgin that represent types which, to a greater or lesser extent, served to inspire the entire art of Christendom of the time — the Orthodox as well as the Latin.

One of these shows the Virgin in prayer. This type of praying Virgin is designated as Hagiosoritissa [30] when only the single figure is depicted; but in this case we are 55 probably dealing with one icon belonging to a group of three — the Virgin, together with Christ and John the Baptist — which constituted a Deësis originally decorating an iconostasis. The heavily shadowed eyes and slightly frowning eyebrows create an impression of gentle melancholy like that in the well-known icon, the Virgin of Vladimir, now in Moscow. Here the expression is truly spiritual, a premonition

perhaps of the suffering the future holds in store for Son and Mother alike. This degree of inner intensity is peculiar to the best Byzantine icons but was rarely attained by imitations in Italy or elsewhere, however great their formal achievement may have been at times.

Our second example is another icon of the Virgin, this time of the so-called Odegitria type.[31] Its archetype was a full-length standing figure, but here we have a 59 half-length figure; what is more, this one is executed in the subtle technique of mosaic wax which in the Middle Byzantine period frequently came to be used for the precious portable icons. The cubes of mosaic are so minute (especially in the face and hands) that they can hardly be made out by the naked eye. This means that the feeling for the material of mosaic was to some degree sacrificed in the imitation of brush technique. On the other hand, the special virtues of the mosaic medium are amply exploited in the gold highlights of the drapery folds, and in the background pattern which imitates cloisonné enamels. In contrast to older iconographic tradition, the Virgin here inclines her head slightly toward the Child; this gives the image a somewhat human feeling, although her gaze does not meet that of the Child. This brings out clearly the basic postulate of Orthodoxy, which limits icon painting to the sphere of the hieratic and transcendental. After a certain period, it was these limitations which artists of the Latin West no longer respected. The weightless pose of the Child, seated so unsteadily on the Virgin's arm that He almost seems to be about to slide off, belongs within the same hieratic convention. Such abstractions are the fundamental presuppositions in icon painting, which aims at a stronger, more religious power of conviction.

We are all too conscious of having given only the most sketchy outline of icon painting from the sixth to the twelfth century. For this we have depended entirely on material preserved in the Monastery of Saint Catherine on Mount Sinai, where the largest body of icons from those centuries has survived. The very few icons known from that period which have been found elsewhere can for the most part be traced back to this monastery. Be that as it may, it would be wrong to assume that the collection on Mount Sinai can give us a complete cross-section of the history of icon painting in the centuries here discussed. Even if it could be proved that, as we have proposed, the two finest icons of the sixth and seventh centuries actually came from Constantinople, certain questions would still remain unanswered. We do not yet know what the icons from Constantinople were really like at the end of the seventh and the beginning of the eighth century; nor do we know whether icons were in fact produced in the capital and the Byzantine Empire proper in the interval between the two phases of the Iconoclast ban on images, or even what the style of the first icons may have been after the defeat of the Iconoclasts. Furthermore, even if our hypothesis that there was a separate School of Jerusalem should be proved correct, it would not alter the fact that Jerusalem was only one of a number of centers where icons were made and that there must have been other centers of equal importance as yet unknown.

If it is a step forward in our knowledge to have identified a few icons as belonging to the tenth century, it must be admitted that they fail to live up to our expectations with respect to that flourishing century. Only in the eleventh century does the Sinai material become sufficiently abundant to permit hope of some day reconstructing a coherent history of the icon's development during this period. Only then will we be

able to establish the basis for an understanding of just how the style of Constantinople — which is more or less synonymous with that of Byzantium as a whole — made its influence felt within the neighboring countries, especially in those of the Balkans, which lie so close to this great center of the past.

1. Much has been written about the Iconoclast Controversy. The references here have been chosen from writings by art historians concerned with the icons that have survived from that time: A. GRABAR, Martyrium, Recherches sur le culte des reliques et l'art chrétien antique, II, Paris, 1946, pp. 343 ff.; idem, L'Iconoclasme byzantin, Dossier archéologique, Paris, 1957; E. KITZINGER, The Cult of Images in the Age before Iconoclasm, Dumbarton Oaks Papers, VIII, 1954, pp. 85 ff.

2. Д Айналовь, Синайскія Икона Восковои живописи, in : Византиский Временник, IX, 1902, pp. 343 ff., Plates I-V

3. G. and M. SOTIRIOU, Icônes du Mont Sinai, I (Plates), 1956, II (Text), 1958

4. O. RUBENSOHN, Aus griechisch-römischen Häusern des Fayum, Jahrb. d. Arch. Inst., XX, 1905, pp. 16 ff., pls. 1-3

5. R. PAGENSTECHER, Klapptafelbild, Votivtriptychon und Flügelaltar, Arch. Anz., XXXIV, 1919, pp. 9 ff., figs. 1-4

6. A third masterpiece of the early period has been revealed under later overpainting, an icon of a bust of Christ, published by M. CHATZIDAKIS in Art Bulletin, 1967.

7 H. ZALOSCER, Porträts aus dem Wüstensand, die Mumien-bildnisse aus der Oase Fayum, Vienna, 1961, fig. 2

8. E. KITZINGER, op. cit., p. 90

9. K. A. NEUGEBAUER, Die Familie des Septimius Severus, Die Antike, XII, pp. 155 ff., pls. 10-11

10. That disc-shaped icons were still common in the ninth and tenth centuries is shown by certain miniatures in the Vatican Menologion and by a few marginal psalters. Cf. A. GRABAR, L'Iconoclasme byzantin, pp. 219 ff., figs. 139 ff.

11. R. DELBRUECK, Die Consulardiptychen und verwandte Denkmäler, Berlin-Leipzig, 1929, nos. 19-21 (Anthemius and Anastasius)

12. The same motif is found on a sixth century ivory plaque, presumably from Syria, the so-called Murano Diptych in the Museum of Antiquities in Ravenna. W. F. VOLBACH, Elfenbeinarbeiten der Spätantike und des frühen Mittelalters, Mainz, 1952, p. 64, no. 125, pl. 39

13. For an attempt to relate a pre-Iconoclastic group of icons with Jerusalem as the most probable place of origin, cf. K. WEITZMANN, The Jephthah Panel in the Bema of the Church of St. Catherine's on Mount Sinai, Dumbarton Oaks Papers, XVIII, 1964, pp. 341 ff.

14. For the archaic inscription ΗΑΓΙΑ ΜΑΡΙΑ and a criticism of the thesis that it was limited to Egyptian art, see K. WEITZMANN, Eine vorikonoklastische Ikone des Sinai mit der Darstellung des Chairete, Festschrift Johannes Kollwitz; TORTULAC, Studien zu altchristlichen und byzantinischen Monumenten, Röm. Quartalschrift, 30. Supplementheft, 1966

15. From the extensive bibliography of recent years on the subject of Christ on the Cross with closed eyes, I shall cite only one study because it corrects the late dating proposed by Grondijs. J. R. MARTIN, The Dead Christ on the Cross in Byzantine Art, Late Classical and Medieval Studies in Honor of A. M. Friend, Jr., Princeton, 1955, pp. 189 ff.

16. J. WILPERT, Die römischen Mosaiken und Malereien der kirchlichen Bauten vom IV.-VIII. Jahrhundert, II, p. 687; IV, pl. 180. E. KITZINGER, Römische Malerei vom Beginn des 7. bis zur Mitte des 8. Jahrhunderts, Munich (dissertation), 1934, pp. 26 ff.

17. K. WEITZMANN, Geistige Grundlagen und Wesen der Makedonischen Renaissance, Arbeitsgemeinschaft für Forschung des Landes Nordrhein-Westfalen, Geisteswissenschaft series, no. 107, Cologne, 1963 (with previous bibliography on this subject)

18. These appeared with all their luminosity only after the icon was cleaned by Carroll Wales, the restorer for the Alexandria-Michigan-Princeton expedition.

19. A. GOLDSCHMIDT and K. WEITZMANN, Die byzantinischen Elfenbeinskulpturen des X.-XIII. Jahrhunderts, II, Berlin, 1934, pp. 13 ff., 25 ff., and pls. I-IX. In the present context we are concerned with the ivories of the so-called "painterly group"

20. A. PASINI, Il tesoro di San Marco in Venezia, Venice, 1885, pls. II, IV, XXIII

21. G. and M. SOTIRIOU, op. cit., I, pls. 165-70

22. The most comprehensive cycles known belong precisely to the eleventh century: the Paris codex Bibl. Nat. gr. 74 (cf. H. OMONT, Evangiles avec peintures byzantines du XIe siècle, Paris, n. d.) and the Florentine codex Laurenziana Plut. VI, 23 (cf. G. MILLET, Iconographie de l'Evangile, Paris, 1916, passim).

23. J. R. MARTIN, The Illustration of the Heavenly Ladder of John Climacus, Princeton, 1954, is a study of the collected illustrated manuscripts of this work.

24. G. and M. SOTIRIOU. op. cit., I, pls. 95-96, 113, 115

25. Ibid., I, pls. 99, 101, 125

26. Ibid., I, pls. 103-111; II, pp. 109 ff.

27. N. L. OKUNEV. La Découverte des anciennes fresques du

monastère de Nerez, Slavia: Casopis pro Slovanskou Filologii, VI, 1927-28, pp. 603 ff.; G. MILLET and A. FROLOW, La Peinture du moyen-âge en Yougoslavie, Fasc. I, Paris, 1954, pls. 15-21; A. GRABAR, Byzantine Painting, Geneva, 1953, p. 141 and fig. p. 143; O. BIHALJI-MERIN, Fresken und Ikonen: Mittelalterliche Kunst in Serbien und Makedonien, Munich, 1958, pl. 26

28. R. LJUBINKOVIC, Stara crkva sela Kurbinovo, Starinar, XV, 1940, pp. 101 ff.; G. MILLET and A. FROLOW, op. cit., pls. 84-85

29. 'Α. Στυλιανοῦ, Αἱ τοιχογραφίαι τοῦ ναοῦ τῆς Παναγίας τοῦ 'Αράκου, Λαγουδερά, Κύπρος.

Perpragmena, IXe Congrès international des études byzantines, Salonica, 1953, Athens, 1955, pp. 459 ff. and pls. 142-57; A. H. S. MEGAW, Comnenian Frescoes in Cyprus, XIIe Congres international des etudes byzantines, Ohrida, 1961, Resume des communications, p. 69

30. S. DER NERSESSIAN, Two Images of the Virgin in the Dumbarton Oaks Collection, Dumbarton Oaks Papers, XIV, 1960, pp. 77 ff.

31. One of the earliest examples of the full-length Odegitria is one of the title miniatures of the Syrian Rabula Codex from A.D. 586. C. CECCHELLI, G. FURLANI, and M. SALMI, The Rabbula Gospels, Olten, 1959, folio 1 verso.

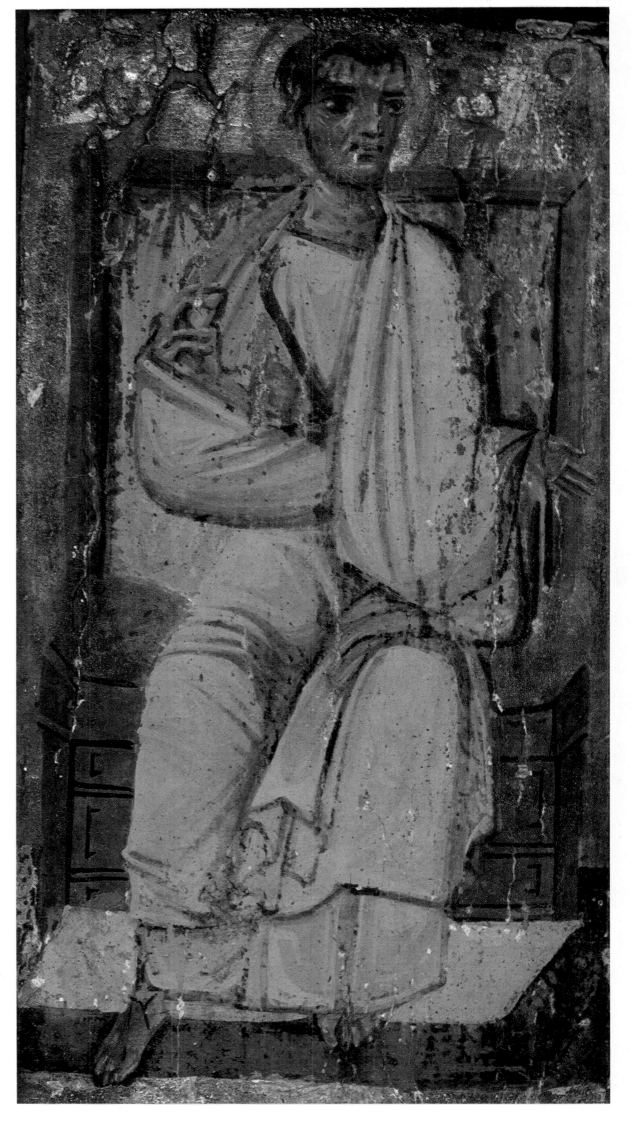

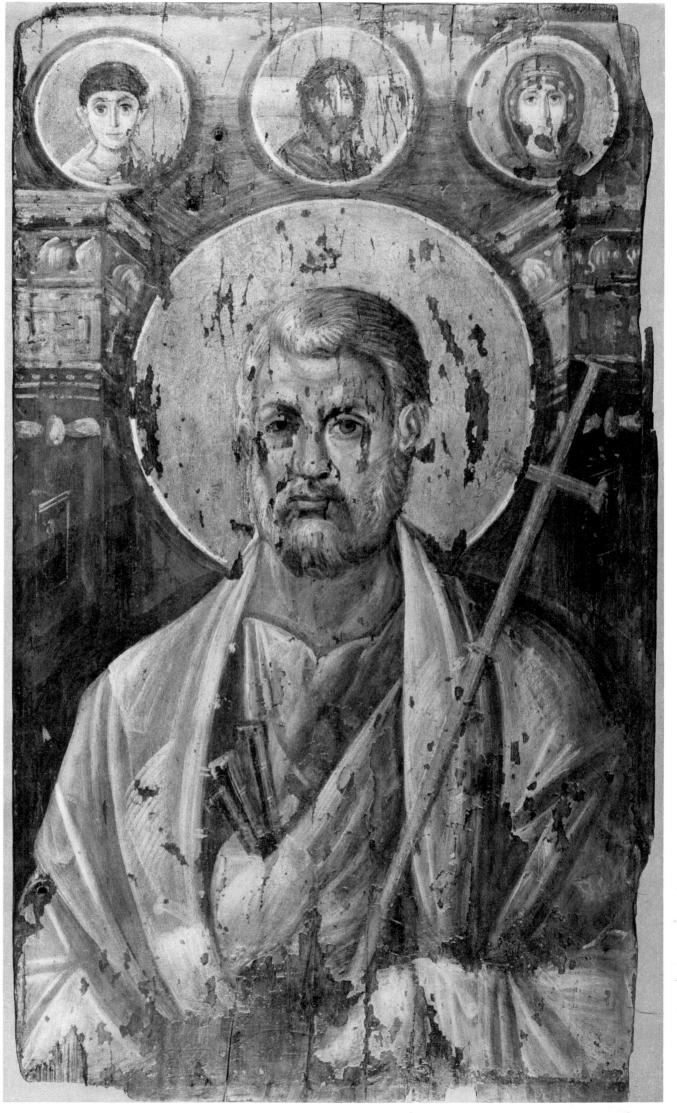

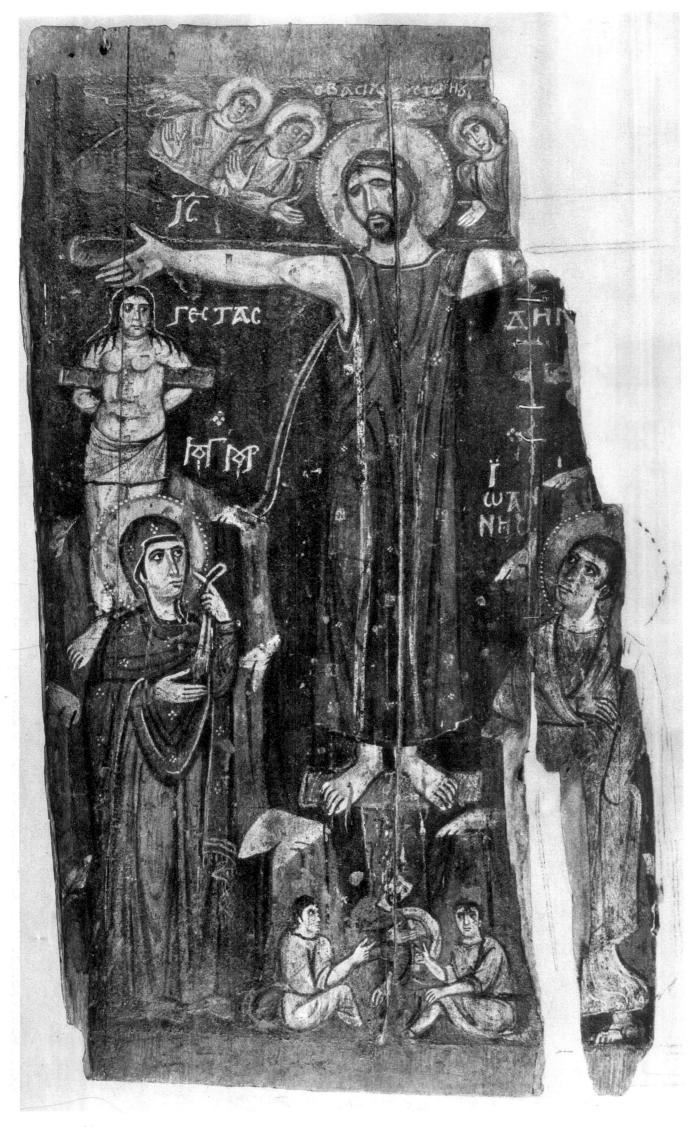

34

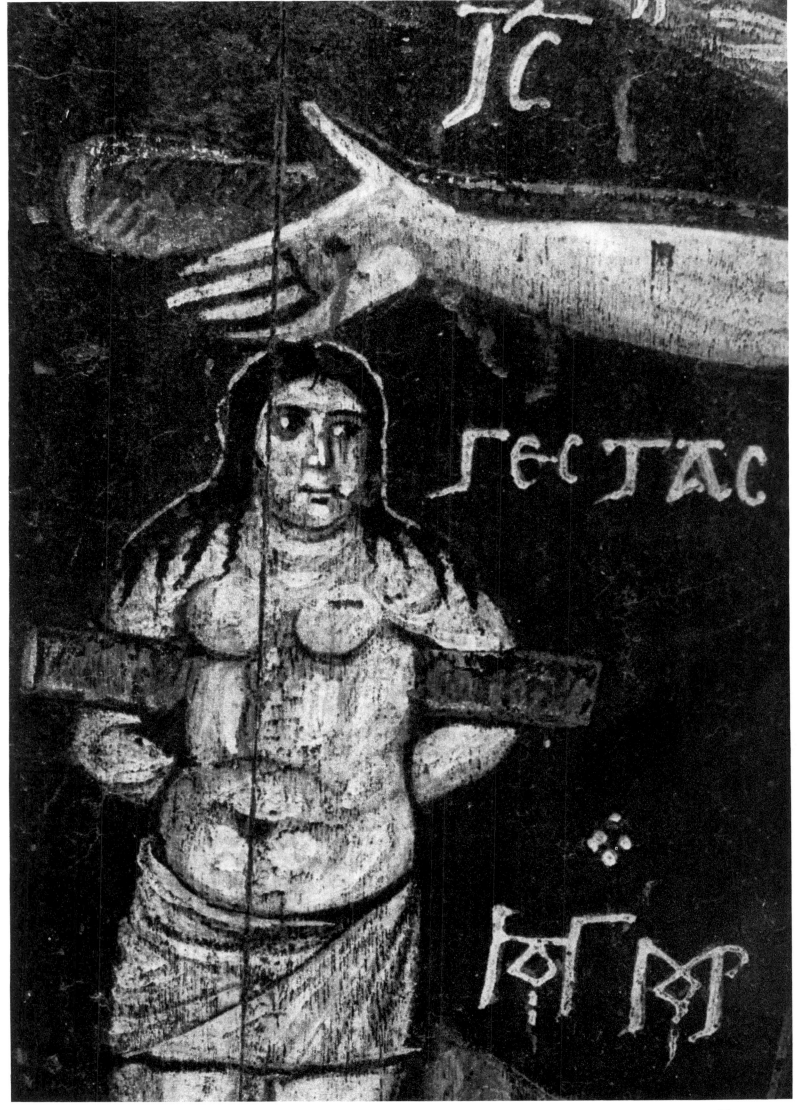

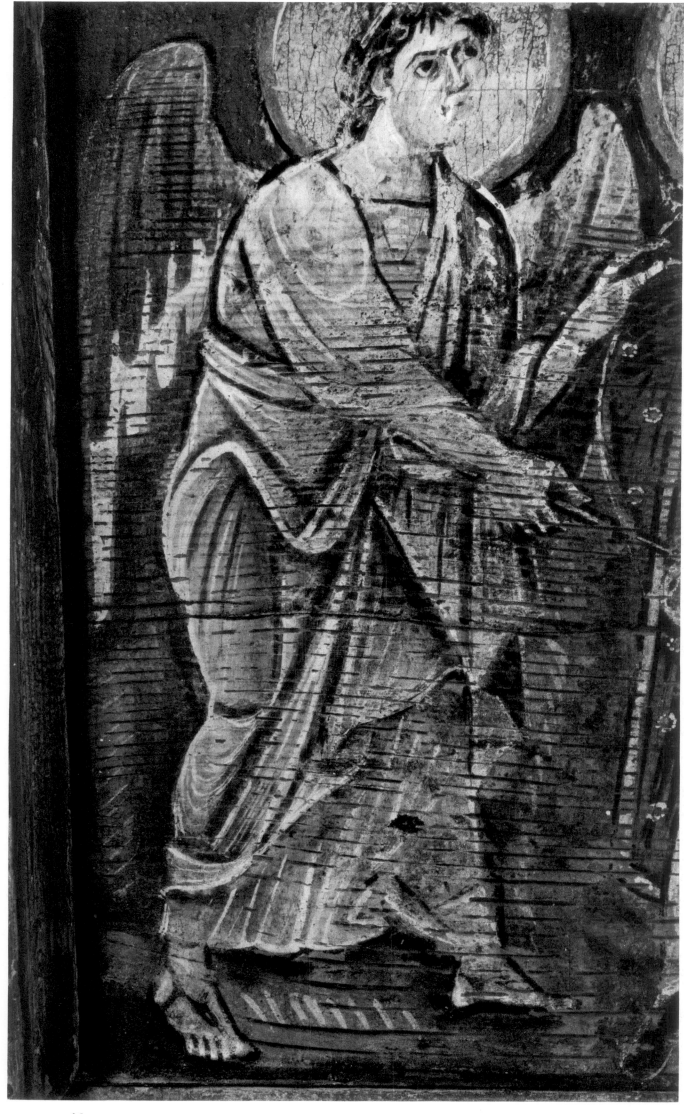

36

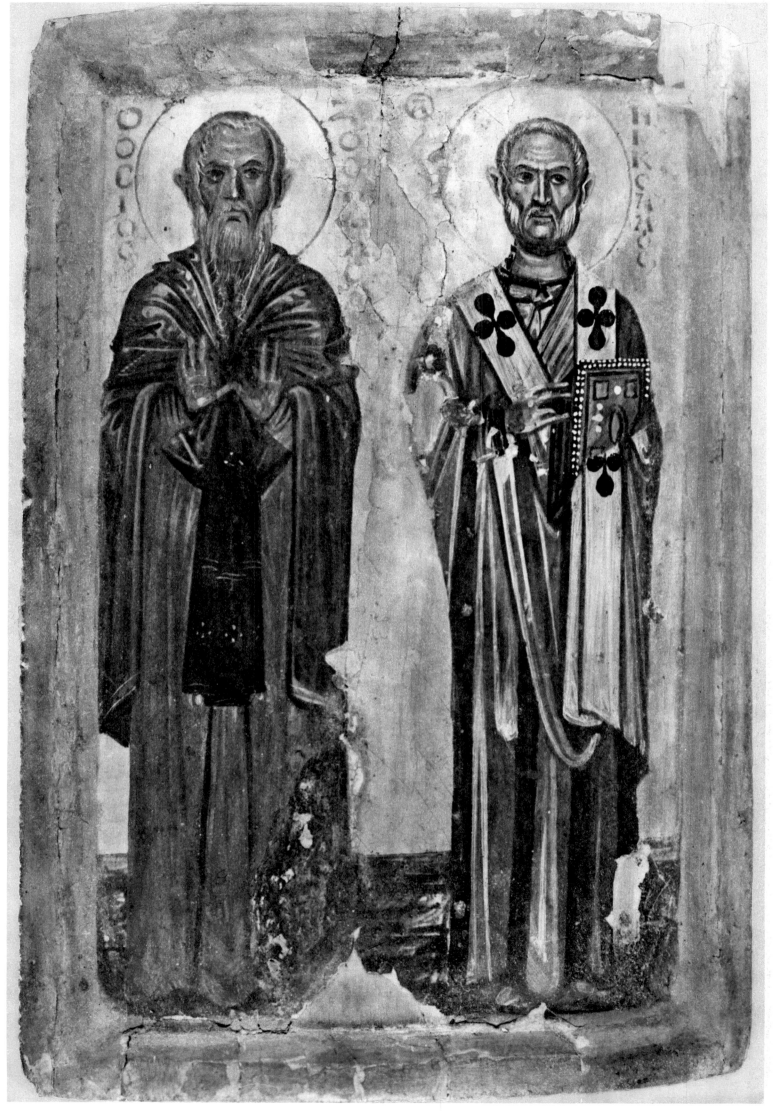

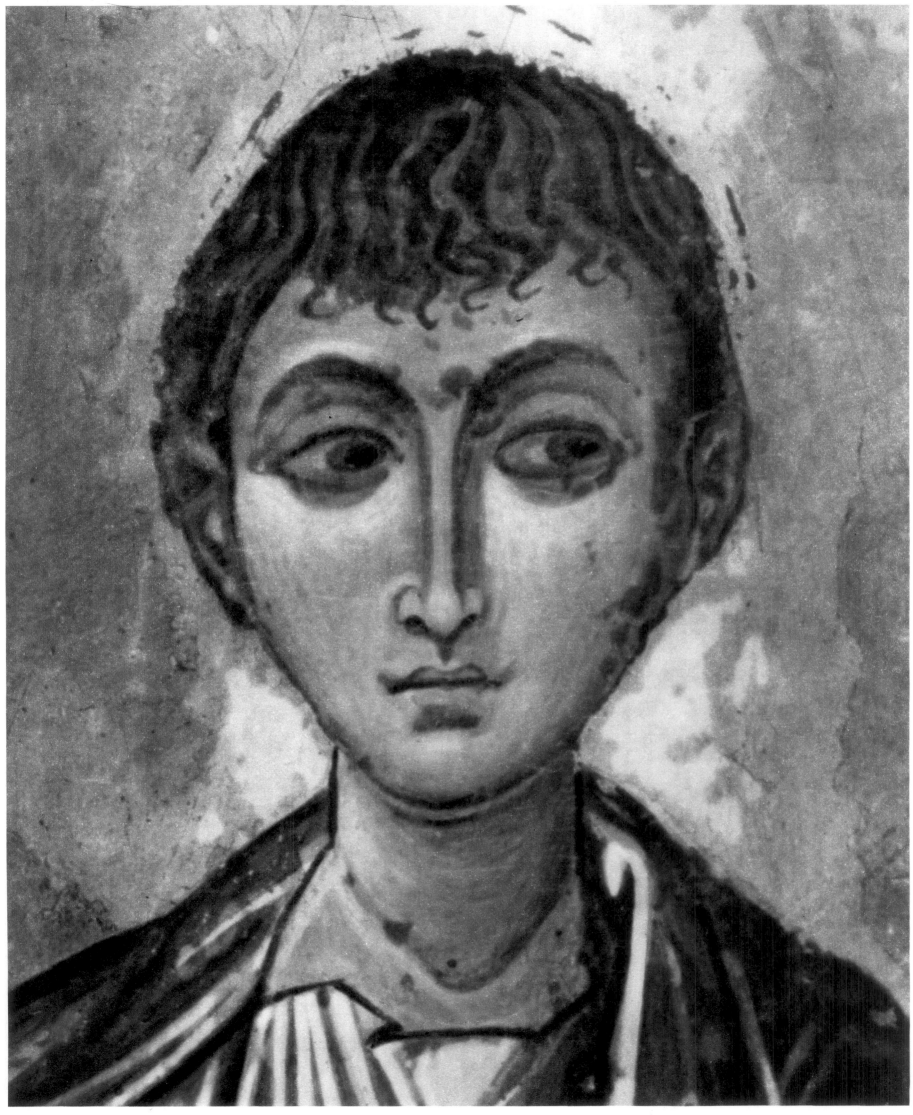

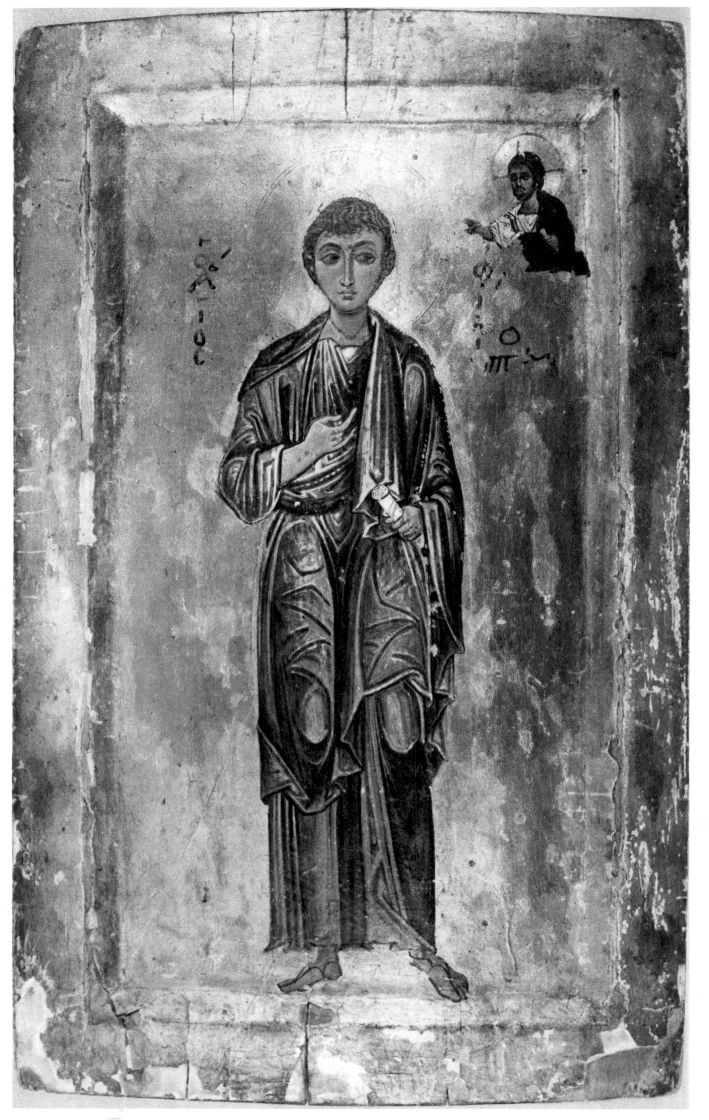

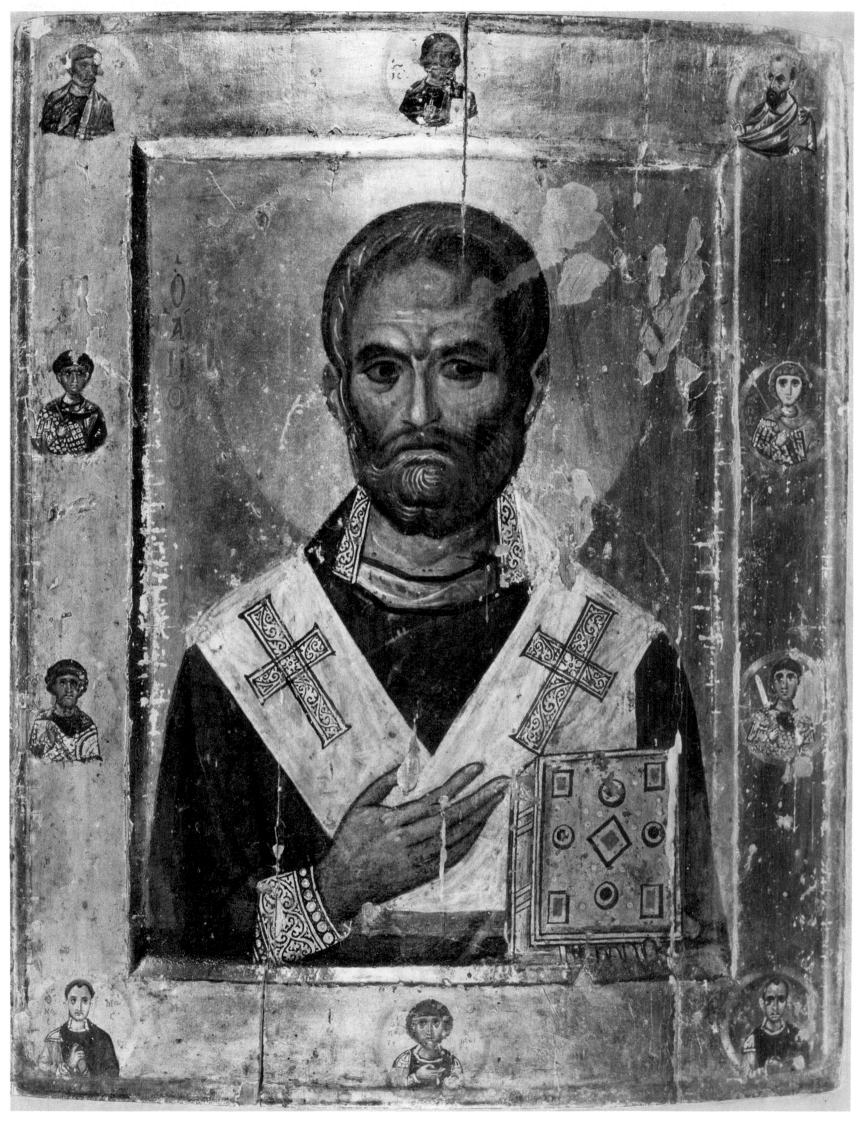

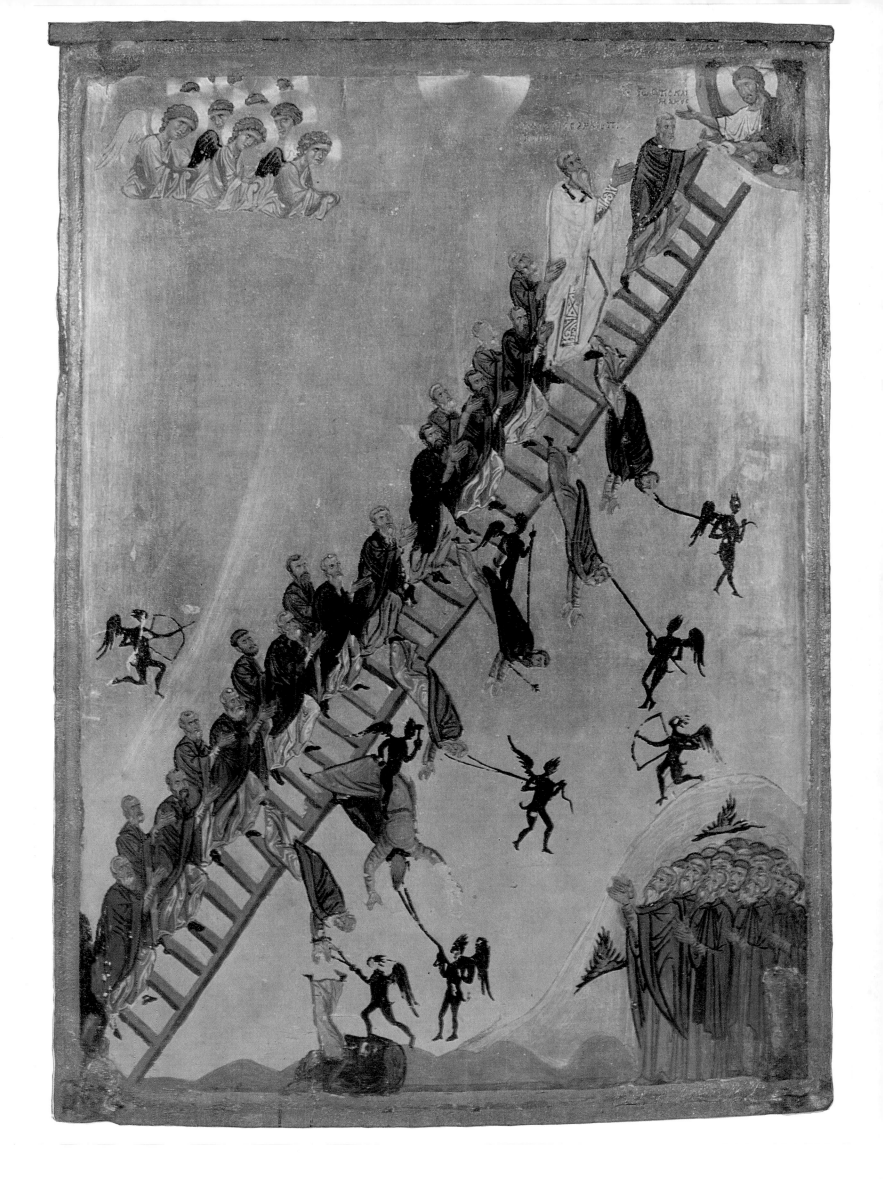

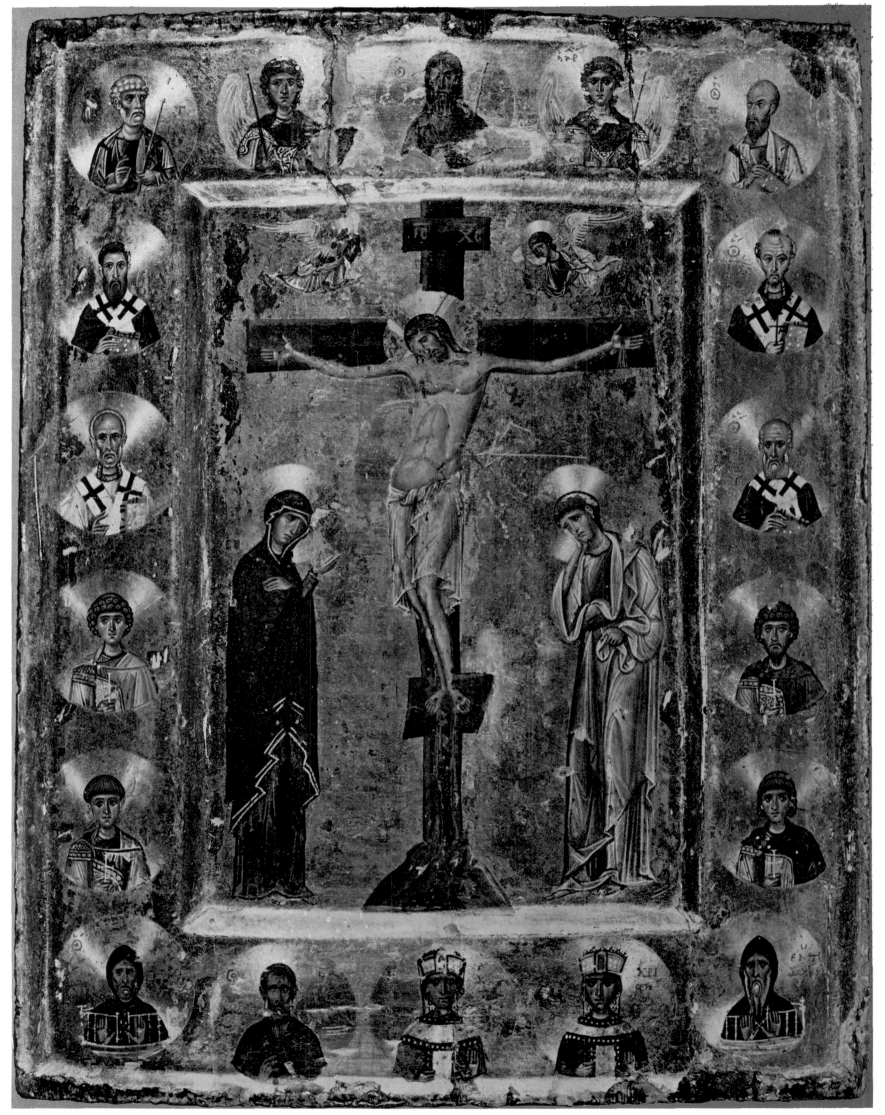

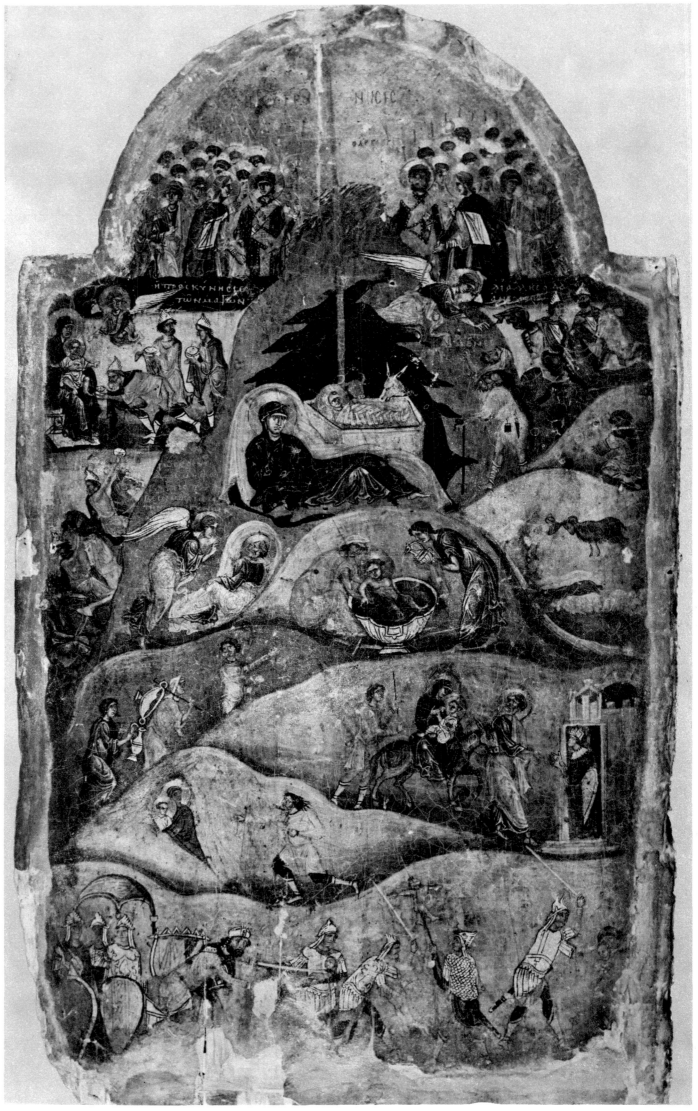

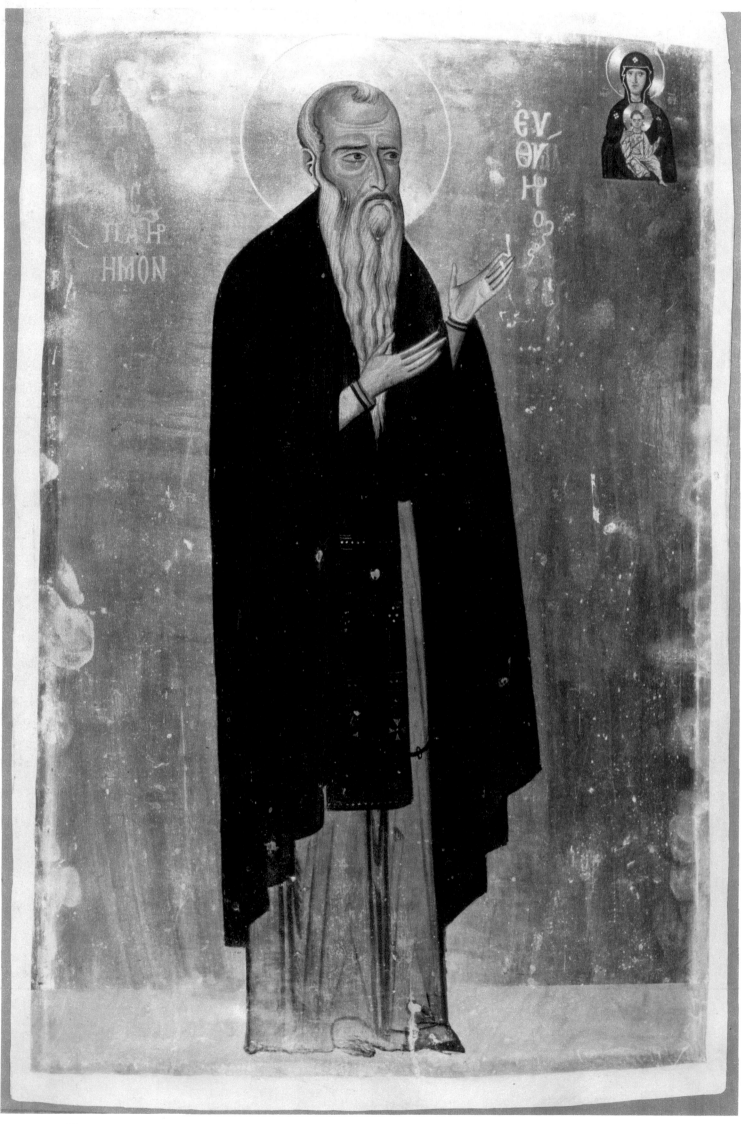

46

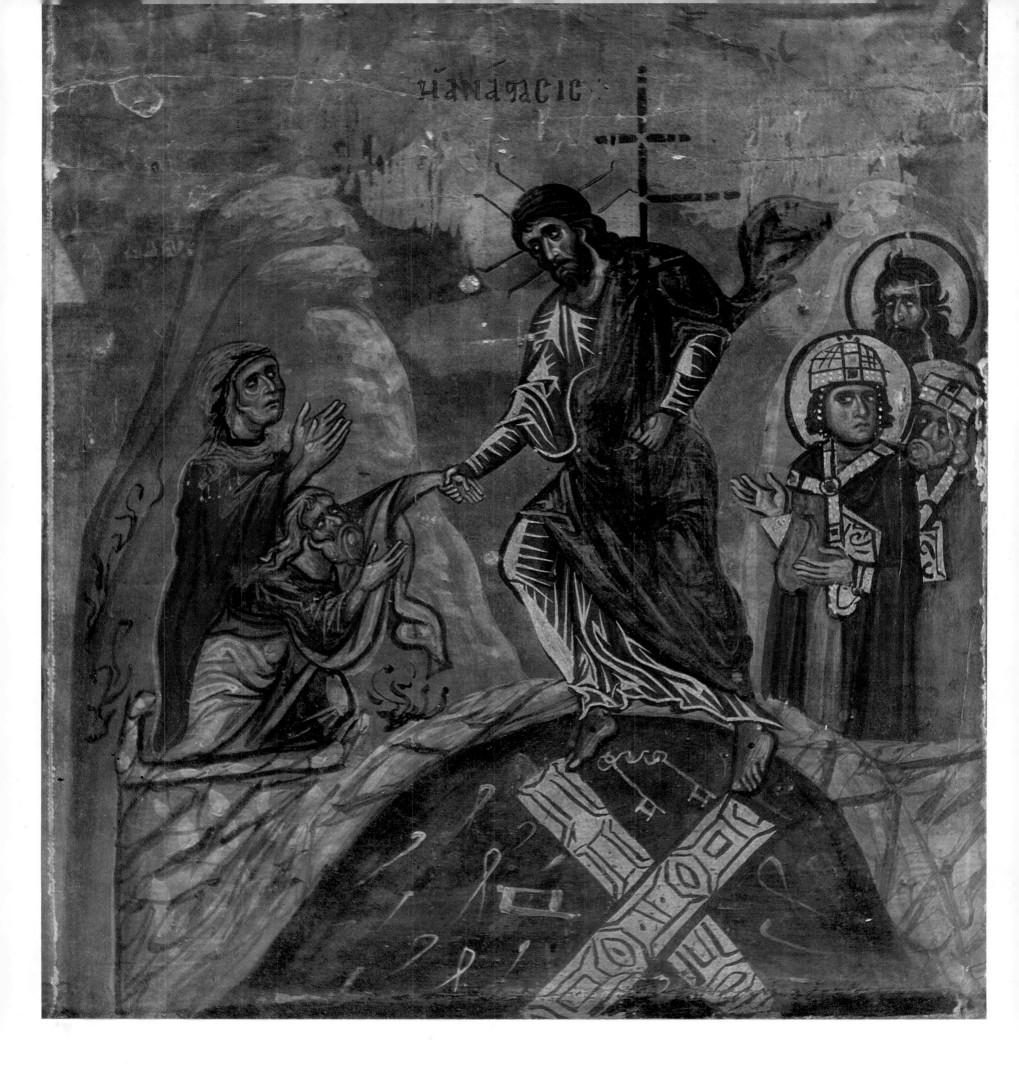

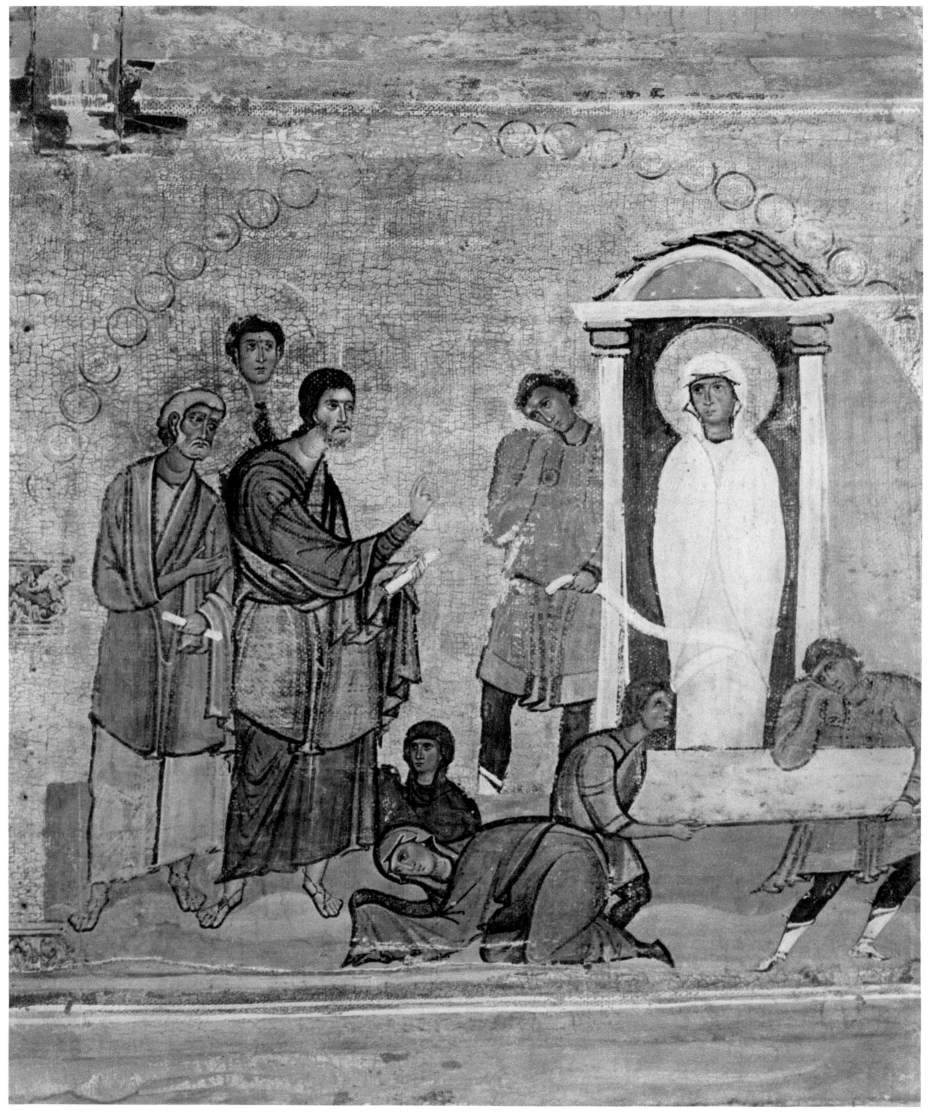

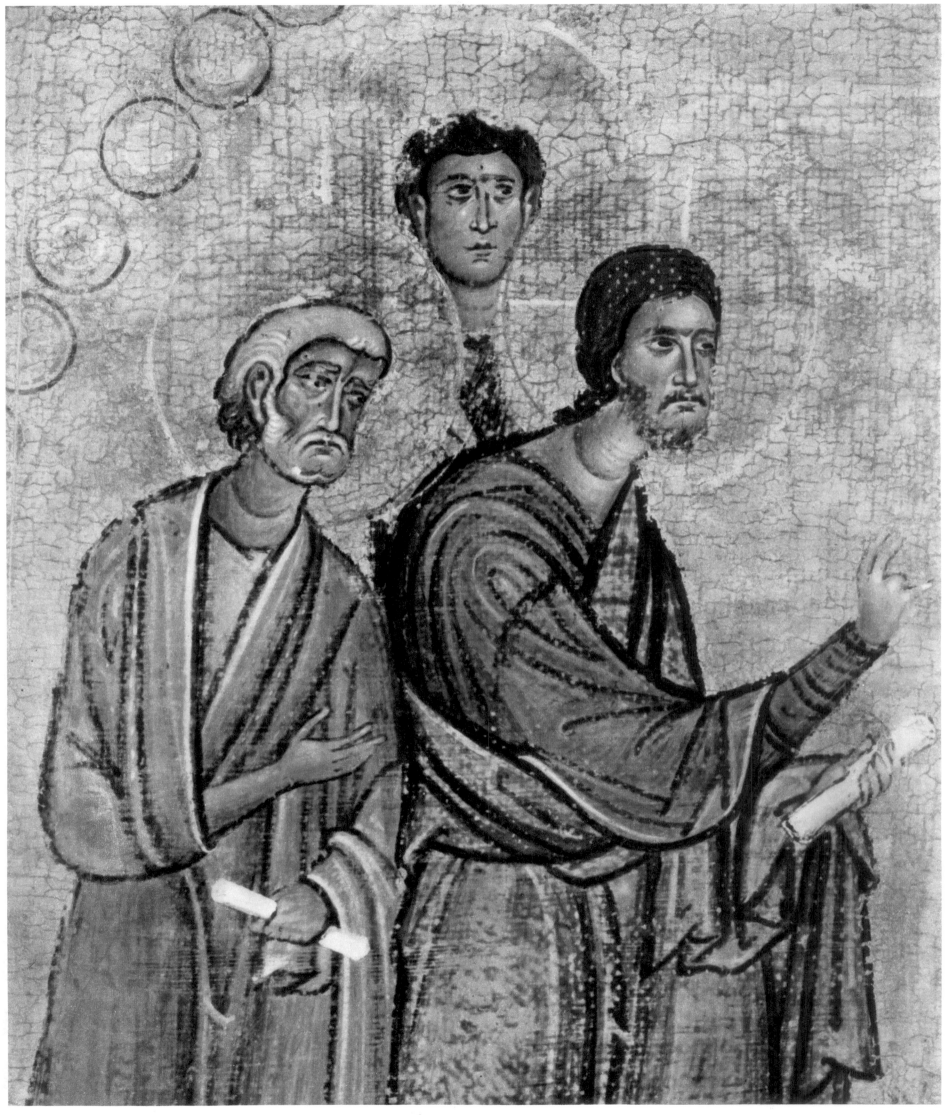

50

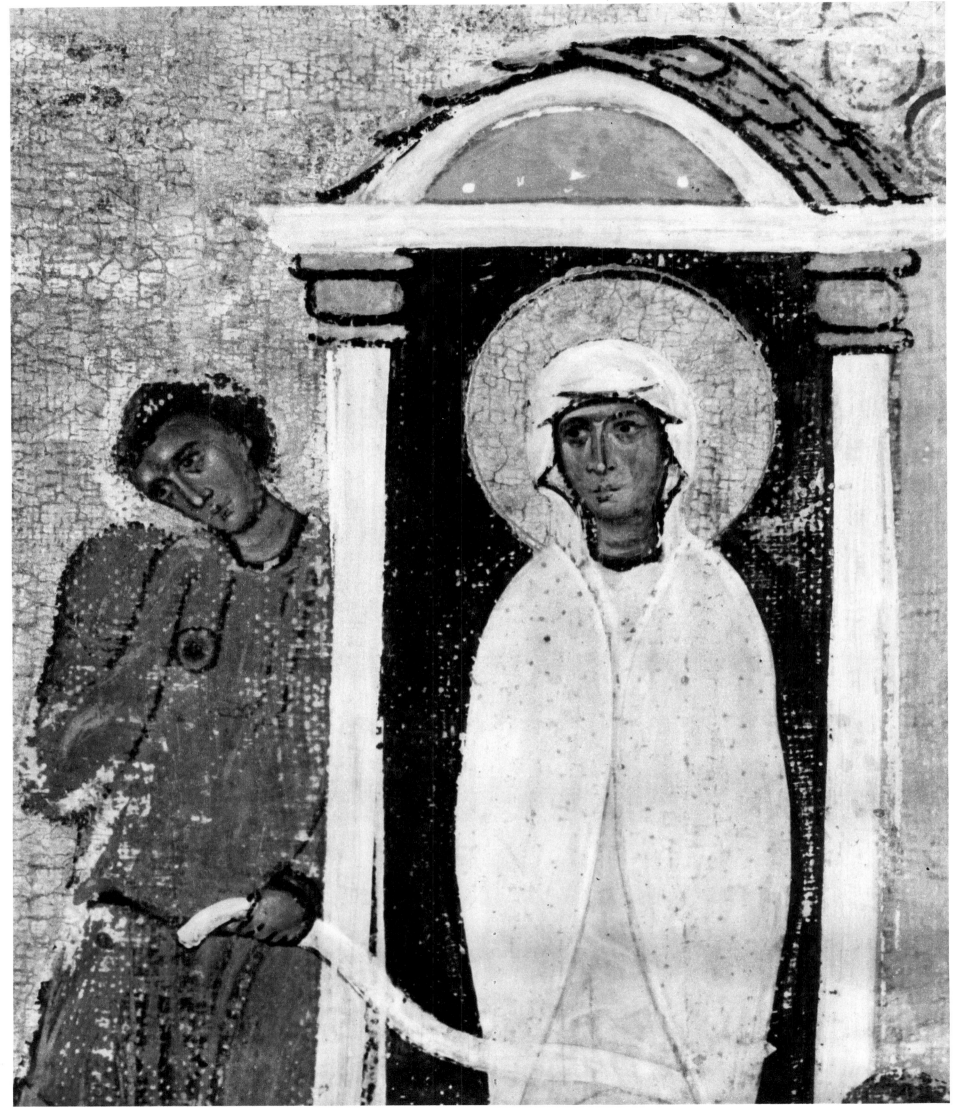

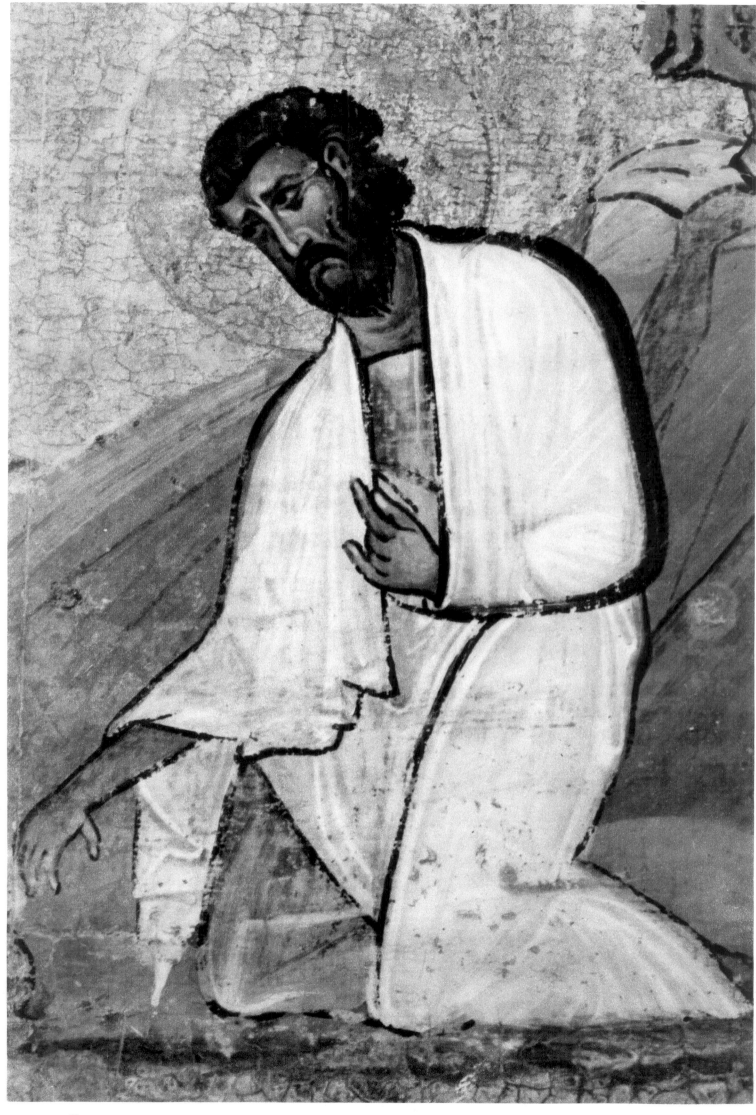

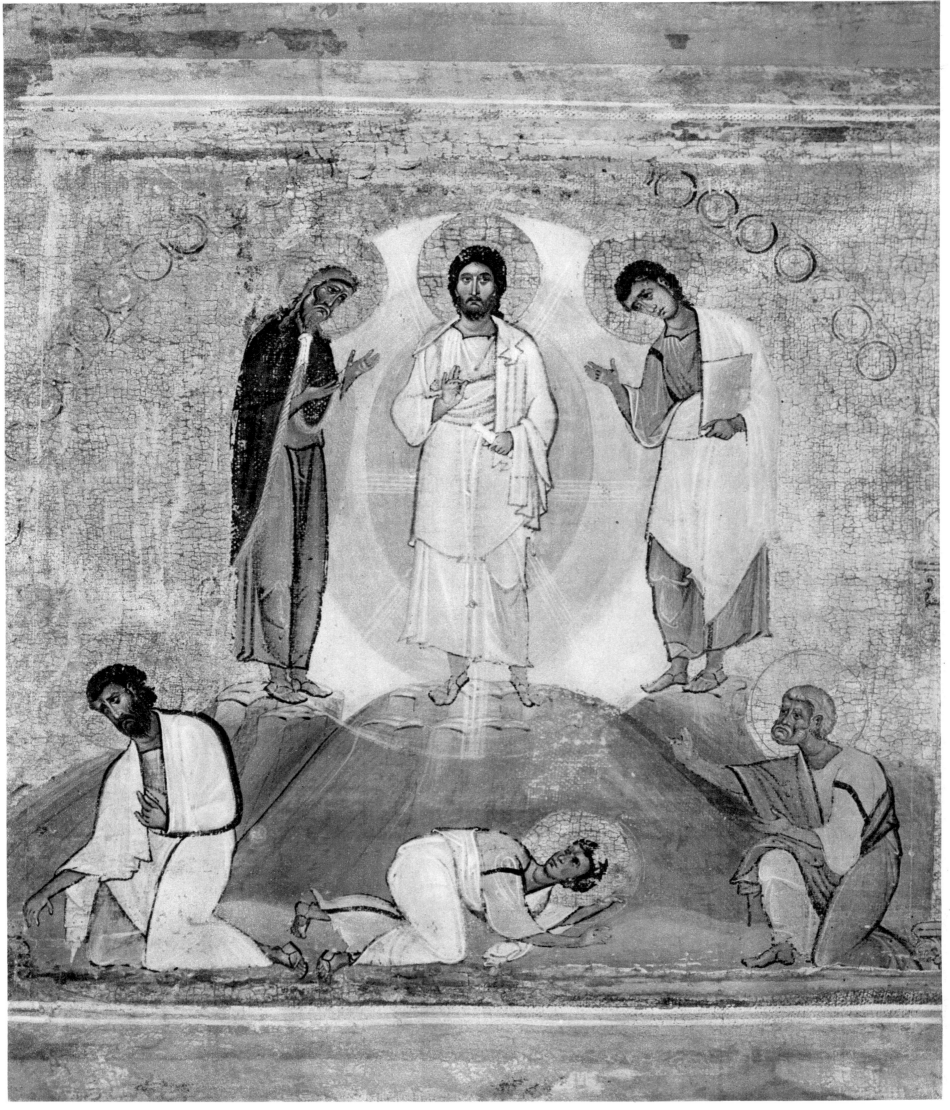

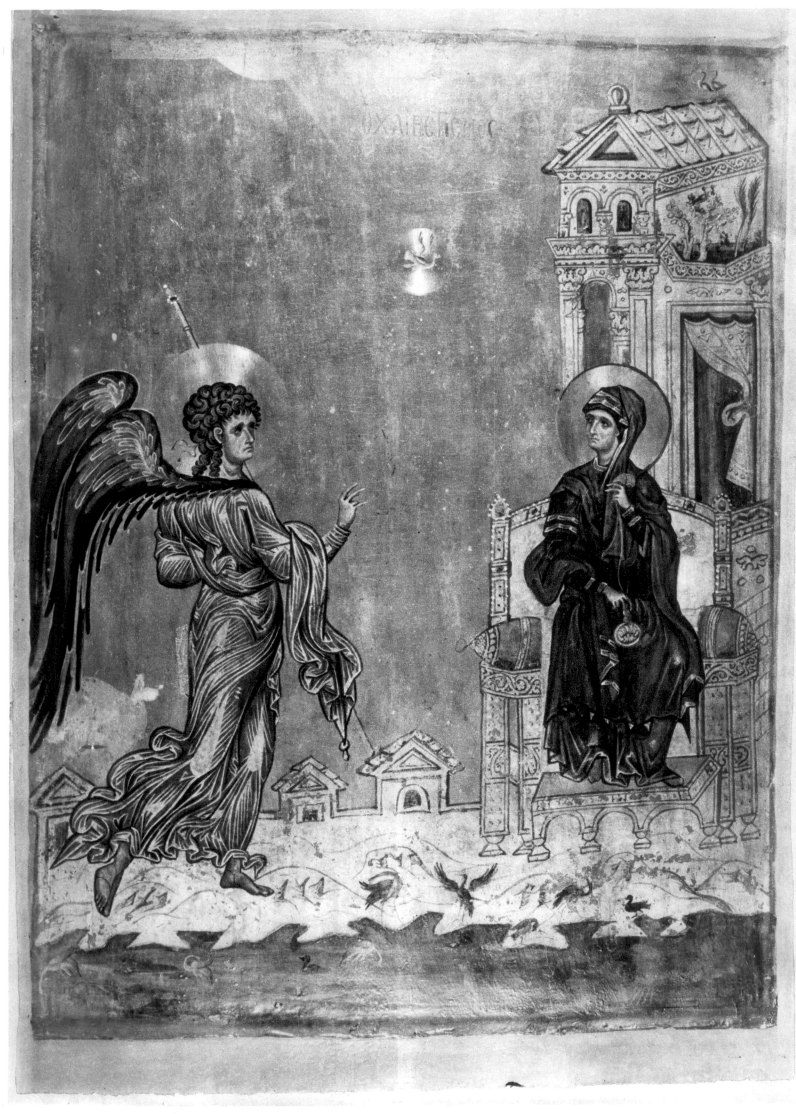

54

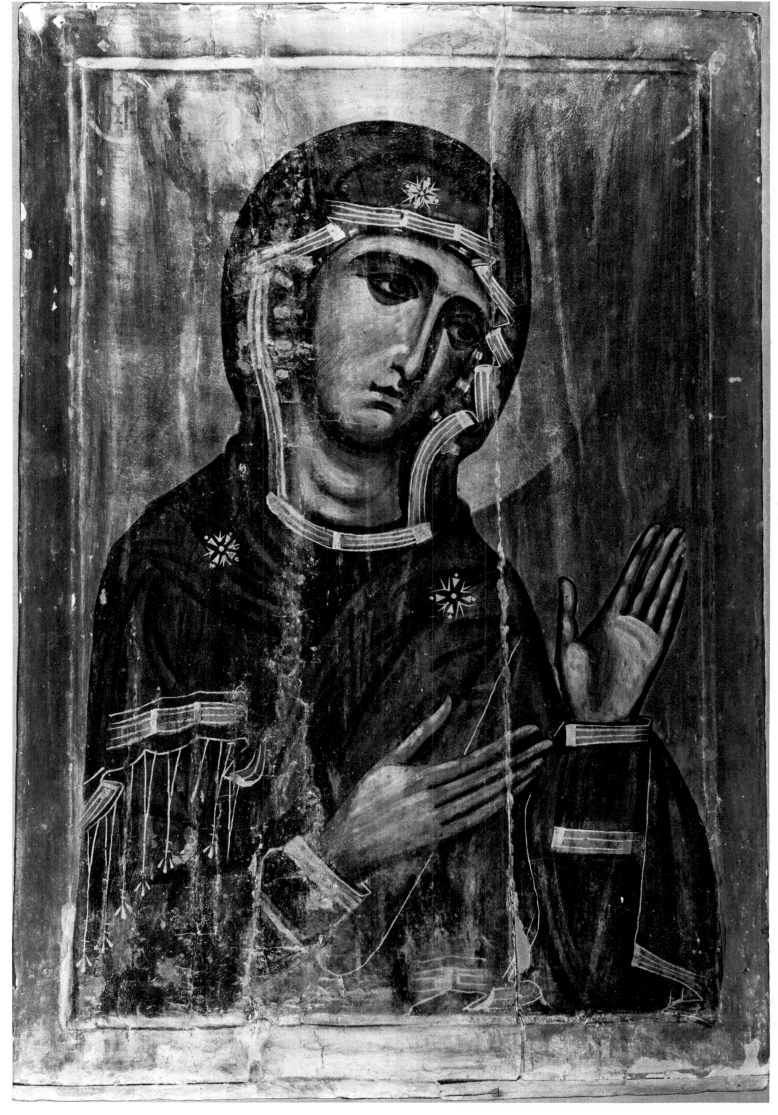

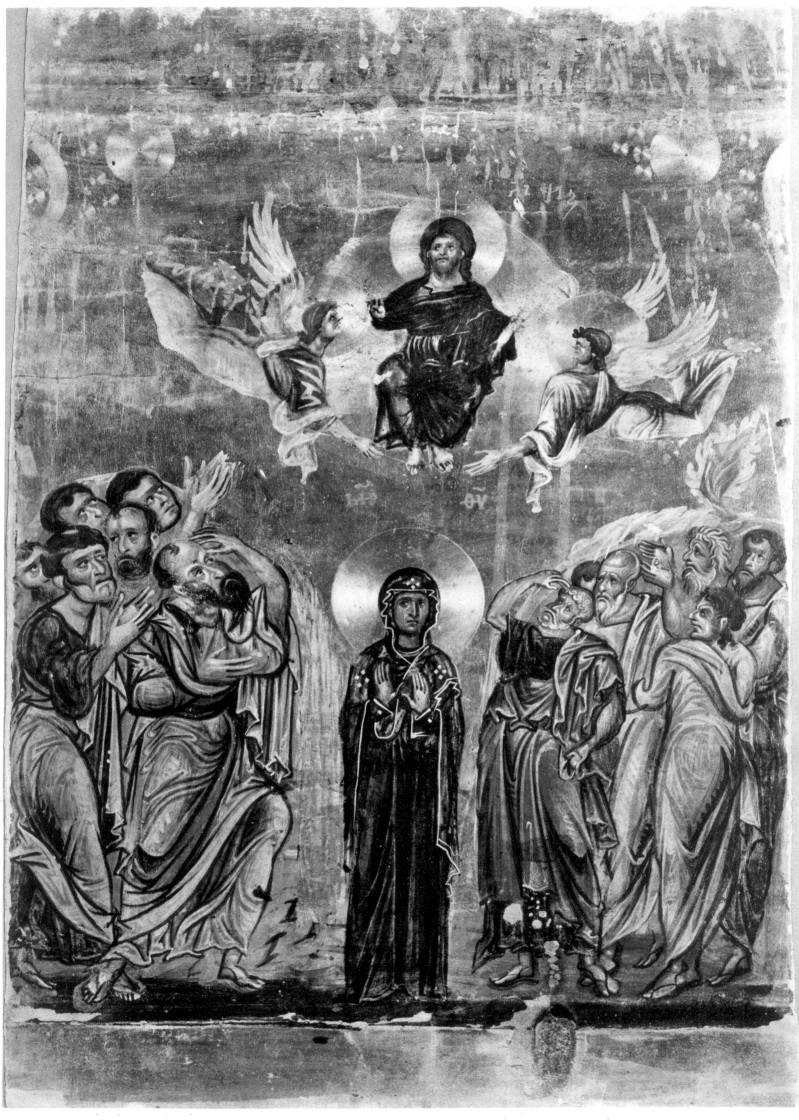

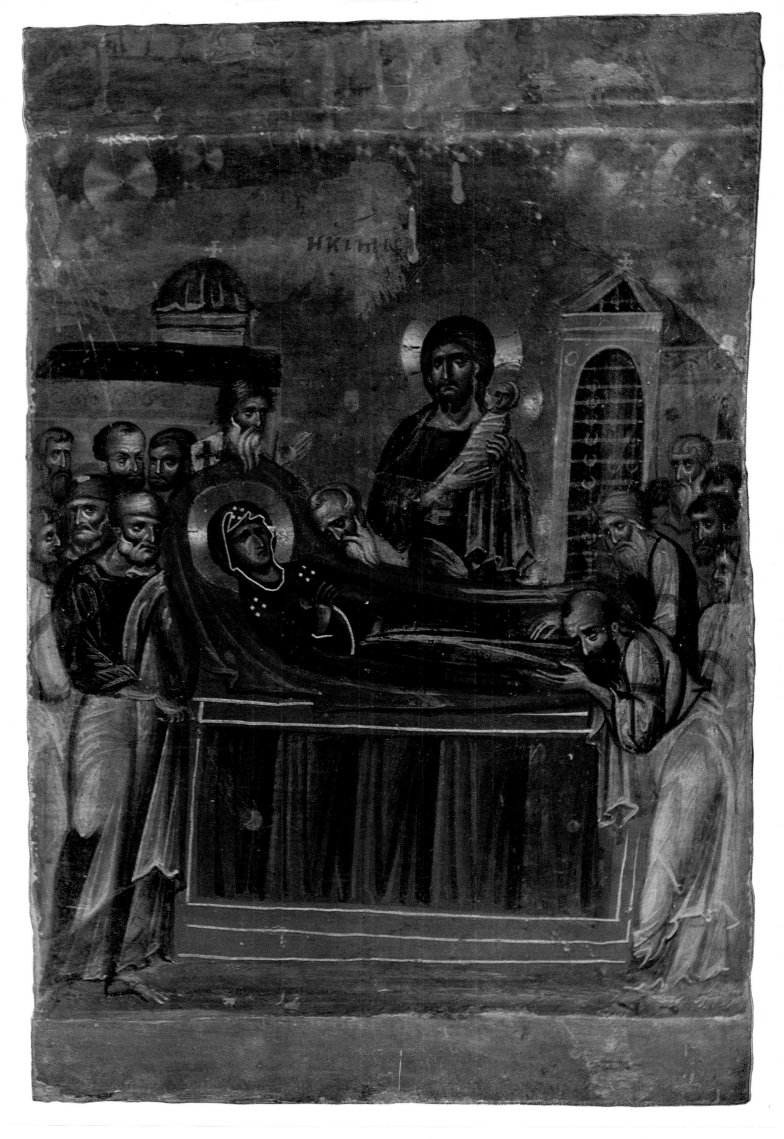

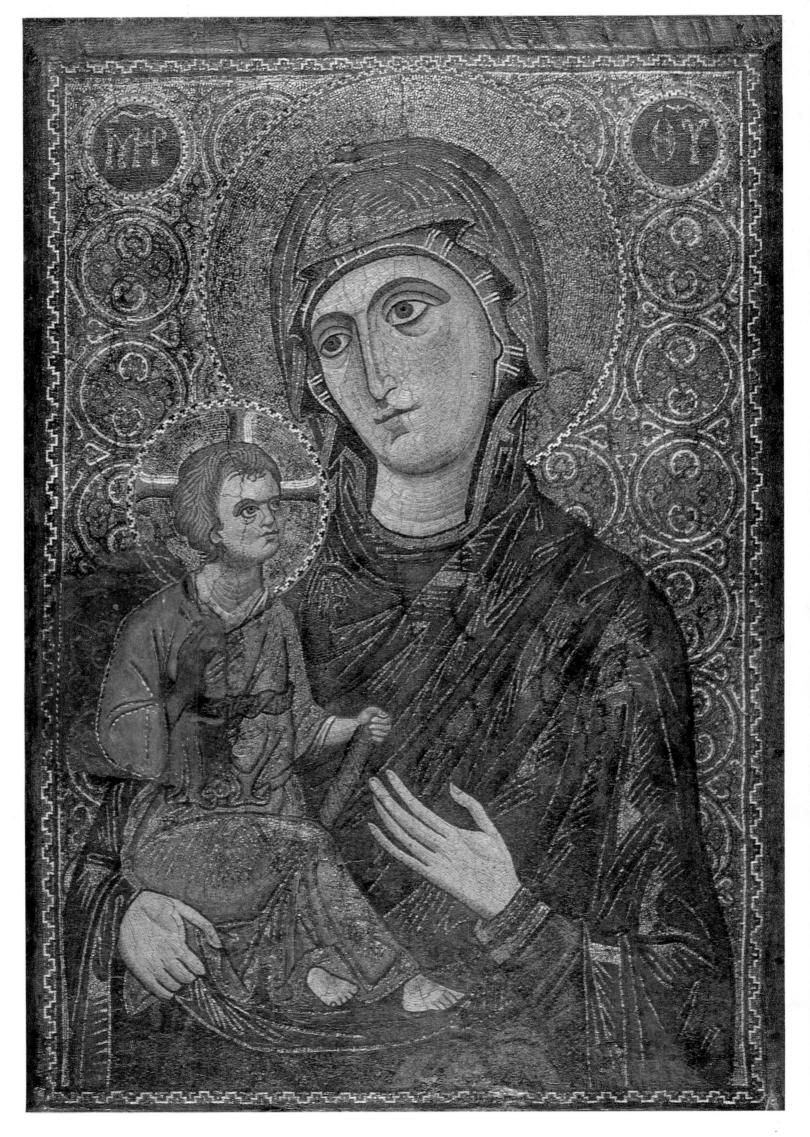

List of illustrations
The icons of Sinai

GREECE

Manolis Chatzidakis
The Icons of Greece

GREECE

Among the Byzantine icons found in Greece today, there is scarcely a single category which we can confidently say originated within the boundaries of the political and geographical entity we now call Greece. But in the Byzantine period — the time before Constantinople fell to the Turks — at least one important center of artistic production existed which is part of Greece today: Salonica. The contribution of Salonica, especially in the time of the Palaeologues, is becoming increasingly clear. Many of the icons reproduced in these pages come from the churches of that great city and can consequently be considered to have been produced there; this claim is borne out in the majority of cases by comparison with other works whose origin was certainly Salonica. Mount Athos cannot be considered an artistic center with a definite character of its own; the icons found there in recent years belong to many diverse artistic currents. There were other centers in Greece, such as Arta, Jannina, and Mistra, but their artistic independence remains to be established. It seems likely that the art of these minor capitals of late and ephemeral principalities merely reflected what was being done in more important places. We can speak rather surely of a School of Cyprus; but when it comes to Crete, whose mural painting of the fourteenth and fifteenth centuries is now better known, we can only hypothesize about the field of icon painting.

Icons, being a portable form of art, easily make their way from one locality to another. Thus we can say with assurance that some of the works dealt with here must have come initially from Constantinople. Not only was Constantinople the chief city of Byzantium, but we also see it as the central source from which a great art spread to the territories and through the entire sphere of Imperial influence. It is because of this that we have not hesitated to discuss certain icons which were not found in Greece but which are clearly linked to the art of the Empire.

For these reasons, our aim here can only be to consider all icons purely and simply as works of Byzantine art, not concerning ourselves with whether they belong to some regional school. All these remarks apply, however, only to icons made before 1453, when Constantinople was conquered by the Turks. The icons reproduced here from the sixteenth and seventeenth centuries can be traced with absolute certainty to Crete, or to Cretan artists working abroad. After the collapse of the Imperial center, the great tradition was carried on in the outlying regions.

The icons presented here do not typify all the aspects to be found in Greek works. Instead we have attempted to select pieces that represent various trends; we have also included a certain number that are less well-known but better preserved or which at least have been recently restored.

Icons dating from the twelfth century are rare in Greece. It might have been expected that there would be more in the great monastic centers, as in the case of the Monastery of Saint Catherine in Sinai. In recent years the cataloguing and restoration

carried out by the Greek Archaeological Service have brought to light a number of icons in the monasteries on Mount Athos; most of them survived because they had been discarded in inaccessible places and, in any case, were no longer in use. It would be interesting to compare these icons with those found in the Sinai monastery, but their number is as yet insufficient to make possible a broad, general study. We shall not hesitate to consider them, however, where appropriate.

Among the oldest icons that are relatively well-preserved is the small icon of Saint 90 Panteleimon in the Monastery of Lavra. The face of the handsome young intercessor clearly recalls that of the famous icon, the Virgin of Vladimir. The large almond-shaped eyes, arched eyebrows, small mouth, fine nose, and the tender yet dignified expression with its slightly sideways glance — all of these classify this icon within the same group as the Vladimir Virgin. The formal conception, the emphasis on line, and the delicate modeling achieved by greenish shadows and rosy flesh are common to both works.

Another icon, monumental in its dimensions, is that of Saint Peter in the Protaton 89 on Mount Athos. The apostle's pose recalls that usually given to large figures of the prophets holding open scrolls. This is one of the most important icons of the late Comnenian period, and it shows the influence of monumental mural art upon icon painting at that time. The features, however, are drawn with a calligraphic attention to clear linear values which is not without academicism.

The same feeling for monumentality is found in the scenes from a Dodecaorton, a 65 cycle of icons for the twelve great feast days; an example is this small icon with the Raising of Lazarus. The rather thickset but well-modeled figures form a composition of imposing character belying the small dimensions of the icon. The figure of Christ near the center is dominant not only through its more imposing stature and larger head, but also by its isolation and expressive intensity. The setting and landscape elements are reduced to a minimum, yet the rather somber coloring of the figures — ranging through shades of blue combined with purplish red and ocher — stands out markedly against the vermilion background. The same, rather rare type of background occurs in a small icon of the Transfiguration now in the Russian Museum, Leningrad, which belongs to the same cycle of Church holidays as our Raising of Lazarus. These two works, however, have more in common than their red backgrounds and similar dimensions: they share stylistic peculiarities and even something individualistic in manner which permits us to attribute them to the same artist. The Leningrad work has been assigned to the twelfth century by Wulff, Lazarev, and Bank, and indeed the monumentality of both icons is typical of the twelfth century. There is further evidence in the treatment of the faces: the features are drawn clearly, the brownish flesh tones are built up rather freely through graduated shades of color, and white streaks on the salient features contrast with red brush strokes on the cheeks and foreheads. The same kind of modeling is found in the Nerezi fresco of 1164, and in the Christ of manuscript 2645 (in the National Library, Athens), which was painted before 1206. Yet, in spite of this, there is a certain stiffness in the draperies, as well as peculiar proportions of the figures, which suggests that both our icons might be better dated around the beginning of the thirteenth century.

It appears that two icons, of the Raising of Lazarus and the Transfiguration, now far apart, must have originally belonged to the same series of icons forming a

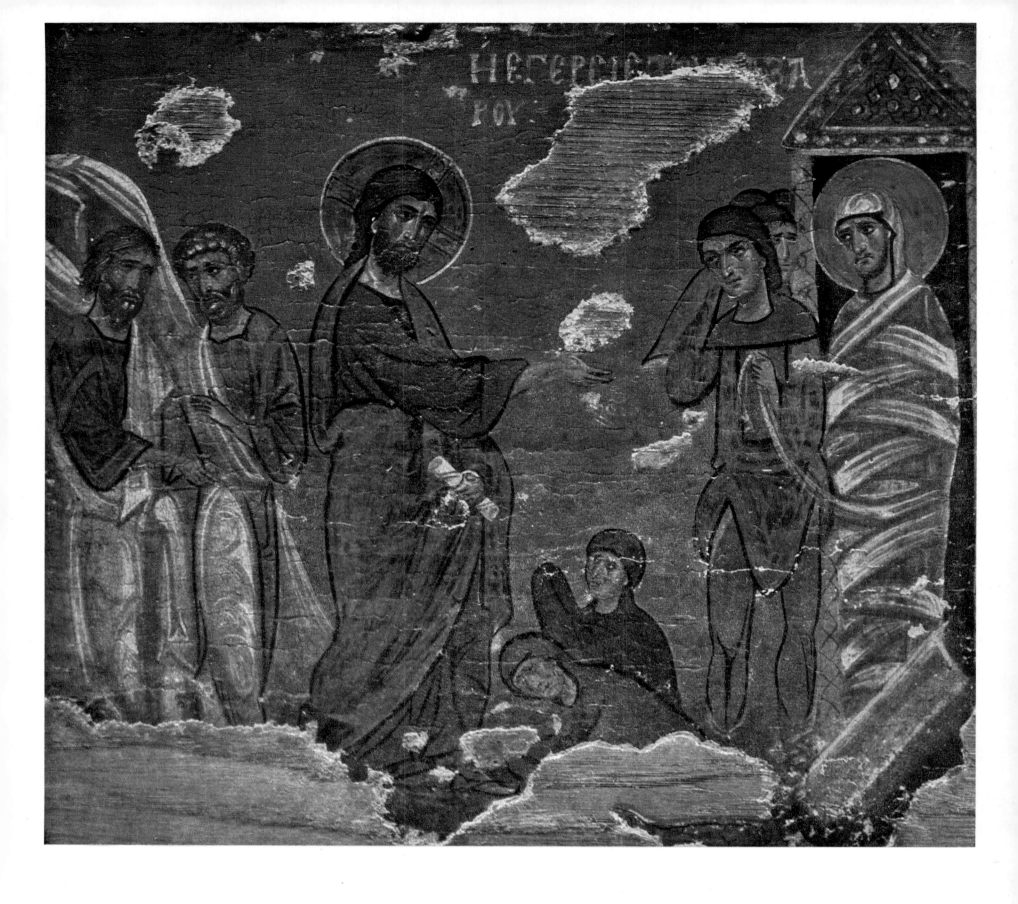

Dodecaorton. This implies that during the twelfth and thirteenth centuries such series celebrating the twelve feast days of the Church must have been grouped together in a place above the iconostasis as a unified group of related pictures.

It seems, however, that the more common way of representing the holidays was to paint the separate scenes on an architrave generally carved out of a single beam of wood. One such architrave, found in the Monastery of Vatopedi, depicts the Christ 91 Pantocrator enthroned in the center of a Great Deësis. The side sections of the architrave bear the scenes from the Gospels appropriate to the cycle of feasts. This manner of arranging the iconostasis used to be known only in Sinai, from the twelfth century on, but it is now established that the gradual transformation of the iconostasis through the use of such painted wooden architraves must have taken place in a great cultural center; this was surely Constantinople, and from there it spread to Athos and Sinai. The painting on the Vatopedi architrave, having the reduced dimensions of a miniature, is related to manuscript illumination in style. This applies to almost all works of the sort. A more delicate manner of painting and greater refinement of expression show that icon painting retained certain qualities peculiar to itself despite the influence of large-scale mural art. Actually, the head of Christ, despite its majesty, is modeled with rich nuances showing a range of gradations, from the delicate green shadows to the bright rose highlights of the skin. The effect of relief is not achieved through excessive emphasis on contrasts and line, but rather by color, and this brings out the very human beauty of the Redeemer's face.

There were still other approaches to artistic expression during the thirteenth century. A double-faced icon, now in the Byzantine Museum at Athens, has interesting features that reveal the vicissitudes an icon may undergo through the impact of a country's history. At the same time, it affords us a glimpse of one significant moment in the evolution of the iconic style. One side of the icon shows a Virgin and Child from the sixteenth century. The other side, of particular interest here, has a Crucifixion showing a peculiar mixture of styles with no semblance of 92, 93 unity. Only since its recent restoration has it been possible to explain that there are contributions from three distinct periods: from the earliest, the ninth century, to the latest, the thirteenth. The head of Christ and the figures of the Virgin and Saint John belong to the third period. They are superior in quality to what survives from the earliest painting, which is still markedly linear and of crude workmanship. The later work is painted in tones of sienna and brighter highlights, and surrounded by slightly green shadows. In these faces we can recognize the attempt to render emotion, even pathos, and yet exaggeration is always avoided. The barely suggested grimace of grief, the narrow form of the shadow around Christ's eyes, the continuous curve of John's eyebrows paralleling the hairline across his forehead, the deep furrow down his cheek — all of these simple devices serve the representation of the fundamental psychic stresses, namely, suffering and grief. And yet, in spite of the conciseness of these expressive means, which have a rhythm of their own, we feel a remarkable power of observation on the artist's part. These qualities still have much in common with the outburst of pathos in the Nerezi fresco of 1164, but are more restrained and more profound, as also befits the nature of icons.

A similar conception is found in another double-faced icon, this one from Cyprus, also with a Virgin and Child on one side and a Crucifixion on the other. The 94

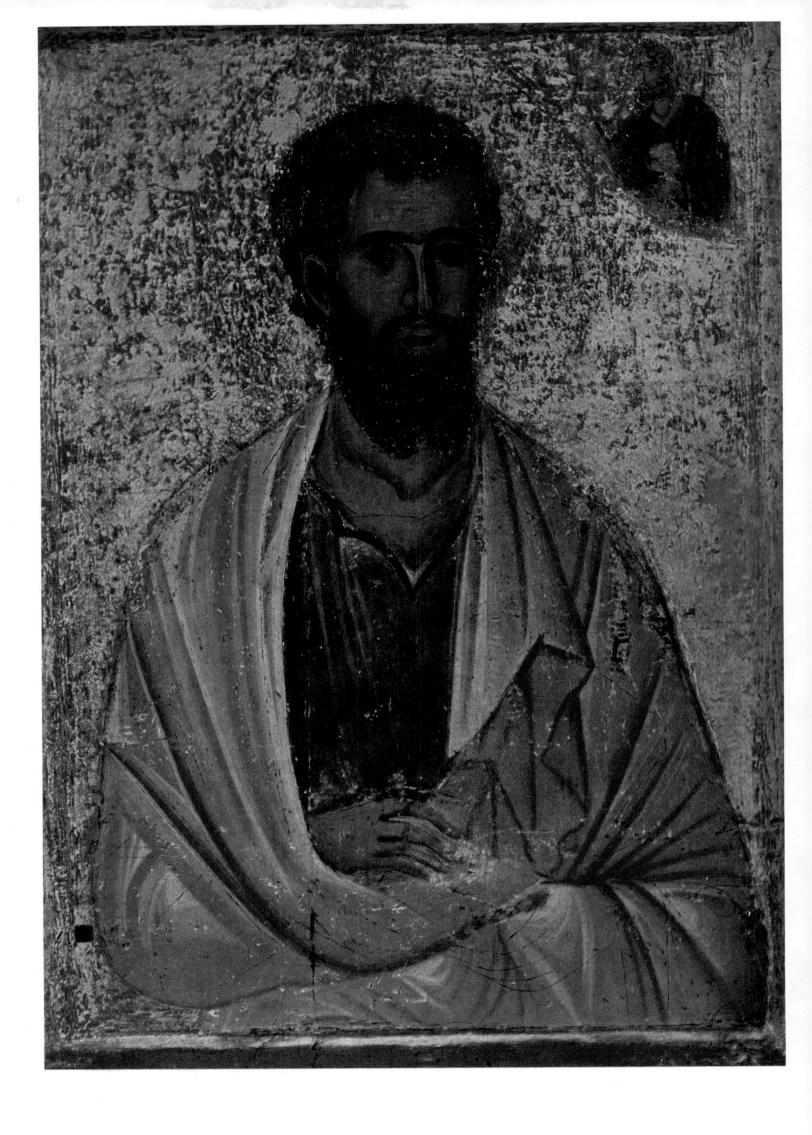

ornamentation in relief for the haloes and backgrounds, seen in the detail of the Virgin included here, is evidence that it comes from a local workshop. A certain elegance in the postures, the delicacy of tension, and the transparency of the subtly varied colors suggest an environment on a cultivated level that was subject to Western influences; likewise indicative are such iconographic details as the transparent loincloth of Christ. These features suggest Cyprus, which was occupied by the French as early as 1192.

Although one of these icons came from Epirus and was later found (after who knows what travails) in a small monastery near Arta, and the other came from Cyprus, they are both contemporary, and it is not too much to call attention to a certain obvious relationship between them. They provide additional and especially convincing evidence of the strength of the new artistic currents emanating from the great centers of culture, and of the rapid spread of such trends to every corner of the lands under Byzantine influence. As for their dating, it is difficult to decide if they should be ascribed to the period after 1204 when Constantinople was occupied by the French, or to the years following its liberation in 1261. In any case, it seems more likely that such innovations came from the capital rather than from the small provincial centers of minor principalities — as, for instance, Arta in the despotate of Epirus.

These two icons present us with a phenomenon that was destined to become a key factor in the formation and development of style in Byzantine painting, and most of all in the icon. This factor is the direct contact between Byzantium and the West; it came about through the events which linked these two cultures, notably the Crusades. Constantinople was occupied only temporarily, between 1204 and 1261, but such provinces as Crete, Cyprus, and the Peloponnesus were decisively won for the West. The icon in the Byzantine Museum can stand for the type of art which 92, provided a Giunta Pisano or a Coppo di Marcovaldo with models for their 94 Crucifixions. On the other hand, the Cyprus icon, with its pronounced occidental traits, is a typical example of the Western influences on Byzantine art, especially in the occupied provinces such as Crete; in frescoes in small country chapels of Crete we often find haloes with ornamentation in relief and European fashions in costume and armor, all Western effects.

To this region and period belongs another double-faced icon, also in the Byzantine 70 Museum, with scenes from the life and martyrdom of Saint George. This icon comes from Castoria and has a rather uncommon feature: the figure of the saint is carved like a relief in the wood of the icon, and so are his halo and shield. His military costume and the design of the shield, with its four fields, are Western in character, but the inscription, rather well-drawn in pseudo-cufic letters around the border of the shield, seems to indicate as place of origin some region close to the Moslem East. The figure itself, lacking elegance and stiffly posed, is quite unlike the Byzantine sculpture of the time. Instinctively one thinks of Romanesque art, in which sculptures and icons in high relief are common. Stone icons carved in relief were not unknown in Byzantine art of earlier periods, and there are even examples in precious materials, such as the two famous gold and enamel icons of the Archangel Michael in the Cathedral Treasury of Saint Mark in Venice, which were made during the tenth or eleventh century. But Byzantine wooden specimens, carved in relief and painted, are rare. One enormous icon, over nine feet high, with Saint George depicted frontally

and at full length, is in Omorphi Ekklisia near Castoria; another, presumably of Saint Clement, is in Ohrid; a few more pieces of lesser importance are practically all that are known. Our task of determining their source is not made easier by the fact that these works come from, or are found at present, in regions where there is scarcely any trace of Western influence.

The painted images on this Byzantine Museum icon, which complement the figure of Saint George, may assist us in our task. There are six scenes on either side of the saint, twelve in all, plus two angels above him and a small figure of the female donor prostrate behind his feet. They are painted in a free, almost impressionistic manner, with green shadows, rosy cheeks, and tiny gleaming white highlights; they resemble thirteenth century miniatures. But the types of figures and a certain mannerism in their postures suggest rather a comparison with the art of the Latin Kingdom of Jerusalem. The two saints on the reverse side of this icon, although poorly preserved, remind us of certain figures of the Virgin from thirteenth century Cyprus with their large eyes and broad modeling. We would willingly assign this icon either to Jerusalem or to Cyprus, the connections between these centers being not yet sufficiently clear. In any case, this solid figure of Saint George and its simplified surfaces shows the trend toward monumentality already noted, a trend which — in addition to foreign influences — continued throughout thirteenth century icon painting, both in single figures and scenes.

An icon from Patmos contains a half-length figure of Saint James. An air of serene 67 majesty emanates from this beautiful figure; its simple rhythmic draperies and lively coloring suggest that its prototype may have been a large statuesque figure like the apostles in the frescoes at Sopoćani. The icon may belong to the same period as the frescoes, around 1265, and to the same spiritual climate of classical reminiscences. It offers important support for our argument that the monumental style of the thirteenth century was not foreign to the panel painting of the time.

There can be no doubt that, from the point of view of style, icon painting was closely bound with monumental painting. There is, however, one type of portable icon which directly reflects the influence of the monumental style even in material and technique. These are mosaic icons, many of which still survive in Greece at Mount Athos, Patmos, the Monastery of Tatrana, and in the Byzantine Museum of Athens. The oldest mosaic icons from the eleventh and twelfth centuries — such as those in the Patriarchate of Constantinople, or the icon of the Virgin in the Monastery of Chilandar — have normal dimensions. The size of the mosaic cubes and the technique that was used hardly differ from those of contemporary wall mosaics. These mosaic icons were intended for marble iconostases (to which their material was better suited than painted wood) and for proskynitaria. As was usual in images intended for liturgical use, they generally present a half-length figure. Later, in the thirteenth century, mosaic technique began to take on certain traits more closely related to icon painting, and it became, about 1300, a vehicle for virtuoso display: the icons were reduced to the smallest possible size, and the mosaic stones were as tiny as grains of sand. In addition, the icon often became a luxurious object in itself, encased in a cover of precious metal sometimes decorated with cloisonné insets. These general observations are enough to show us that these icons originated in the aristocratic circles of the capital, if not in the Imperial Palace itself.

At the beginning of the fourteenth century, mosaic icons were further

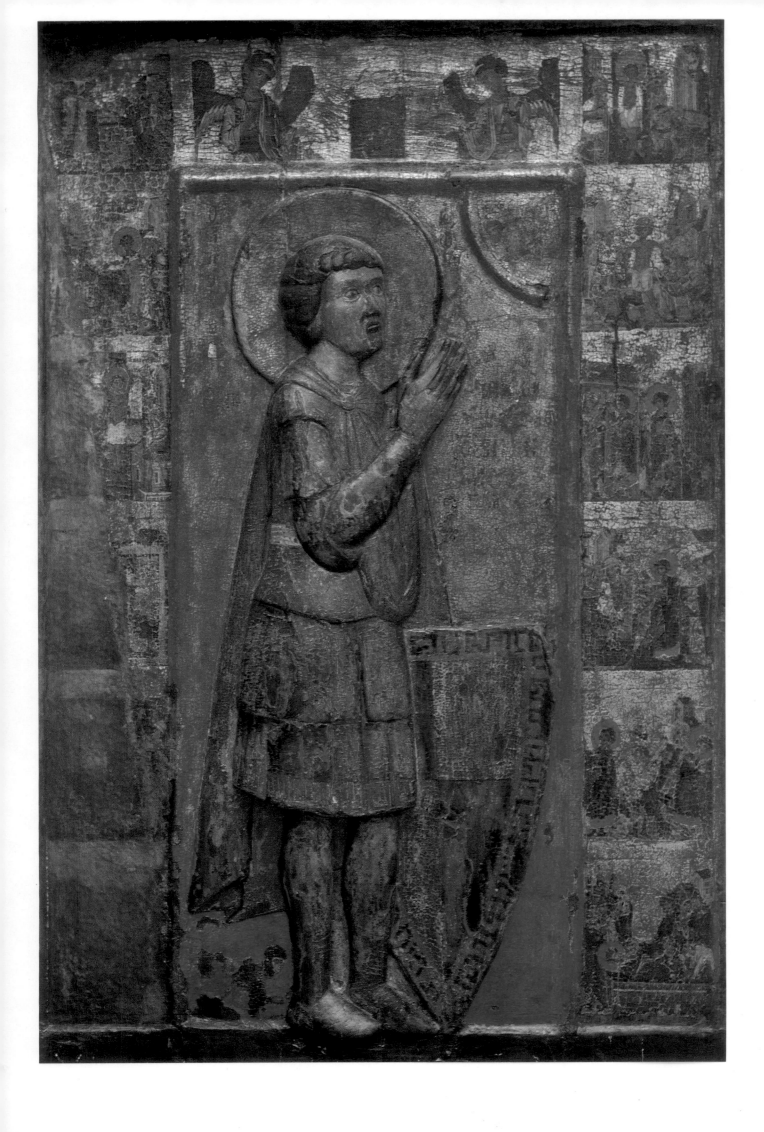

distinguished by the fact that they often included entire scenes, among these the twelve feasts of the Church ⁺the Annunciation, the Transfiguration, the Crucifixion, the Forty Martyrs, or saints on foot or horseback. In the Palaeologue period, life-size figures in half-length continued to be produced for liturgical use, and remained very similar to mosaic wall decorations. We show here the icon of Saint 95 Nicholas in the Monastery of Stavronikita on Mount Athos; it is not a virtuoso work like the miniature mosaic icons, but is composed of glass cubes of the usual size — although very tiny tesserae were used at that time even in monumental wall mosaics. In technique, style, and quality this work can be compared with certain figures in the mosaics of 1315 in the Church of the Holy Apostles at Salonica. The Prophet Jonah is especially similar to Saint Nicholas: they have the same shape of brow, and of eyes, nose, and mouth; the same broad planes are highlighted by lines of warmer tones that complement each other and contrast in a free, almost impressionistic‧manner with the greenish shadows. This technique, so supremely apt for mosaic, contributes a certain animation to the venerable figure of Saint Nicholas, in his traditional hieratic pose; the broad white omophorion with its large black crosses and the blue vestment lend a coolness of tone to the entire icon. On the basis of these facts, it is not too much to conclude that the work was produced in Salonica at the beginning of the fourteenth century.

Another icon of this sort, now in the Byzantine Museum, comes from Triglia in 77 Bithynia. The Virgin holding the Child on one arm belongs to the type known as Glykophilousa or Eleousa ("Virgin of the Sweet Embrace" or "Virgin of Compassion") and the icon bears the inscription in mosaic: Μήτηρ Θεοῦ ἡ Ἐπίσκεψις. From this evidence it is probable that this icon is a copy of another icon similarly titled. The fact that it is not the conventional bust but a half-length figure suggests that the Virgin must have appeared full-length in the original. Tenderness and affection are seen in the picture despite the rigidity of the specifically formal elements: the firm rhythmic treatment of the draperies and the closed symmetrical composition using broad curves. These characteristics were probably derived from the prototype, which must have been of top quality, and they were not very successfully copied here. The drawing of the faces is somewhat crude and the feet of the Child clumsy, betraying a want of sensitivity. Yet this deficiency is effectively masked by the brilliant coloring with gold highlights on the dark draperies, and by the richness of the mosaic material itself. The author of this early fourteenth century mosaic icon must have been, all things considered, a craftsman rather than an artist.

Finally, in a mosaic icon of Saint Demetrius in Sassoferrato, the slender figure has 107 that unstable pose which we find in the seemingly weightless figures typical of painting after the middle of the fourteenth century; it is the formal symbol of an aristocratic, even effete, youth. The face, modeled with extremely fine cubes of mosaic, is expressionless, almost indifferent, but it nevertheless belongs to a type familiar to us from the patron saints of Salonica. The figure and background are overladen with geometrical decorative elements, such as the star-shaped interlocking squares containing the name of the saint, the cross-grid pattern of the halo which reappears in larger form on the pavement tiles, and the fine checkerboard of the leg guards. A diagonal is formed by the edge of the mantle, the left-hand border of the shield, and the sword belt that, with the lance, cuts the picture into two triangles of almost identical shape. The impression of a mixture of heterogeneous elements is

reinforced by the lion on the shield that is at once heraldic and realistic in treatment — and, in both respects, decidedly Western. It is not difficult, therefore, to date this delicately wrought but eclectic work toward the end of the fourteenth century, since it reveals a fully formed and self-confident style that is free to pick and choose its means.

One of the fundamental traits of icons, insofar as religious personages are represented, is that the likeness is based by theoretical principle on a true or accepted resemblance to the prototype. In a famous phrase, Saint Basil used the word "prototype" to designate the sacred personage, but it can also be used in its modern meaning. Since the divine grace of the icon is transmitted through its resemblance to the figure depicted, that grace is perpetuated in icons which resemble their prototype — that is, the original icon — to the extent that they copy it faithfully. One might expect, then, that once the likeness of a saint had been established — as happened after the Iconoclast Controversy — it would be repeated endlessly without change. But the fact is that Byzantine art was a living art closely linked to historical circumstances and, above all, to the spiritual currents of its time. Thus the sensibility of its artists was able to find endless forms of expression for the same subjects, not only from one period to another but also within a single period.

In both theory and practice the sacred portrait aimed only at reproducing the general characteristics of the person depicted. We know this from texts that, although unofficial, nevertheless reflect Byzantine thought on this matter. Among these are the remarkable writings of Elpios, a Roman who lived in the ninth and tenth centuries. His text describes the most important sacred personages, for the most part in detail; some are described more succinctly. There are also descriptions of saints found in their biographies and in the Synaxaria, or finally, in the later editions of the Herminia, the book from which Byzantine painters took the accepted formulas for their depictions. From the practical point of view, it was necessary for the worshiper to be able to recognize the saint depicted immediately through certain essential characteristics, without having to read the inscription. Once these requirements had been fulfilled, the rest was left up to the painter. He had only to work in accordance with the ruling of the Seventh Council which said that only the art belonged to the painter, but that the exact disposition (διάταξις) was to be decided by the Holy Fathers. However, the painter worked with technical procedures and within aesthetic traditions which went back to the Hellenistic-Roman period and late antiquity. Traces of these origins of Christian portraiture can be discerned throughout the entire development of Byzantine painting. The tendency of Byzantine painters to allow the real to become permeated by the unreal culminated in the transfiguration of the human figure into a Christian image, and in a transformation of the language of art. But whatever the painter did, the fundamental basis remained the same, and the painter merely approached it or departed from it. Icons depicting saints afforded the artist the possibility of maintaining the abstraction, or of infusing the abstract image with an individual content and thus turning the icon into a true portrait. A series of icons from the fourteenth century is instructive in showing the variety of ways in which the painters of that time carried out their task, and how they adapted natural forms to represent the unreal world of their ideals.

As an example, an icon from the Monastery of Vatopedi, showing Saint Demetrius 102 as a young warrior, reveals the antique sources of the image. The frontal pose is not

hieratic and the gaze fixed on the spectator is earnest and direct. With its long prominent nose, fleshy ears, low forehead, and large eyes with heavy eyelids, it could easily be a portrait of a real but perhaps everyday person, a contemporary of the painter. The melancholy expression of the mouth and eyebrows and the asymmetrical cast of the features reinforce this impression of life and verisimilitude. The face is made more lifelike by the contrast of warm flesh tones and green shadows, with a few white highlights emphasizing the conspicuous features. In opposition to this, the costume, the armor, and the himation falling from the shoulder are treated much more conventionally. Their shapes and colors are primarily employed to emphasize the wealth of expression in the face. These traits, which can certainly be called realistic, connect the icon with the movement for renewal at the end of the thirteenth and beginning of the fourteenth centuries. In particular, the use of complementary colors and the curious shape of the ears recall the procedure of the Protaton painter. They are, however, not unlike the work of the painters Eutychios and Michael Astrapas in the Church of Peribleptos at Ohrid in 1295.

Another icon, Saint George, which is from the Monastery of Lavra and 103 contemporary with the icon from Vatopedi, is remarkable for the intense gaze of his large eyes, set close under the heavy shadow of the continuous double-arch of the eyebrows. The narrow, dark shadow outlining the face and nose contrasts with the broad planes of the flesh of the cheeks, forehead, and chin, which are flecked with red as if reflecting the vermilion mantle draped across the shoulders. The wealth of decorative elements — the martyr's crown, the pearl-trimmed borders of the gown, and the tight curls that wreathe the handsome Oriental face — seems to be a survival from the pictorial tradition of the twelfth century. But the expressiveness which gives the impression of a living presence belongs unquestionably to the beginning of the fourteenth century.

An icon of a warrior-saint at Mytilene follows the typical pattern for depicting such 101 saints, with abundant curls framing a youthful face; but the personality portrayed is entirely different from that of the preceding warrior-saint in the Lavra icon. Delicate modeling, based especially on chiaroscuro and complementary colors, lends a quality of mingled tenderness and seriousness to the fragile features of the young man. Technically, the workmanship is much like that of a series of heads from the late thirteenth and early fourteenth centuries, which for the most part go back to the art of Constantinople.

Yet another Saint George — an icon found at Aighion and restored for the 117 Byzantine exhibition in 1964 — shows a further development of this type of portrait. With the passage of time there was a loss of realism we noted previously as an essential factor and innovation in religious pictures. The approach here is much like that of the icon from Mytilene, but the total effect is more abstract and decorative. The asymmetrical face, its large eyes so close to the bridge of the nose, must be the result of an inexact copy of a model with the head turned slightly to one side. It has a certain beauty but lacks that inner life which animates our other images of the same saint. We can mention the unnatural hair, which is like a wig pushed down on the head, and the exaggerated emphasis on the concentric circles spreading across the armor. The artist's desire for a decorative effect in the composition must be noted; it is seen in the two circular motifs, the breastplate and the halo, of which the latter is decorated in relief work. It is difficult to say if this tendency toward the abstraction of

everything ethical and human was a product of the development of art, or if it was the result of a provincial artist's attempt to copy a great work. In this case the latter seems more likely.

Such determined striving for faithful personification was not limited to saints of secondary importance, such as in the icons we have been considering; it also affected images of Christ and of the Virgin, which were usually less liable to variations in fashion. It is well known that, of all the forms of Byzantine art, these liturgical icons, which were usually placed on the iconostasis, were those most rigorously controlled by tradition. Nevertheless, a few icons of Christ or the Virgin from about 1300 prove that even these subjects were influenced somewhat by the new ideas of the time. A Virgin and Child of the type known as Odegitria, located in the Byzantine Museum at 85 Athens, no longer shows the Virgin with the serene and dispassionate beauty found in such other images of the time as the Virgin Saviour of Souls in Ohrid, or those in the Church of Chora (Kariye Cami) in Istanbul. Instead, she is here a mature woman with round, full cheeks, a narrow, aquiline nose, a prominent chin, and a small, melancholy mouth. Her general expression is in accord with that of her eyes, which gaze anxiously into space. The aristocratic head with its individualized features is set on a graceful neck and framed by a gold-bordered, reddish-purple veil which falls in soft, rhythmic folds; and the contours above the forehead and at the base of the neck emphasize the length of the face. In its facial appearance, the icon most akin to this one is in the Tretyakov Gallery in Moscow, ascribed to Pimen, where the Virgin has the air of a great lady, at once severe and compassionate. But the Child in our picture, with its large head, high forehead, broad and full-fleshed face, and short, sturdy neck, comes from another tradition if not from another iconographic type. He is shown in three-quarter view in a rather uncomfortable posture — leaning slightly backward; His body and long rigid legs are tightly swaddled by the himation. He differs from the Child in a beautiful icon at the Hellenic Institute of Venice, who is more comfortably covered in the antique manner by a loose garment. Moreover, the two figures in our icon do not show a homogeneous unity, although the same technique is used for both — a technique much like that of the Saint Demetrius icon from Vatopedi.

Another icon of the Virgin in the Byzantine Museum at Athens shows a face with 76 features so markedly individualistic, even disharmonious, that it borders on ugliness. The two sides of the face as well as the large eyes are asymmetrical in every detail. The contrast between the broad light surfaces of the apricot-colored skin and the greenish shadows is accentuated in order to intensify the impression of relief. The face of the Child has the same characteristics. Such wholesome young faces, with frank, open gazes fixed on the viewer, were only possible in Byzantine painting around the year 1300, at which time a feeling developed for the realistic aspects of the personages depicted. One is inclined to ascribe this icon to the region of Salonica, at least until the center from which such tendencies were spread has been more convincingly determined. In any case, this type of Virgin gives an indication of the models for the Madonnas by Tuscan painters of the fourteenth century, which show very similar features.

This departure from the usual classical ideal of beauty in Byzantine painting, occuring at a time when Hellenistic reminiscences were returning in strength, was probably due to a conscious opposition to the classicizing tendency, for it was a

widespread phenomenon. The reaction may have been connected with the realistic mood of the period, or it may have been a real change in the concept of physical beauty, a question with regard to which these icons could be very instructive. This evolution continued into later periods, and finally culminated in a form of extreme expressionism in the Macedonian popular art of the sixteenth and seventeenth centuries. Late in the fourteenth century, however, there was a reversion to more abstract and beautiful faces as part of a general return to idealism.

The large and beautiful icon of the Archangel Michael in the Byzantine Museum, 96, 97 Athens, exhibits the traces of earlier periods that turn up in late fourteenth century works. Since the youthful, beardless face is so well preserved, we can fully appreciate the fineness of the workmanship in the play of light and shadow; the nose emerges strongly, and likewise the chin is made more prominent by the shadow on the neck. Unfortunately, we know from an icon of the Pantocrator from Zrza, near Prilep, dated 1394, that such lifelike rendering soon degenerated into a mechanical method of painting lights on the projecting sections. In our icon, the inscription on the globe, made up of the initials of Χριστὸς Δίκαιος Κριτής, "Christ the Righteous Judge," is typical of the image of Christ in the Great Deësis, itself a summary representation of the Last Judgment; thus it is likely that this icon was one of a series of five or seven icons of half-length figures which together made up a Great Deësis. One of the 91 earliest examples is on the architrave from Vatopedi described above, which must have decorated the top of an iconostasis. In point of fact, according to Simeon of Salonica, who lived in the fourteenth century, "above, on the architrave, were the Saviour in the middle, and to either side of Him the Virgin and Saint John, angels, apostles, and other saints." A few such series are known; one is in the Tretyakov Gallery, Moscow, which came from Serbuchov but had been sent there from Constantinople toward the end of the 1300's; another is in the Monastery of Chilandar on Mount Athos; and there are still others. This arrangement of the iconostasis remained usual until the mid-sixteenth century. It then disappeared, surviving only in the architraves of small chapels or in isolated districts like Corfu, where the Great Deësis composed of fifteen separate icons was in use until the eighteenth century. In our icon, which must be dated from about 1350 to 1375, the characteristics of the portrait style are retained and the delicacy of the Virgin's face is combined with the earnestness of a young man's. This mixture is important in establishing the ideal of serene human beauty and the ethical values dominating the art of the capital at that time; it shows how capable that art was of realizing its high aims.

In studying the treatment given to the human face during this time, we have until now examined icons that represent busts of Christ, the Virgin, and some saints in the frontal position, that is, in the posture most nearly approaching the portraits painted in classical antiquity. To round out this survey of portrait icons we must look at another category — the likenesses of real persons. There is no lack of these in mural paintings and in icons, for the donors of the work were often depicted. An icon of the Incredulity of Thomas from the Monastery of Meteora, recently published, is 108 especially interesting from this standpoint because it can be dated and because portraits of actual people mingle unexpectedly here with the sacred personages. In it Christ is bending down before a closed door to expose the wound in His side; His arm is raised and His hand touches the head of a woman in ceremonial dress and a man who is not one of the apostles. These have been identified as the Serbian princess,

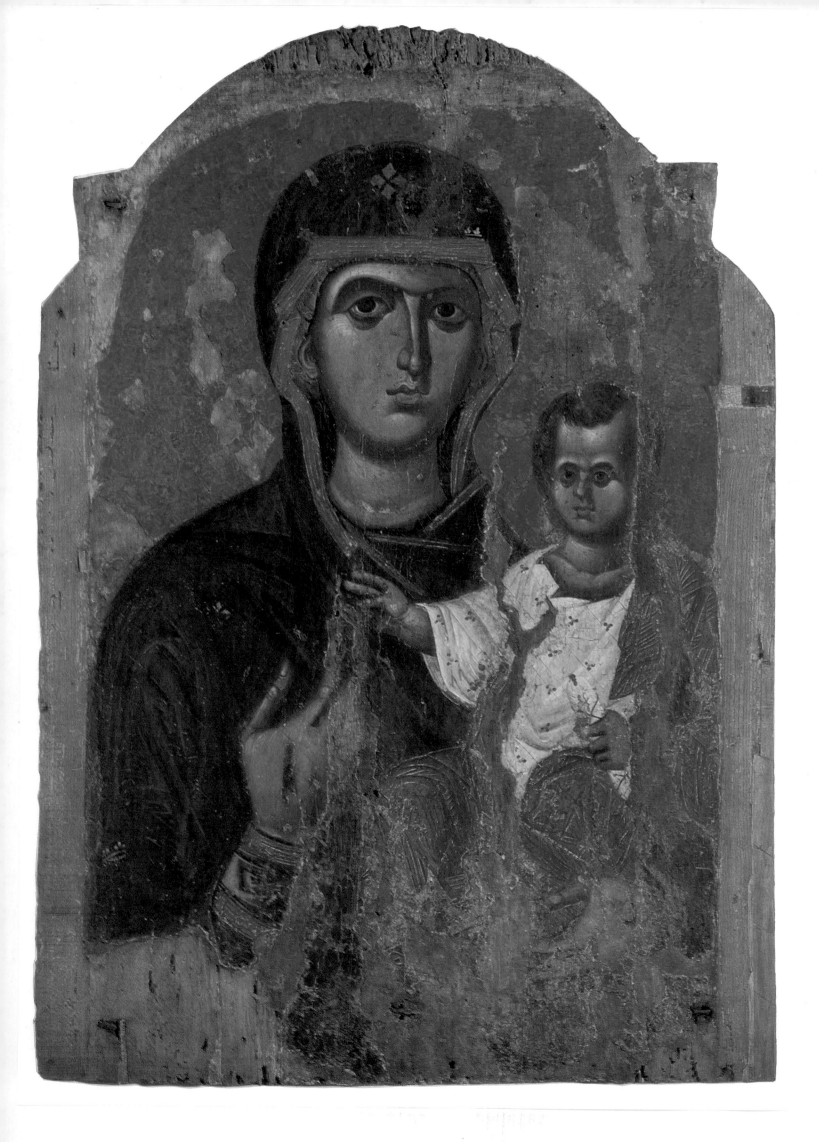

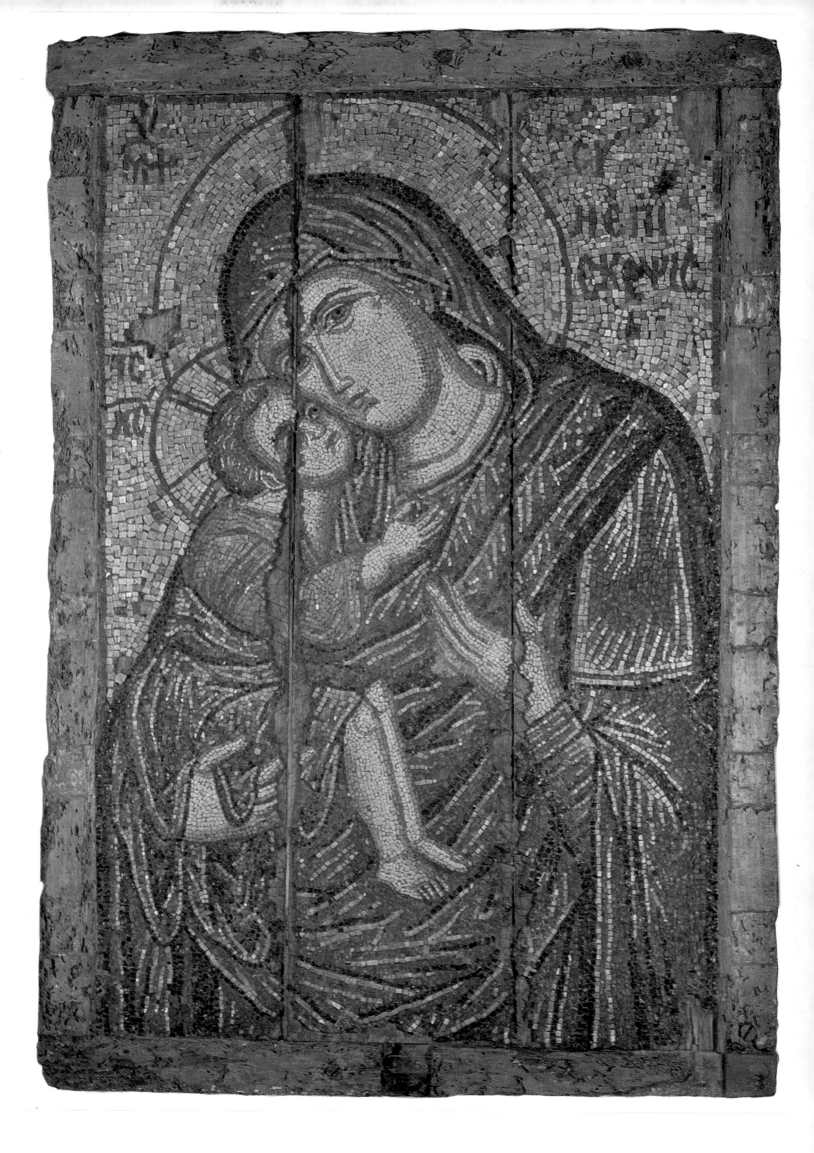

Maria Palaeologina, and her husband, Toma Preljubovic, Lord of Jannina (1361-84). This is the only known portrait of Toma and is probably a true representation, since he has an unpleasant appearance befitting his reputation as a despot. There are, however, two other portraits of the princess and we can check on the accuracy of this painting. One is found on the wing of a diptych, in the same monastery, also commissioned by Princess Palaeologina; the other is on a copy of the complete diptych that is now in Cuenca, Spain. Although the figure of Maria is very small in all three cases, one can recognize the same features, and no attempt seems to have been made to flatter her. Particularly in the icon of the Incredulity of Thomas, this gentle female face with its melancholy expectancy stands out among the abstract faces of the apostles. While the work could have come from a workshop in Jannina, such workshops may well have included artists from other centers such as Salonica.

Other themes were used for icons, and these themes provide invaluable insight into the representation of feelings such as suffering, pain, and grief as rendered by Byzantine painters in the second half of the fourteenth century.

The fine diptych in the Monastery of the Transfiguration at Meteora includes, on 105 the right half, the dead Christ; on the left half is the Virgin, who contemplates her 104 Son. Comparing these figures with the corresponding ones in the thirteenth century Crucifixion, or with the Virgin in the Tretyakov Gallery, we see that the starkly dramatic contrasts have been softened in the later works. Consequently the tone is milder despite the more competent handling of details such as the eyebrows and the eyes. There is in the Meteora diptych an elegance of gesture and attitude that embodies the feelings of self-control and mute suffering. The noble countenance of Christ reveals how, despite his anguish, His spirit did not crack. From the standpoint of technique, we find in the naked torso of Christ the same use of fine close lines to cover a surface which we noted in the faces of certain works discussed earlier. The date cannot be later than 1375.

The famous Crucifixion in the Byzantine Museum must be assigned to the same 79 period. The use of three figures was not new; in the earlier period it had been reserved, however, for monumental compositions without narrative details. In this case the composition appears monumental principally because of the large Cross, and because the three figures are isolated in space but linked in their grief by rhythmic movement. What is new are the large, elongated figures whose height is emphasized by the low horizon, on which the simplified architecture of Jerusalem can be made out. The body of Christ is now only slightly bent, and the same curve is repeated in the figure of John, robust but harrowed with sorrow. The tall silhouette of the Virgin rises straight as a pillar, slender and aristocratic, wrapped in her great mantle. Her fragility introduces a lyrical note into a composition whose emotional elements are extraordinarily restrained. The somber colors seem muted by the diffuse light striking the bodies and draperies. ·This somberness determines the melancholy harmony of the entire composition, which resembles the Crucifixion at Daphni in its serene elegance. So moving is the result that one scarcely notices the three faces have been willfully disfigured by some barbarous hand.

In the same period, narrative composition was also changing in conformity with the spirit of the times. ·As it developed, numerous figures in movement were distributed throughout the depth of the picture plane, and secondary scenes and

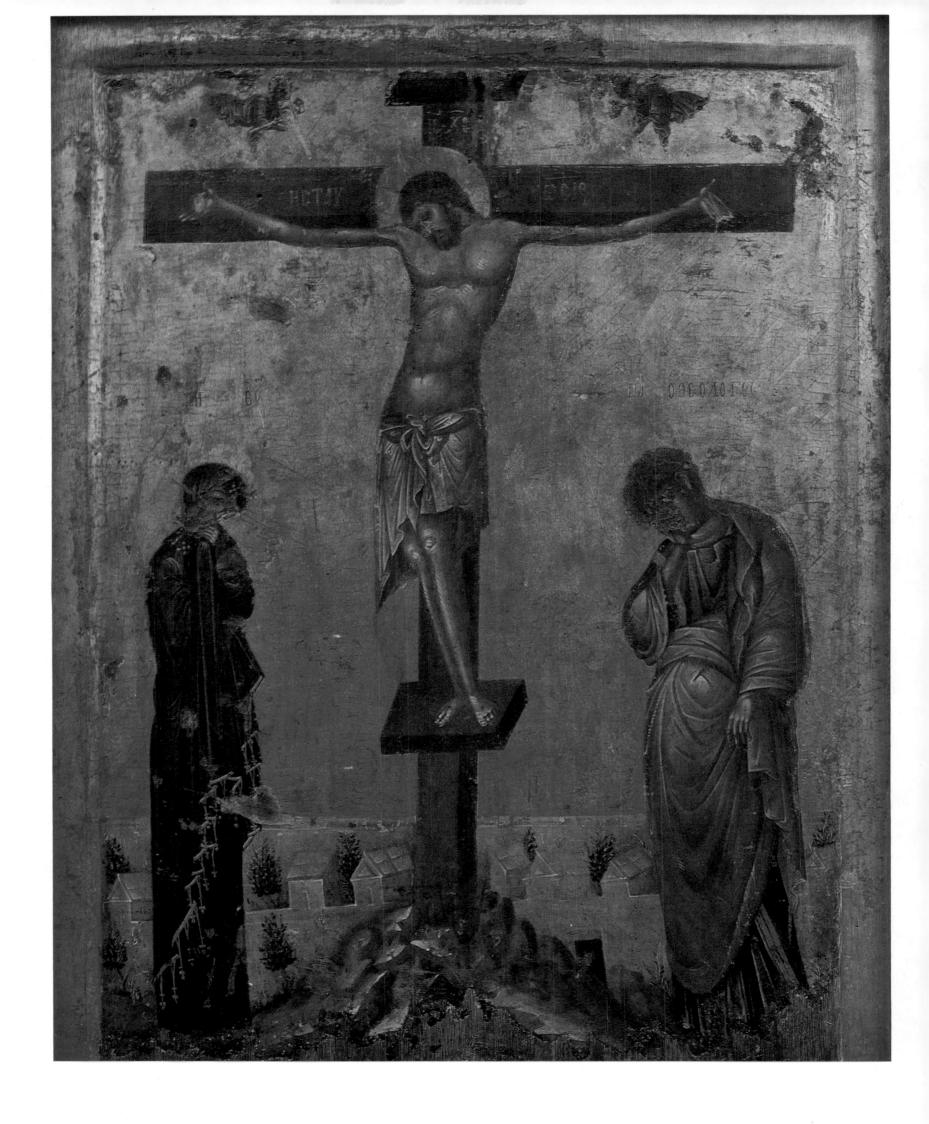

incidents were included. A frequent subject during that period was the Miracle at Chonai; this can be studied in a fine icon, from the Greek Patriarchate of Jerusalem, 106 that was restored for the Byzantine exhibition of 1964 in Athens. The entire left half of the picture is filled by the impressive figure of the Archangel Michael in a *contrapposto* pose; the wings move in rhythm with the gestures and action of the body while the draperies flutter in the air. This impetuous yet elegant figure resembles that of another miracle-working angel in the frescoes of the Church of Chora (Kariye Cami), Istanbul, in which the angel drives away the Assyrians from the city of Jerusalem. The archangel in our icon retains the completely plastic fullness, the facial beauty, and the almost feminine hairdressing of its presumedly monumental prototype, but it becomes more impressive by contrast with the smallness of the figure of the monk Archippos. Here we recognize again the exploitation of contrast that was favored by the artists of the Palaeologue period.

Next to be considered is an icon of the Crucifixion from a church on the island of 99 Patmos, shown for the first time in the Athenian exhibition previously mentioned. The entire composition is in the form of a pyramid; the crucified Christ stands on a rocky peak and the other personages are deployed along the two slopes. In the lower portion of the picture a small triangle of people dividing the garments of Christ fills the space in front of the hill. Behind the Cross, against the gilded background, rise the walls and towers of Jerusalem. Despite the geometrical structure, the movement sweeps out in all directions, and the composition is still free enough to permit displacing the Cross from the middle ground to the rear to allow room for the crowd of Jews. There are a few iconographic peculiarities: Saint John is placed near the Virgin (instead of on the opposite side of the Cross) in the same attitude of deep despair that we shall encounter again in the reliquary of Bessarion; the centurion is placed in front of and among the nine Jews; his young comrades are not in military costume, and one of them, seen partly from the rear, makes a violent gesture challenging Jesus to descend from the Cross. The painter followed a prototype that incorporated various innovations, and that can be dated about 1300. The coloring of the Patmos icon has a blend of gray and ocher tones, of purplish red and dark violet; the vermilion tunic of the soldier crouching in the foreground, on the axis of the Cross, seems to underlie and intensify the entire chromatic scheme. The lighting, which is reinforced by the full figures, is accentuated by white brush strokes that bring the figures into relief by outlining the folds of the draperies. This kind of modeling is familiar to us from the icon of the Incredulity of Thomas in the Monastery of Meteora, and we shall encounter it many times again. 108

Another interesting example of the Crucifixion is represented on the cover of the 125 reliquary which the Greek Cardinal Bessarion presented in 1463 to the Scuola della Carità in Venice; it later came to the Accademia of that city. The reliquary was unquestionably made in Constantinople. The Crucifixion is rigidly symmetrical, and composed of two groups: the Madonna with the Holy Women on one side of the Cross; Saint John, the Centurion, the sponge bearer, and the Jews on the other. The Christ on the Cross is fragile in physique but on a larger scale than the other figures, and His body is slightly twisted. At the foot of the rock three figures sit dividing up the cloak; one of them, as usual, is a soldier. The groups are arranged in depth like the entire composition, which moves from the trio in the foreground to the fantastic walls of Jerusalem in the background. The remarkable, finely executed silhouettes of

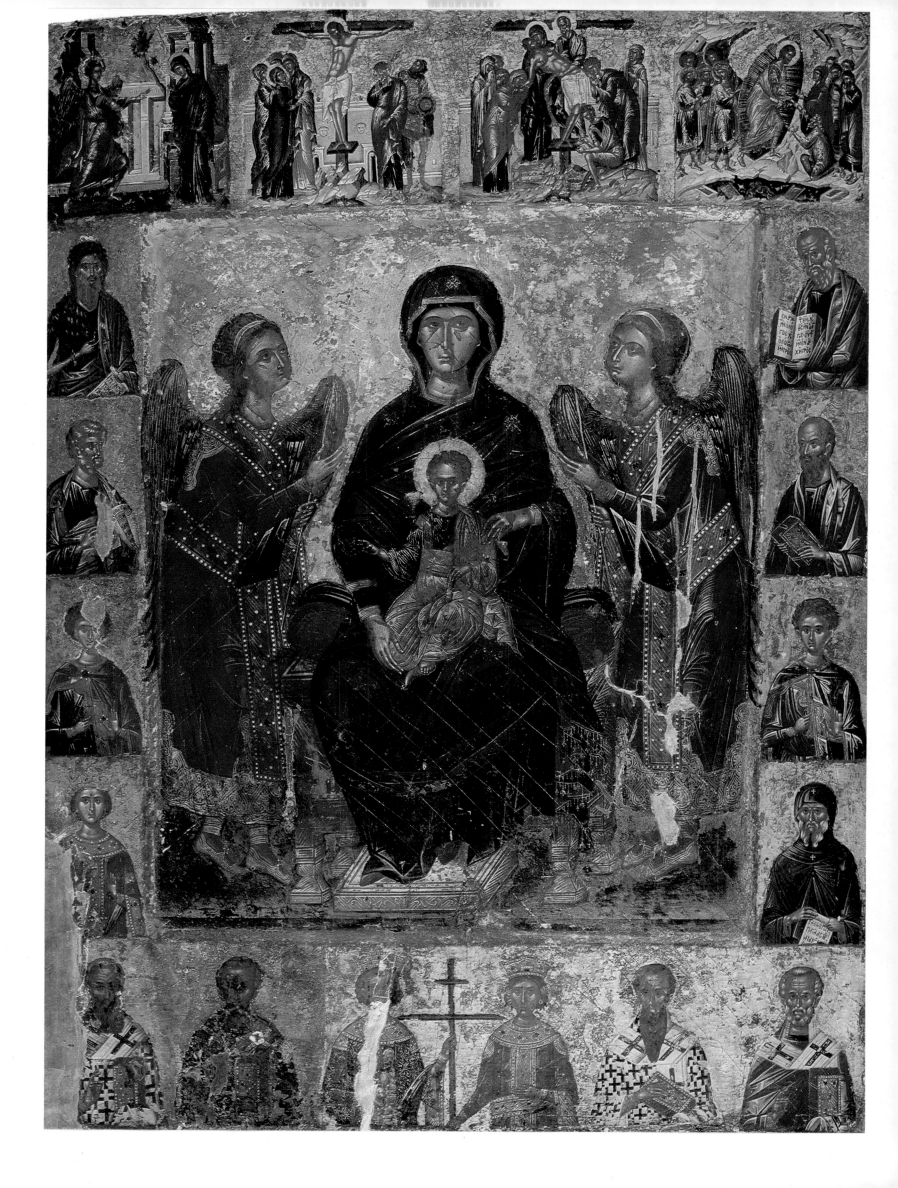

the various figures are elongated, slender, and weightless — thanks chiefly to the thin streaks of light on the flesh and pale rivulets on the curves of the garments' folds. There are further reasons to place the work in the fourteenth century, after the Patmos icon, such as its relationship to the Incredulity of Thomas from Meteora, 108 whose date is certain. The lightness of the modeling, which reflects a gracious and idealistic spiritual attitude, has already been noted in the icons of Meteora and Patmos. It has a long history and was used especially in miniatures. In the fourteenth century it spread to icon painting and remained one of the most frequent methods for three hundred years, as shall be seen when we examine the Descent into Limbo by Michael Damaskinos. 122, 123

An icon of the Hospitality of Abraham in the Benaki Museum, Athens, shows the 110, 111 ultimate point reached by these idealizing tendencies at the close of the century. While the pictorial space is very clear in the Patmos Crucifixion, it had always been employed most sparingly, and in this icon loses much of its significance. The plane of the oval-shaped group of angels can scarcely be distinguished from that of the buildings in the background. Furthermore, the graceful figures have been rendered even more ethereal through the bright illumination and light brushwork. The decorative element has become more marked; the completely conventionalized architectural forms with their arrangement of verticals and horizontals serve to frame the principal figures. The emphatic brightness of the picture highlights the narrow black patches of the doors and windows and the shimmer of light, pure colors. Through the radiance of these delicate colors, as well as the grace and elegance of the human forms, a mystical religiousness is here expressed. This is in full accord with the theme of the picture, an Old Testament motif symbolizing the New Testament's Holy Trinity.

The same spiritual attitude is incorporated in an icon of the Archangel Michael in 109 the Civic Museum of Pisa. There is an easy grace about the figure's pose and gesture despite its seeming massiveness; there are subtle harmonies of green and violet in the draperies; and there is fine modeling, in which the white lines of the folds trace somewhat angular arabesques. All of these factors suggest that this icon should be dated near the end of the fourteenth century. The half-effaced inscription in Latin, the embossed frame with the arch, and its corner ornaments in the form of triangles suggest a Western origin for this icon; but many of these traits are also found in a series of icons, at Sinai, that are unquestionably Greek.

Finally, an icon depicting the Baptism of Christ, from the Greek Patriarchate in 113 Jerusalem, proves that the approach to form was far from homogeneous at the end of the fourteenth century; it also shows that the graceful Hellenizing style, which had prevailed throughout the century, became more rigid at that time, and followed a geometrical tendency that was previously unknown in Byzantine art. The modeling perpetuates the manner we noted in works from the early part of the century which sought to bring out the plastic form of the body. But the light-streaked surfaces of these draperies assume angular shapes without losing their basic function; the nude body of Christ is almost anatomically perfect and has sharply defined shadows, while the rocks seem to have been cut out by scissors. As a result of this schematizing, the poses are quite mannered — especially that of the Baptist. Two small figures in grisaille near the lower edge of the picture, who symbolize the Jordan and the sea, have the usual picturesqueness of accessory figures but become, through their strictly

symmetrical arrangement, relatively static supporting elements. Such traits are common in sculpture and miniatures of this time period. Despite all these discrepancies, this icon remains a work of high quality.

In the development of icon painting, the division between the fourteenth and fifteenth centuries cannot always be traced clearly, and, therefore, many of the works we are about to consider may well belong to the end of the fourteenth. There is, for example, a large liturgical icon in the Byzantine Museum which portrays Saint 115 Marina as a holy martyr. The figure retains all the nobility and stateliness of a great lady in spite of her sad fate; her draperies fall in slow rhythmic folds which broaden out in her hood. Such traits are typical of icons from the thirteenth and fourteenth centuries, as we have seen in the Saint James; but certain aspects lead us to date this 67 fine icon about 1400. The lack of plasticity in the red veil, the face that is disproportionately small and rather harsh in aspect — these features recall in their technique the works of Theophanus the Greek in Russia about 1405, and the angel in the Great Deësis at Chilandar.

On a double-sided icon in Mytilene, Christ occupies one face and John the 127 Evangelist the other. The great bulk of Saint John bursts beyond the limits of the frame; his huge head shows a wild expression, and his powerful hands hold a large, open Gospel. Vigorous contrasts bring the head into strong relief. This sculpturesque and far from spiritual figure was derived from the fiery old men painted around 1300 by Manuel Panselinos on the walls of the Protaton, or by Eutychios and Michael Astrapas in the Peribleptos at Ohrid. What leads us to date the icon after 1400 is a certain stiffness in the draperies, the similarity of its forms to those of the apostle in the Deësis at Chilandar and finally, the similarity of its modeling in comparison with certain figures done at the Pantanassa Monastery at Mistra in 1428.

It must be recognized that such a regression to models of a school which to all intents and purposes had been extinct for three generations was not an isolated phenomenon. There is, for example, a triptych in the Benaki Museum showing the 129 Virgin and Child on the central panel and a saint on either wing. The broad modeling, the wrathful expression of the Child, and details like the shape of the ears remind us of icons from the beginning of the fourteenth century. Other traits, such as the delicate workmanship and vivid coloring, suggest a date at least one hundred and fifty years later.

An icon of the Dormition of the Virgin from the Monastery of Saint John on Patmos 126 brings us to another aspect of icon painting in the fifteenth century, namely, the influences exerted by Italian art. Thirteenth century icons, as we have explained, 70, 94 reveal certain direct consequences of the immediate contact with Western art, especially during the French occupation. In the 1300's, however, Western effects definitely abated, even in regions occupied by the Venetians and other "Franks." But in the fifteenth century signs of a certain influence of the West upon the East crop up more frequently. As a result of the narrow frame of the Patmos icon, its composition is typically simplified, and dominated by the elongated figure of Christ. Everything in this icon is Byzantine except the two buildings; the peaked roofs with rose windows in the pediments and, above all, the perspective treatment clearly betray their debt to Giotto.

The sixteenth century perpetuated the traditions of the preceding periods with a fidelity that may sometimes confuse even the specialists. The artistic center was

shifted to Crete, and to the island came painters from Constantinople, such as Alexios Apokavkos in 1421 and Nicholas Philanthropinos in 1419; and others came from Mistra, including Xenos Dighenis in 1461; all brought with them the styles of the great centers. This explains the purity of the iconography and style in sixteenth century Cretan painting which made it the quasi-official school of painting for the Orthodox Church. The best features of this art are apparent in the icon of the Nativity, now in the Hellenic Institute of Venice. The richness of the landscape composition, the 128 stratification of planes, and the pictorial motifs, as well as the soft modeling and the measured grace of the poses have all been taken with fidelity from some Palaeologue prototype. But the composition has become calmer and more symmetrical in the sixteenth century icon; the arrangement of the draperies is now subordinated to a geometrical rhythm, and the mountains are more severely stylized. Moreover, accessory elements borrowed from Italian art are discreetly introduced here and there — the rabbit and doe remind us of Pisanello. The manger is correctly rendered in perspective and chiaroscuro.

But most of the scenes are untouched by any Italian influence: for example, the 121 Descent from the Cross painted on the border of an icon of the Virgin now in the Benaki Museum. This firm composition with its tall figures full of nobility and restraint could be enlarged to the dimensions of a mural painting without the slightest change. And we find, in fact, the same severe, sober style and the same masterly workmanship in the frescoes done in the mid-sixteenth century by Cretan painters on Mount Athos, or in the monasteries of Meteora.

At times one has the impression that an artist was striving to return to the forms of the previous two hundred years, as in certain icons by Michael Damaskinos, the outstanding Cretan painter of the second half of the sixteenth century — notably in the Descent into Limbo that bears his signature, in the Benaki Museum. The 122, 123 transparent coloring and delicate brushwork in the modeling of the figures, which are at once grave and ethereal, remind us strongly of the fourteenth century icons we have discussed.

Sixteenth century icons with single figures retain and, indeed, reinforce the sculpturesque feeling which, although weakened in form, had been handed down from the 1300's and 1400's. The icon of Saint John the Evangelist from Patmos repeats 124 the type that was current in the fourteenth century, in which he is depicted as a writer with his inkhorn clasped under his arm. The figure fills the entire pictorial field; the powerful head with its exaggerated brow is inclined to one side in grief, but the bulk of the body seems nonexistent beneath a mass of draperies. Highlights outline the drapery folds in straight-edged triangles with no hint of a curve; this peculiarity is common to icons by the painter Euphrosynos, dating from 1542, and to a number of other Cretan icons from the mid-sixteenth century. This conservative spirit was carried over into the seventeenth century, as we see in the large icon in the Benaki Museum signed by Emmanuel Tzane in 1637. This youthful work shows Saint Anne 131 with the Virgin holding a flower as a symbol of Christ. The outstanding Cretan artist succeeded in retaining not only the impeccable technique of the great tradition but also the expression of serene majesty and austere tenderness. These qualities have always, from time immemorial, constituted the great glory of Byzantine painting.

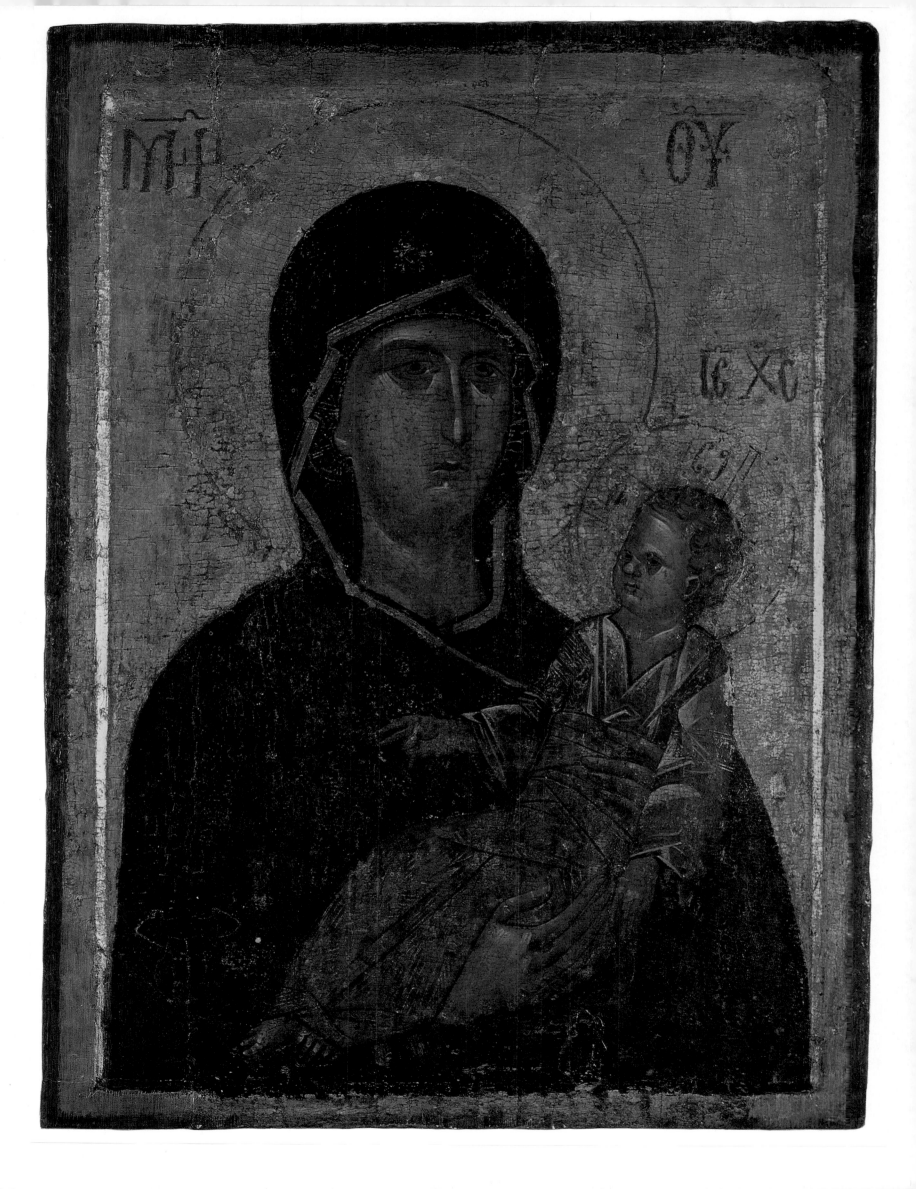

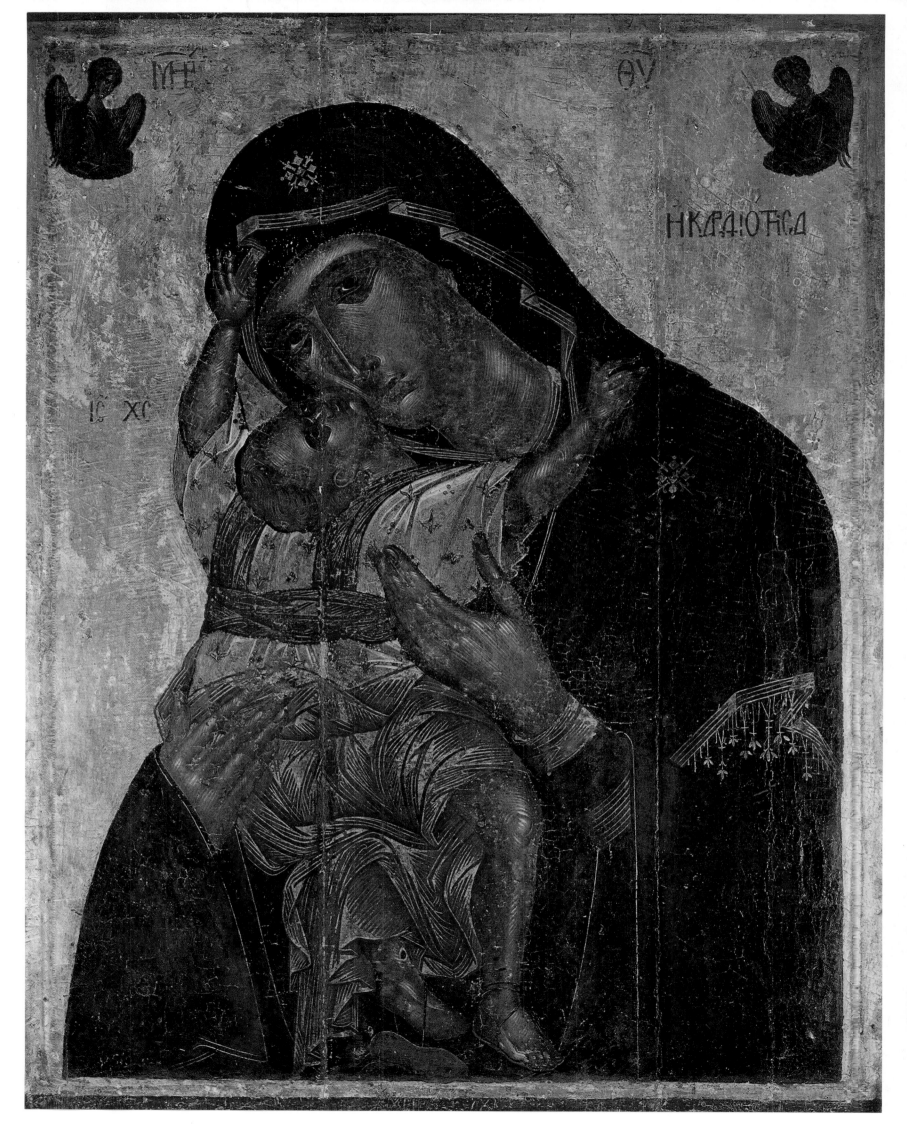

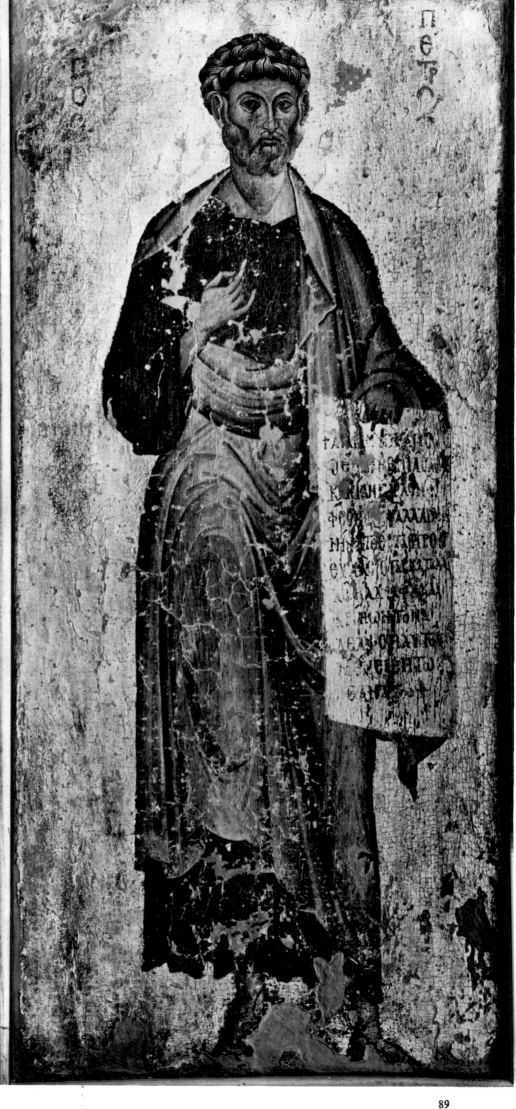

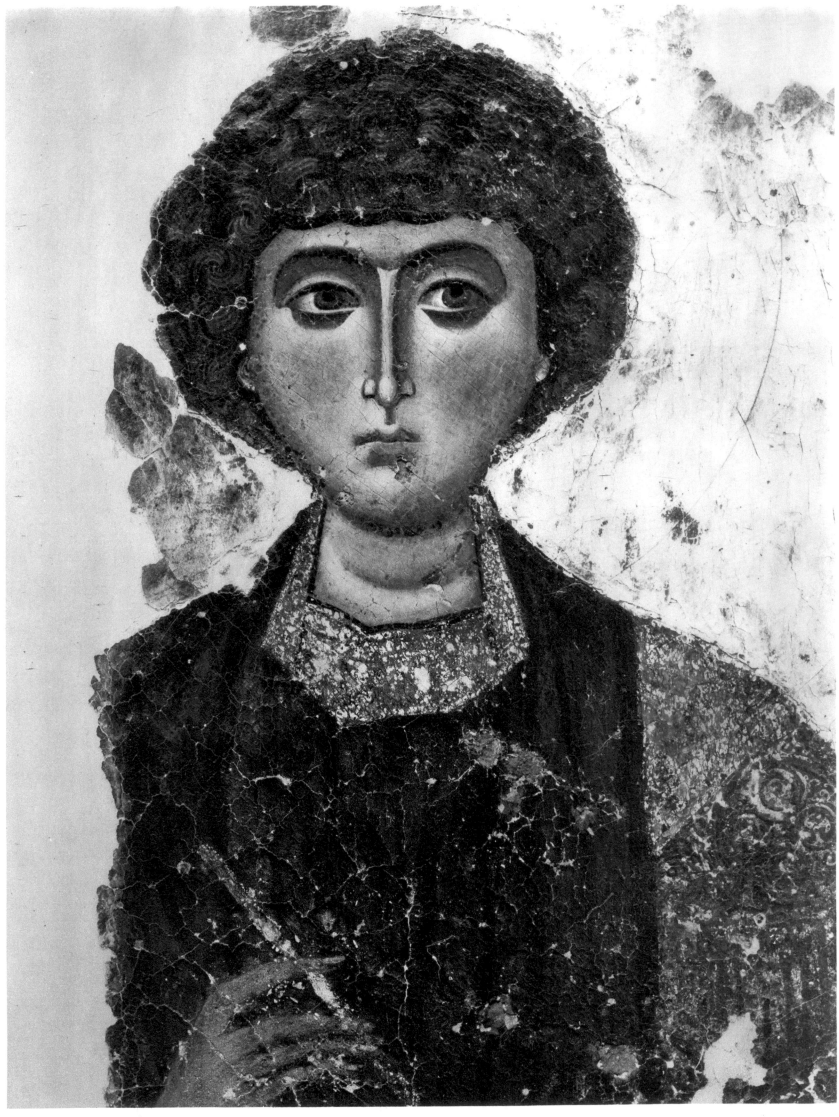

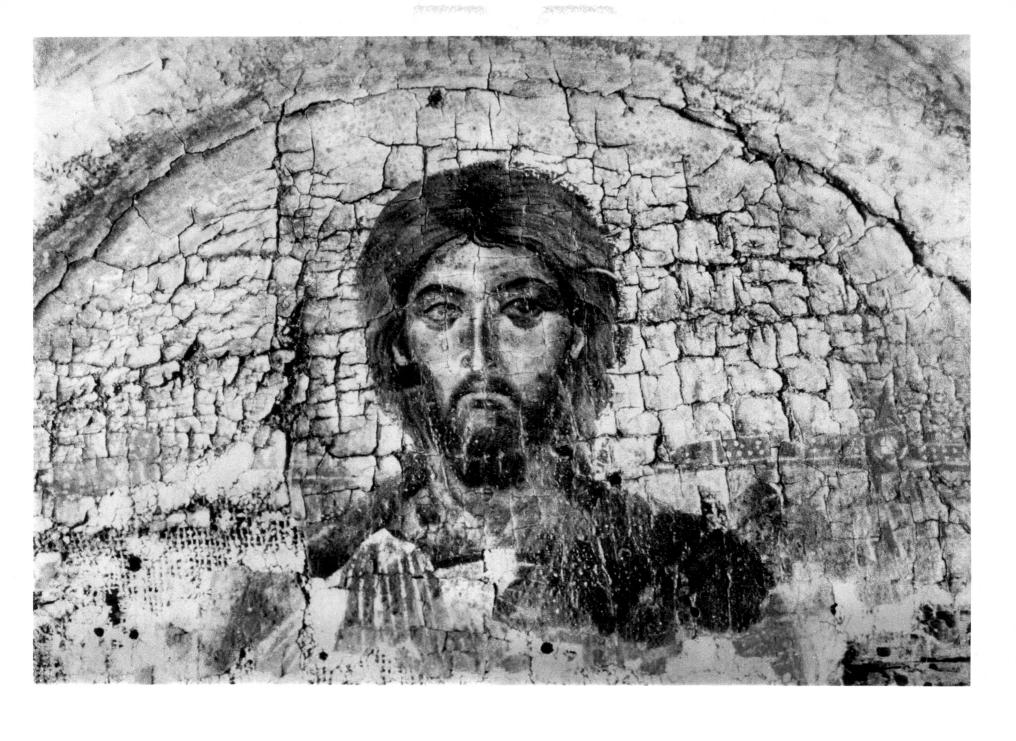

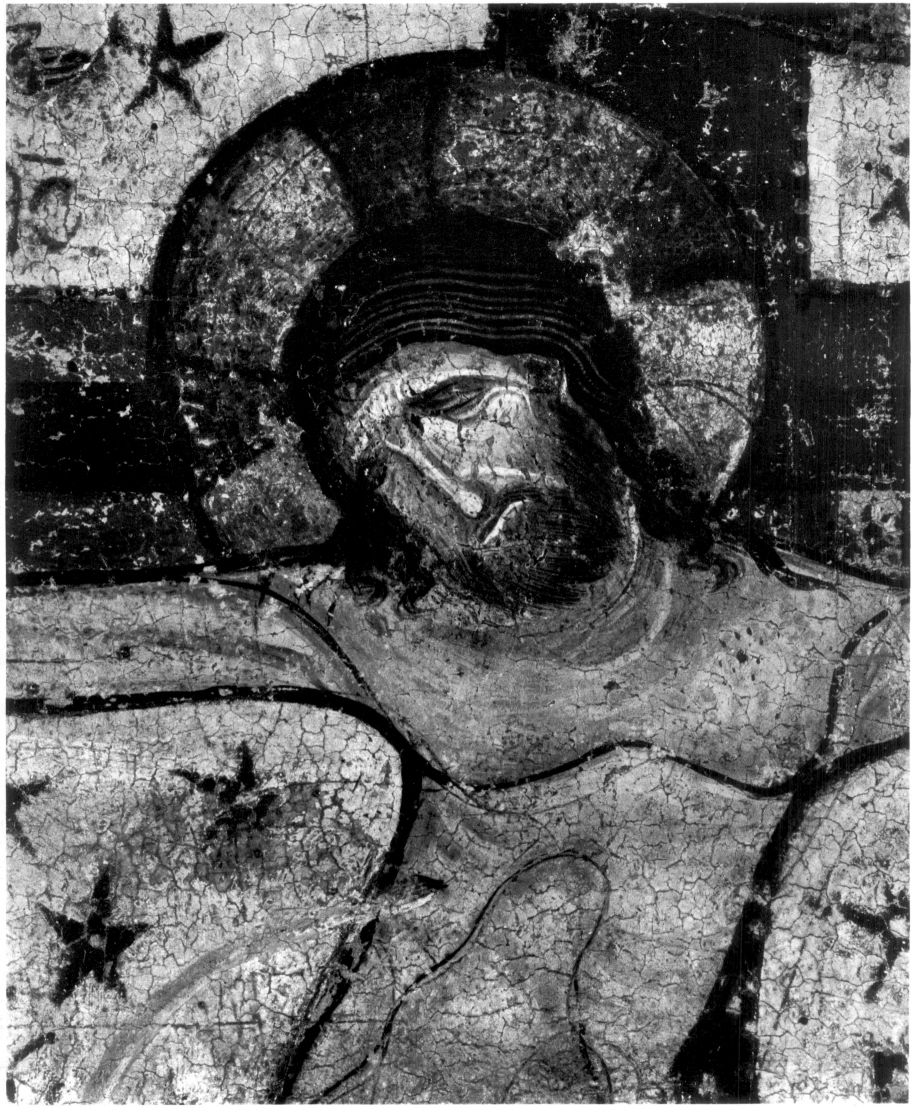

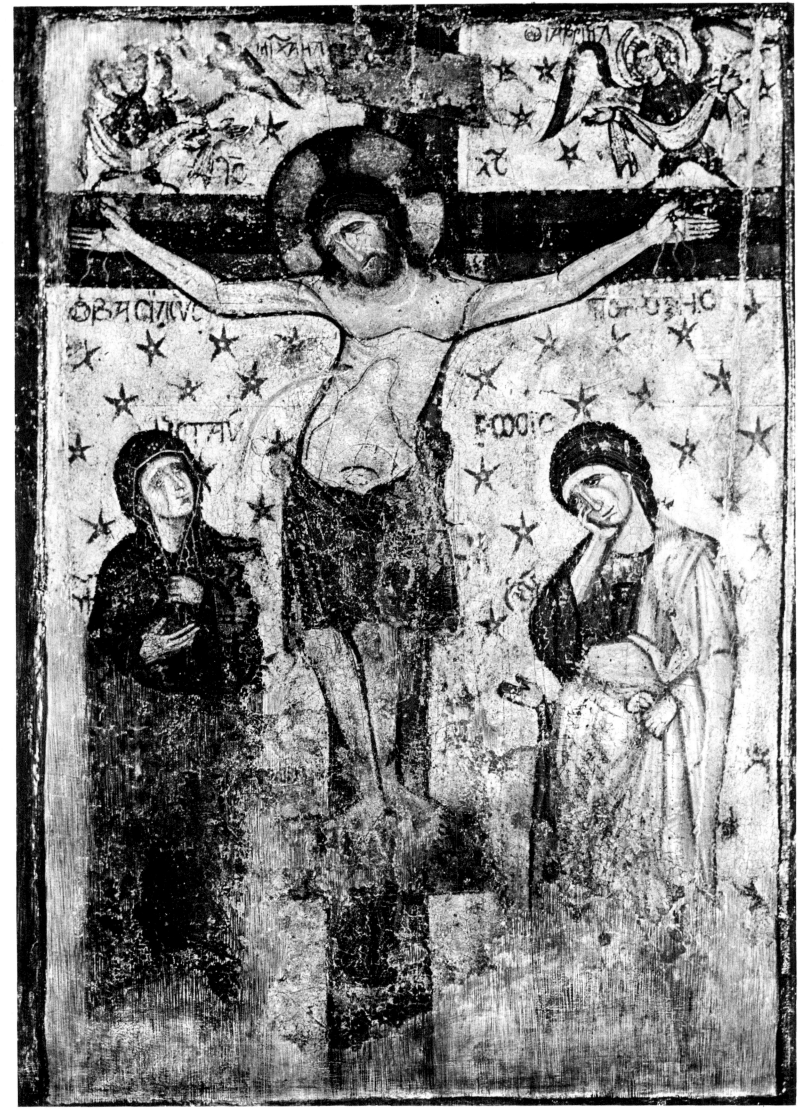

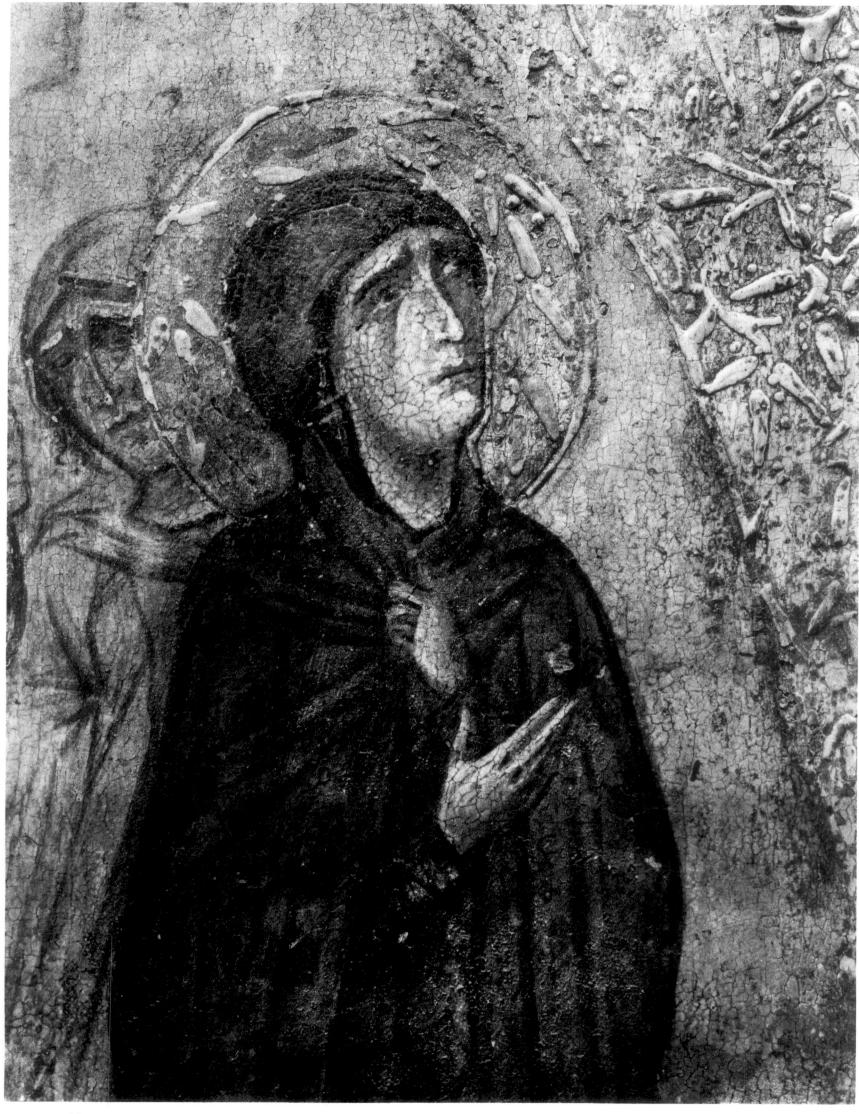

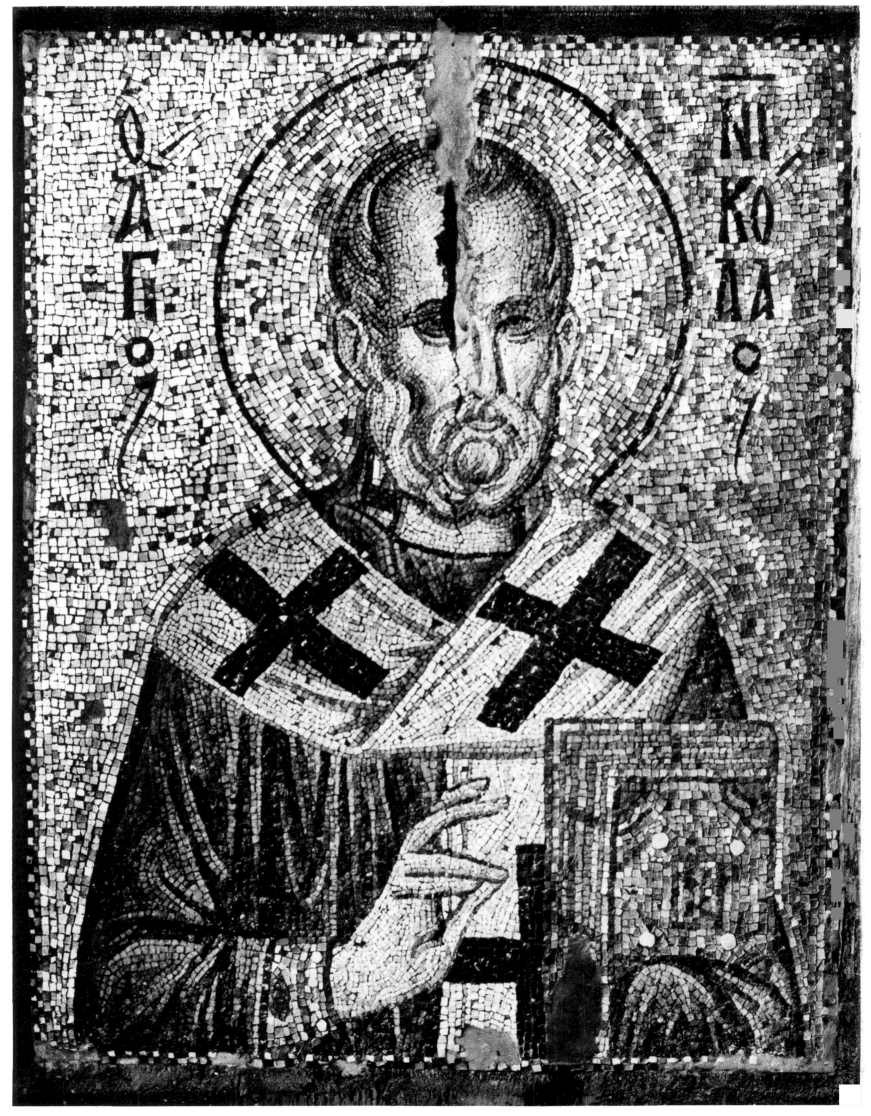

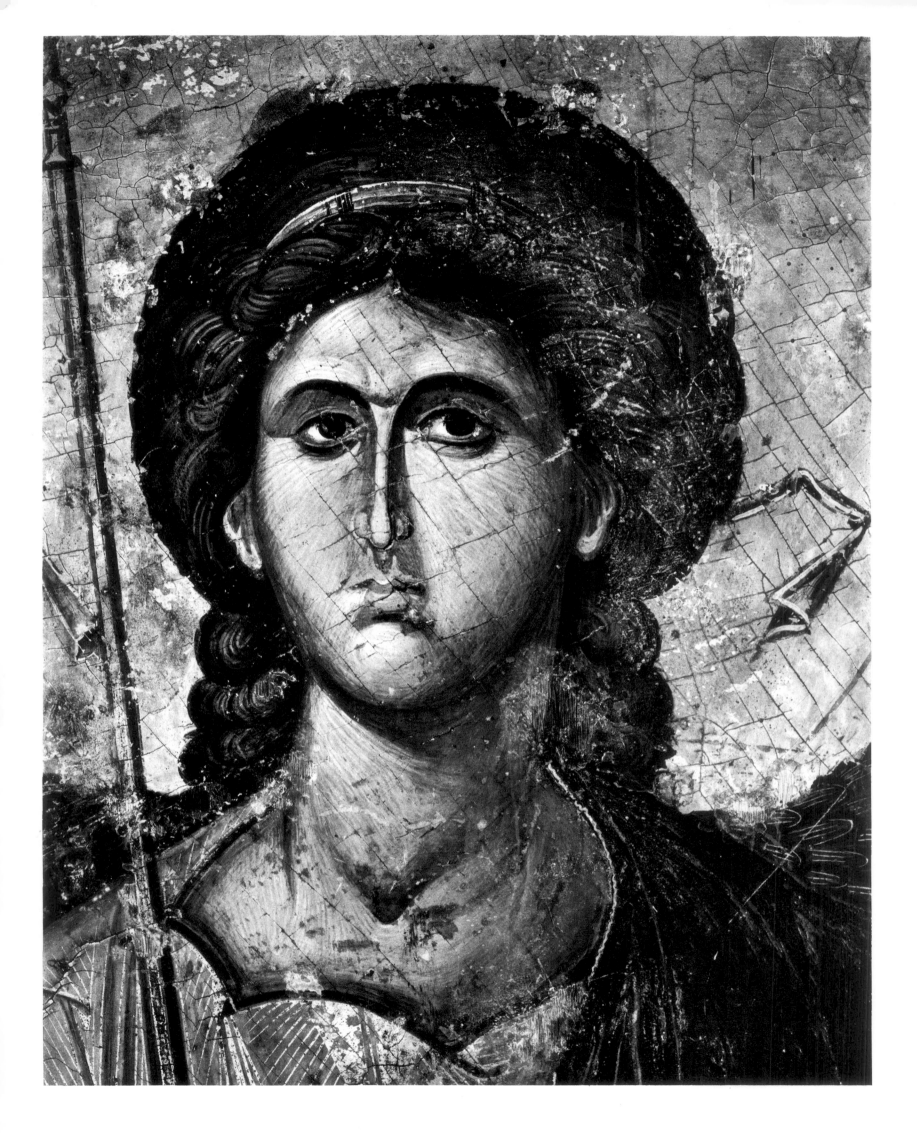

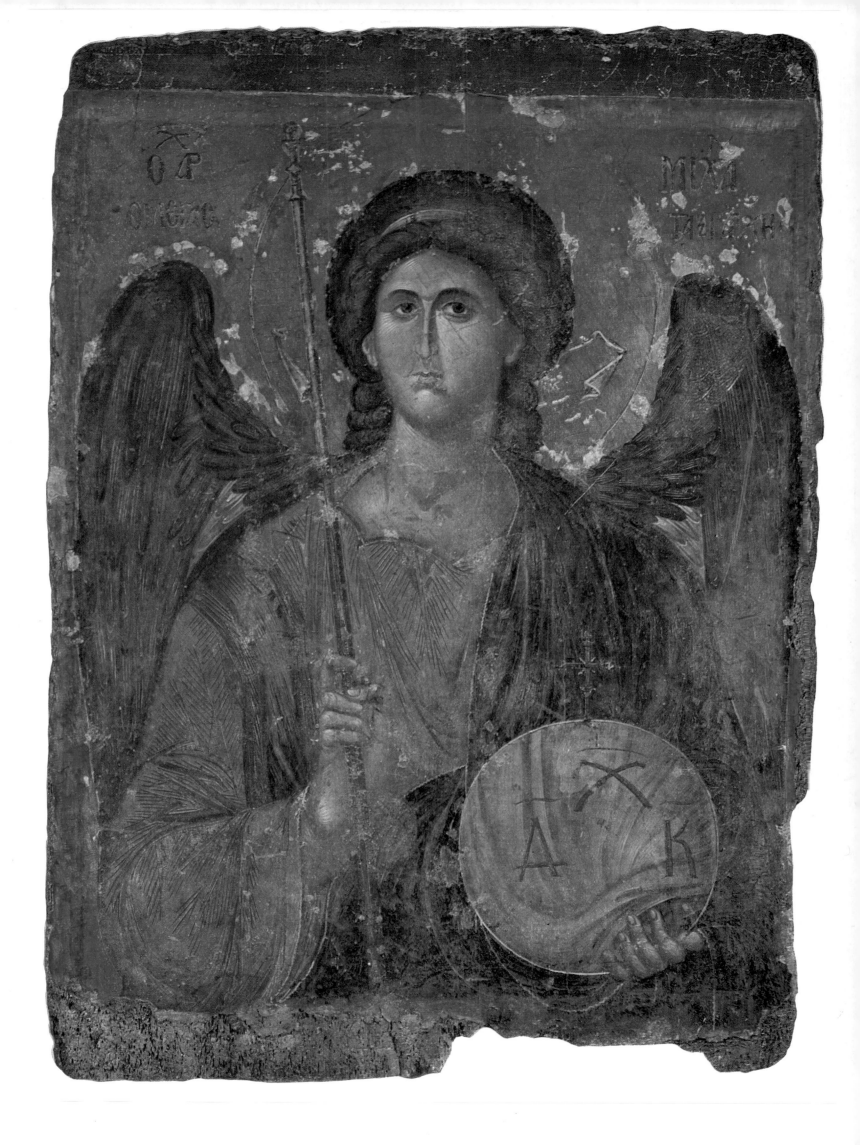

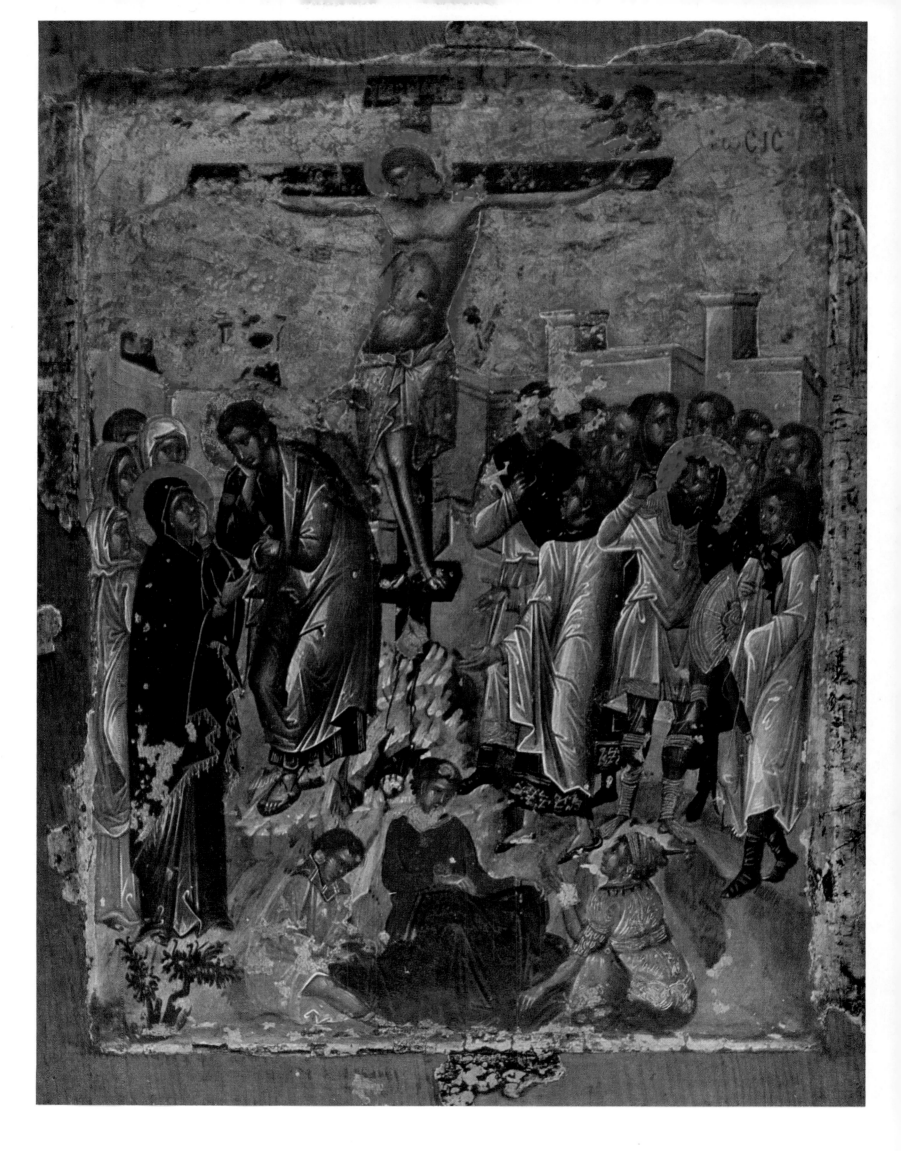

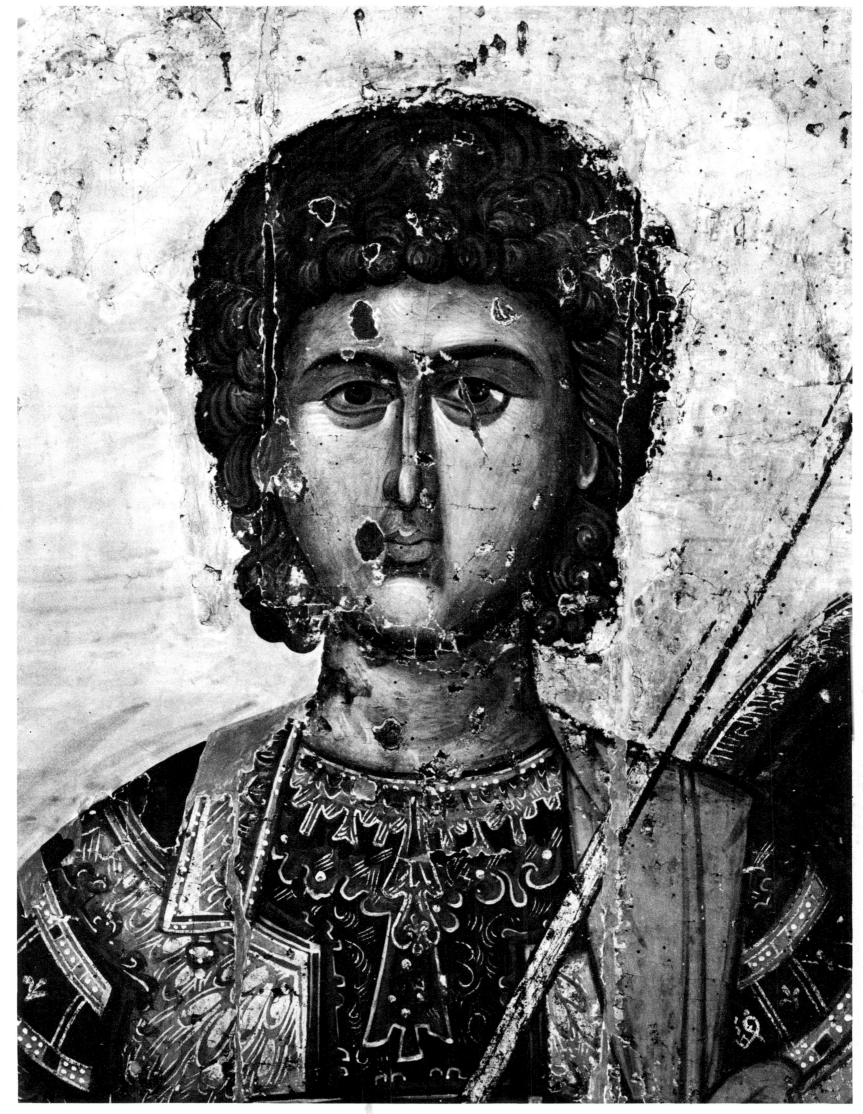

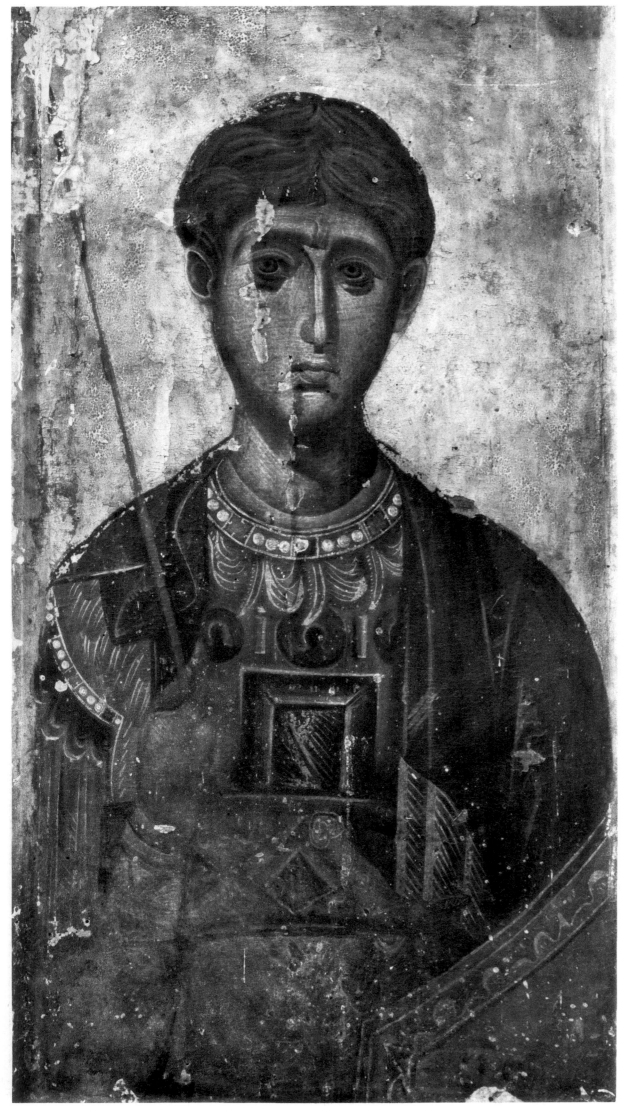

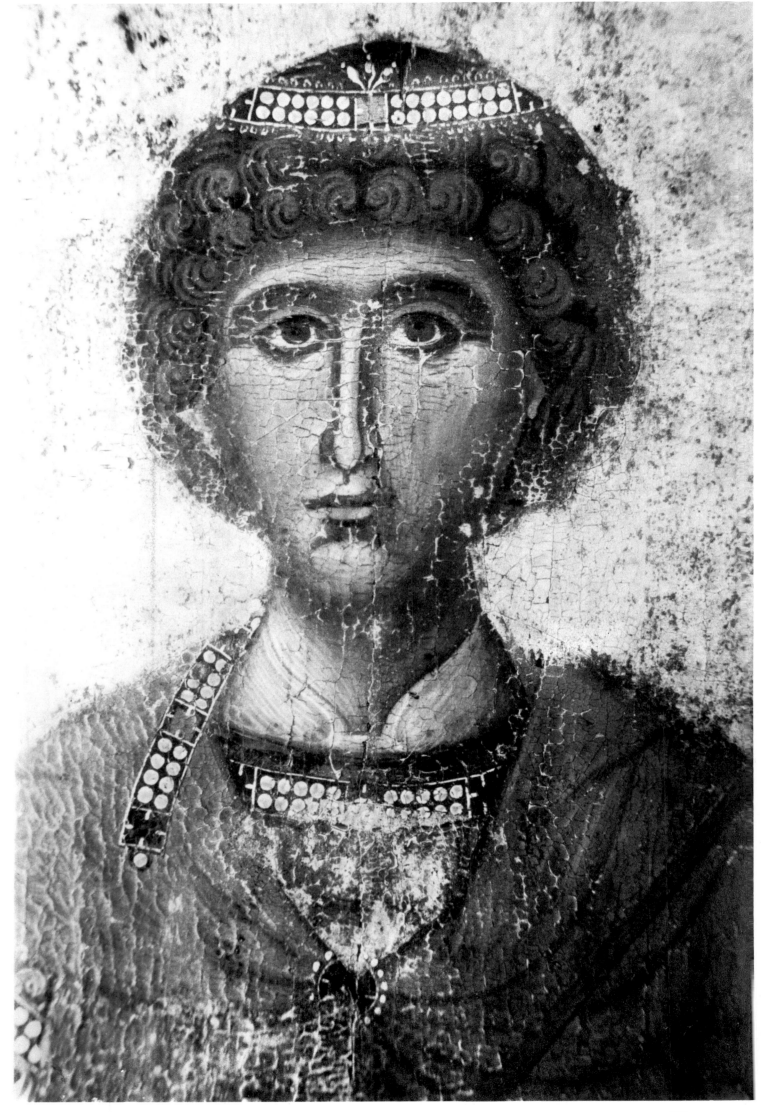

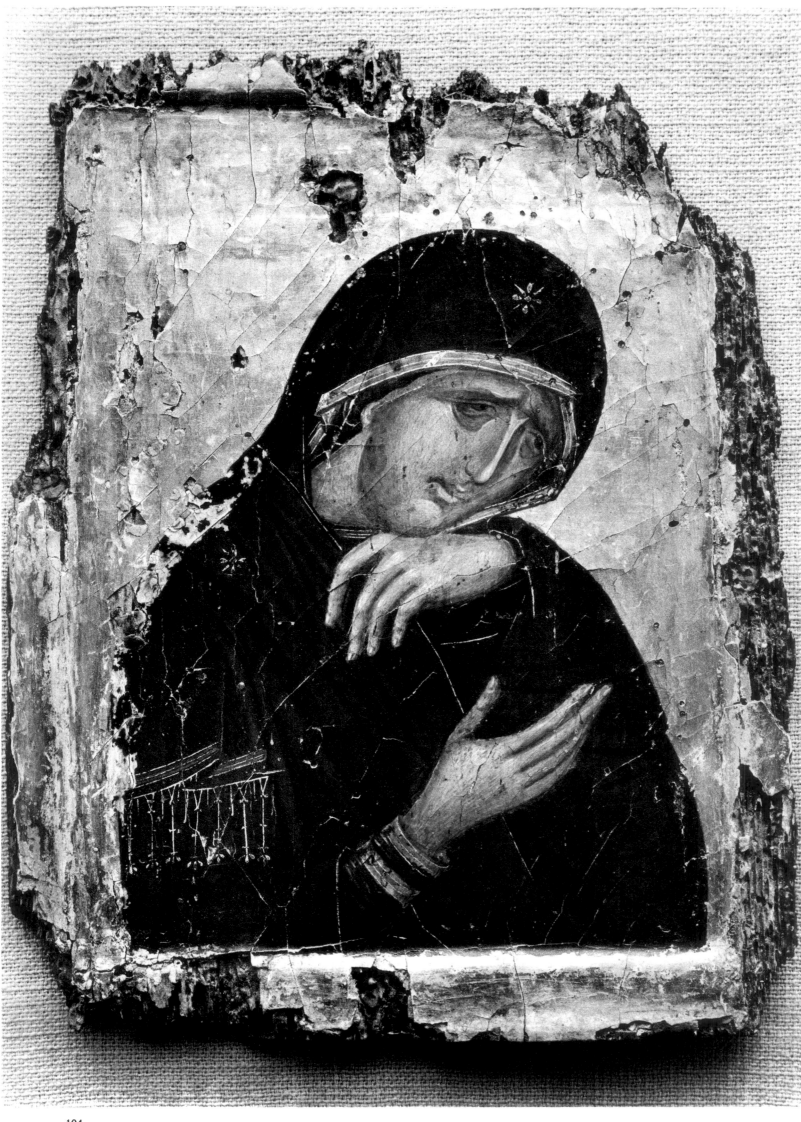

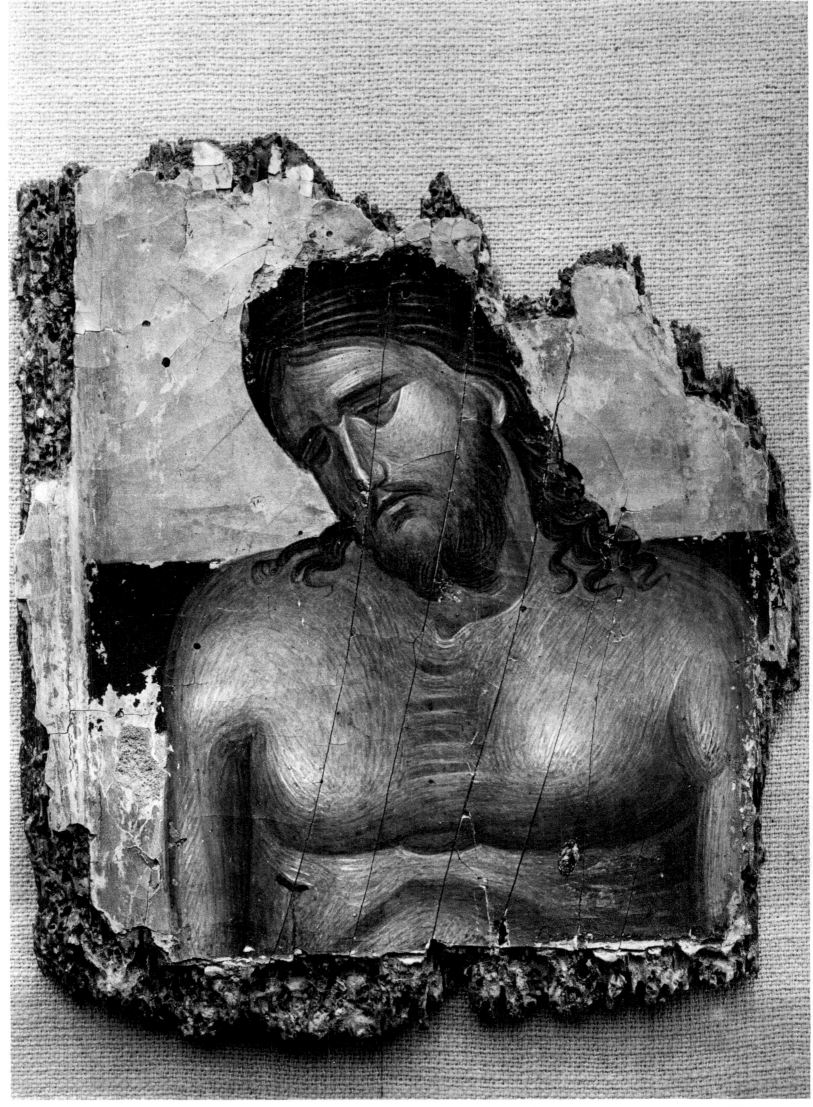

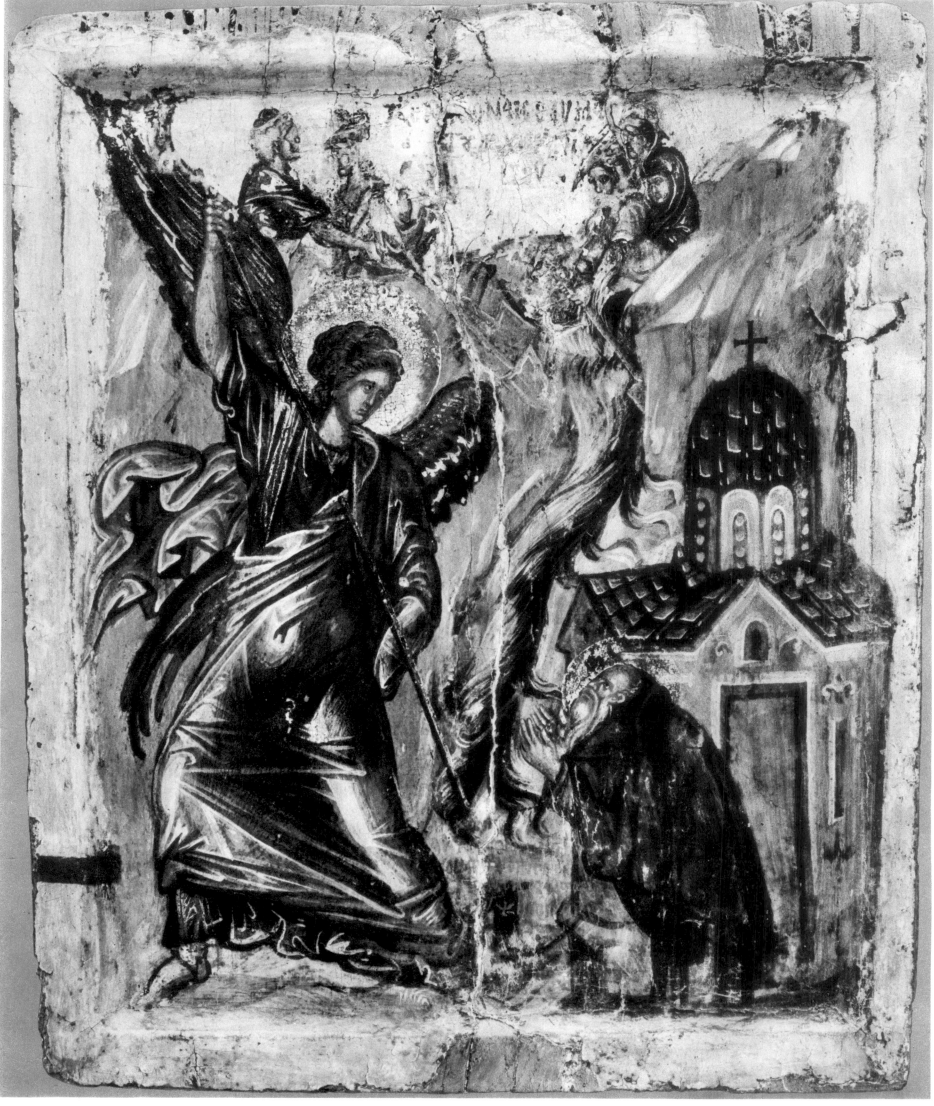

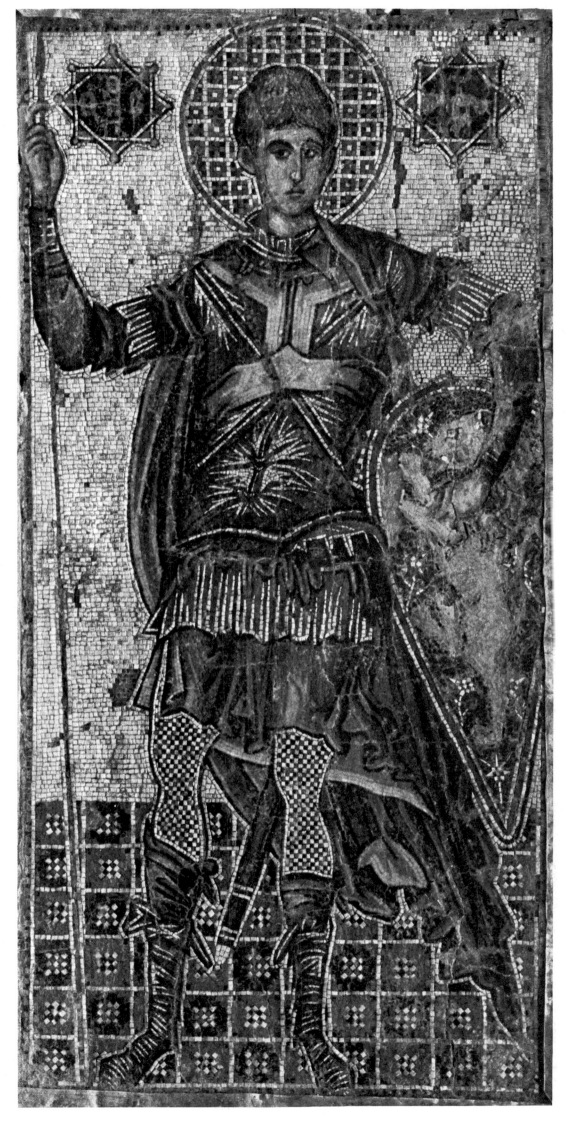

107

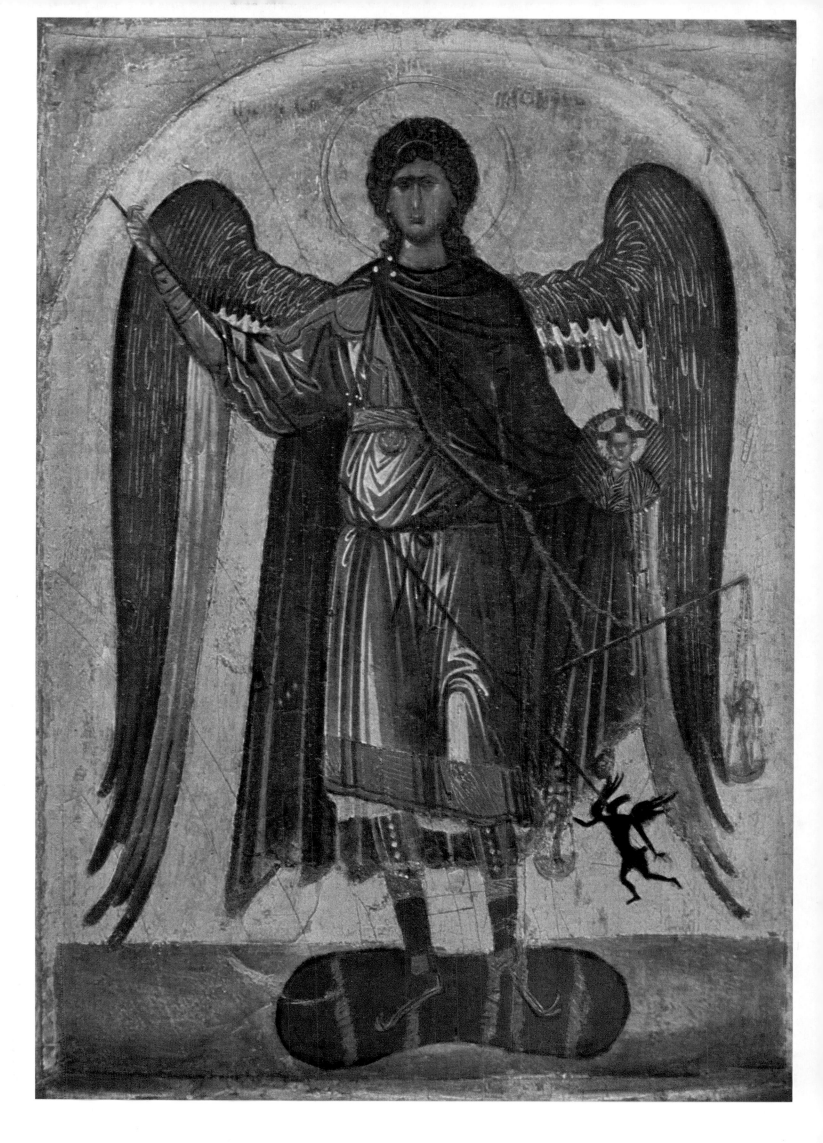

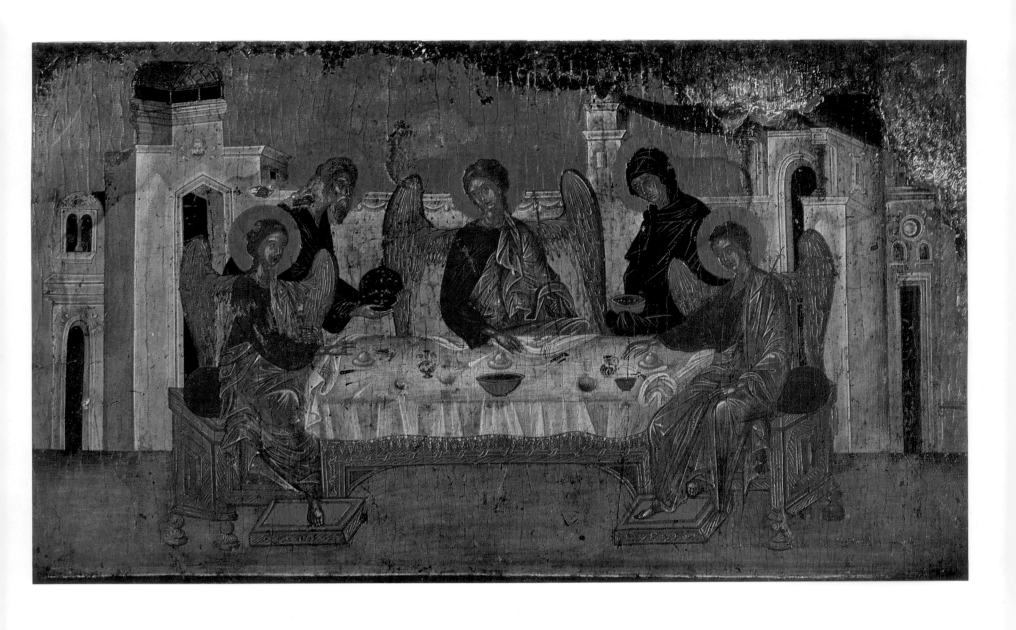

110

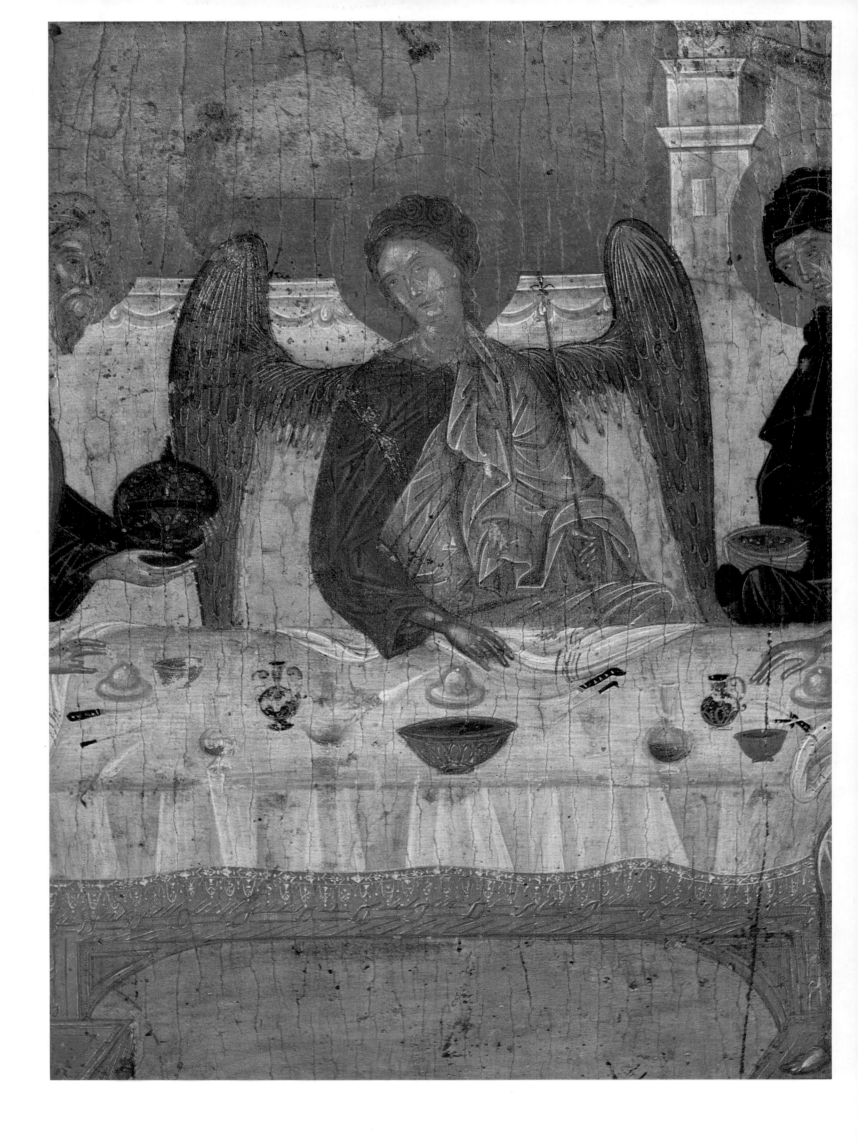

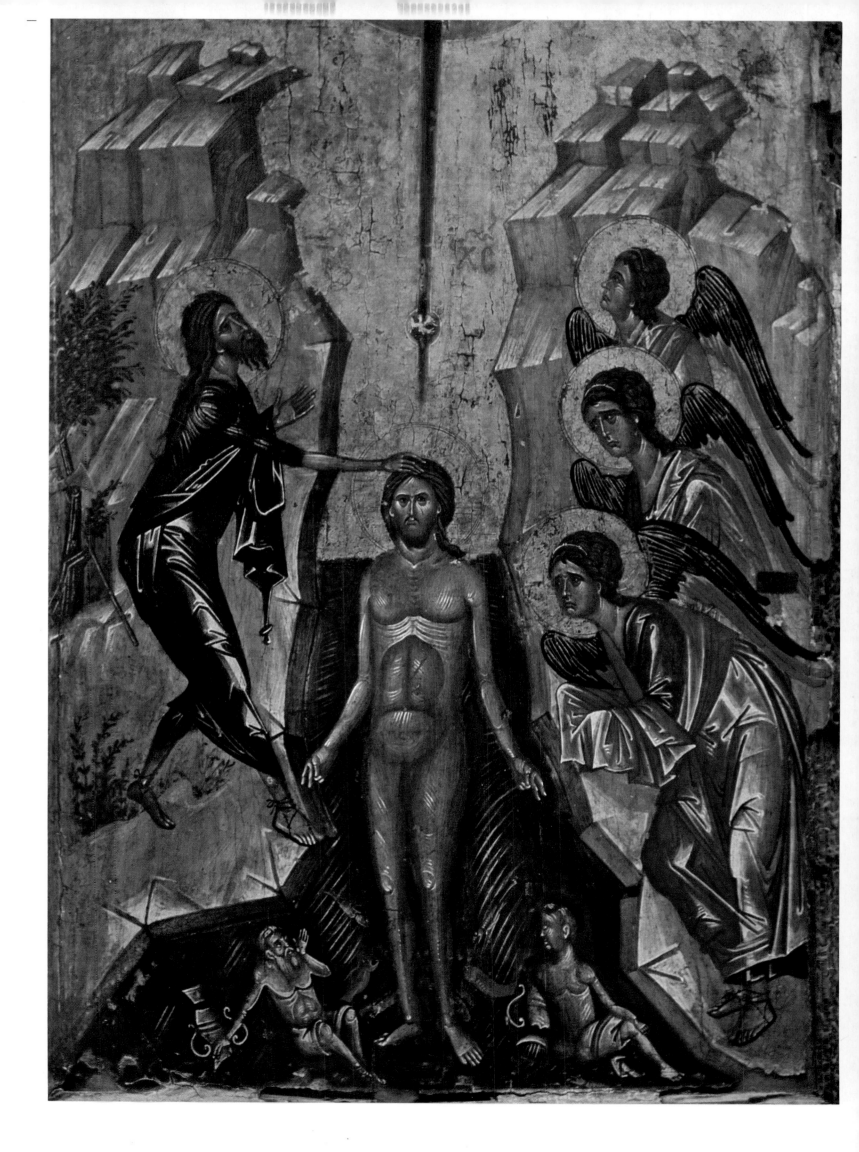

113

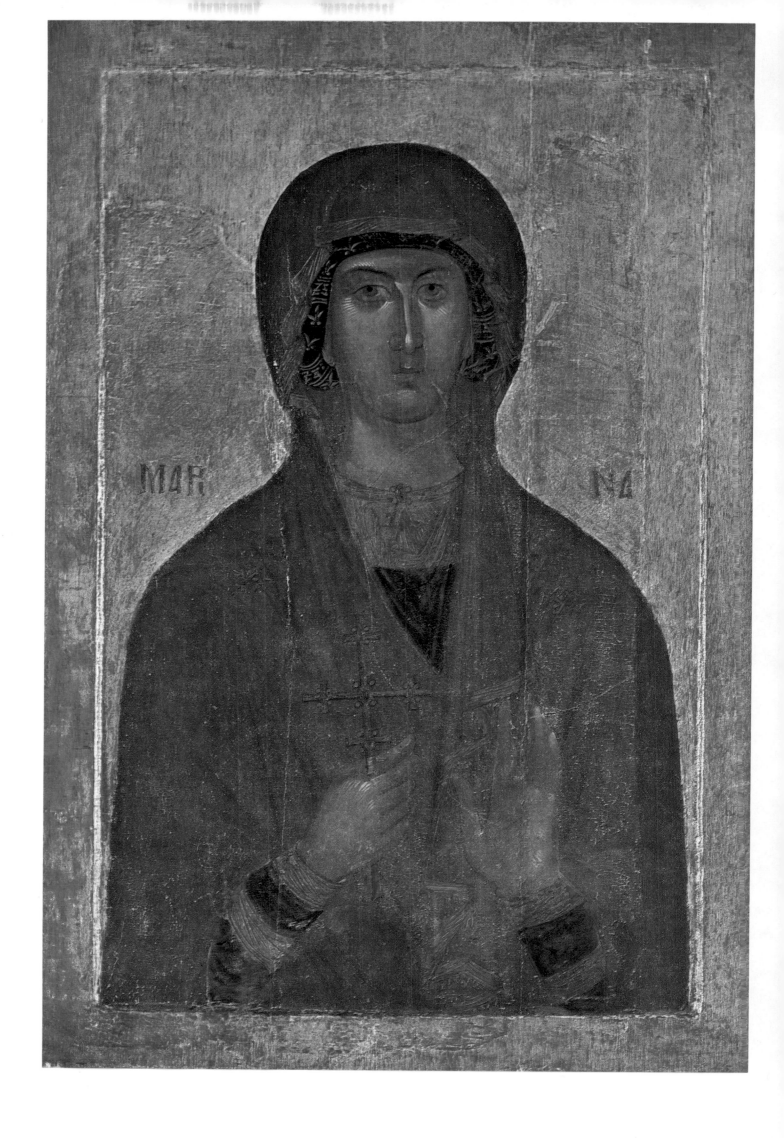

MAR NA

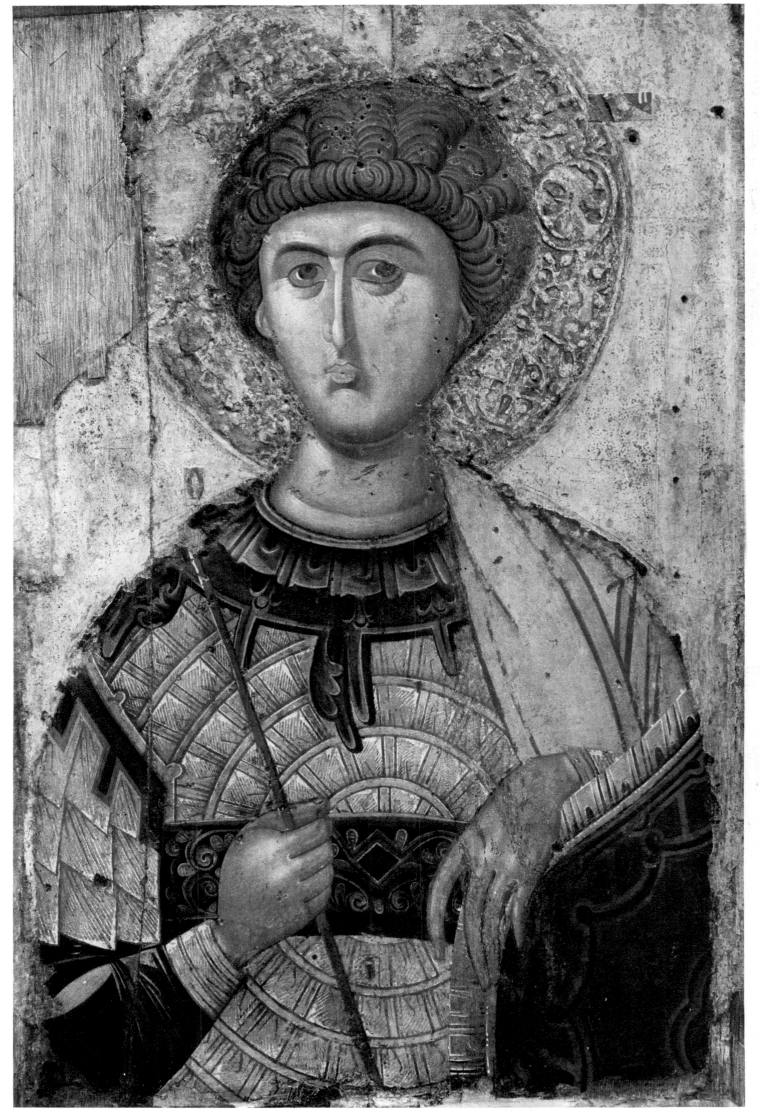

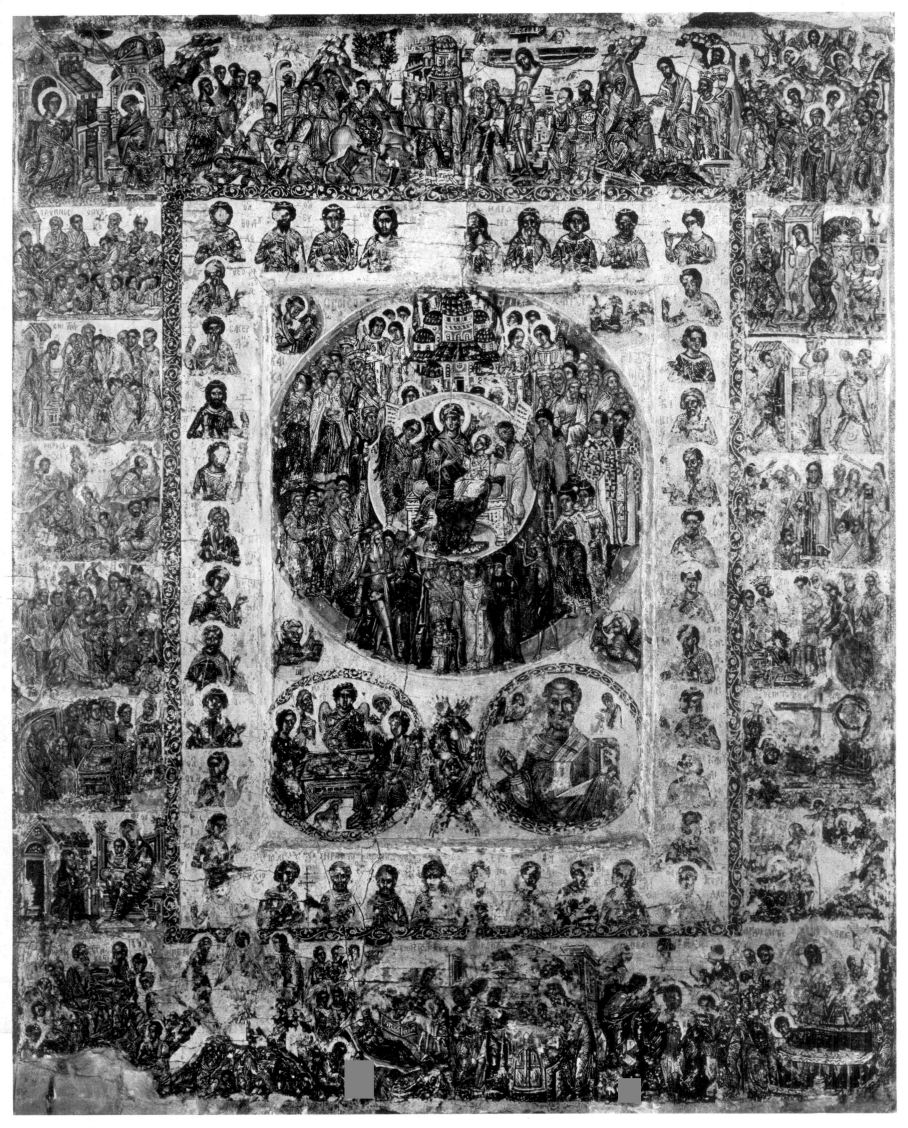

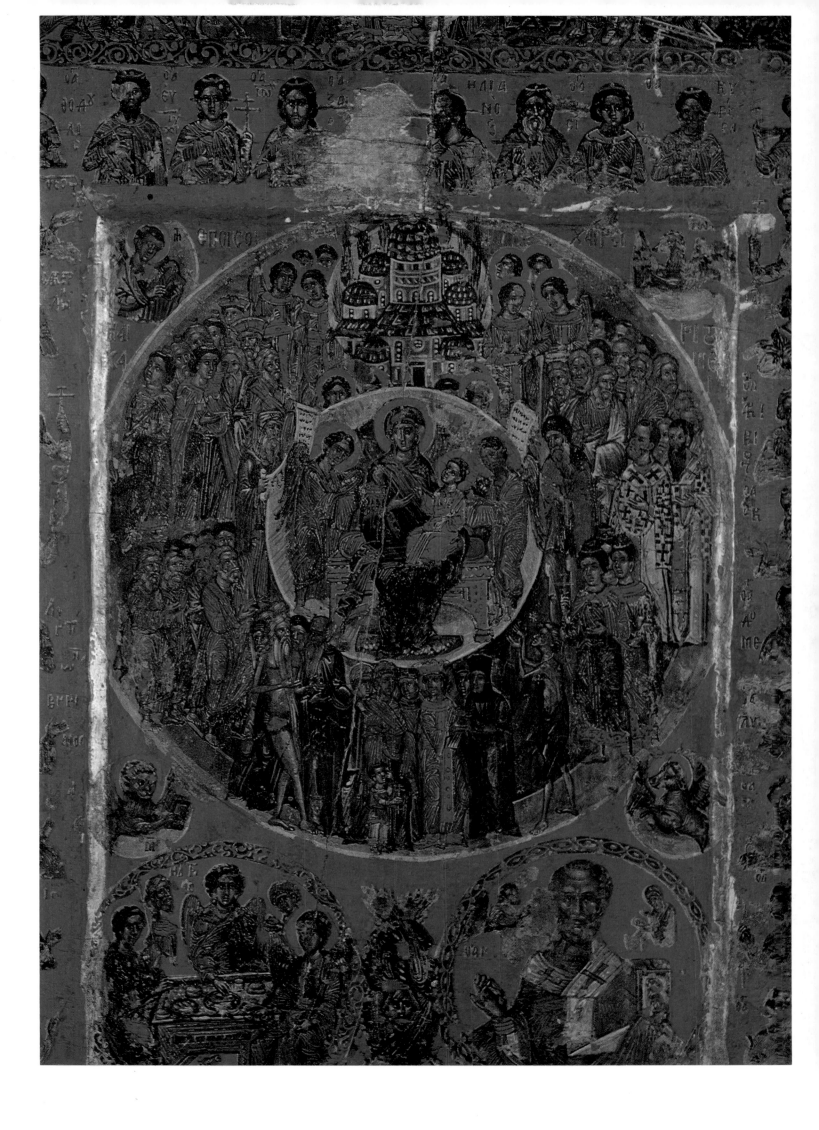

119

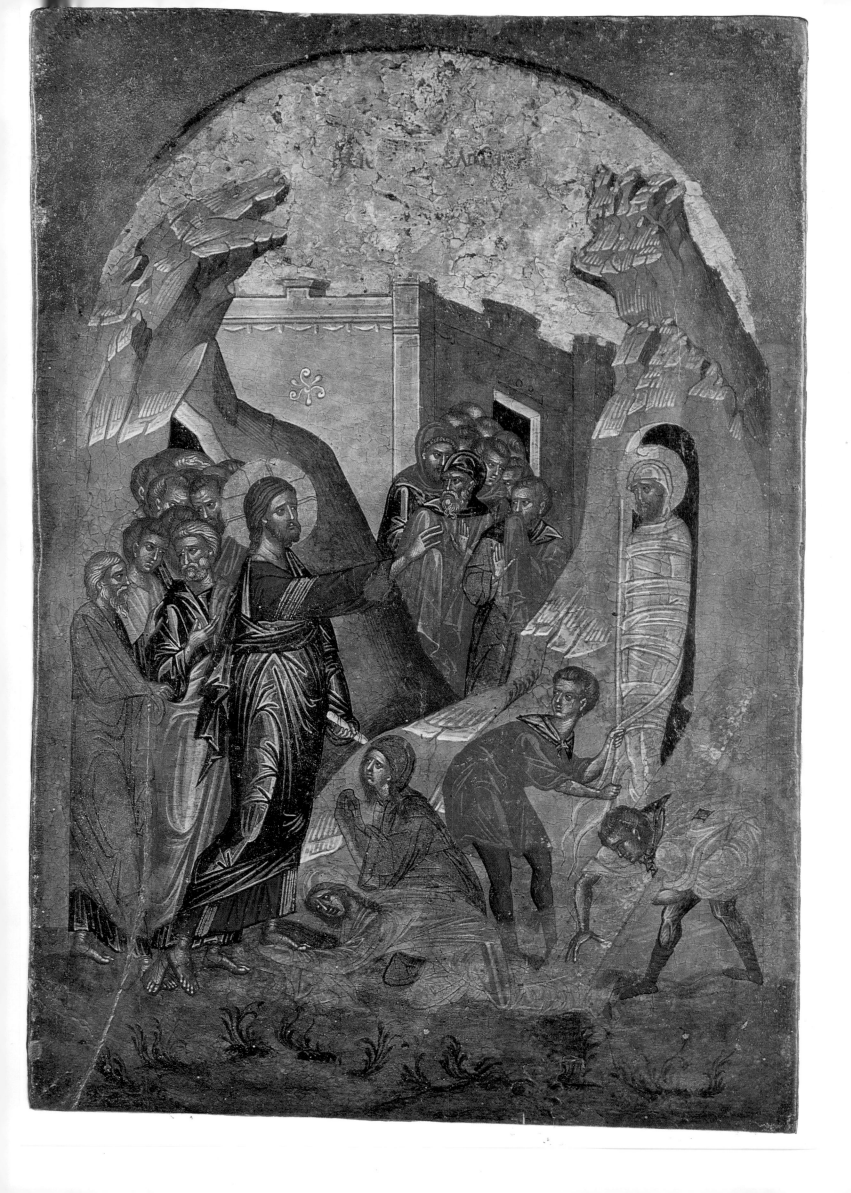

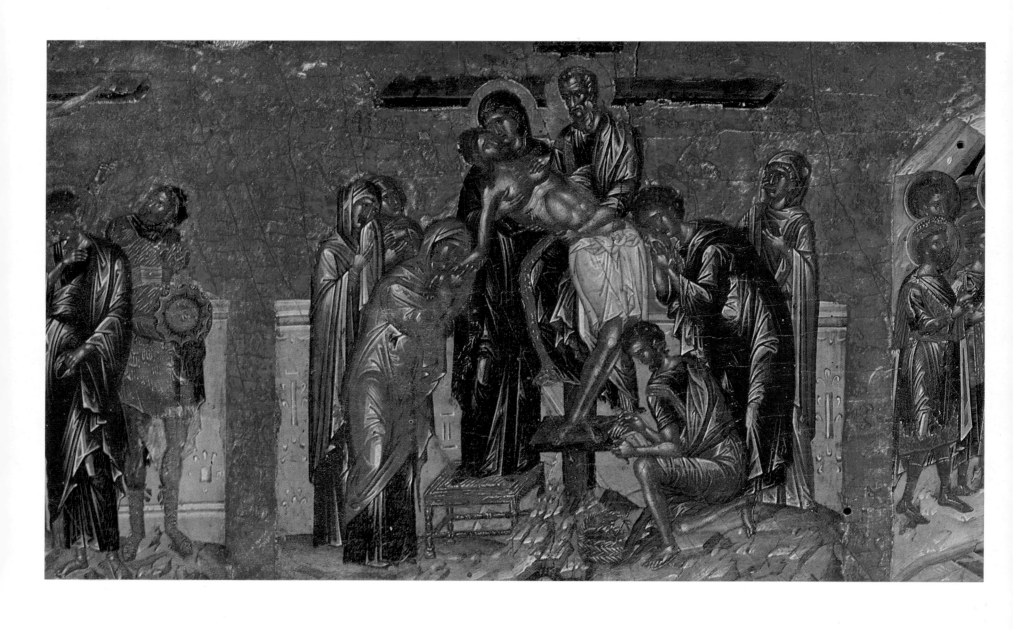

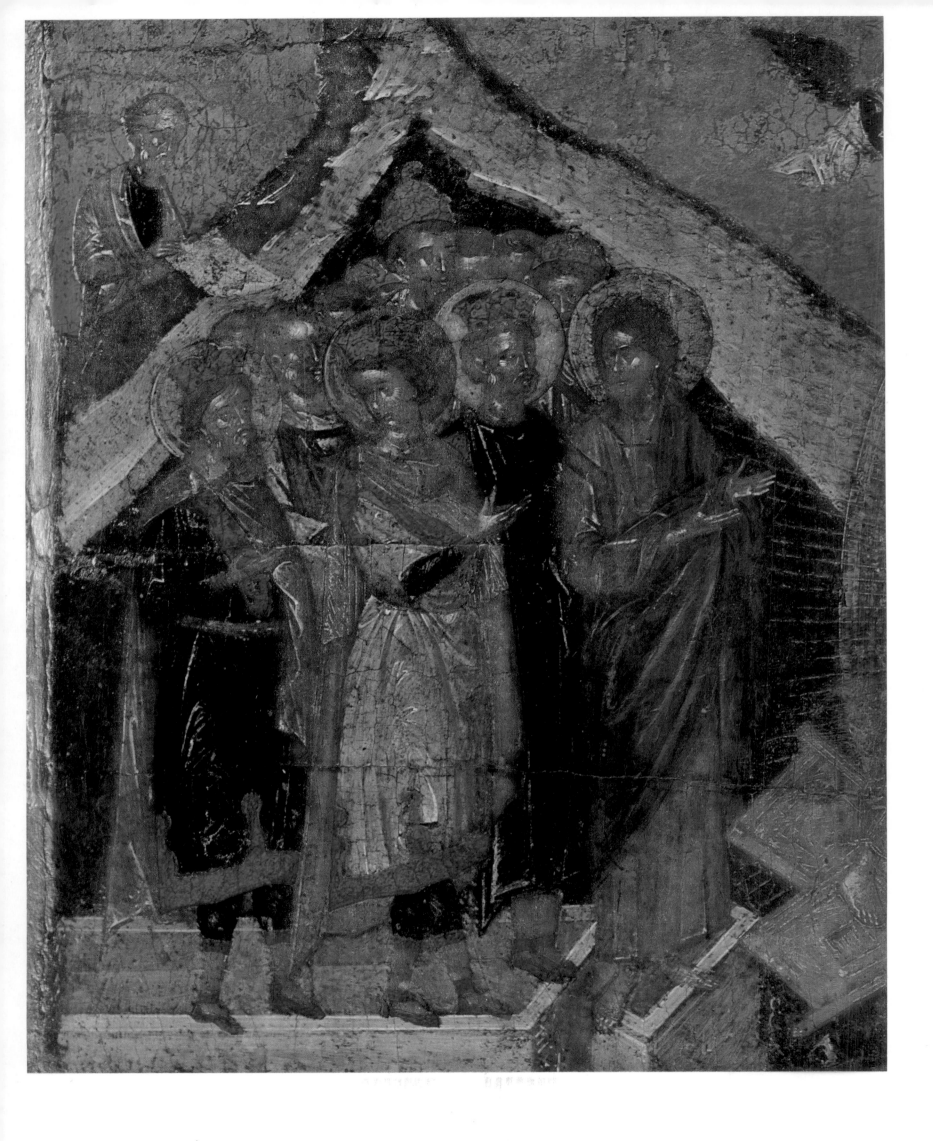

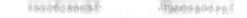

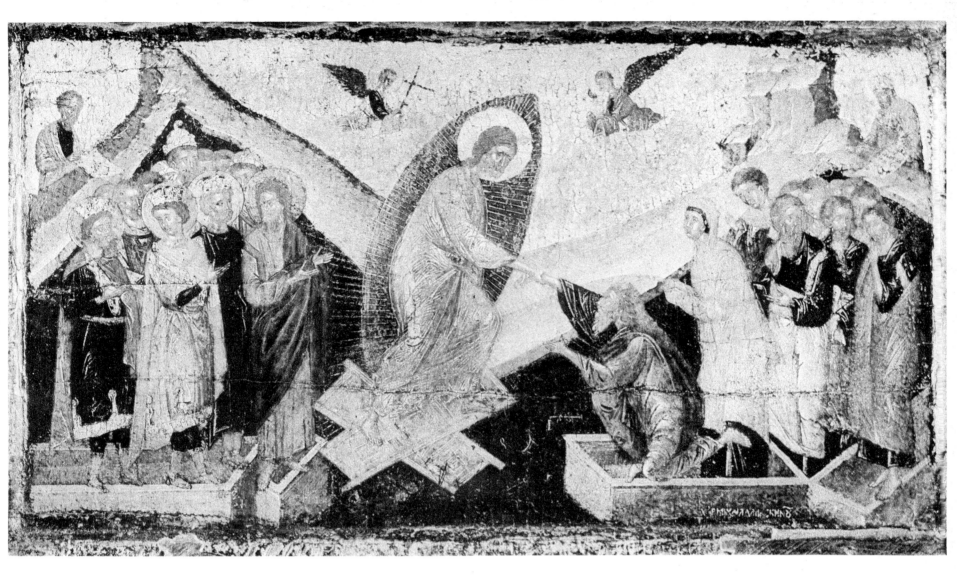

123

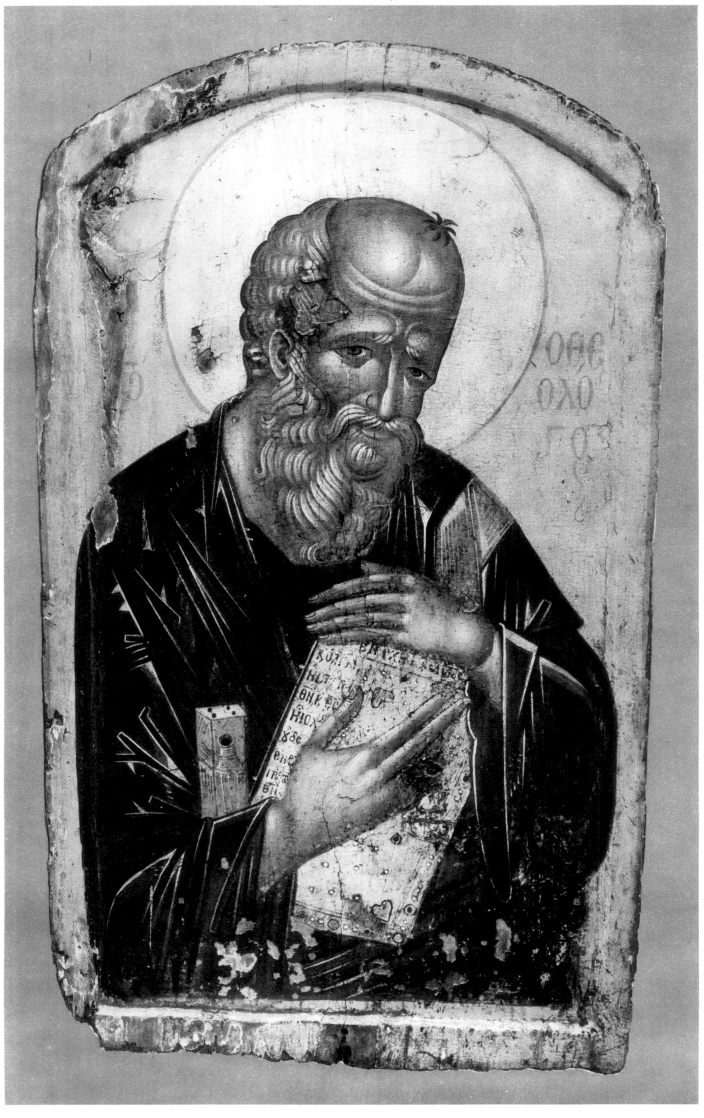

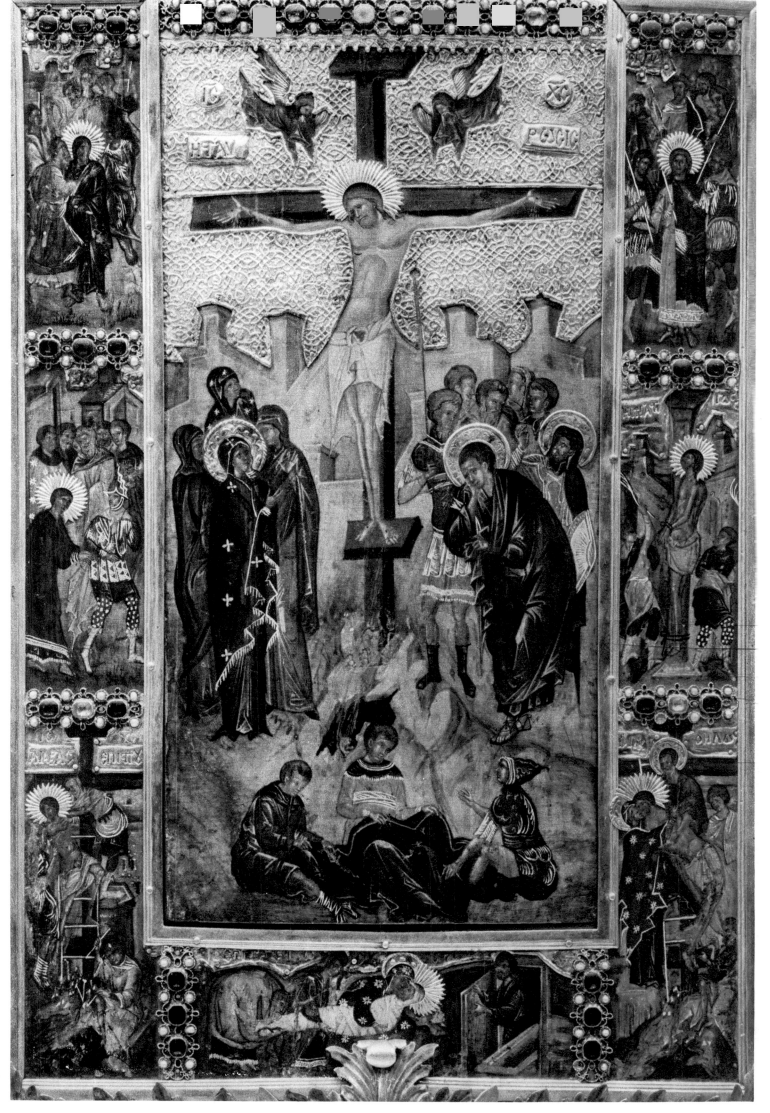

125

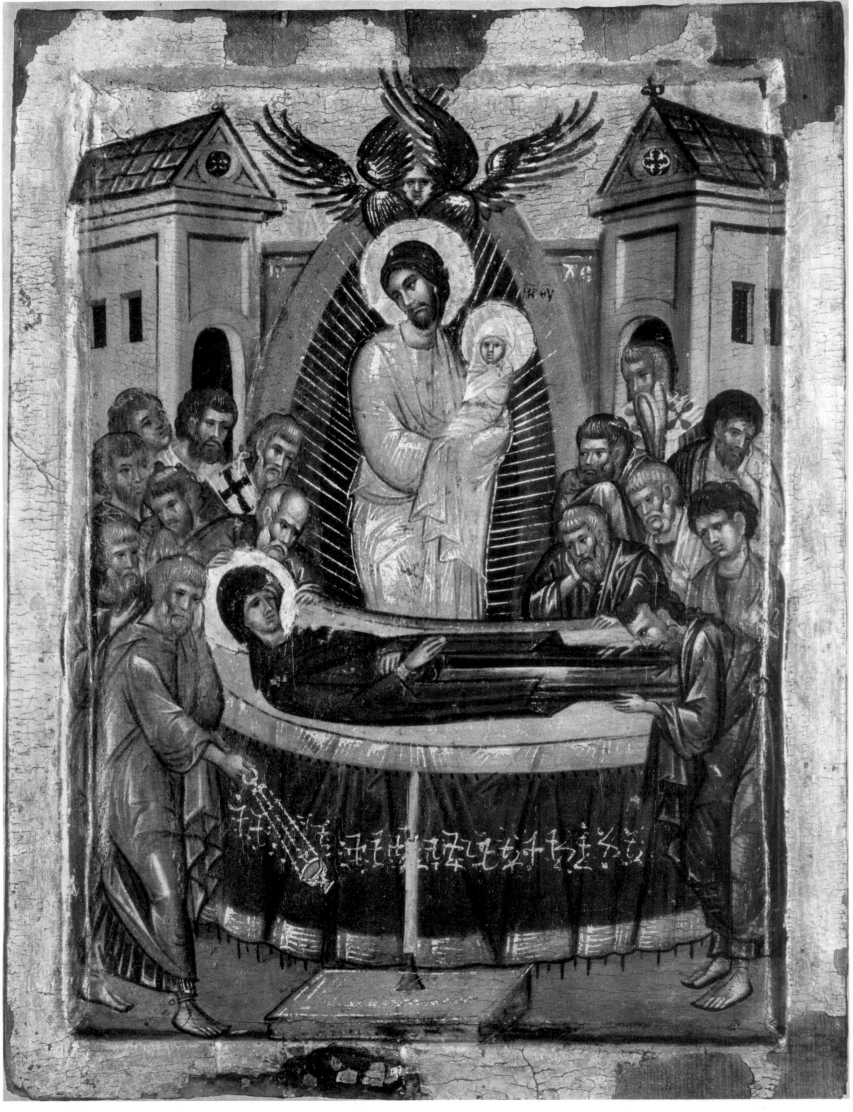

126

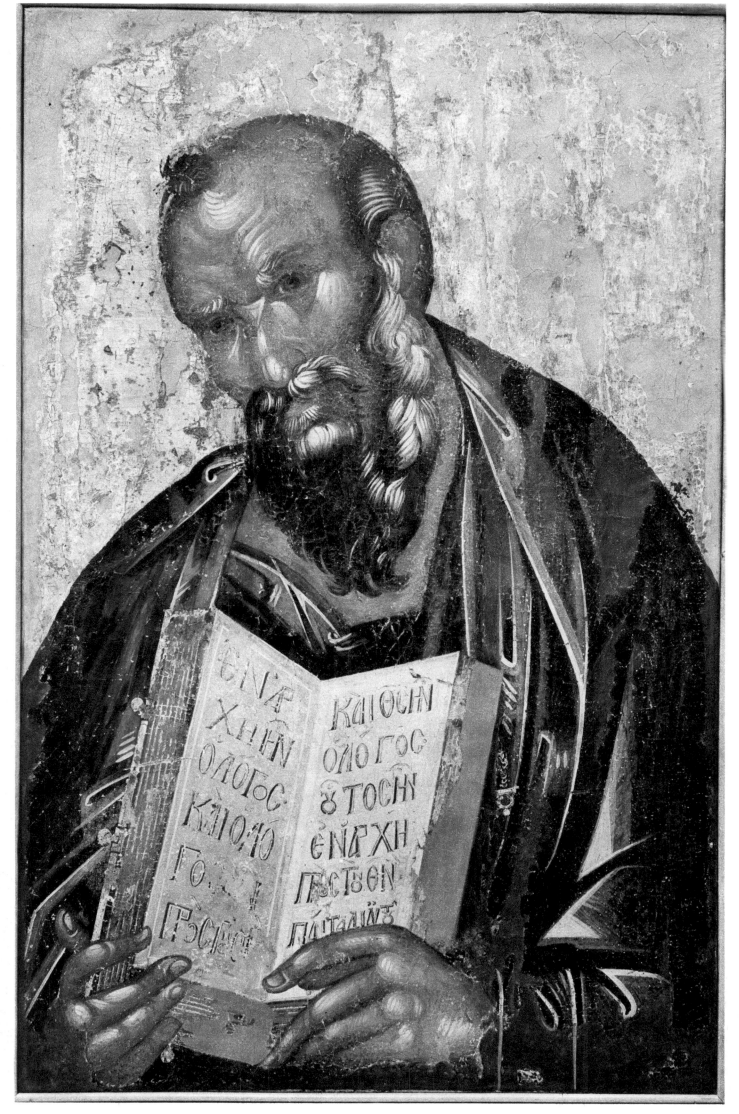

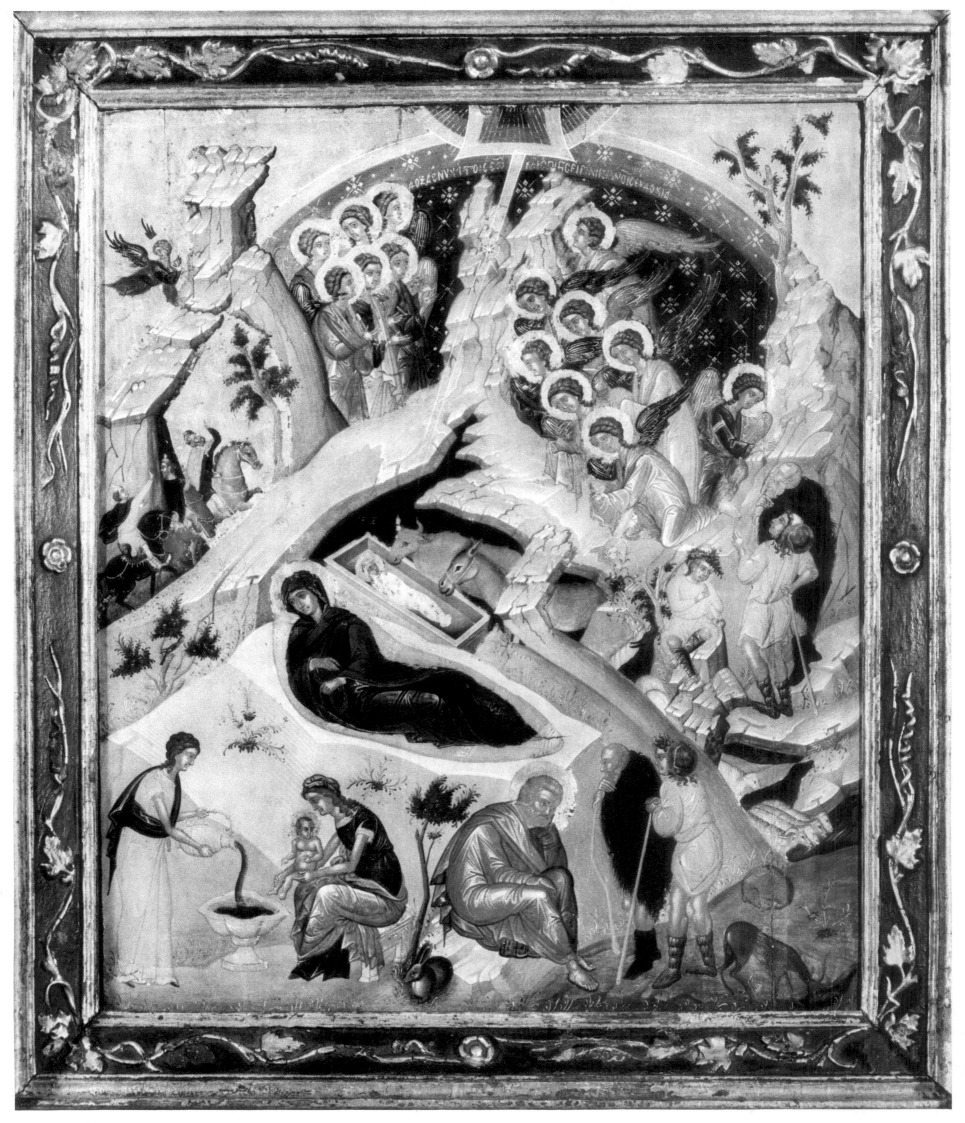

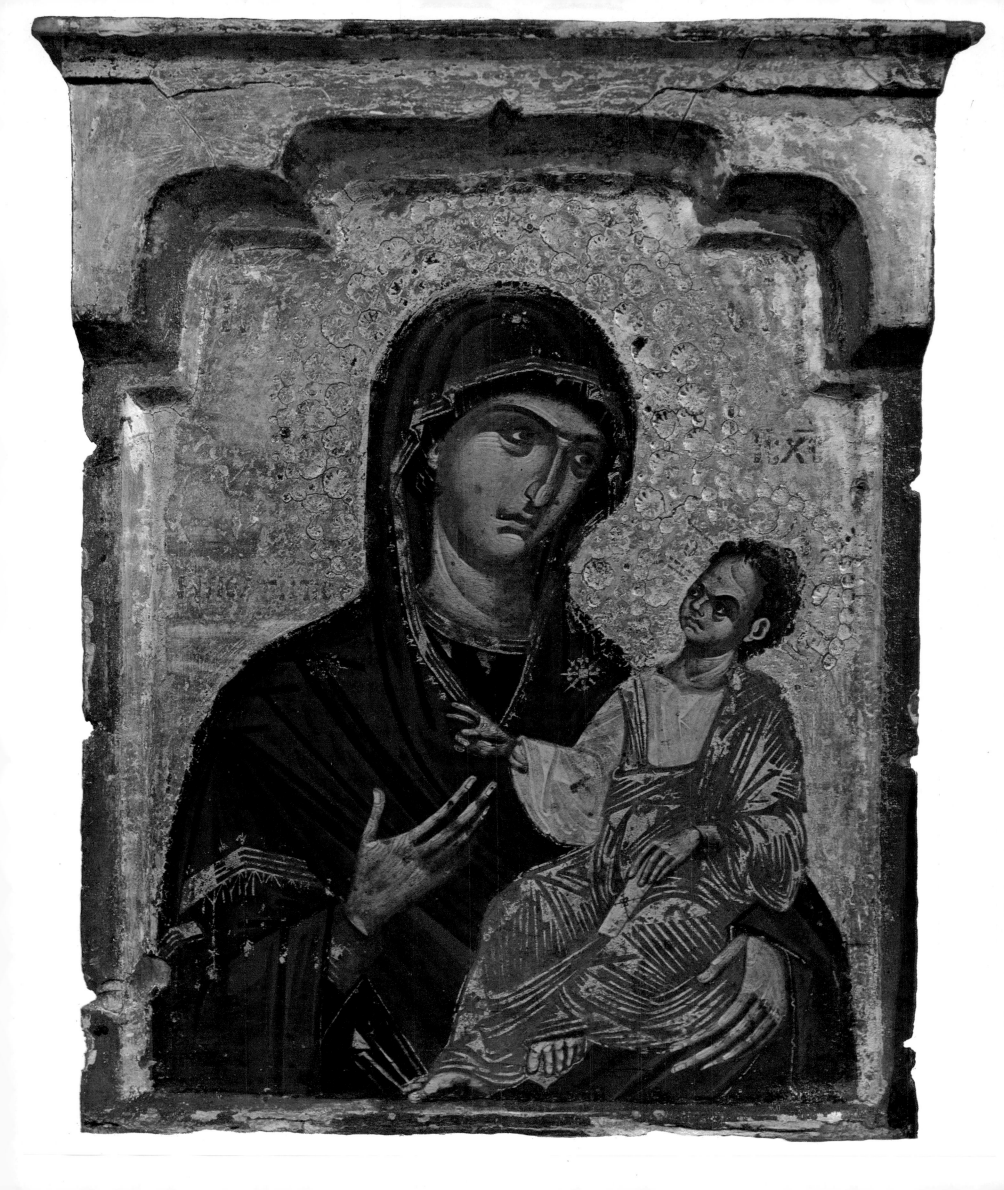

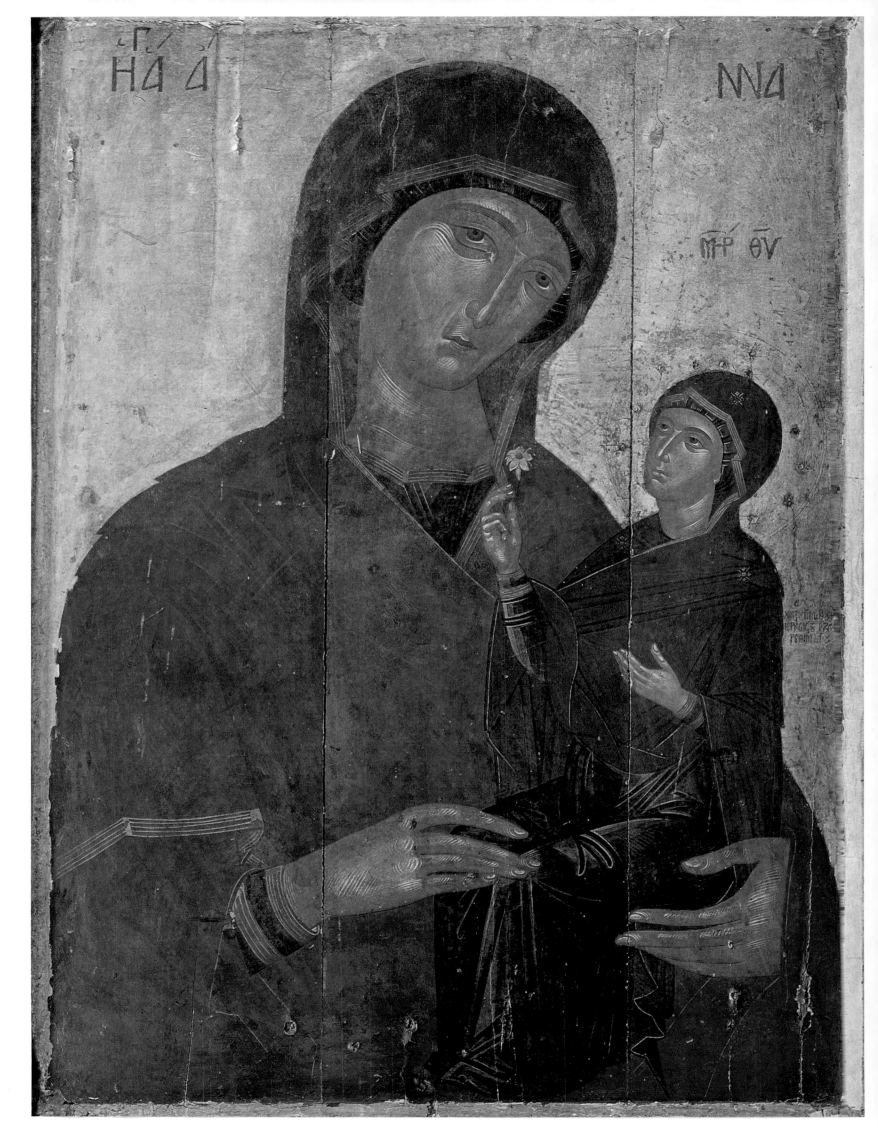

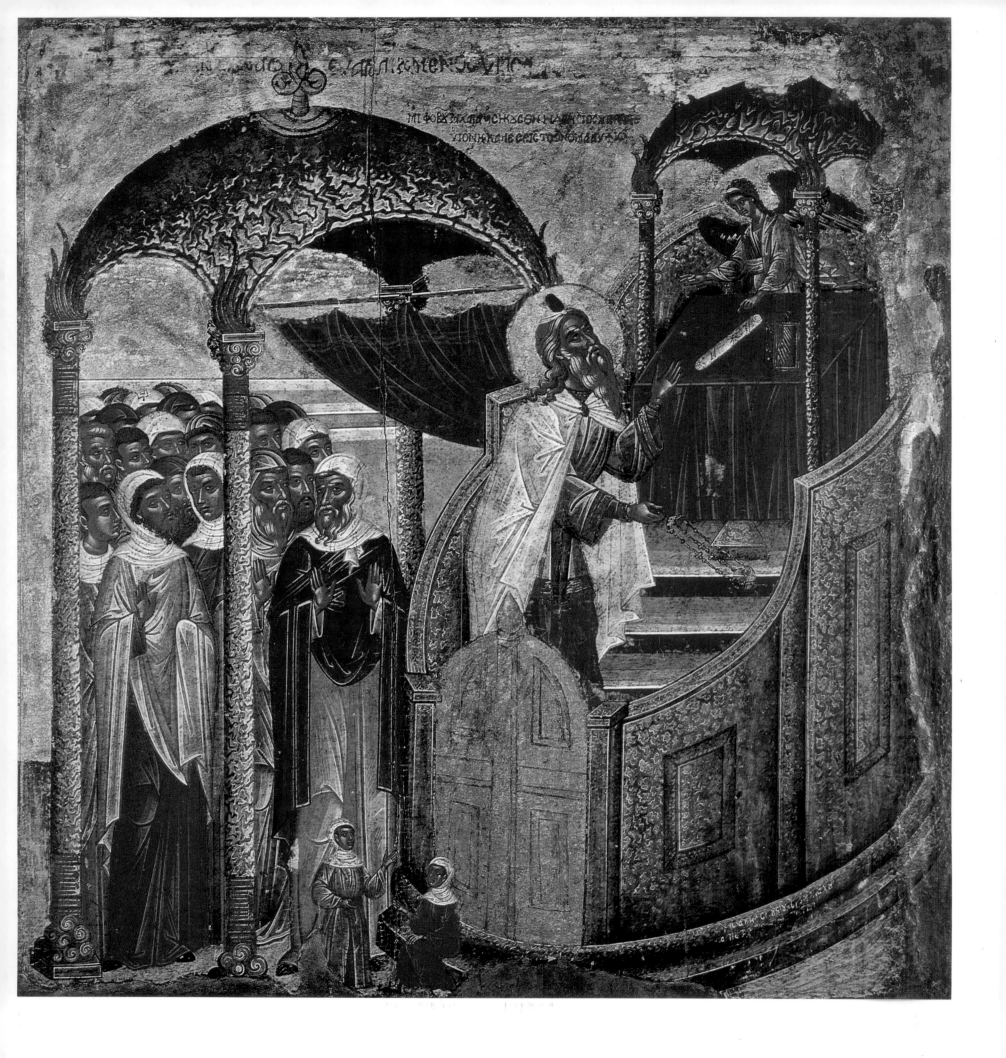

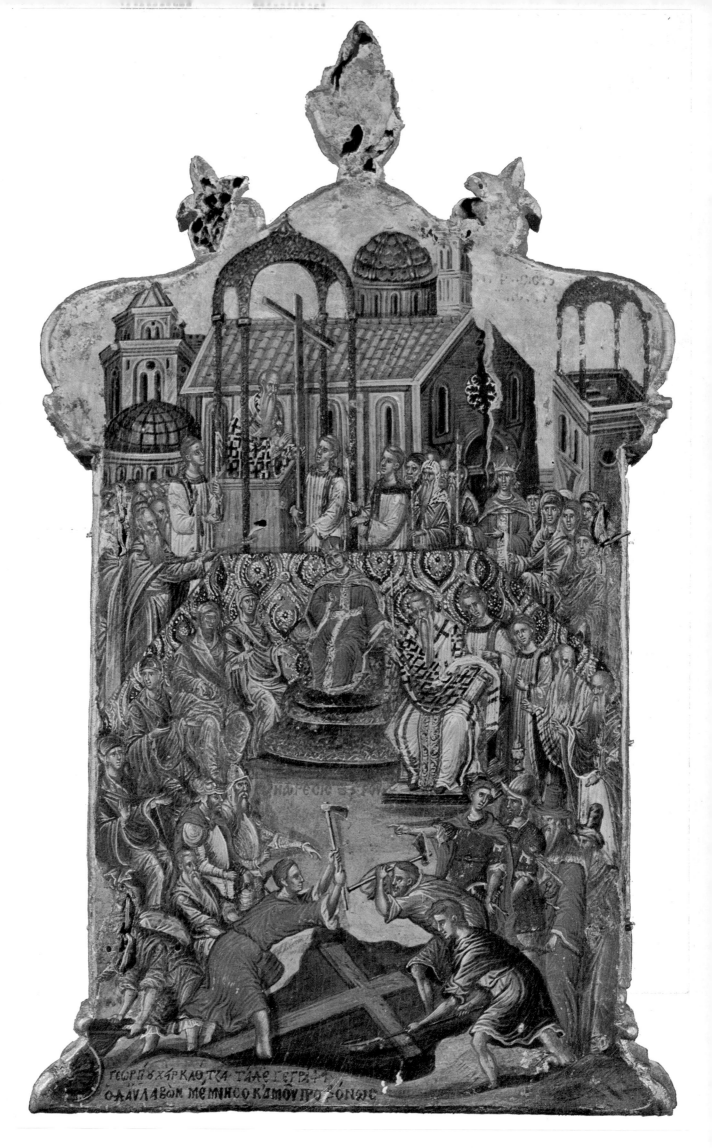

Damaskinos. 14 3/8 x 25 5/8". Benaki Museum, Athens.

124 SAINT JOHN THE EVANGELIST. Middle of 16th century. 38 x 23 5/8". Monastery of Saint John the Evangelist, Patmos.

125 RELIQUARY OF CARDINAL BESSARION. 14th century. Wooden reliquary with sliding lid. 18 1/2 x 12 5/8". Galleria dell'Accademia, Venice.

126 DORMITION OF THE VIRGIN. 15th century. 12 5/8 x 9 5/8". Monastery of Saint John the Evangelist, Patmos.

127 SAINT JOHN THE EVANGELIST. 14th-15th centuries. Double-faced icon. 42 1/8 x 27 3/8". Church of Saint Therapon, Mytilene.

128 NATIVITY. Middle of 16th century. Dimensions without frame, 22 1/2 x 18 3/4". Hellenic Institute, Venice.

129 VIRGIN AND CHILD WITH SAINT PAUL OF XEROPATAMOU (?) AND SAINT ELEUTHERIUS. 15th century. Triptych. 11 1/4 x 17". Benaki Museum, Athens.

131 SAINT ANNE AND THE VIRGIN. 1637. Signed and dated by Emmanuel Tzane. 41 3/4 x 29 7/8". Benaki Museum, Athens.

132 THE ANNUNCIATION OF ZACHARY. End of 16th century. 25 1/4 x 24 3/8". Benaki Museum, Athens.

133 THE DISCOVERY AND ELEVATION OF THE HOLY CROSS. End of 16th century. Signed by George Klotzas. 12 x 5 7/8". Monastery of Saint John the Theologian, Patmos.

YUGOSLAVIA

Svetozar Radojcic
The Icons of Yugoslavia from the Twelfth to the End of the Seventeenth Century

YUGOSLAVIA

Byzantine art spread over Europe, Asia, and Africa for many centuries, but there came a time when its sphere of influence was reduced to no more than the Balkan peninsula. Icon painting had by then a long-established tradition behind it which specified exactly what an icon should be. The looting of Constantinople in 1204 was particularly disastrous for the older works of Byzantine icon painting, and precious examples were either dispersed abroad or destroyed en masse. Thus the student of the history of Byzantine icons must make do, for the most part, with works which were transported to other countries — Russia, Sinai, Georgia, or the West — at some early date. So few of the icons that were made in Constantinople or the Greek islands before the thirteenth century have survived that it is not possible to trace the course of art in them before that time. Only in recent decades has the evolution of the Byzantine icon between the sixth and thirteenth centuries become somewhat clearer, thanks to the unique collection discovered in the Monastery of Saint Catherine on Sinai.

For too long there was a deep-rooted misconception that the icons of Byzantium, and of the regions under its artistic influence, were rigidly stereotyped by the heavy hand of tradition. Recent research has demonstrated exactly the contrary; that, in fact, the icon was often chosen as the means of launching new ideas in art. With this new insight, the history of the icon has become steadily more fascinating during the past few years. Perhaps this book, in its attempt to give an overall view of icons in the Balkans, will demonstrate that icons of the later period must be subjected to historical analysis if light is to be thrown on the many-sided complexity of the art — for during the Middle Ages and throughout the centuries of Turkish rule it spread seemingly without hindrance across the frontiers separating one region from another.

Byzantine historians of the early thirteenth century describe in detail the tragic fate of the works of art plundered in Constantinople. The great lament "De signis constantinopolitanis," by Nicetas Choniates, is almost a funeral oration for the old art of the great center. But recent studies on the origins of the Palaeologue renaissance have made the later art of Byzantium appear in a quite different light; indeed, this last metamorphosis of Byzantine art now seems to have been the latest but most beautiful gift of liberated Constantinople to Europe. It may well be that only in the realm of art could a state that was exhausted in strategy and economics still manifest its magnificent maturity.

In old eulogies addressed to Constantinople, one encounters the poetic idea that the young New Rome was the state "embraced by both land and sea," the

outstretched hand of Europe "kissed by the waves of Asia." It is true that Constantinople received from the East in the thirteenth century the final impulse for the transformation of its art, from Asia Minor and especially from Nicaea where the emperor had taken refuge. Around the middle of that century, the art of the region, monumental and epic in its sweep, broadly and clearly conceived, became the model for the art to be produced by the younger peoples of the Balkans.

In the first decades of the thirteenth century, Serbia had become a kingdom with an autonomous church under its own head. Although the young Nemanja dynasty staunchly rejected the authority of Byzantium, it was precisely in those years, when it was shaking off the political control of Constantinople, that it most closely joined hands with Byzantine culture. Saint Sava, the founder of the independent Serbian church, expelled the Greek bishops from their sees on Serbian territory, yet his ties to the Orthodox Church remained unshaken. Together with his father, he founded a monastery on Mount Athos and induced artists from Constantinople to emigrate to a country that was still in the Dark Ages. Under the Nemanjas Serbian art took on new life. Thereafter it continued to flourish without interruption within the framework of Byzantine art as a whole, through the fall of Smederevo in 1459 — and, indeed, until well into the seventeenth century in spite of Turkish domination. Closely linked to Byzantine and so-called post-Byzantine art, early Serbian painting never abandoned the principles of Eastern Christian conceptions. A comparison of the Greco-Byzantine, Bulgarian, Macedonian, and Serbian icons reproduced in this book will show most effectively what qualities they had in common and what was peculiar to each of them.

The icon has many features distinguishing it from other branches of painting. It is neither fixed permanently to a wall nor, like miniatures, associated with a text in some particular language; therefore, it is both portable and easily copied. New ideas and outstanding achievements of master painters were quickly disseminated by means of their icons. Thus an icon by a great master, when brought into a culturally provincial region, inevitably exerted extraordinary fascination and was soon adopted as a model for others. In early Serbian art, icons were done by Greek painters for the most part; they were the more esteemed for that. These paintings bring out the difference between the Greek and the native conceptions. This contrast between foreign and native products helps us to pin down the complex, often barely discernible peculiarities of the regional art. Yet it would be naive and anachronistic to try to reconstruct some sort of medieval national style emerging from a conscious opposition to Byzantine models. Whatever was specifically Slavic was manifested more spontaneously and, for that reason, is more precious. There are the merest forebodings of such a style in the epic sweep of its treatment of subject matter, and a certain fierceness of temperament in its insistence on what was already an individual cultural tradition. A tenuous but nonetheless distinct notion of what constitutes physical beauty was also carried over from the real world onto the gilded surfaces of icons. In a development that covered centuries, these individual traits coalesced, ripening into a specific mode of artistic expression that, particularly in early Serbian painting, brought about a mutually dependent relationship between icon painting and fresco painting. This, in turn, was to lead to new artistic phenomena of even greater significance.

The close relationship between icons and frescoes is evident in the art of Ohrid as

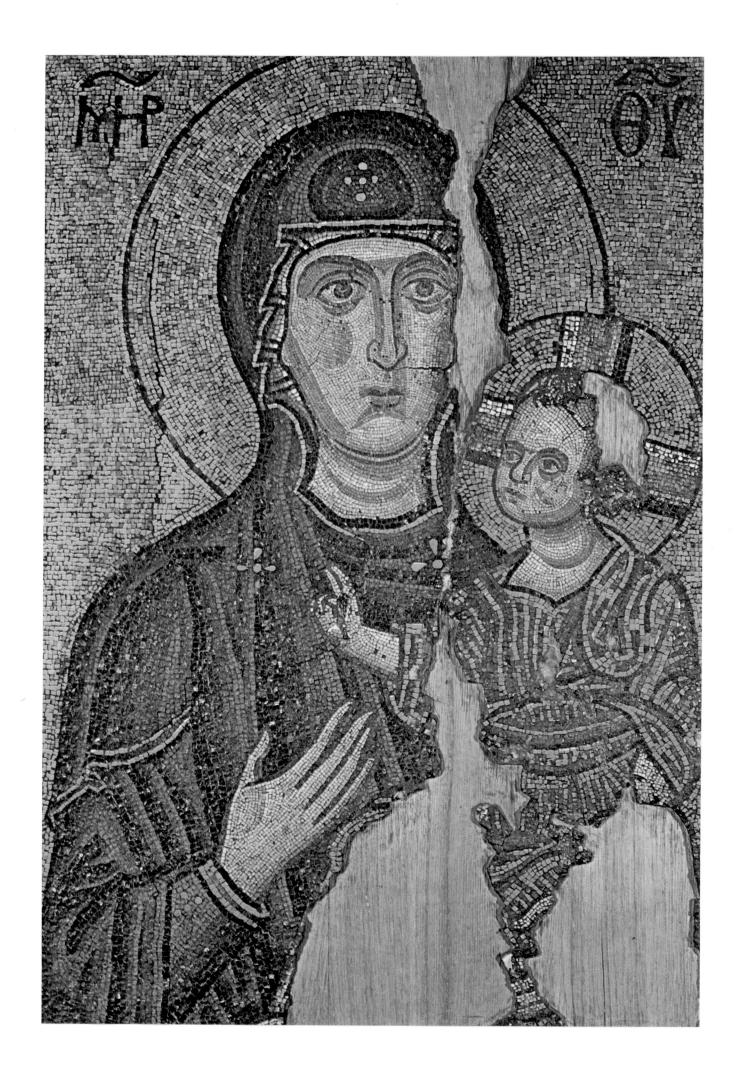

early as the eleventh century. Although not a single icon from that time is still extant, their appearance and style are known to us from the imitations of them, painted in fresco, in the altar area of the Church of Saint Sophia in Ohrid. Naturally enough, these imitations include only those iconic features easily reproducible in fresco technique. The icons in beaten silver cases that are listed in the inventory of the Monastery of the Merciful Mother of God near Strumica must certainly have been executed in a far more subtle technique, and must have had a quite different appearance.

In the eleventh century, it was the urban centers of the Balkans which particularly favored Byzantine icons. The Imperial protospatharius Ban Stephen presented five icons, one in silver, to the Church of Saint Chrysogonus in Zadar on the shores of the Adriatic in 1042. Certain cathedrals, in cities which are-still the seats of bishoprics, contain very old, so-called wonder-working icons that have been preserved through the ages because they were thought to protect the faithful against dangers. The cathedral in Skopje, for one, takes its name from the icon of the Three-handed Mother of God that has been kept there. It seems that already in the eleventh century, and certainly from the twelfth onward, the Archbishopric of Ohrid was an important artistic center, but where its influence did not extend, icons were not so much in use. From the biographies of the first members of the Nemanja dynasty, one learns that icons were even deliberately discarded in Serbia during the twelfth century, under the prompting of the heretic sect of Bogomils. As soon as Saint Sava was made archbishop, he particularly stressed in his sermons that icons ought to be revered, asserting that gazing on icons "raises the eye of the spirit aloft to the original of the holy personage therein portrayed." Expressing his devotion to the cult of icons, Saint Sava thundered against "those who cast aside the holy icons and who neither paint them nor bow down before them." When the young dynasty was finally won over to Byzantine Orthodoxy, it placed special emphasis on the icon; even during the lifetime of Stefan Nemanja, Saint Sava, who was Stefan's son and biographer, stressed that the venerable founder of the dynasty had endowed the monastery of Studenica with "icons and liturgical vessels... books and vestments and draperies." It is known that the monastery of Zica received gifts of icons from Saint Sava and from Stefan the First-Crowned. Later the historian Danilo, in his *Lives of Kings and Archbishops,* pointed out again and again that the founders of monasteries presented them·with "icons in splendid beaten gold and adorned with choicest pearls and precious stones, along with many relics of saints." Danilo singled out for particular praise Queen Helena, because she endowed the monastery of Gradac with icons, and King Milutin, for his gifts of richly worked icons to the Monastery of the Virgin in Treskavac.

Even the earliest Serbian texts from the thirteenth century give detailed descriptions of these icons. Theodosius, the biographer of Saint Sava, recounts how the saint commissioned two "standing" — that is, full-length — icons of Christ and the Virgin from "the most skillful painters" of Salonica, as gifts for the Monastery of Philokalas in that city. He adds that one of these icons shows the Virgin of the Mountain, so called because of the vision of the prophet Daniel. We even learn how the icons were ornamented; the saint had them both adorned with "gold wreaths, precious gems, and pearls."

The beginnings of icon painting in Serbia, in a milieu as yet without its own artistic

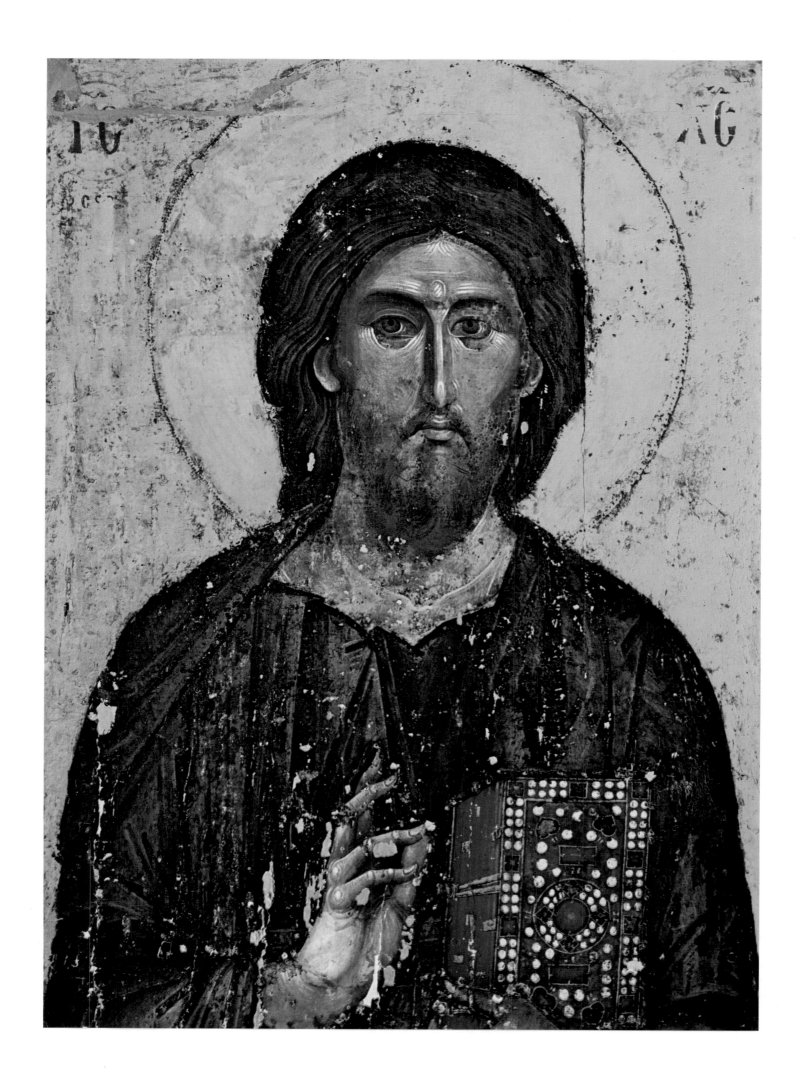

tradition, can scarcely be determined from the very few icons that survive from the late twelfth and the first half of the thirteenth century. The earliest icon from a Serbian monastery is at Chilandar, a Virgin in mosaic of the Odegitria type dating 141 from the late twelfth century. The work is still closely tied to monumental wall mosaics and fashioned from rather large stones. Its style is close to Venetian-Byzantine work and was probably made on the Adriatic coast, perhaps in Dalmatia; it made its way to Mount Athos, perhaps as a gift from Saint Simeon Nemanja, the founder of the new Monastery of Chilandar.

In the mausoleum of Stefan Nemanja at Studenica, the frescoes dating from the early thirteenth century include two imitation icons, which give us some idea of the appearance and style of Serbian icons at that time. On one fresco, now badly faded, an old icon of Studenica with the Virgin Kyriotissa can be made out; this icon was itself an imitation of an icon in the Monastery of the Virgin Kyriotissa in Constantinople. The other fresco, in good condition, depicts the transporting of the bones of Nemanja from Athos to Studenica, and includes a carefully executed copy of an old icon of the Virgin Paraklesis. This image, though part of a narrative fresco, repeats a type whose iconography was already well fixed and often copied, although its style already reflects considerable deviation from the Byzantine prototypes; the face of the Virgin is characteristically Slavic. The rather simplified drawing and bright clear colors lend the painting a lyrical and intimate note that is quite alien to icons originating in Constantinople and Salonica.

Icons that portrayed with a certain measure of freshness and freedom the motherhood of the Virgin and the infancy of Christ were especially popular. The miniatures of a thirteenth century illuminated Gospel from Prizren, destroyed by fire during the bombardment of Belgrade in 1941, included two which were, in essence, naive copies of icons. One represents an attempt to copy an icon of the Virgin of Pelagonia, the other an icon of the Virgin of Consolation. Some idea of the intimate lyrical quality of Serbian icons of the first half of the thirteenth century can also be gleaned from the writings of the time, indirect as such evidence must be. Thus, the archives of Dubrovnik contain a document deposited there in 1281 by .Queen Beloslava, consort of King Vladislav who, around 1235, had founded the Monastery of Mileseva. This document is an inventory of the family collection of icons; it is the first known catalogue of such a collection in Serbia, and full of valuable information. Of the twenty-one icons, two were reliquaries, one was a portrait of King Vladislav, four were of Christ and an equal number were of His Mother, two showed the apostles Peter and Paul, and others showed popular saints — Nicholas, John the Baptist, George, and Theodore — as well as the Archangel Michael. There was one family portrait, an icon of the founder of the dynasty, Saint Simeon Nemanja; this was richly encased in silver — "cum argento et cum septem petris de cristallo." It is interesting that one of the icons of the Virgin is described as being made of bone — "de osse." The remaining icons have no indication of their subjects. One icon contains an interesting suggestion of the general character of the collection: the inventory remarks that it represents "Christus sicut dormivit," in other words, an *imago pietatis,* a Christ as Man of Sorrows. This subject, lyrical and at the same time dramatic, was often used in early Serbian painting.

The expulsion of the Latins from Constantinople in 1262 and the advent of the Palaeologue dynasty exerted a strong influence over the development of art in the

Balkan interior. In those years, the last great flowering of art began in Constantinople. The Palaeologue renaissance, whose initial phase was marked by a monumental classical style with broad forms and bright colors, is best known through the frescoes in Sopoćani and a group of illuminated manuscripts that are not yet definitely dated. We can only guess at what icons must have looked like in the new, clear, classical style of the mid-thirteenth century, since none has been preserved. There may be a hint, however, in the standing figures in the first, lowest tier of the Sopoćani frescoes. It is only in the sixties of the thirteenth century that the history of icon painting in Serbia and Macedonia becomes clearer, for some icons have survived from that time and certain of them are even dated and signed. In 1262—63, Archbishop Constantine Kabasilas of Ohrid presented to a church in that city a large icon of Christ which has come down to us in good state, even to the dedicatory inscription on the back. Another signed and dated icon is the damaged Saint George from Struga. The original inscription on the back is from 1266—67 and identifies the donor, John the Deacon, and the artist, named John, who described himself as a "historiographer."

It seems that as early as the beginning of the thirteenth century, the better icon painters acquired enough fame to be known by their names. A devout pilgrim, Anthony of Novgorod, remarked in his description of Saint Sophia in Constantinople, about 1200, that a certain "skillful Paul" had in his time painted the Baptism of Christ in the baptistery. In the collection of the Serbian Monastery of Chilandar, on Mount 143 Athos, there is an extraordinary icon of Christ's head which must have been done by one of the leading painters of the half-century before 1300. It is very close stylistically to the fresco in the cupola of the Church of the Apostles in Peć, painted no more than a decade earlier. Somewhat harder and less consistent, but otherwise very impressive, is the icon from Ohrid with the Odegitria Virgin on the front face and the 184,173 Crucifixion on the back. The hard drawing and strikingly sculpturesque modeling, and the expressiveness of the Virgin at the foot of the Cross anticipate the so-called First Style of Michael and Eutychios, the well-known painters of Ohrid. The finest and certainly the most artistically significant icon from late thirteenth century Ohrid is a large image of the Evangelist Matthew. Done shortly before 1300, it was strongly 174,175 inspired by the classical Byzantine style of the tenth century. In style and iconography it closely resembles the full-length figure of the evangelist in a manuscript held by the National Library in Vienna.

The stylistic development of icon painting in some parts of Macedonia, for example in Ohrid, at the end of the thirteenth century ran parallel to that of the better-known monumental wall paintings. It proceeded from the relatively dry calligraphy of the Christ of Archbishop Kabasilas, through the dramatic Crucifixion, to the classicism of the Evangelist Matthew. This was a single continuous phase that corresponds to the steps in the development of the contemporary frescoes in Manastir, Macedonia; these began with the First Style of Michael and Eutychios, in the Church of the Peribleptos in Ohrid, and ended with the classicism of the frescoes in the Church of Saint Nicetas and in Staro Nagoricino.

In Serbia, icon painting was exposed to influence from the east and the southwest. The proximity of the region to the Adriatic coast, with its Romanesque-Byzantine provincial art, is most obvious in thirteenth century Serbian miniatures; in these, Romanesque ornamental initials remained in vogue right up to the end of the

century. There is a similar influence to be seen in the sculpture of the time. In painting, Romanesque elements persisted in mural art up to 1240, disappearing only later. The powerful Western impact on Serbian icon painting in the second half of the thirteenth century is conspicuous in a fresco copy of an icon in the Cathedral of Prizren, and in a late thirteenth century Serbian icon belonging to the Treasury of Saint Peter's in Rome. The painted copy in Prizren Cathedral is in the lowest tier of frescoes, dating from around 1270; it depicts Christ the Nourisher, in markedly stylized, expressive drawing that much resembles the style of Florentine madonnas from those years. The icon in Saint Peter's has come to the attention of scholars largely through W. F. Volbach's efforts; even in its overall appearance one is immediately struck by the absence of Byzantine formal conceptions. It is divided horizontally into two areas, the upper one larger, the lower one narrow and elongated. In this respect it resembles Western votive pictures. It may originally have belonged to a series of similar icons that were sent to Rome by Serbian rulers. Of special interest is the lower area, on which are portrayed the Kings Dragutin and Milutin, their mother Queen Helena, and a sainted bishop blessing the queen. In style this icon is closely related to a thirteenth century icon from Sinai which Sotiriou attributes to some Apulian workshop. Our icon, now in Rome, of Saints Peter and Paul probably originated in a workshop in Kotor, the principal Serbian port on the Adriatic. It was a thriving art center in the thirteenth century, sending forth goldsmiths, painters, architects, and sculptors, most of them to work in the interior. The art of Kotor, like that of the nearby towns Bar, Skutari, and Dubrovnik, was at the time closely linked to Apulia in Italy, on the opposite shore of the sea. Be this as it may, the Vatican icon has much in common with the other products of Serbian art in the 1200's.

The icons that have survived from that century clearly show that Serbian painting of the time was far from uniform, either in style or in quality. Written sources permit us to conclude that in mid-century the icon was the most prized form of painting; it may be that the special reverence paid to icons in medieval Serbia came about through opposition to the heretical notions of the Bogomil sect. It remains true, however, that in Byzantine art as a whole the icon was at that time steadily assuming a more prominent place in the activity of painters and was in ever greater demand for the decoration of church interiors.

With the new classicism of the mature Palaeologue style, the feeling for broad surfaces and monumental expression was discarded in favor of a more intimate, miniature-like precision. There was a general predilection for reduced format and concentration on pictorial values. This explains why the fourteenth century icon was increasingly awarded a place of honor in the system of painted decoration. In accord with the general trend throughout Europe, painting on separate wooden panels began to predominate in Serbia as early as 1300. Slowly but surely, the iconostasis developed into a wall completely covered by panel paintings which not only appropriated the finest themes from mural art but ended by exerting a disastrous influence on that art. Little by little, mural painting came to be no more than a discreet accompaniment, a mere echo of what was so solemnly and impressively presented in the icons set up on the iconostasis.

In the Balkans, the transformation of the stone altar screen into a true iconostasis was long and slow. From the late thirteenth until the late seventeenth century, the

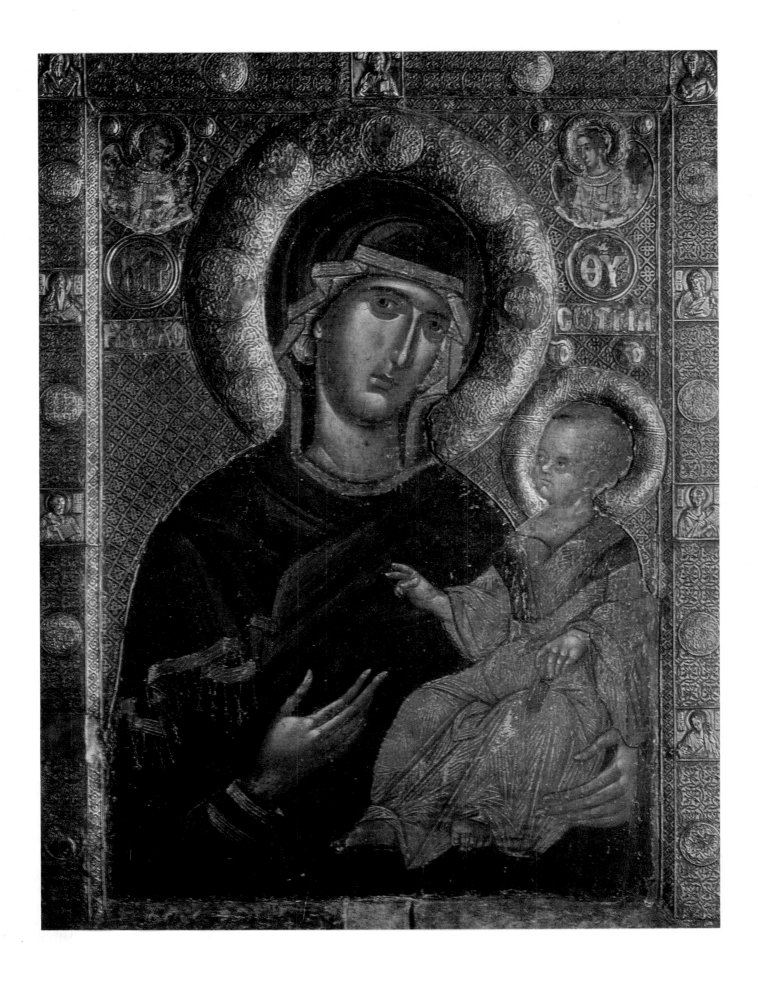

changes in the iconostasis had a marked influence on icon painting and on the development and use of the various types of icons. Finally, there came to be a vast range of icons — from the icons representing the feasts of the church and those used for processions or calendars, down to the miniature imitations of entire iconostases.

Until the end of the thirteenth century, the altar screen in Byzantine churches was part of the stone decoration and its form scarcely differed from that used in early Christian basilicas. But after the defeat of the Iconoclasts, painted decorations became a permanent feature. As a rule, large icons with full-length figures were hung on the masonry pillars — the steloi — on either side of the center of the screen, and the upper parts of the icons were ornamented with carved frames of stone or stucco. The common idea that icons were "returned" to the pillars at that time is based on the supposition that before the Iconoclast Controversy these monumental icons had normally been placed on the iconostasis. But the earliest surviving specimens indicate that this type of screen with large icons was not known before the twelfth and thirteenth centuries. All the elements needed to reconstruct the original stone screen in the Church of Saint Sophia in Ohrid — even the two icons — have been preserved, but the church was converted into a mosque; the materials were then incorporated into the floor of the altar area and the "mimbar," the Moslem pulpit. However, the twelfth century altar screen in the Church of Saint Panteleimon in Nerezi has survived almost intact. This transitional form, between an altar screen and an iconostasis, lasted in Serbian and Macedonian regions until the first years of the fourteenth century. Its basic components consisted of screen slabs that enclosed the chancel, small columns, an architrave, and large icons to either side of the doors. The spaces between the columns were left open, and curtains were drawn across them only when the liturgy required it. Near the end of the thirteenth and the beginning of the fourteenth century, the custom of introducing icons into the spaces between the columns was initiated. This meant that those icons which had formerly been hung high on the columns were now lowered almost to floor level. Instead of portraying full-length figures they now showed half-length figures; but below them hung sumptuous textiles that gave the impression that the figures were standing behind curtains which concealed them below the waist.

The iconostasis of 1317 from Staro Nagoricino gives us an idea of how, in the interior of the Balkan peninsula, the altar screen was transformed into the iconostasis, with only minor changes. It is complete down to the last detail, although the icons themselves and the drapery below them were imitated in fresco. While the evolution of the iconostasis in the Balkan countries certainly had its own peculiarities and perhaps its late forms as well, it can be followed in detail in the surviving examples. Precisely for this reason, the early iconostases of medieval Serbia have greater significance for us today than merely local and provincial monuments. The innovation of placing the icons in the spaces between the columns of the stone screen led to the creation of a special type of large icon that required an appropriate, firmly established format and a new character. Lowered from its former high position and brought closer to the worshipers, the icon underwent considerable change. The earlier icons of full-length figures, permanently fixed high up, were in essence not very different from frescoes: immobile and lofty as murals, these icons shared their monumental character with murals in many respects. When, however, they were set lower between the columns, the new icons were on an equal footing, so to speak,

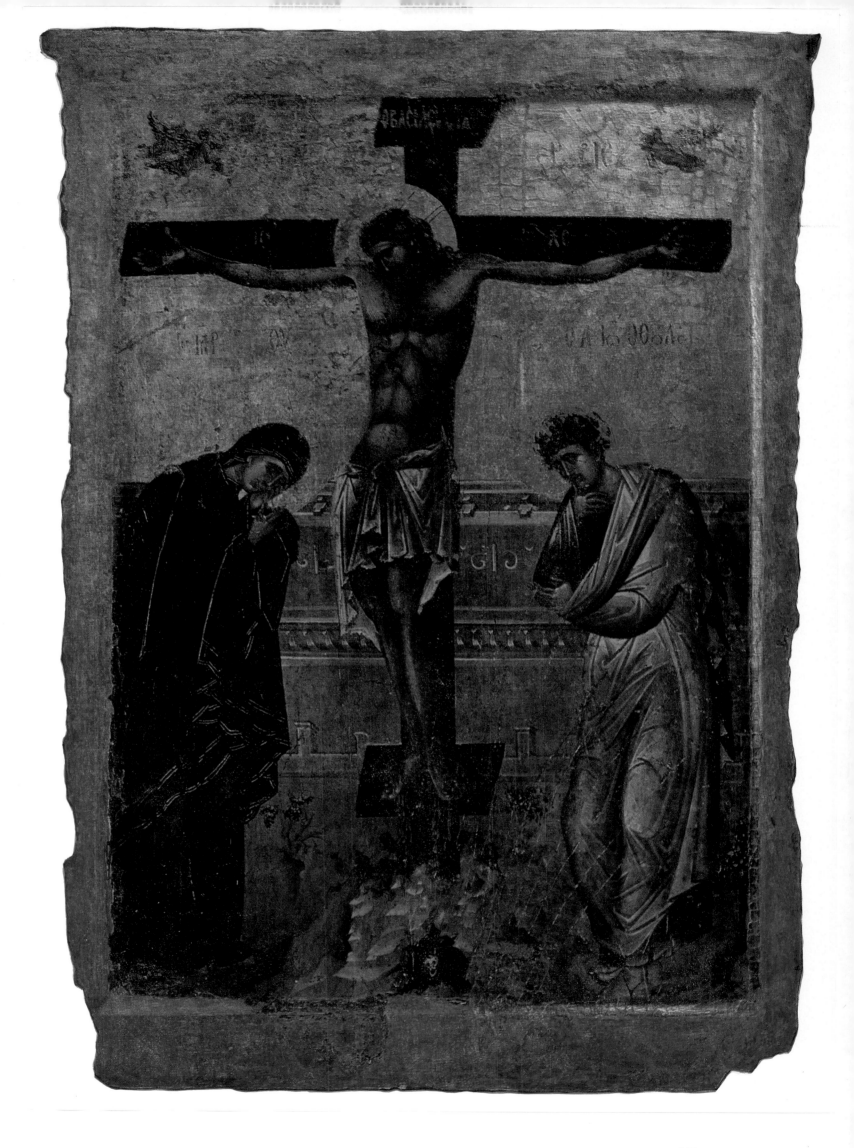

with those who revered and kissed them; brought close to the eyes and lips of the believers, the images themselves became more human. To remove them somewhat from the sphere of mortals they were provided with lavish frames; and just as the images were painted to be seen from close by, the frames were executed with precision, carved finely so that attentive worshipers would be led to marvel at their painstaking perfection.

Once the large icons were transplanted into the spaces between the columns, they no longer needed to be of monumental size and fixed in place. The older icons were thought to be protectors in time of public need, and according to the monastic rules they were never to be taken down except in the event of fire or earthquake. But by the fourteenth century, the large icons were even taken outdoors on the occasion of great feasts, and special notches and recesses were carved into the lower part of the frames to facilitate their being carried about — as we know from later Russian examples.

Most of these icons of the Balkan Slavs were painted on both front and back in accord with fixed liturgical prescriptions. At the start of the fourteenth century, the large ceremonial icons continued to repeat the traditional iconographic themes, but motifs of a significantly more intimate character began to appear. The very names given to these new icons tell us that they originated in Constantinople. The well-preserved, silver-encased icon of the Peribleptos Virgin, from the church of the same name in Ohrid, is probably a copy of a Constantinopolitan prototype, the icon in the Monastery of the Peribleptos Virgin. (The latter was built in the eleventh century but enjoyed special fame from the start of the thirteenth up to the fall of Constantinople.) In the Ohrid icon the characteristic traits of the Palaeologue renaissance are well in evidence: the classical forms of the figure of the Virgin, the restrained coloring, the emphasis on feeling. The new intimate relationship between the Mother and Child becomes especially striking when one compares this icon with older variants of the same type which basically conform to the iconographic model of the Odegitria Virgin. Originally painted on one side only, the reverse was painted with the Purification of Mary at the end of the 1500's.

The monumental pair of icons in Ohrid showing Christ and the Virgin as Saviours of Souls date from the transitional years between the thirteenth and fourteenth centuries; they rank among the finest icons of Ohrid and, indeed, of all Byzantine art. Both are double-faced: on the back of the icon of Christ is the Crucifixion; on that of the Virgin, the justly famous Annunciation. The front paintings on each icon retain the hieratic character of their earlier iconographic prototypes, although it is discreetly toned down. In the icon of the Virgin, the pose is shifted from the traditional frontal axis, and there is a more intimate relationship between the Mother and Child. While the painter's approach remains severe, with muted colors and powerful modeling, an element of refinement suitable to the basic conception is introduced by the lavishly embossed silver background. The harmony between silver and paint is particularly successful in the icon of the Virgin, whereas in that of Christ extensive repainting in the sixteenth or seventeenth century has left only the forceful head relatively unaltered.

The images on the back faces — the Annunciation and the Crucifixion — unlike those on the front, are probably each by a different artist; the one responsible for the Annunciation was beyond doubt the more significant. A large number of fourteenth

181

178, 147

149
167, 169, 171

century Annunciations have come down to us but the example from Ohrid holds a special place among them for its purely artistic qualities, in addition to its format and excellent state of preservation. All the beauty of the early style of the Palaeologue renaissance seems concentrated on the golden surface of this icon. The thoroughly calculated impression of depth, the modeling of the figures, the contrast between movement and repose — all were carefully designed and rendered with masterly assurance. There is no trace of the usual soft sentimentality which, in later Palaeologue painting, ended in pantomimic gesture, cloying sweetness, and a certain lukewarm indifference. The master who painted the Annunciation cultivated a dramatic style with solid forms and strong colors. But his art was not without defects: a glance at the stiff position of the Virgin's left hand suffices to reveal his uncertainty as a draftsman; and he failed to create an overall atmosphere which would unite figures and action into a whole. The artist who did the Crucifixion, however, achieved a most convincing general mood. Conventional as his drawing and composition were, he nevertheless combined his feeling for portentous lyricism and poignancy into a whole by his use of softly modeled forms and refined coloring. The Annunciation and the Crucifixion, from the same year and in the same style, show how similar conceptions, when realized by quite different personalities, could diverge. This occurred in spite of the fact that, especially in the first decades of the fourteenth century, icon painting was striving toward unity of style.

It was difficult to apply the new artistic outlook of the Palaeologue renaissance to the large monumentally conceived icons; these, as fixtures in the liturgy, resisted any deviation from the venerable iconographic formulas. More vigorous and imaginative solutions were found for smaller icons, unless they were reduced copies of more imposing works, as is true of the finely painted Saint Panteleimon from Chilandar. 172 Otherwise, most of the small icons from the first half of the fourteenth century adhered to the new classicist trend. A series of small icons — no more than eighteen by fifteen inches — found in Ohrid has been restored: the icons belong, beyond doubt, to the first half of the fourteenth century. They include a badly damaged Nativity, and a Baptism, Crucifixion, Descent into Limbo, and Incredulity of Thomas. 183,177 They were all produced by the same workshop, but were based on different prototypes. The Incredulity of Thomas belongs to the severe early classical style and has much in common with the large icon of Saint Matthew. Its composition clings to formulas that had long been traditional and are often found on sarcophagus reliefs. Extremely symmetrical, static in form, and subdued in color, it differs considerably from the more attractive and lively icons of the Baptism and Descent. These were painted by the same artist, and their agitated drawing, powerfully modeled forms, and intense color represent an early variant of the "romantic" Palaeologue style which sprang up in Serbia between 1314 and 1320. The same traits are found in the extraordinary frescoes from the royal churches of Studenica and Gracanica.

In addition to the powerful influence of Constantinople on Serbian icon painting in the early 1300's, other tendencies can be discerned that were faithful to the native tradition. A rather badly damaged icon of the Purification, signed in Serbian but from 190 Chilandar, shows very clearly how Serbian artists adapted and modified Palaeologue classicism. Firmly bound to tradition, their manner of drawing relied more directly on a severe linearity similar to that of the late Comnenian period. Proportions, drapery, and figures were appropriated from the new art of Constantinople, but there is an

overtly realistic drive in the handling of movement and emotional expression. The fragment that includes the maidens escorting the Virgin is fortunately better preserved and perfectly reveals the Serbian variant of the early classicism of Constantinople. In this art of freely combined elements, traditionalism and realism are brought into a happy synthesis with the contemporary trend toward the imitation of antiquity. As interpreted by this master, the group of maidens loses the rigorous and clear-cut rhythm typical of bas-reliefs but, at the same time, it gains a conviction which comes from more realistic, fresher pictorial expression.

Similar linear elements and realistic figures are found in the icons on the Decani iconostasis, about 1350. Following the earlier practice, icons with full-length figures were placed in the spaces between the columns. This is a mid-fourteenth century iconostasis in all its precious entirety with well-preserved images of the Virgin, Saint 187,215 John, Saint Nicholas, and an archangel, plus a panel in poor condition showing Christ. The painters of these icons came to the interior of Serbia from the coastal town of Kotor, whose archives still contain important information about the Greek painters who fostered the "Greek" style of art along the seaboard. The identity of style in these icons and the vast gallery of frescoes in Decani was recognized long ago, and a comparison between them tells us much about the icons as works of art. Although the signatures in Decani are in Serbian as a rule, the mistakes in orthography show that at least some of the artists were not familiar with the language. The most likely assumption is that the founders of the workshops in Kotor were Greek but that they had taken on, in compliance with the laws of the town, local youths as assistants and apprentices. We know that this caused the art of the Greek masters in Venice and Dubrovnik to become, in turn, permeated with native qualities, and it was apparently the case in Kotor, too, for there were workshops and masters in Kotor prior to those in Dubrovnik, and of greater distinction. The only artist who signed his name on the Decani frescoes was a certain Srdj (Sergius), but he did none of the paintings on the iconostasis. The style of the anonymous master who did the icons is so close in character to the uncomplicated, bright, fresh manner of painting which was non-Greek in origin that we can be sure he was a local artist. Although the artists of Kotor belonged to the westernmost regions reached by Byzantine influence, they were acquainted with what was being done in Constantinople in their time. Actually the icon of the Eleousa Virgin in Decani is, in its iconography, an exact copy of the fresco in the parecclesion of the Church of Chora in Constantinople; every gesture of its prototype is repeated, but each is reinterpreted according to its own style. The Constantinople fresco is meticulously painted in muted colors with the subtlest variations throughout, whereas the Decani icon, also the work of a fresco artist, is rich in contrast, clearly composed, and never gives in to naiveté. The Decani master remained faithful to the unchanging qualities of Serbian art, its intense color and vigorously beautiful forms, and did not seek inspiration from figures on classical marble reliefs.

All the refinement of mid-fourteenth century Byzantine painting is revealed in an icon of the Baptism of Christ, now in the National Museum of Belgrade. It is a 153 masterwork of mature icon painting of the Palaeologue renaissance because of its richness of symbolic and intellectual content and because of its virtuosity in manipulating form. A comparison with the Ohrid Baptism clearly reveals what took place between 1300 and 1350: together with an agitation in the painting technique 183

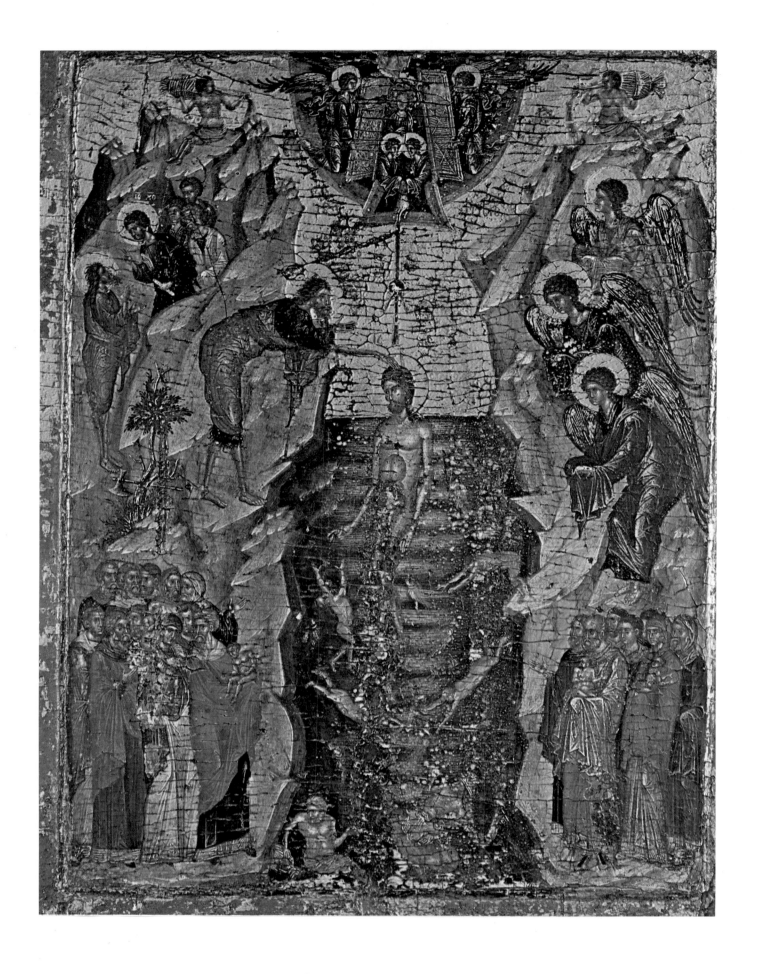

itself, the Ohrid icon — classical and romantic at the same time — also has the clarity and symmetry of a work of antiquity. The Belgrade Baptism, on the other hand, is complex in content and overcrowded, yet it is also narrative — symbol and vision are one. The composition is vertical and has the format typical of ceremonial frescoes painted on vaults, as, for example, in Staro Nagoricino. The valley of the Jordan is transformed into a rocky canyon crammed with figures, all playing a part in the interpretation of the broad subject matter. Toward the end of the thirteenth century, such depictions of the Baptism, accompanied by illustrations of accessory events, appeared in fresco painting in Constantinople. Anthony of Novgorod reported, about 1200, that the painter Paul had portrayed the Baptism of Christ with secondary scenes in the great Baptistery of Saint Sophia in Constantinople, where catechumens were baptized with solemn ceremony on Epiphany and Saturday of Holy Week. The Belgrade icon belongs to this iconographic type. On the left side, we see the meeting of Christ and John, and John's parable of the tree and the axe. According to Anthony, the Constantinople Baptism showed "how John instructed the folk and how young children and adults leapt into the Jordan." The principal scene, the Baptism itself, is based more upon the Epiphany trope of the Orthodox liturgy than on the word of the Gospel. John lays his hand reverently on Jesus' head, and three angels — symbolic of the Trinity — bow toward Him. Directly above the central group, two angels open the Gates of Paradise to reveal Christ as Emmanuel the Son, in accordance with a verse of the trope. Below this image, two smaller angels bow above the hand of God the Father from which the Holy Ghost, in the shape of a dove, takes flight. On the mountain peaks, which "skipped like rams, and the little hills like lambs" (Psalm 114:4), sit almost nude personifications of Jor and Dan pouring waters from their great vessels into the Jordan. In the stream below, Jordan and the sea are personified, with animated gestures in accordance with Psalm 114: "What ailed thee, O thou sea, that thou fleddest? thou Jordan, that thou wast driven back?" Christ Himself blesses the water of the stream. To the left, two youngsters splash acrobatically in the water, while to the right two others dive in headfirst. These energetic children inevitably remind us of frolicsome Amors swimming about in some antique depiction of the birth of Venus. At the bottom of the icon, two symmetrical groups of Jews, holding naked children in their arms, gaze with wonder on this half-ceremonial, half-festive scene.

This icon, signed in Greek, teems with picturesque details, and was painted meticulously and clearly with great finesse in its drawing and color. A certain academicism led the artist to dampen the dramatic effect of the rocky landscape by superimposing the three angels upon it in poses of solemn reverence. The rigorous geometry of this visionary scene contrasts with the antics of those in the water. Although the form of the painting is calculated down to the finest details, it is full of such small but effective contrasts. Free of exaggerated tension, it is the product of a scholarly art which conceives everything in willfully aesthetic terms; it presents almost a kind of intellectual play that challenges the viewer to puzzle out the riddles for himself. Yet this icon shows no trace of the classicism which, in the first years of the fourteenth century, strove to revive antiquity in all its aspects. Only a few highly effective antique elements have been retained: the four allegorical personifications that are relegated to the marginal areas of the composition. In the mid-fourteenth century, Serbian churches and monasteries were particularly partial to such art as this

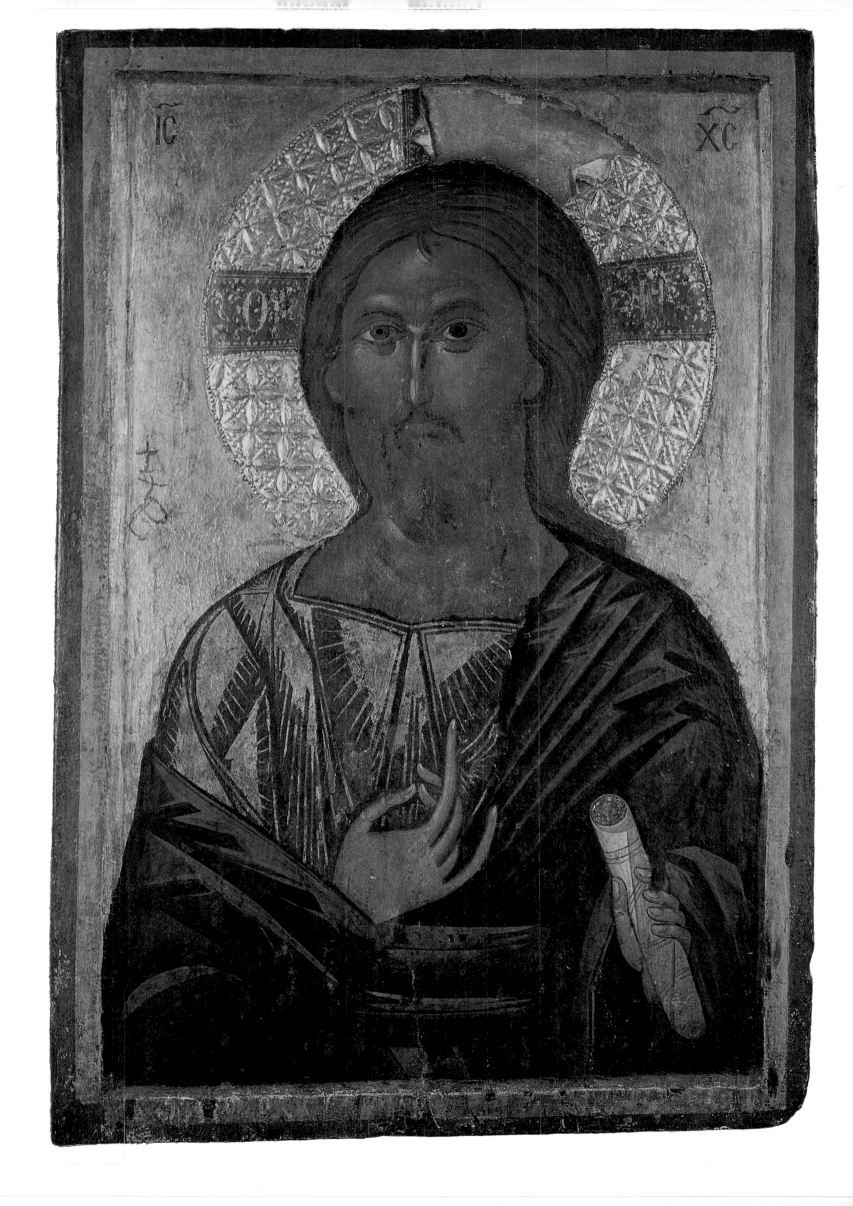

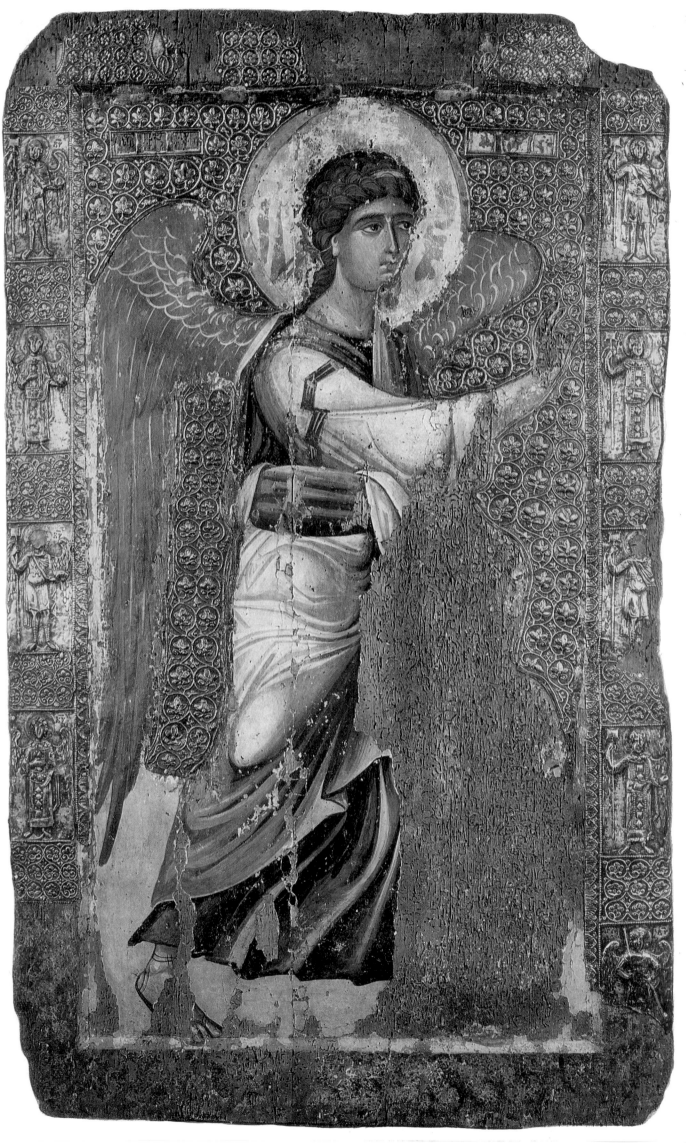

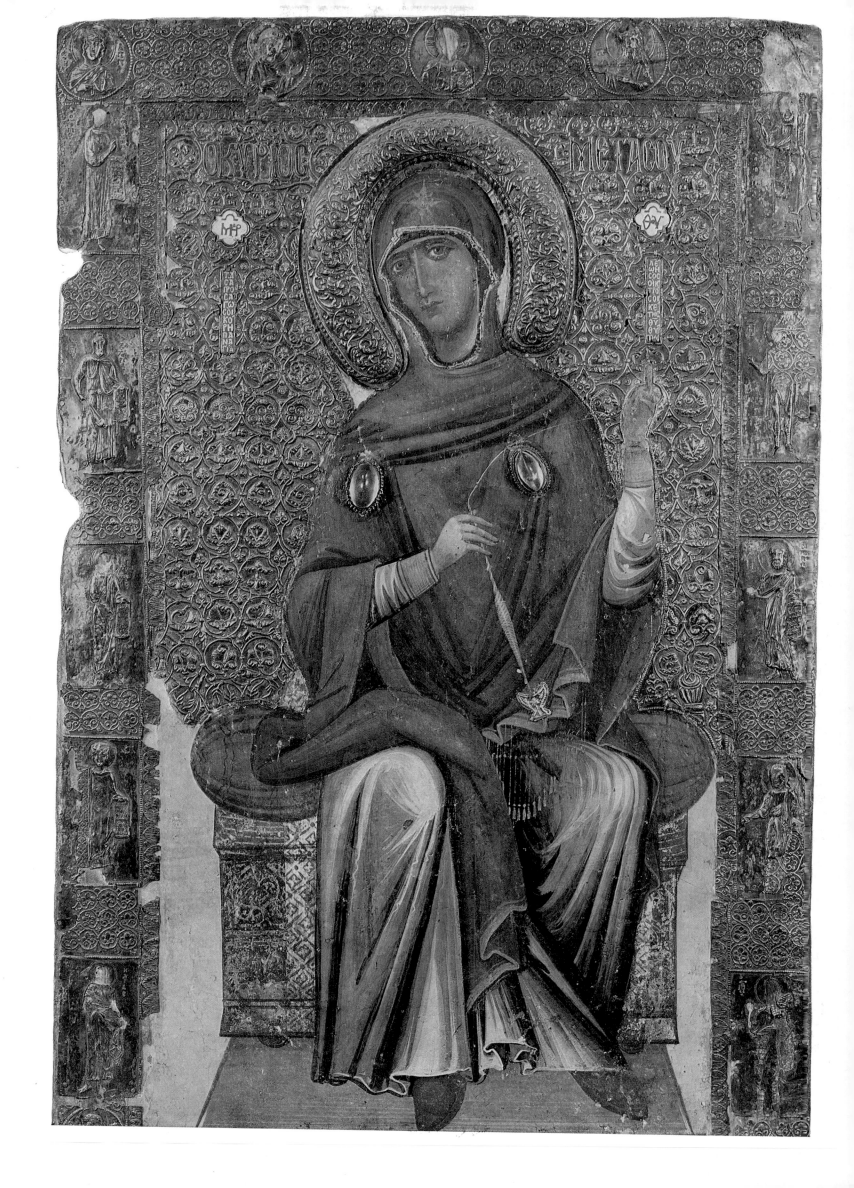

painted, not only the large icons used in processions but also smaller ones for calendars and the series of liturgical feasts.

Although icon painting in Serbian and Macedonian regions from the early sixteenth to the end of the seventeenth century certainly belongs to post-Byzantine art, it occupies a special position within the general framework. The consequences of the political collapse of Serbian secular power were acutely felt in the first decades of the 1500's. The more significant artworks were created in the outlying regions to which the nobility had fled. In Krusedol, in the monastery of the last members of the Branković family, the upper tier of icons from around 1515 survives on the iconostasis. During those same years the old, so-called Greek style of painting was revived in the western border areas of Herzegovina and Montenegro. Icons from around Dubrovnik are found both in Orthodox and Roman Catholic churches and are a mixture of Italian and Greek styles, though still closely bound to the Orthodox tradition. In those years certain traits which were to remain constant for the next two centuries appeared in the icon painting of the Balkan interior; notable was a stubborn insistence on orthodoxy. Even in their aesthetics, sixteenth and seventeenth century icons reveal a clear tendency toward conservatism. Consciously opposing Western naturalism, sculptural forms, and the lifelike rendering of space, Serbian icon painters of the later period borrowed certain ornamental elements from the East and 200 certain types of stylization from Russian icons. In their basic conception they still clung to the old ideals, especially to the prototypes handed down from the 1300's. Up to the sixteenth century there must still have been many old icons in the great monasteries. Later artists in, for example, Decani and Gracanica were surrounded by icons that were impressive as objects of worship and as works of art; these artists made a thorough study of the technique and artistic expression of their predecessors. Fascinated by the models at hand, they often painted icons that today may puzzle even specialists in the field; less experienced collectors sometimes date icons of the 1500's some two centuries too early. Nevertheless, the works that were deliberately fashioned in imitation of an older style still bear the mark of their own time: shadows are more pronounced and colors are subdued; the patina of age was merely imitated; and the tendencies toward literary conceptions and abstraction are marked.

Such works are clearly differentiated from the many variations of the Italo-Greek style as well as from Russian art. In adhering to the old iconography, the artists exercised a very exclusive choice of what to include and what to reject; this consistency became highly impressive in itself, and it led to these icons becoming sought after and revered, especially in Russia. We know from Russian documents between 1550 and 1699 that Serbian monks traveling there took icons by native artists with them as gifts to the court. Customs declarations issued at the border town of Putivlj show again and again that these monks crossed over with icons, usually ones of Serbian saints revered as the founders or patrons of monasteries; these were stated to be gifts for the tsars, tsarinas, and crown princes, and on most of the forms appear the words "in gold." The interest in Serbian icons must have been very great in the royal court during this time. There was even a Russian translation of a Herminia, a painter's manual; it was written by an adventurer who purported, perhaps fraudulently, to be a bishop, and pretended to be Serbian though he was more likely Greek. (The handbook was completed in Russia on July 24, 1599, and the author was named as "Bishop Nektarios from the city of Veles." In reality, he was probably an

itinerant Greek painter who knew Serbian or Macedonian and lied about his identity — for one thing, Veles was never a bishopric.) Be that as it may, this "Typikon" is a valuable source of information about fresco and icon technique in the late sixteenth century Balkans. Research by Russian historians of icon painting was able to show that the book had considerable influence on the technique of later icons in their country. In Serbia itself, the later icon painters perpetuated the traditional methods of painting, and composed handbooks and manuals. Among these is a very practical book of instructions, the *Book of the Art of Painting by the Priest Daniel from the Year 1674;* the author had painted frescoes and icons in 1667 for the small Church of Saint Nicholas in Chilandar, which is still beautifully preserved.

This insistence on traditionalism in technique, iconography, and aesthetic conception in no way reduced art in Serbian and Macedonian lands to the level of superficial repetition. The course of Byzantine art was marked from its very inception by successive returns to the past. The tradition-bound art of Constantinople drew its inspiration from the rich treasures of the church and from old, even antique, prototypes. This process of interpretation and re-interpretation was not the lifeblood of this art — as certain writers having a naturalistic bias have claimed — but the essential expression of the Byzantine conception: the idea that the holy and lofty origins of art could only be maintained through repeatedly restoring to life the models of the ancient past. Icon painting endured as long as that principle remained in force, regardless of the circumstances attendant on the collapse of Christian political power in the Balkans. It is pedantic to divide icon painting into two periods — the first authentically Byzantine, the second post-Byzantine — separated by the date of the final fall of Constantinople. Western influences did more harm to the art of Byzantium than the Turks did. With its own long history behind it and its principles clearly formulated, Byzantine art was free of the limitations that are inevitable in an art based on the observation and imitation of nature. Painting as a whole, and icon painting in particular, enjoyed an internal freedom within its own conventions. It could profit from the subtle variations of aesthetic expression which continued to reappear, to merge, and to disappear regardless of the seeming external monotony of the formulas.

Unity of style in late Serbian icon painting was the product of drawing and composition. The palette had a range from black and white, through monochromy or intense polychromy, to the highly effective enamel-bright colors which were often used to underline or to interpret the inner, psychological values of the subject. The 196 early Serbian predilection for narrative painting did not vanish in the sixteenth and seventeenth centuries. Numerous icons were, so to speak, biographical: large panels 204,205 with a saint in the center, surrounded by small scenes recounting episodes from his life. In these tiny, often miniature-like scenes filled with schematic and semiabstract forms, the events could not be illustrated realistically. Instead, they were transformed in many late Serbian icons into a stately ceremonial, or perhaps a dramatically expressive pantomime, or even into an almost childlike puppet play. But regardless of the form they assumed, the style of the icons remained "Byzantine" without alien elements from Renaissance or Baroque conceptions. True, in the sixteenth and seventeenth centuries Balkan icons often sank to the level of mass-produced articles turned out for easy sale to village dwellers. Such productions, poor in quality and muddled in conception, are responsible for the oft-repeated

judgment that the art of the Balkan peoples reached its lowest level under Turkish rule. But one gets an entirely different picture of the achievements of the art of the time when professional works are considered, for these were produced by outstanding masters whose names were known and who were proud to sign their works.

Icons of fine quality were made in Ohrid, Srem, Montenegro, and Herzegovina in the first half of the sixteenth century. At that time, Serbian and Macedonian icons did not differ from those by Greek artists. One of the loveliest icons in San Giorgio dei Greci in Venice, a well-preserved Last Supper with Saint Stephen and the Archangel Michael, dating from the sixteenth century, is entirely in the Greco-Venetian style although it is signed by the famous Serbian printer Bozidar Vukovic.

After the Serbian patriarchate was reconstituted in 1557 a new art, in which icon painting took a prominent place, began to emerge in the broad territory under the jurisdiction of the reorganized church. The first distinguished icon painter was Longinus, an artist and writer belonging to the patriarchate of Pec, whose finest work was done in the Monastery of Decani. Although he was active in the latter years of the sixteenth century, his paintings were often inspired by earlier Serbian literature. The greatest Serbian painter of the Turkish period, George Mitrofanović, learned his 198,199 art in the Monastery of Chilandar on Mount Athos and achieved distinction as a painter of frescoes and icons. His masterpieces, the frescoes in the Chilandar refectory, are unquestionably the most significant achievement of painting done at Mount Athos in the early seventeenth century. Rich in content and inexhaustibly inventive, the frescoes show a spirited, precise draftsmanship that is in harmony with the lyrical, light, and refined coloring, and this synthesis produces an exceptionally fresh and original unity. Among the artist's followers two are outstanding: Cosmas and John. The rather enigmatic Cosmas, of whose works two survive, is famed for his great icon of Saints Simeon and Sava with scenes from the latter's life. This imposing 203 icon from the Monastery of Moraca is a microcosm of mid-seventeenth century Serbian icon painting: the full tragic depths of the tradition-bound art stand revealed in this work which, at first glance, seems to be no more than a routine product of a pedantic painter-monk. Yet Cosmas, like talented Serbian painters before his time, was tormented by an insoluble problem. In the same way that artists in thirteenth century Mileseva continued to paint Byzantine frescoes although they were acquainted with Romanesque art, so this seventeenth century artist subjected his work to the old rules of icon painting despite his familiarity with the course of Western art. Cosmas' sensitive feeling for the values that dominated his traditional conceptions is reflected in his skillful manipulation of Western elements to make them conform to the unshakable rules of his own tradition. The head of the deacon sunk in meditation, on the small icon that represents a scene from the life of Saint Sava, is modeled by contrasting light and shade, and also has an intimate psychological intensity — both typical traits in Dutch portraits of the time. However, this head is in no way an alien intrusion in the Byzantine structure of the picture; thanks to the painterly conception, it is transformed into an element of beauty entirely characteristic of the art of icons. The painter John, Cosmas' contemporary from Chilandar, whose portrait icon of the Patriarch Pajsije in the National Museum 206 at Ravenna is among the finest Serbian portraits of the 1600's, shows the same feeling for more intense and individual delineation of character.

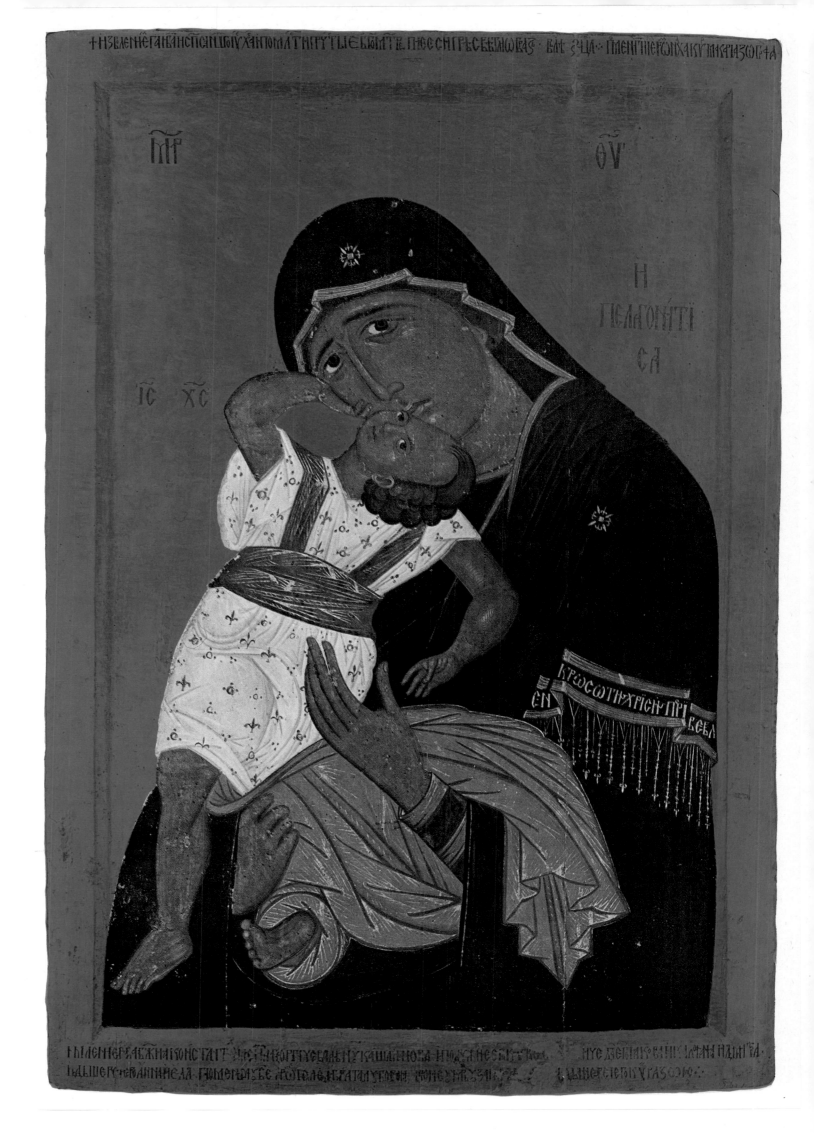

163

· In the last generation of Serbian icon painting, three names are particularly significant. Danilo, a priest from Chilandar, was a conventional, cold, pedantic technician whose works have survived in excellent state. Radul, artist for the patriarchs of Peć, was a prolific but uneven worker who had many mediocre followers. Finally, there was Avesalom Vujicić, a monk of the Monastery of Saint Luke in Moraca, who was a restless adventurer and a fine artist. In his home monastery is the large icon of Saint Luke, the patron saint of painters: the small scenes from the life of the saint are especially valuable illustrations of the artistic environment of the time. Saint Luke is shown in his studio seated before an easel, rather like the usual depictions of the evangelists in their studies; but the saint is here surrounded by a clutter of objects all connected with the act of painting. Yet the great difference between artistic creation in the West and the East is brought out clearly here: in Western pictures of this subject — for example, the Madonna with Saint Luke by Rogier van der Weyden — the painter-saint works from a living model; in the icon, however, he relies on his own inner vision, since, even in this late Byzantine tradition, it would be unthinkable to show two Virgins on a single icon.

The fundamental character of Serbian icon painting, with its stern remoteness from nature, was perpetuated up to the end of the seventeenth century, thanks to the imaginative gifts of the Montenegrin painter-monks. But when the offensive of 1690 failed to regain the Balkans for Christendom, a new wave of Turkish terrorism engulfed the surviving monasteries, and the sparse educated class which had fostered religious art took refuge north of the Sava River. It was only then that the social and material bases of the old art were finally lost. In the course of the eighteenth century, the Serbian refugees in Srem, Slavonia, and Hungary developed a new urban culture of their own and a new art which was not religious. In these surroundings, icon painting was transformed into a native variant of orthodox Baroque art which, for the half-century after 1750, blazed up in all its exotic beauty on Serbian iconostases. But once the wellsprings of religious inspiration had become dry and the entire creative process of the artist had altered, the art of the icon, too, passed out of existence. As the role of icons in the painted decoration of churches dwindled in the nineteenth century, they lost their character and their intrinsic value.

In the regions around Debar and Ohrid, the icon met a similar fate. In the early 1700's the little-known Macedonian iconostases of wood, carved in low relief and then gilded, were more impressive for their sculpture than for their paintings. Among the most beautiful iconostases of this period is the finely carved and gilded one of Saint Nahum. The early nineteenth century was marked by the emergence of the familiar carved wood iconostases in Macedonian churches; these were executed in a lavish, peasant-inspired Baroque style overcrowded with carved foliage and figures. Lost in the chaos and exuberance of such decorative iconostases, the cold, hard painting of the icons degenerated into an unsuccessful attempt at a folk style. The icon had become overripe as an artistic form and was fated to die out.

There is some significance in the fact that during the seventeenth century crisis in Russia, when the old way of painting was questioned and there were heated discussions within the Church about new art versus old, the Serbians were the most adamant defenders of traditional painting. In the manifesto of the new Russian school of icon painting, sent in 1664 by the artist Joseph Volodimirov to the famous icon painter Simon Uschakov, the Serbian archdeacon John Plecković was singled

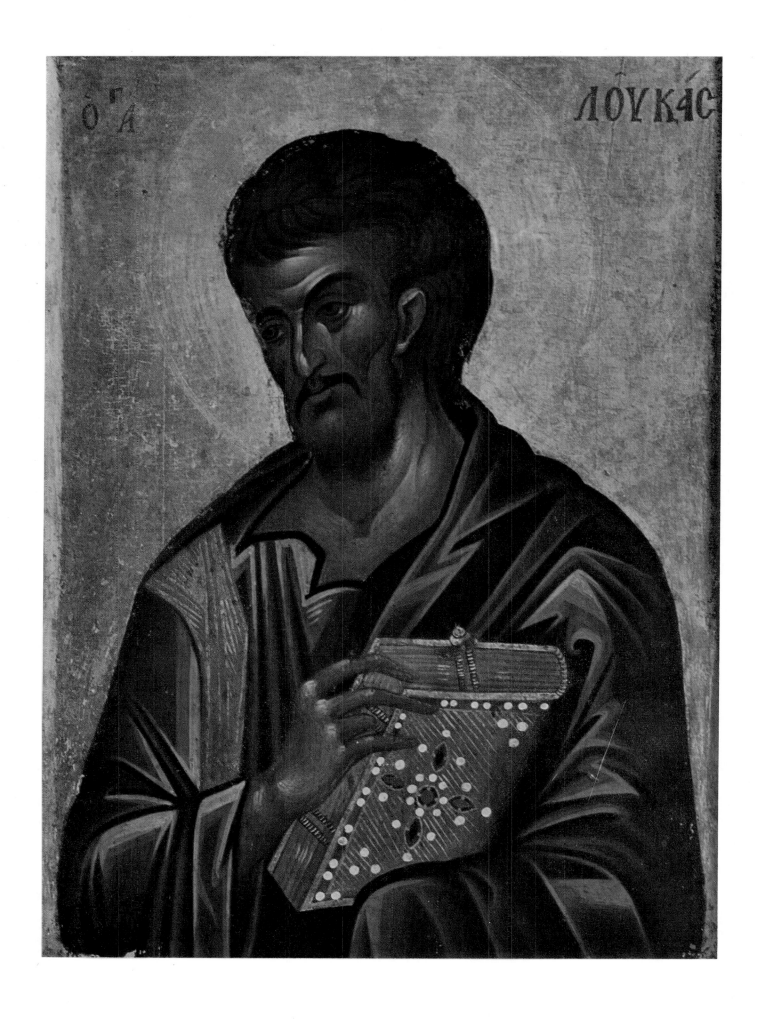

Ὁ Ἅ ΛΟΥΚΆC

165

out for attack because of his stubborn loyalty to an archaic style. The attitude of the Serbians is easy to understand. As the westernmost Orthodox nation, they were the most exposed to propaganda pressures, and thus the most persistent champions of the orthodoxy of their art — even more persistent than the Greeks. The old style of Serbian icons had been jealously guarded for confessional reasons and remained virtually untouched by Renaissance and Baroque influences right up to the end of the century.

The degree to which icons in the Serbian and Macedonian regions continued to preserve their original artistic expression in the 1600's can be seen in a beautiful icon of Saint Nahum from Ohrid. Painted after a model from the early fifteenth century 211 that is still extant, it remains faithful iconographically to its prototype but it does not try to match the refined subtleties of the earlier period. Instead, its more forceful drawing and subdued coloring spontaneously recall ways of painting which belong to the earliest history of the art of the icon.

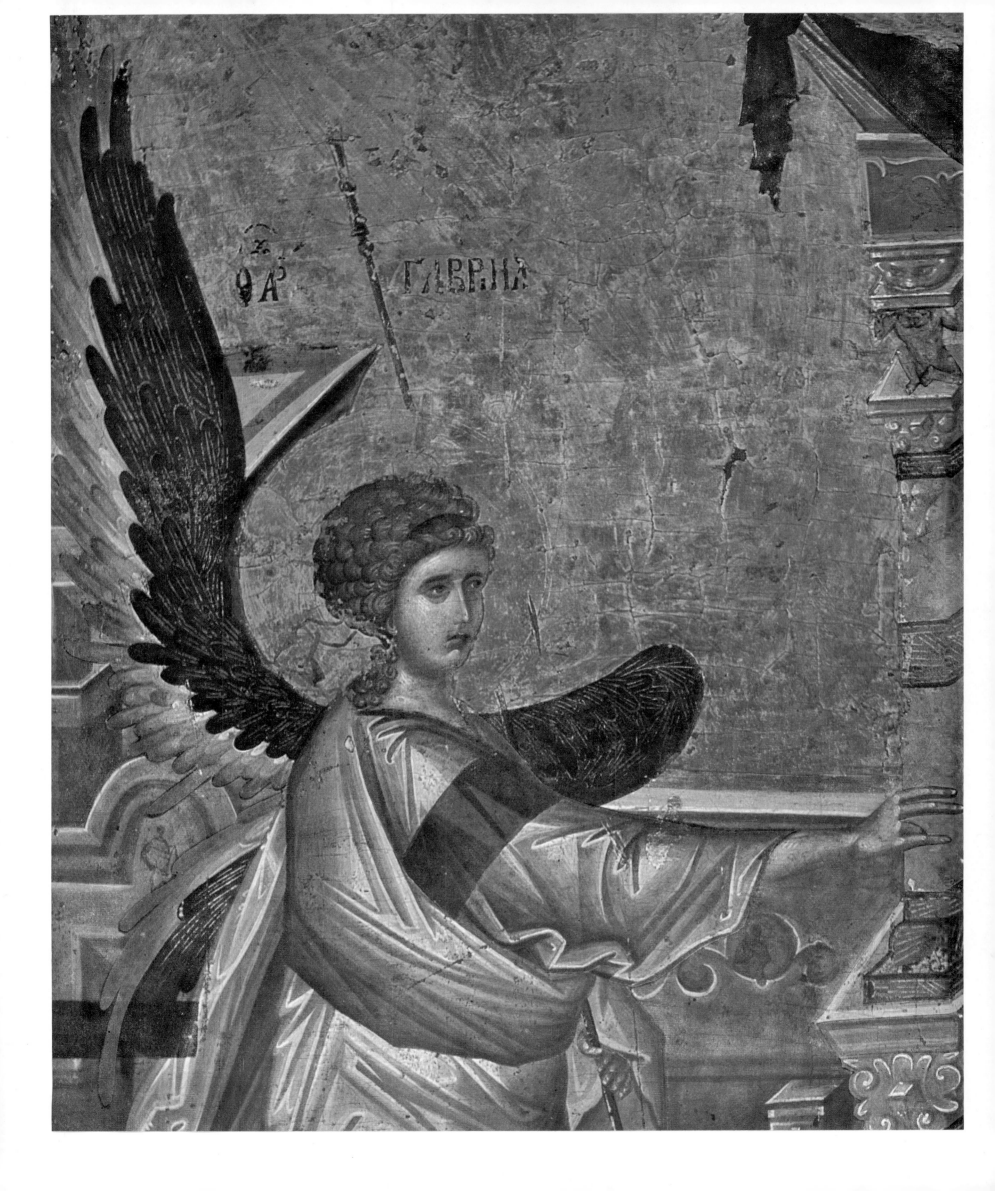

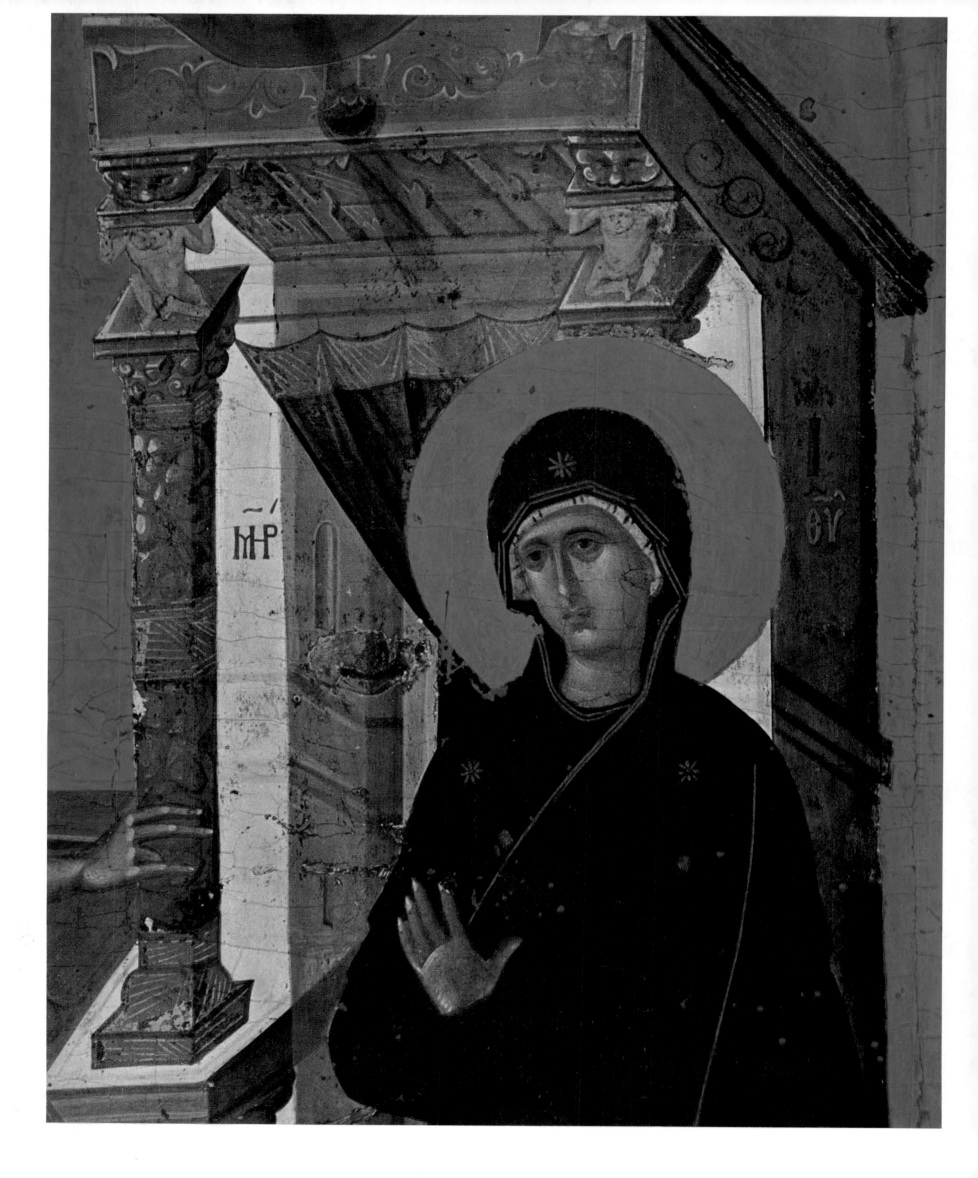

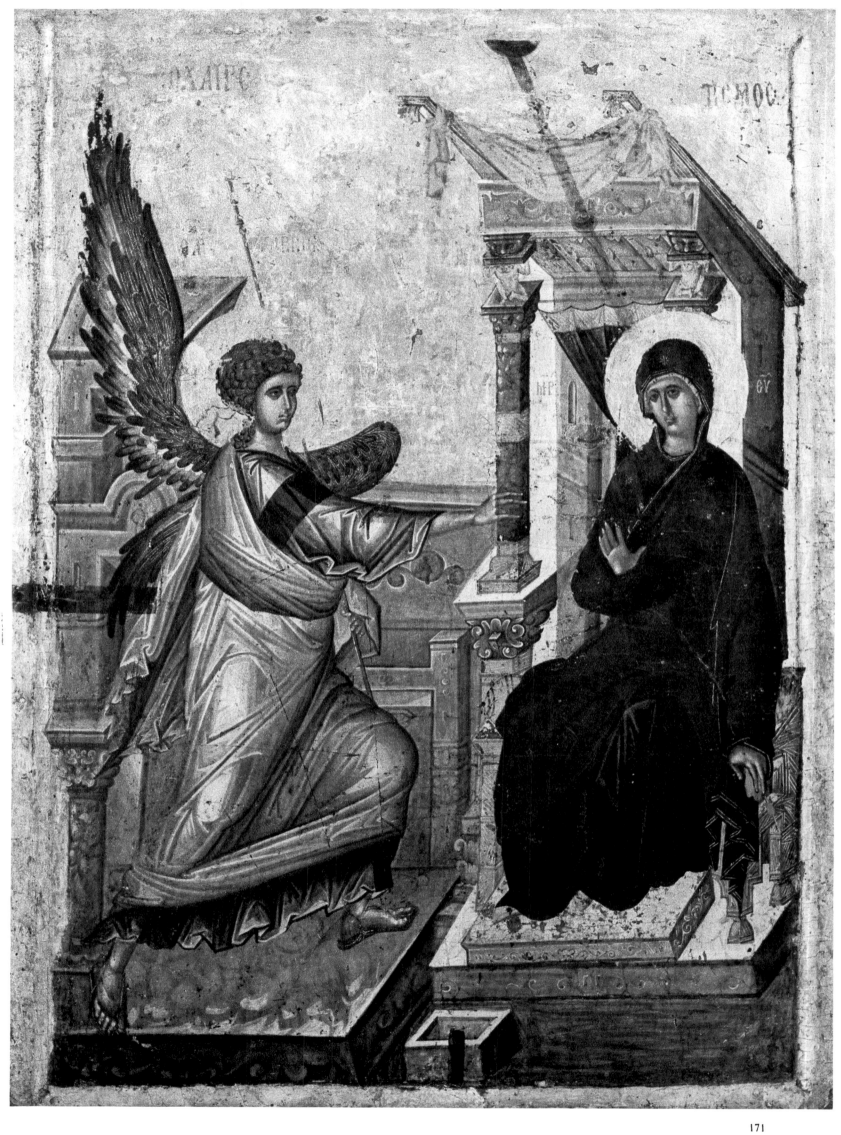

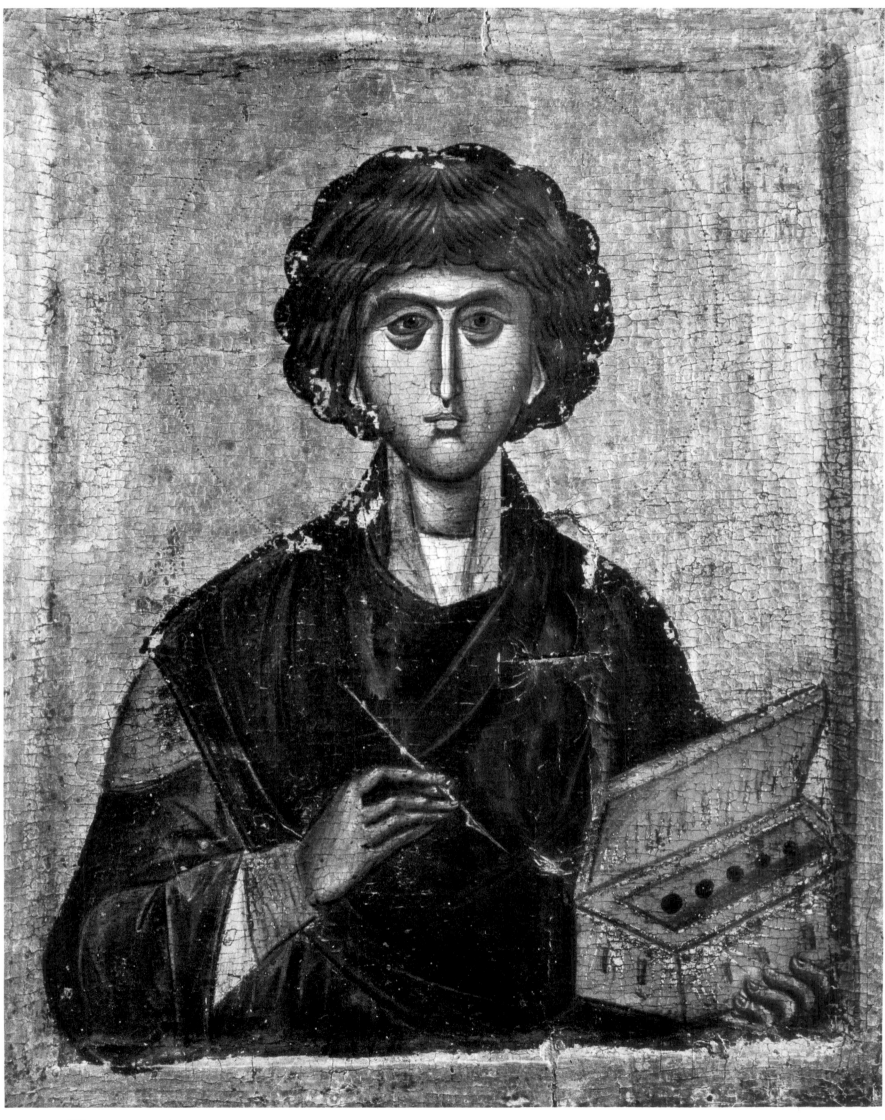

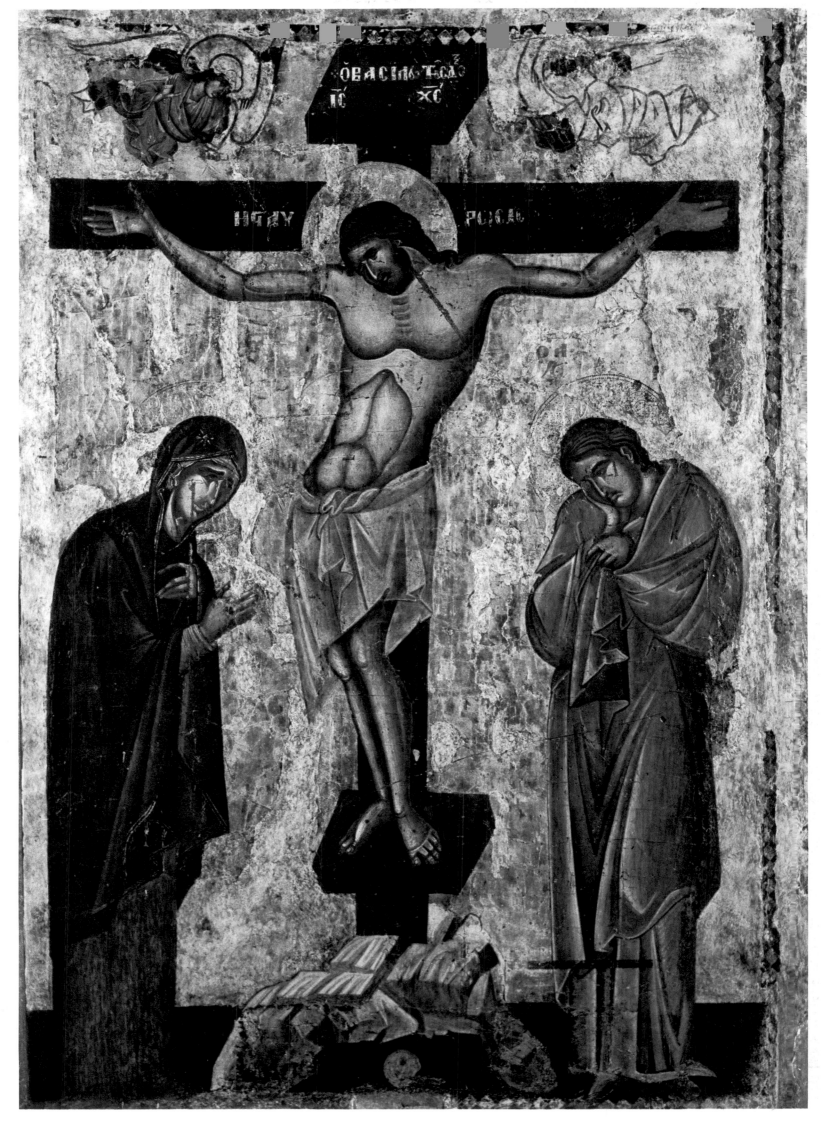

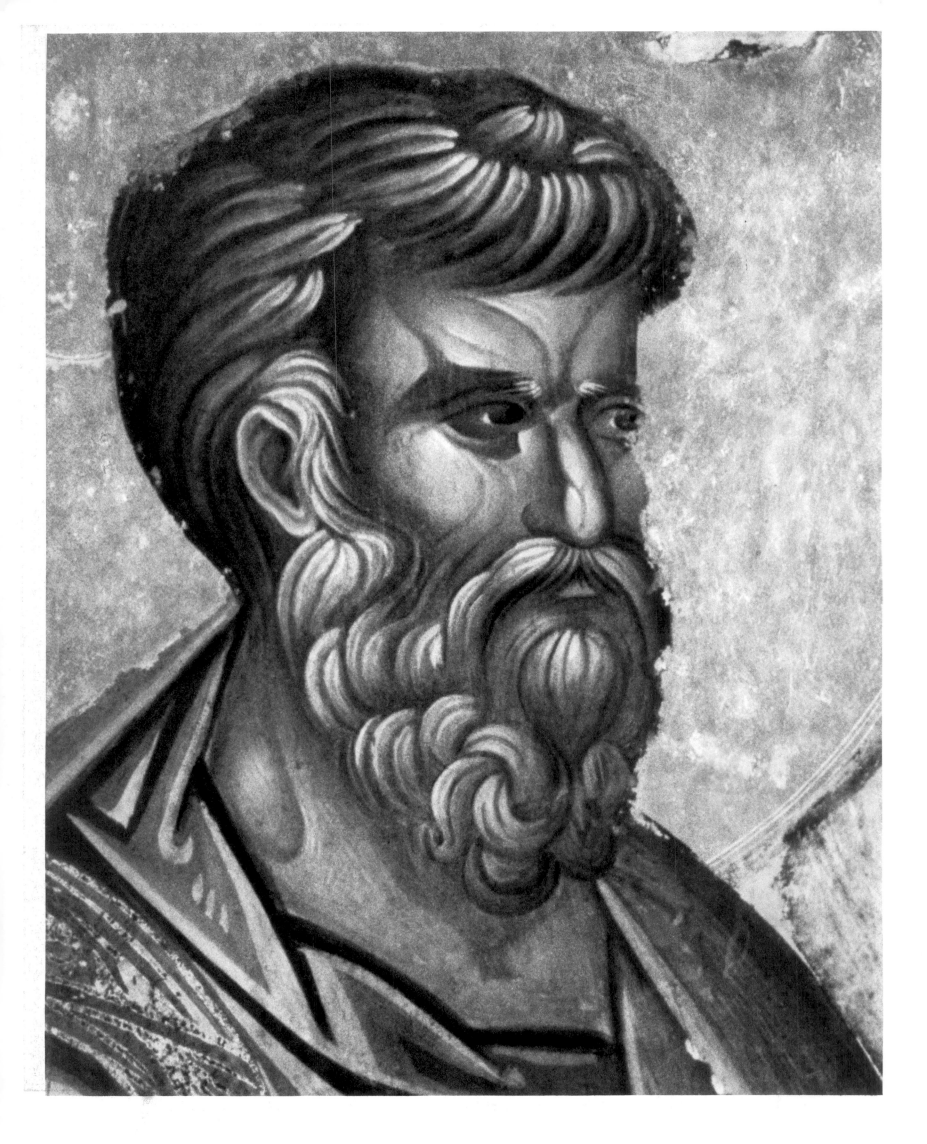

174

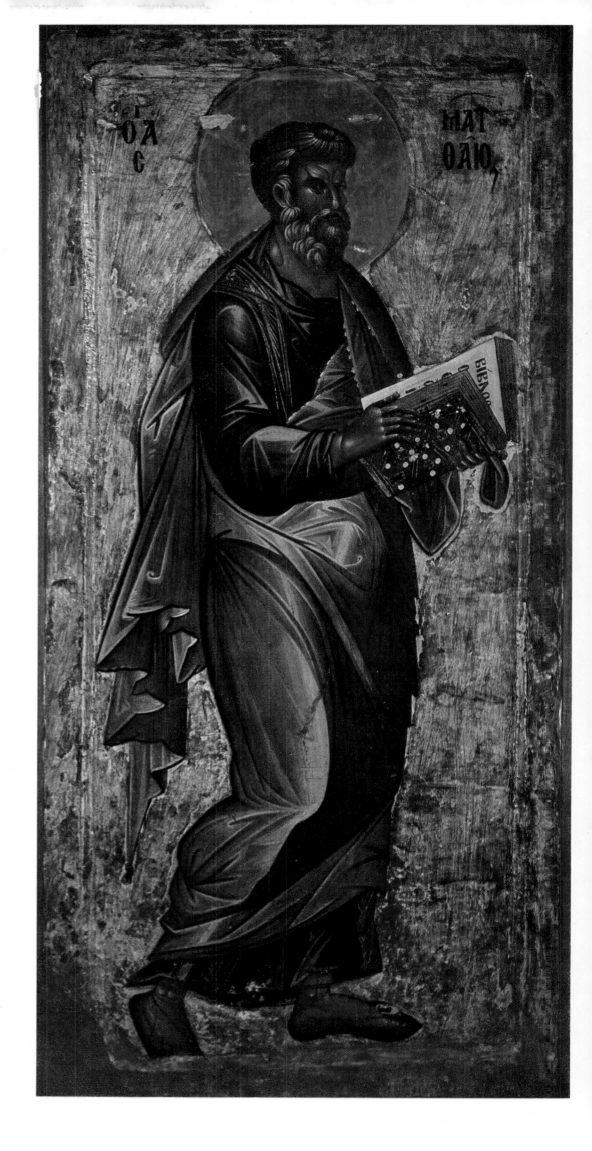

Ὁ ἍΓΙΟС ΜΑΤΘΑΙΟС

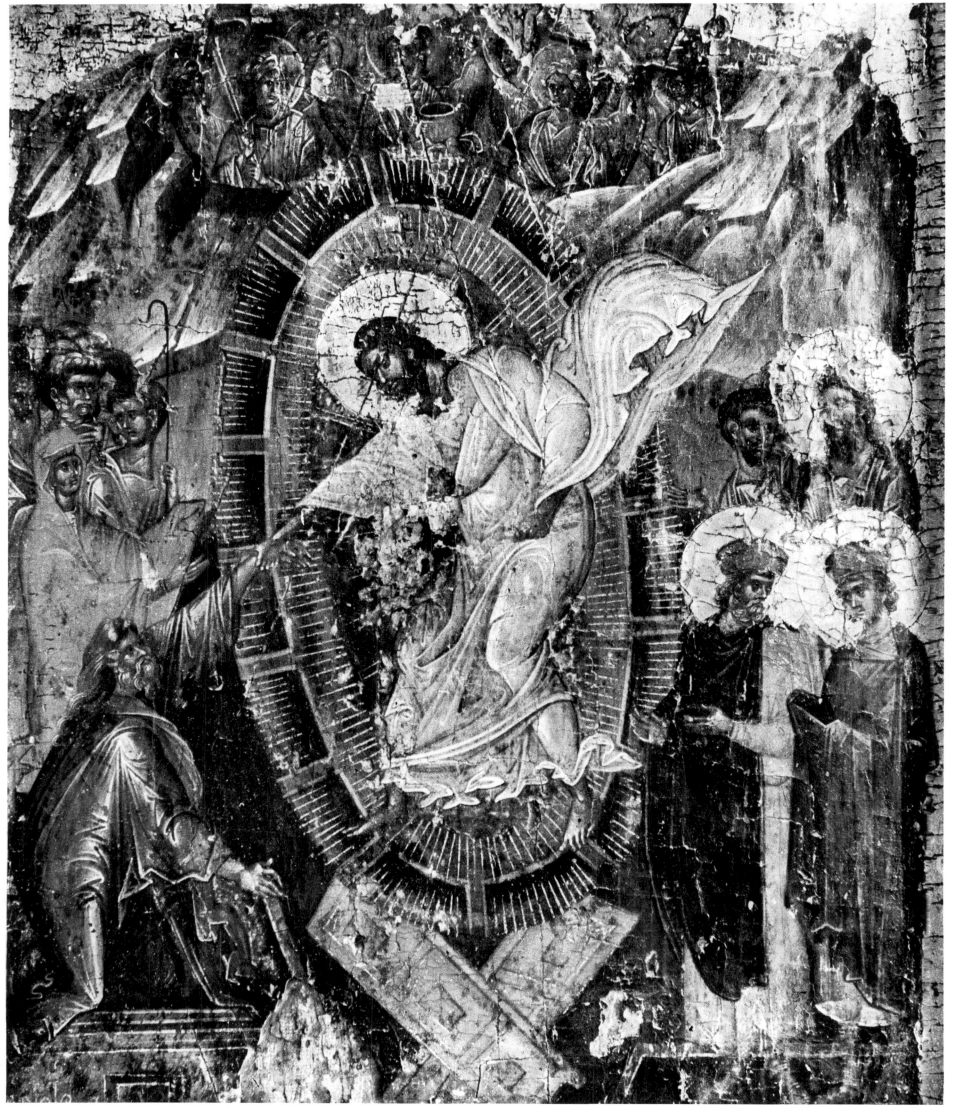

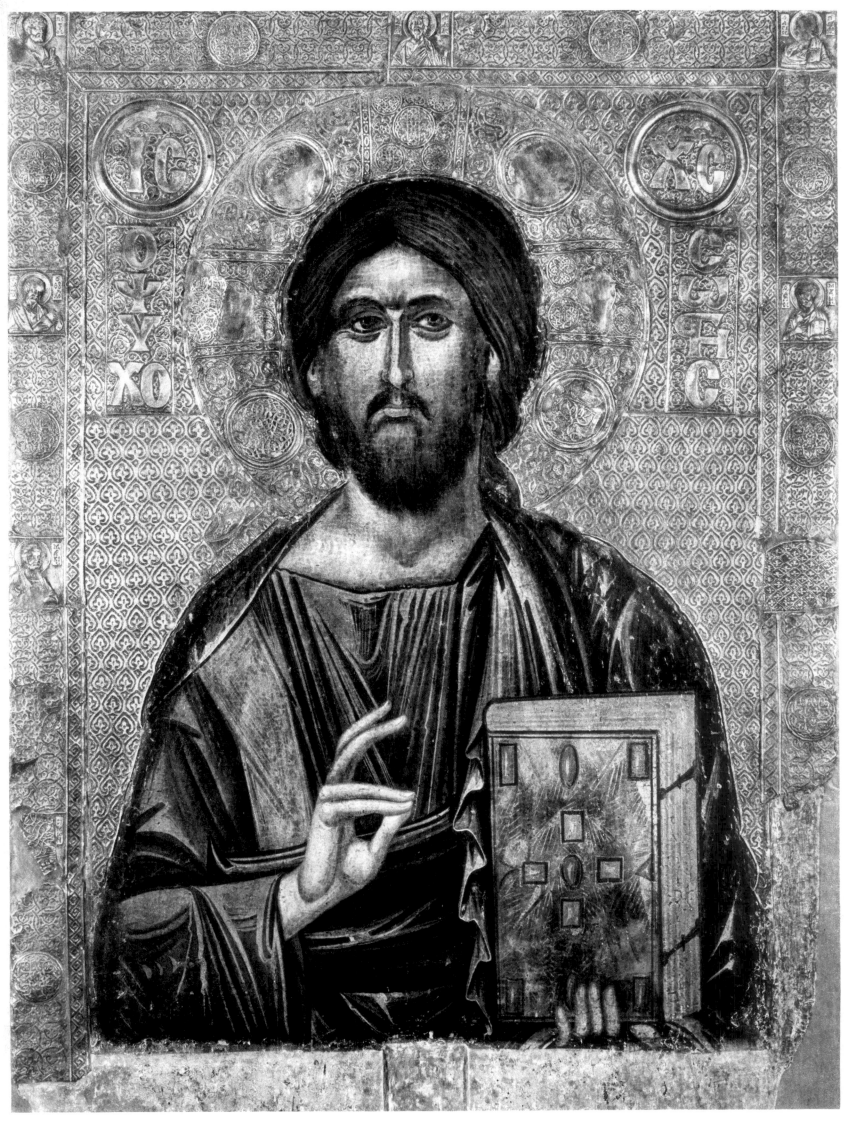

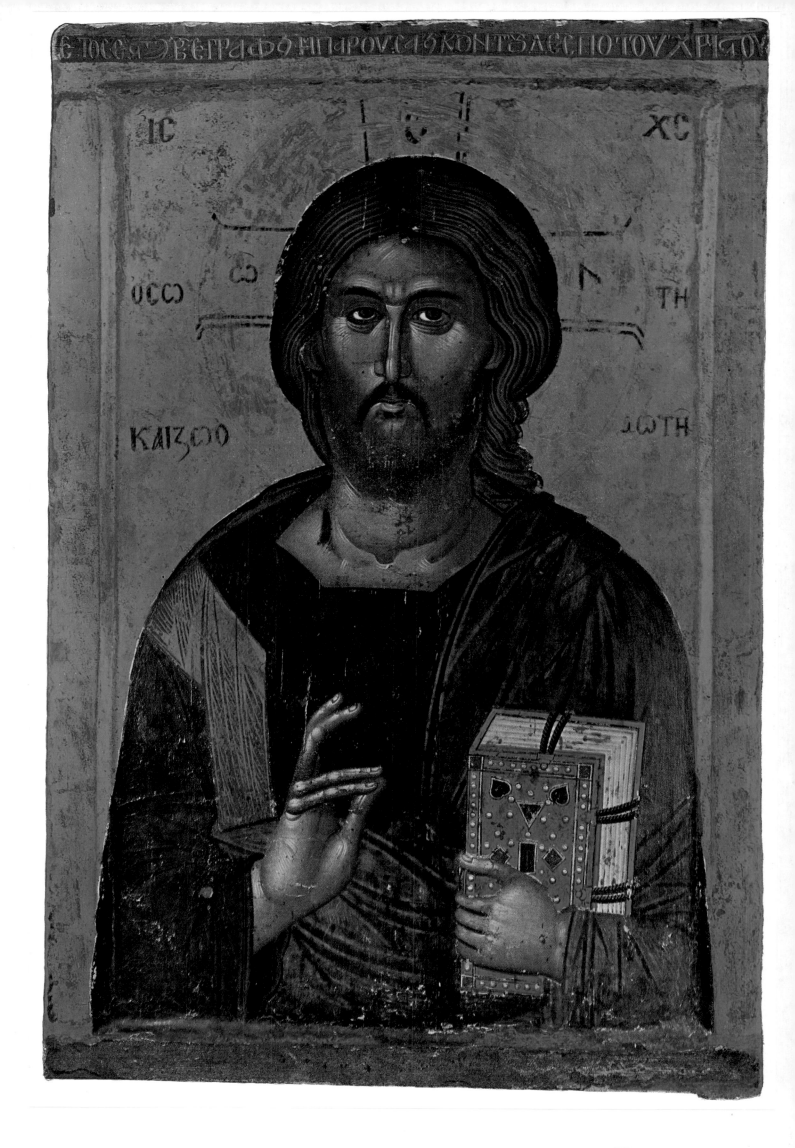

IC XC

179

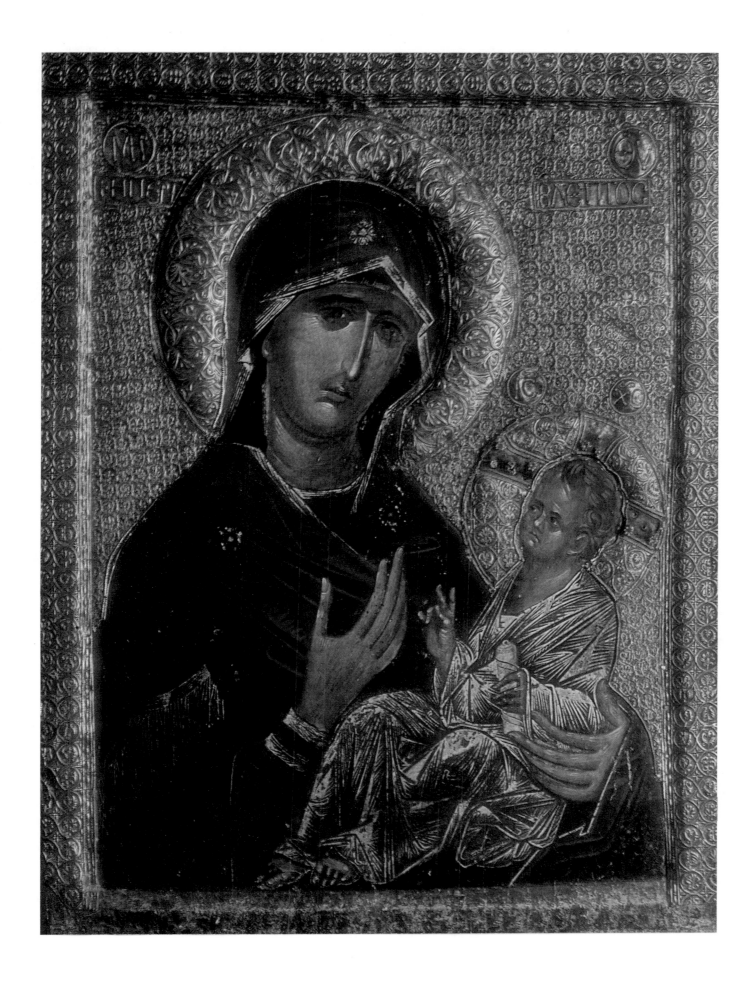

181

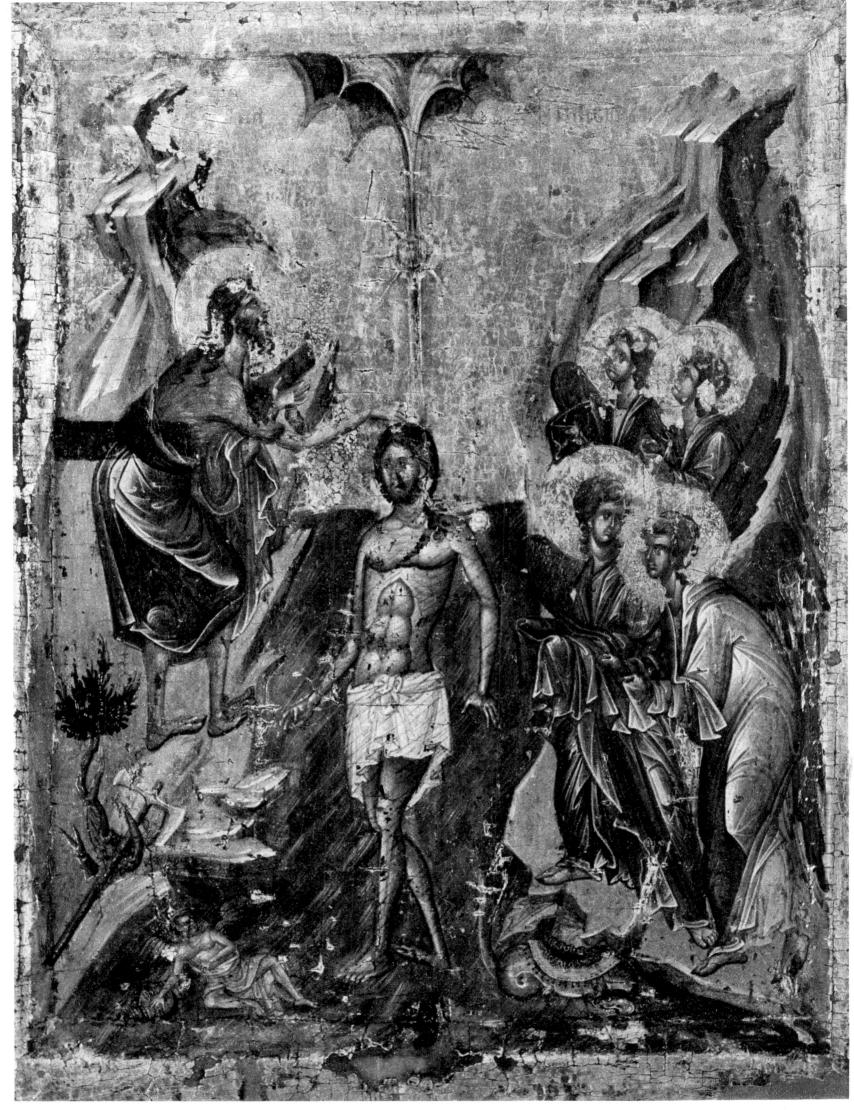

183

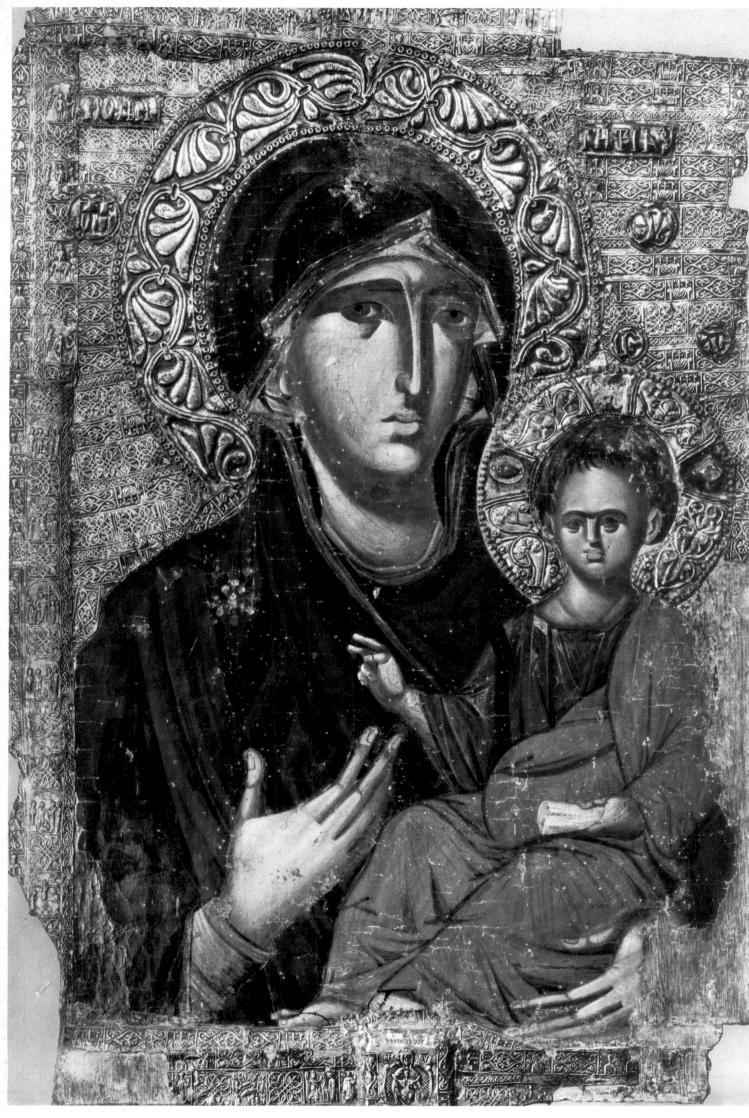

184

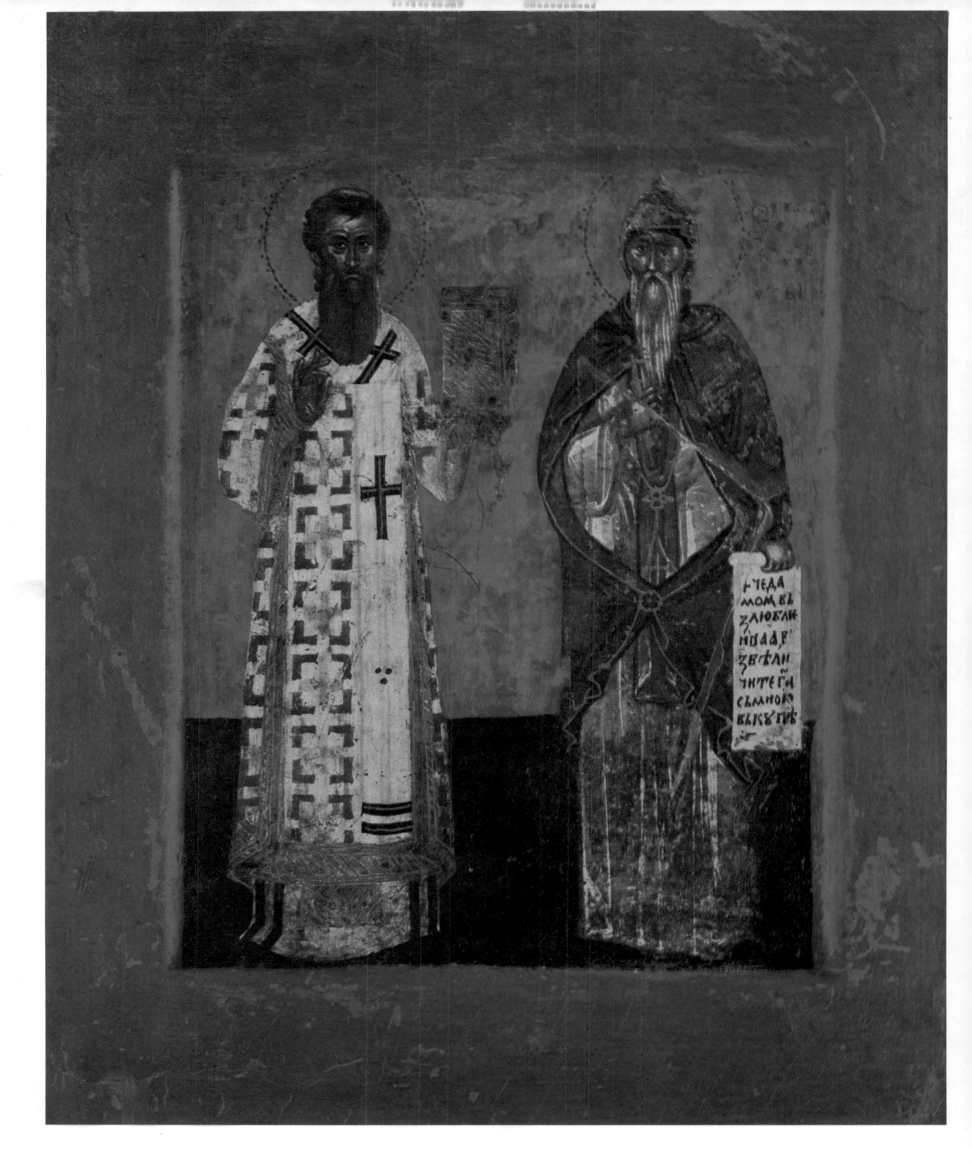

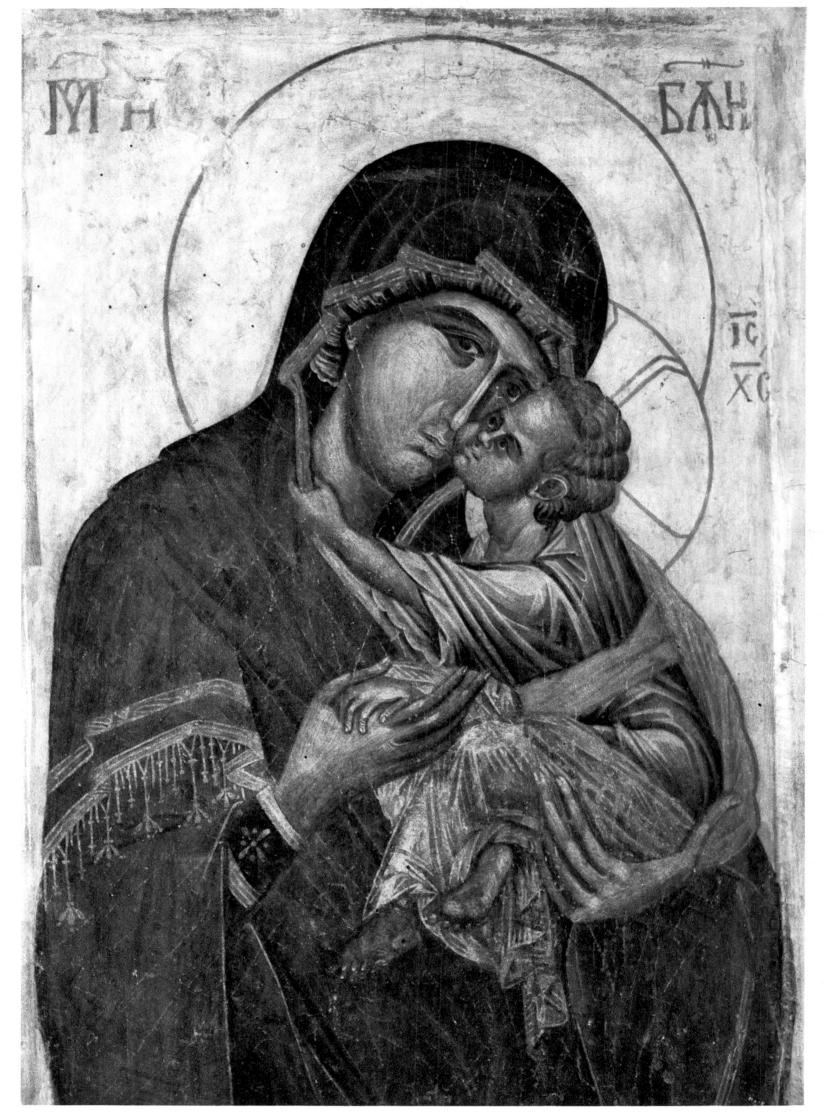

187

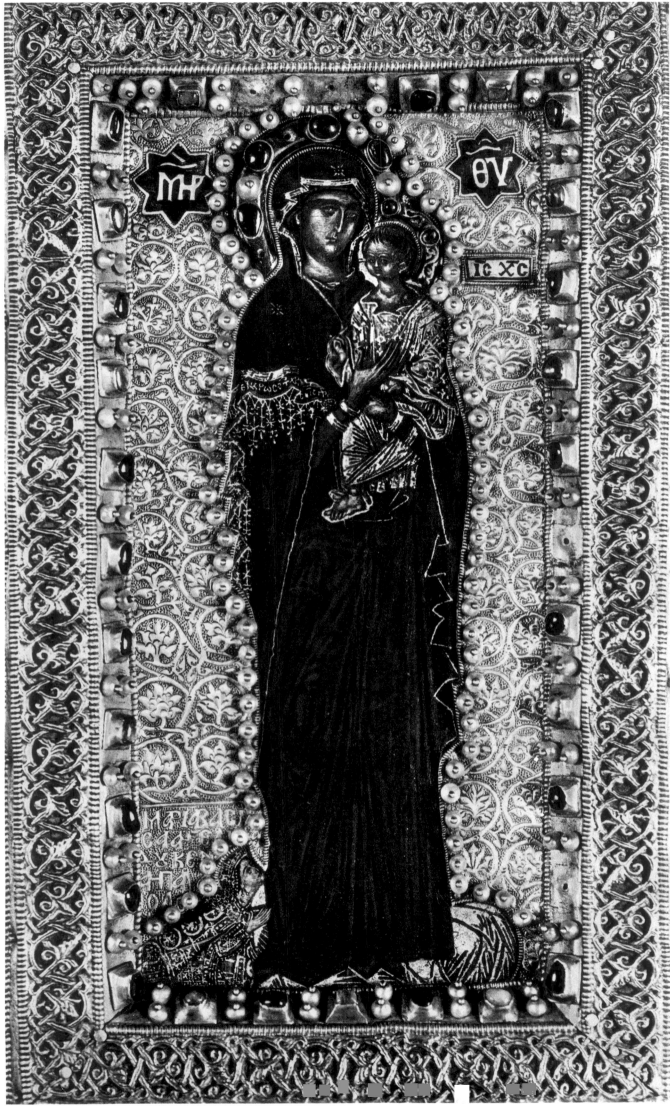

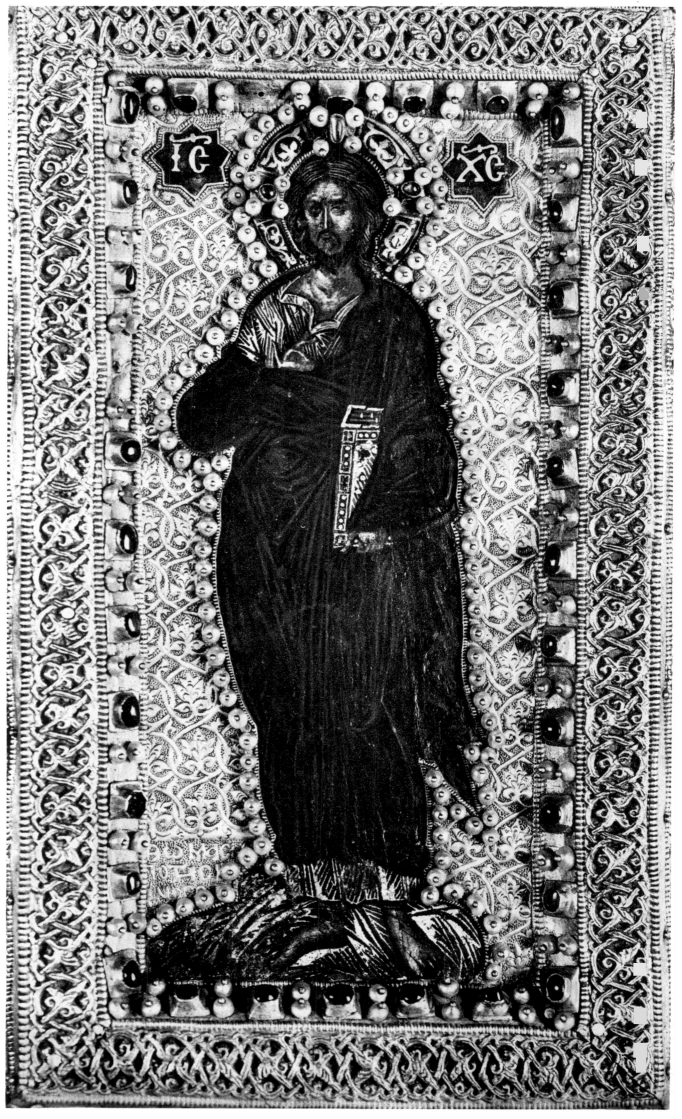

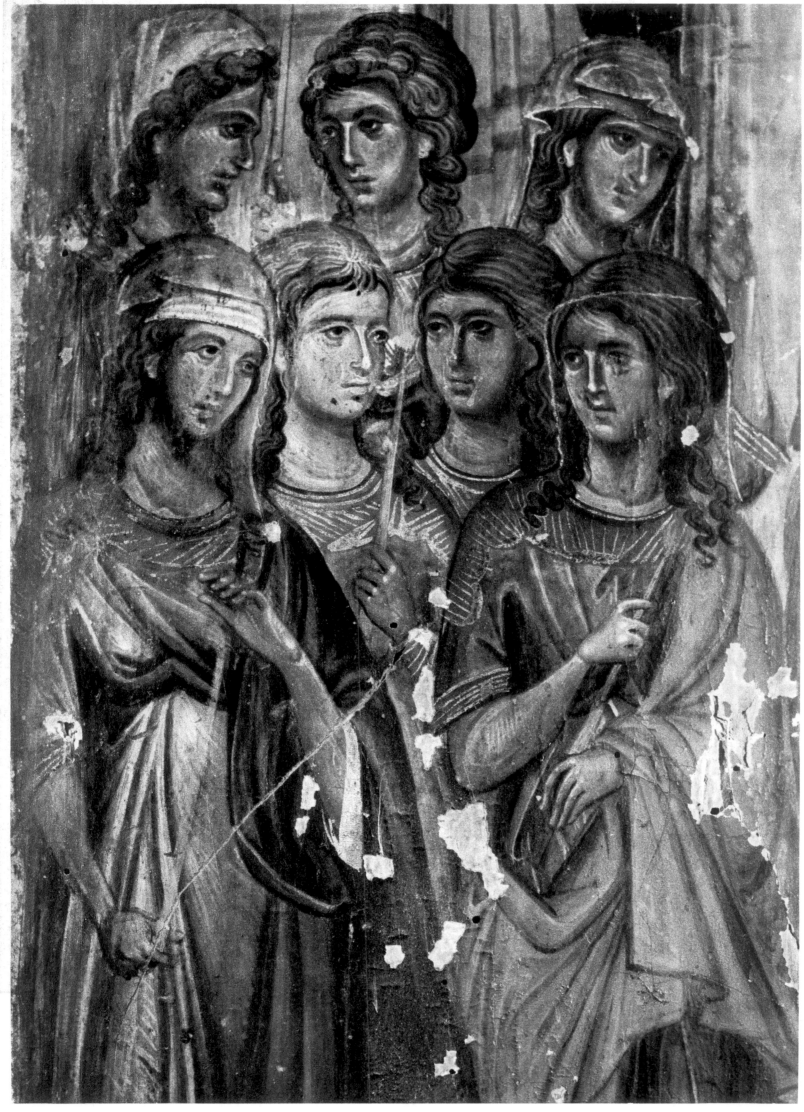

190

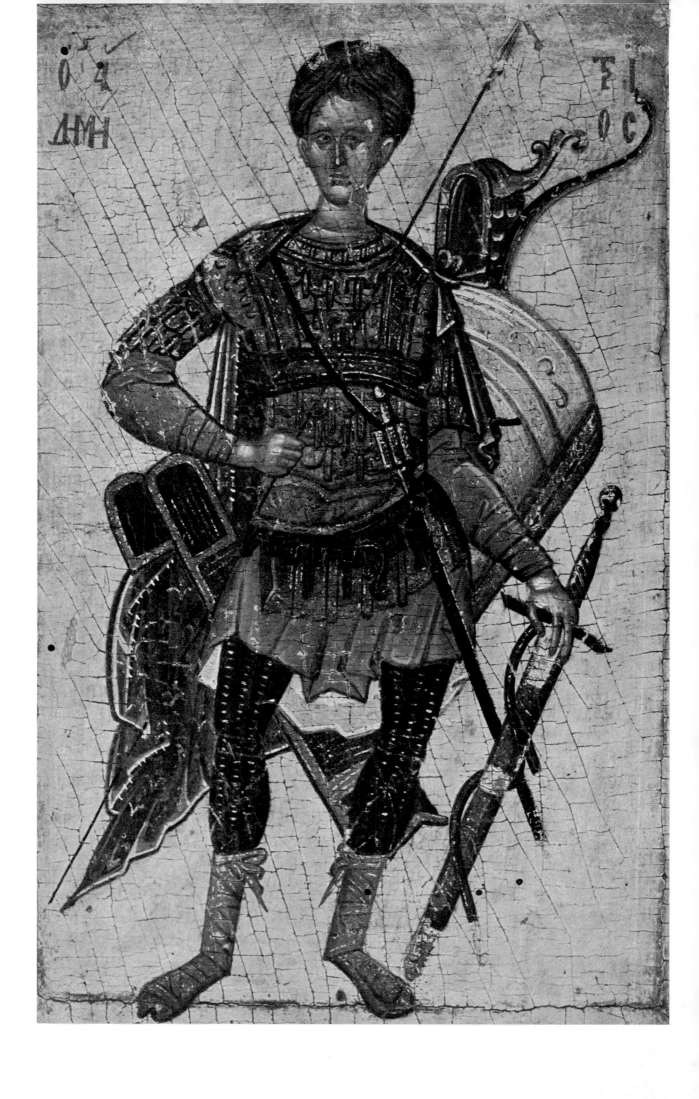

Ο Ἅ ΔΗΜΗ ΤΡΙ ΟС

191

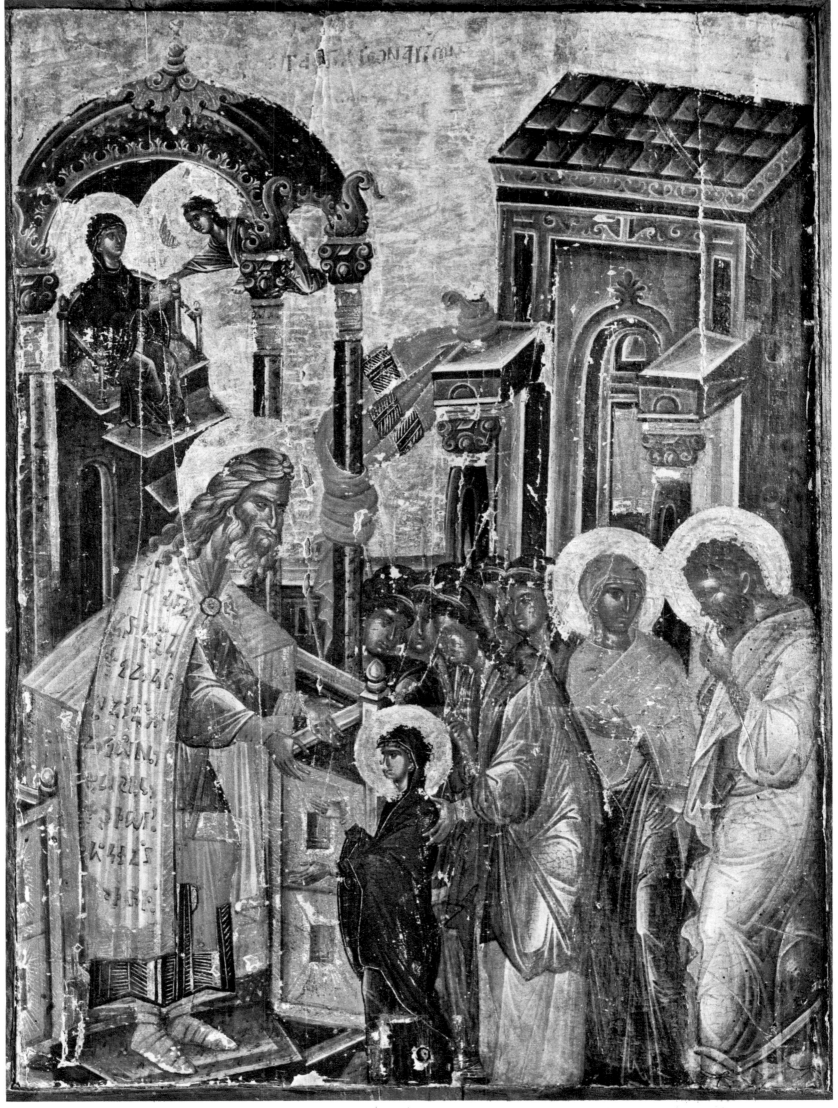

195

196

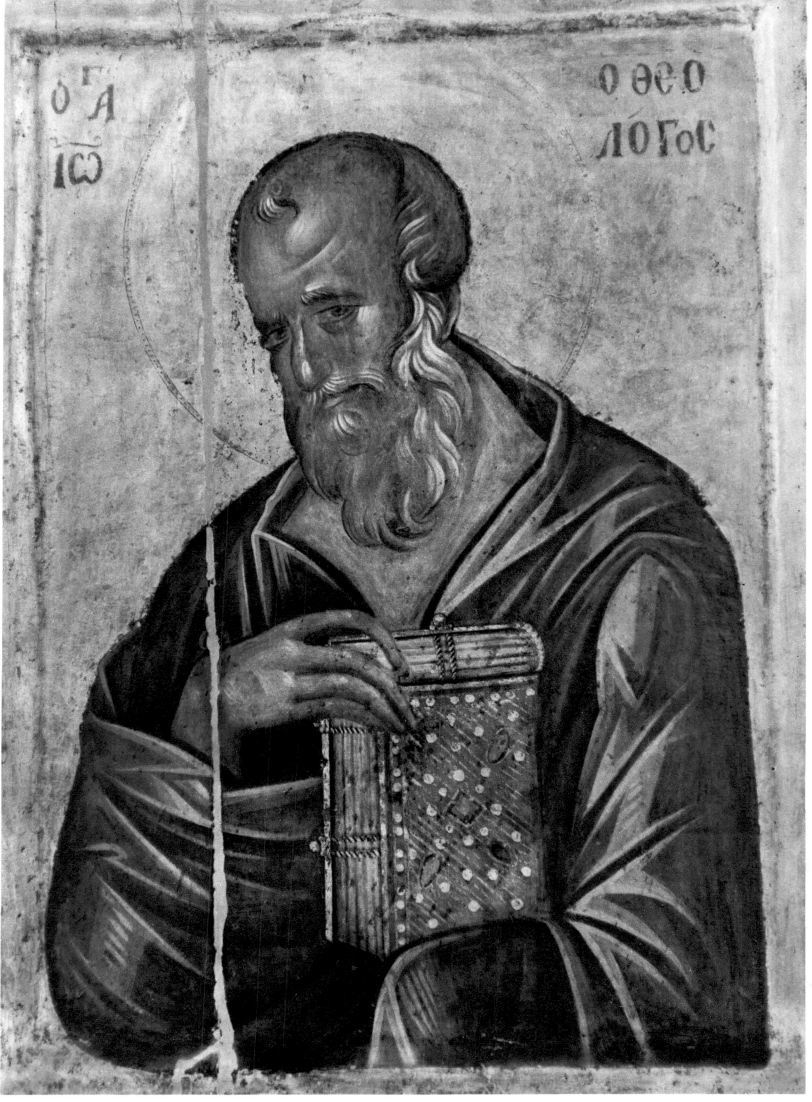

Ο ΑΓ ΙΩ Ο ΘΕΟ ΛΟΓΟС

197

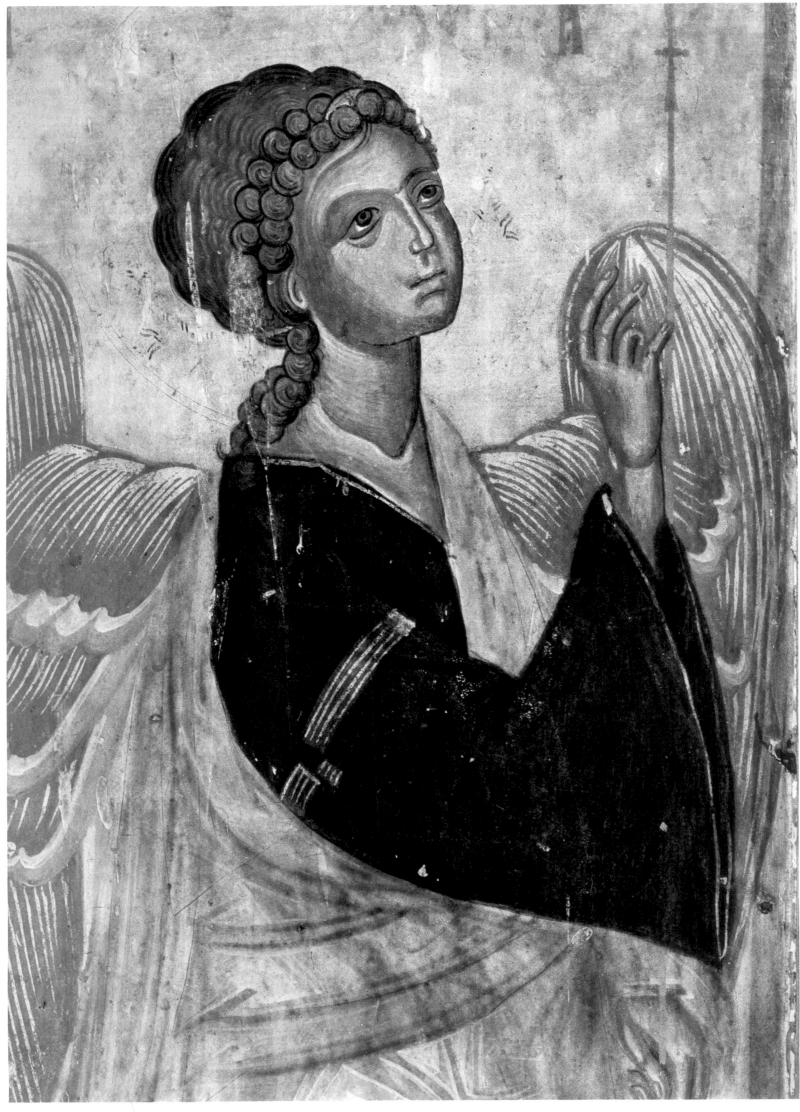

198

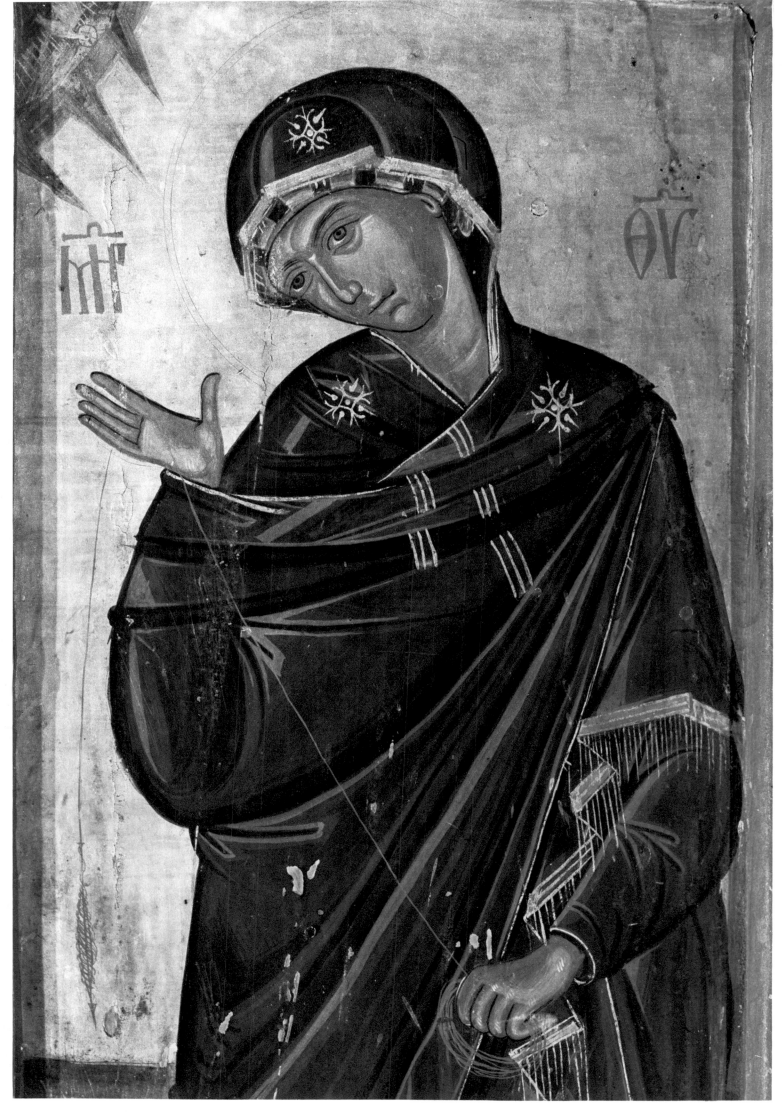

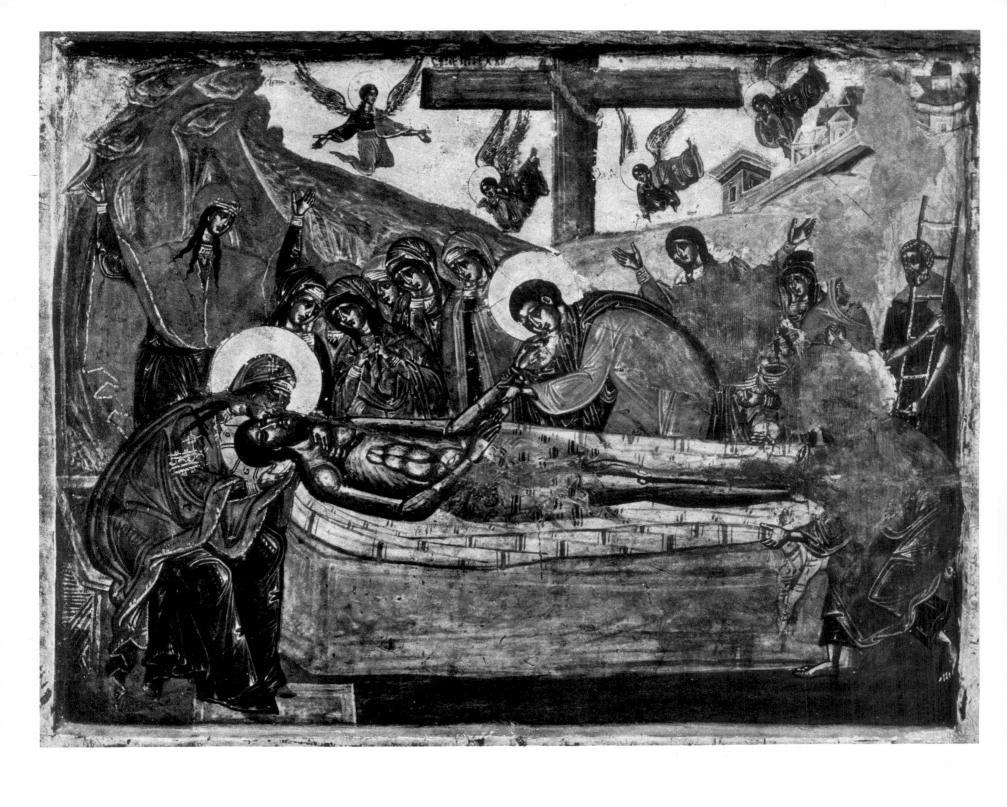

204

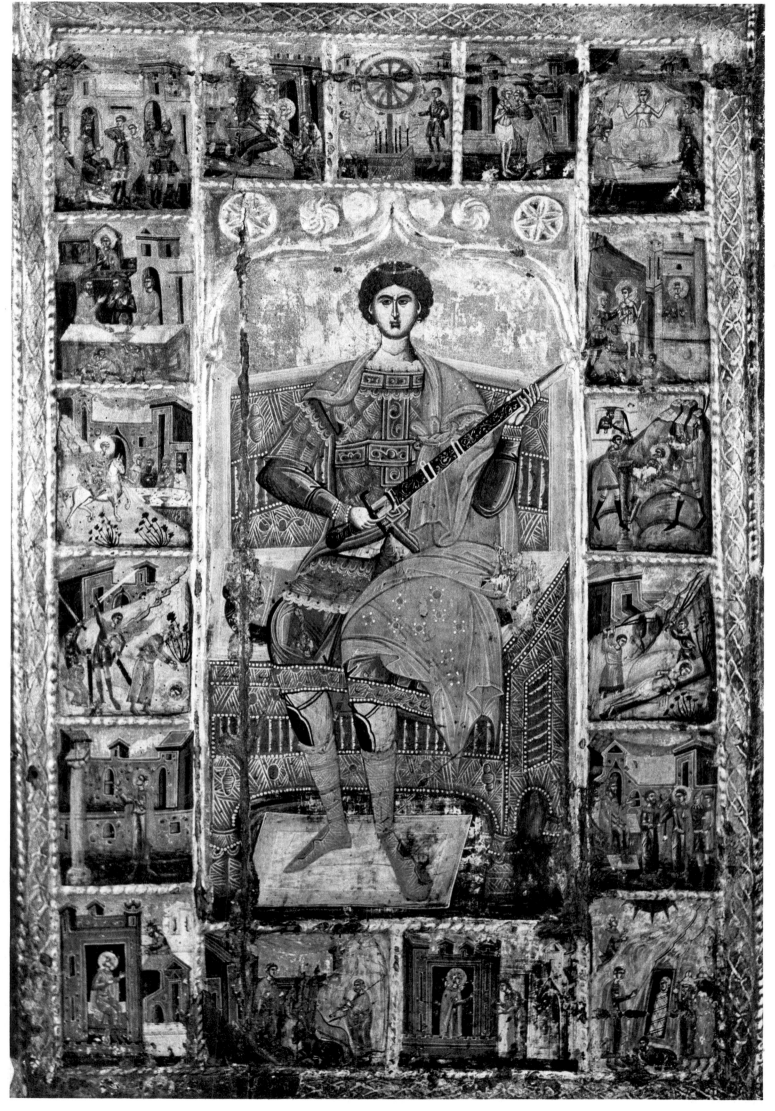

205

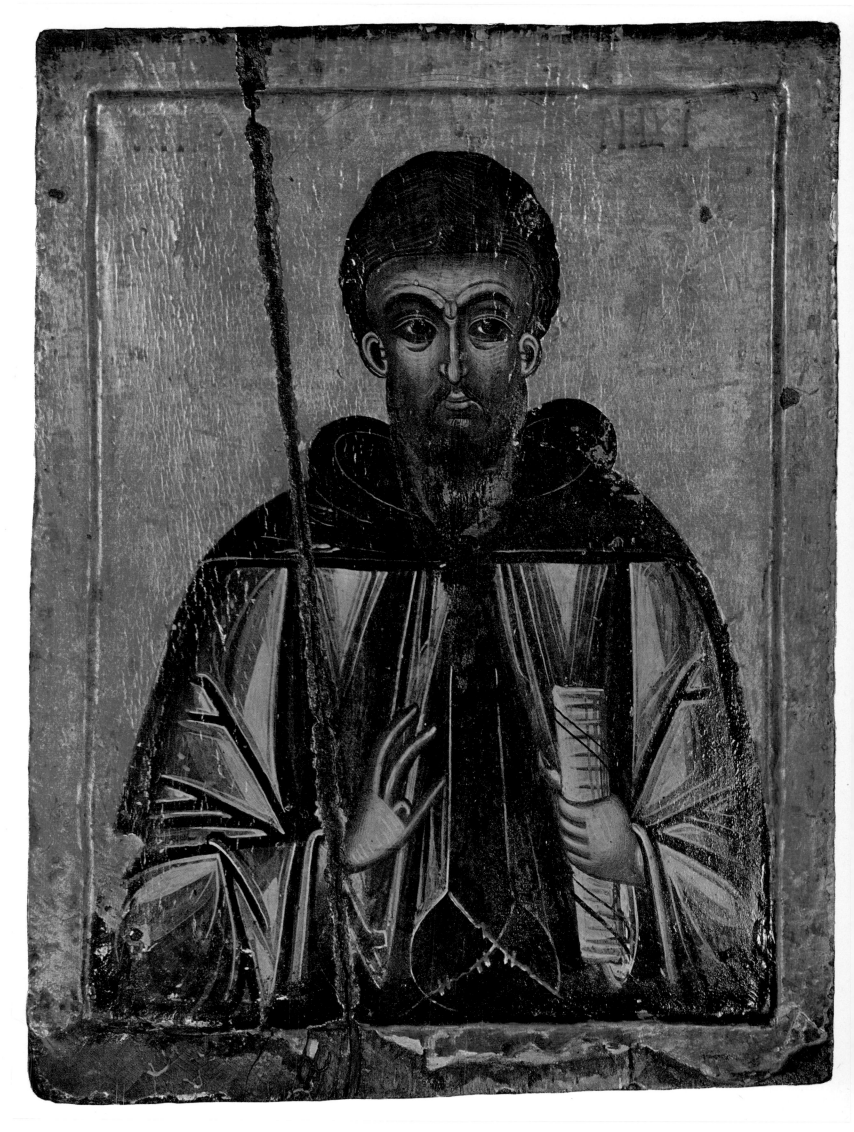

207

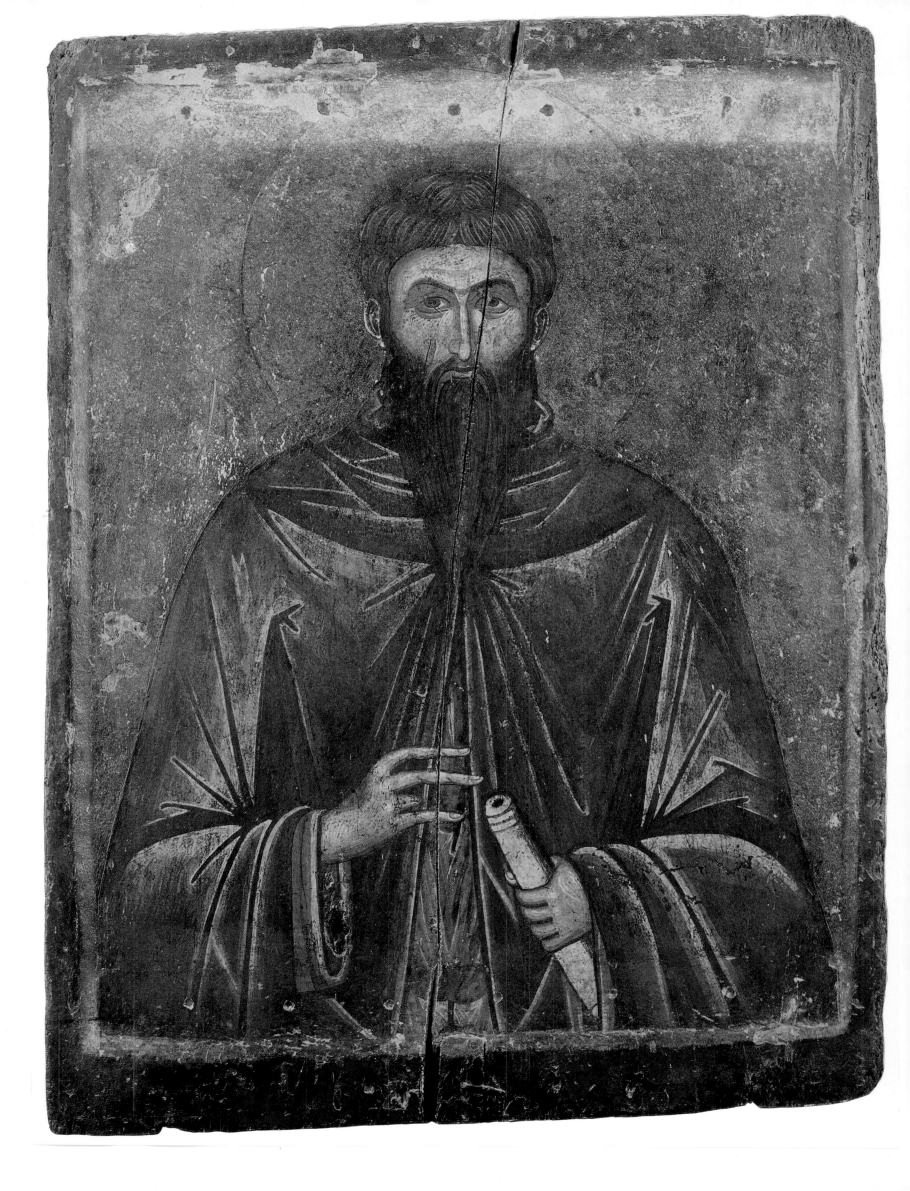

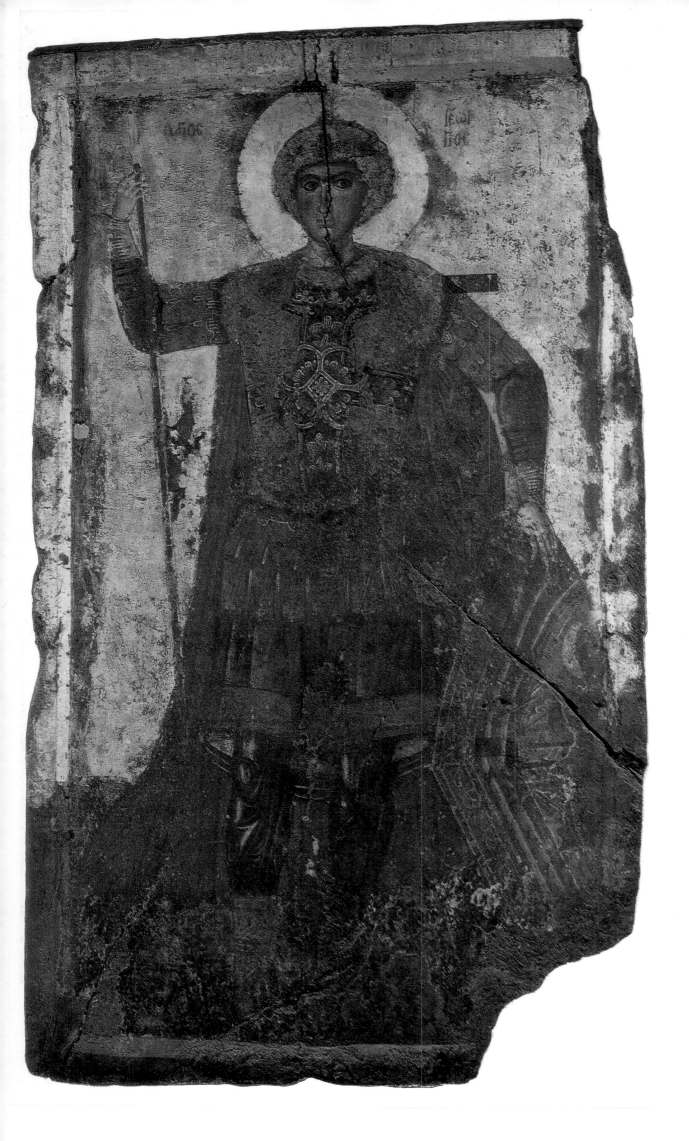

ΑΓΙΟC [ΓΕΩ]
 [Ρ]ΓΙΟC

212

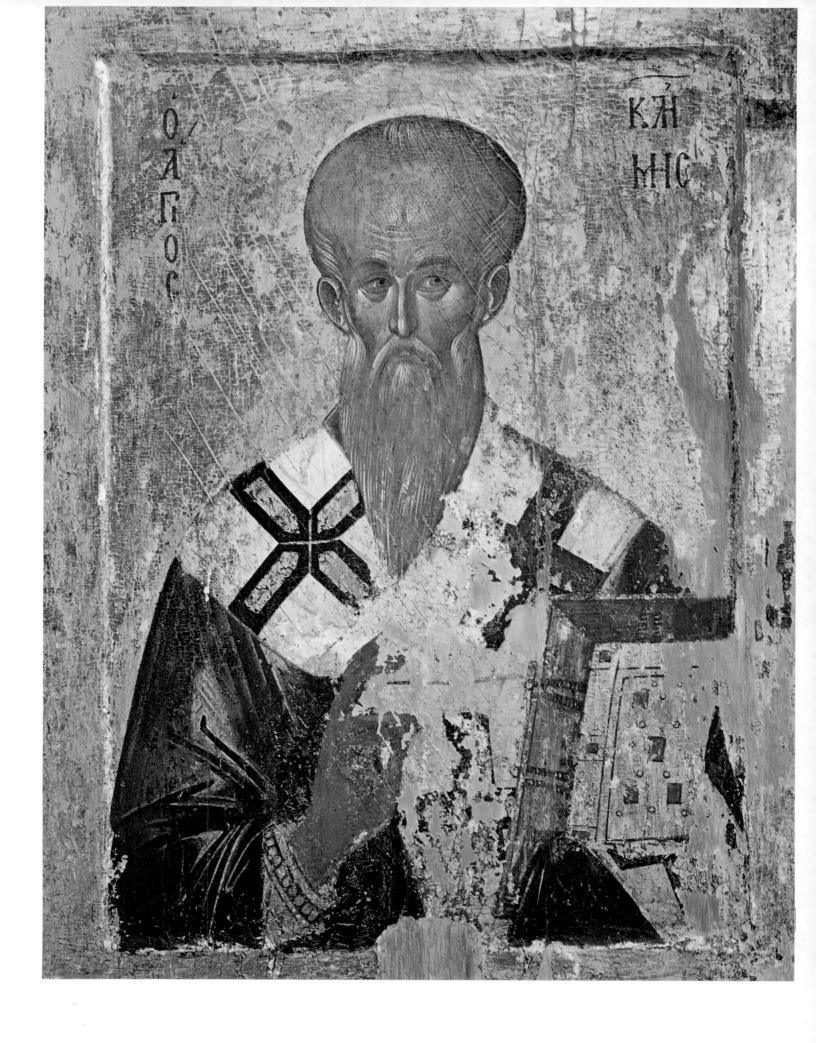

213

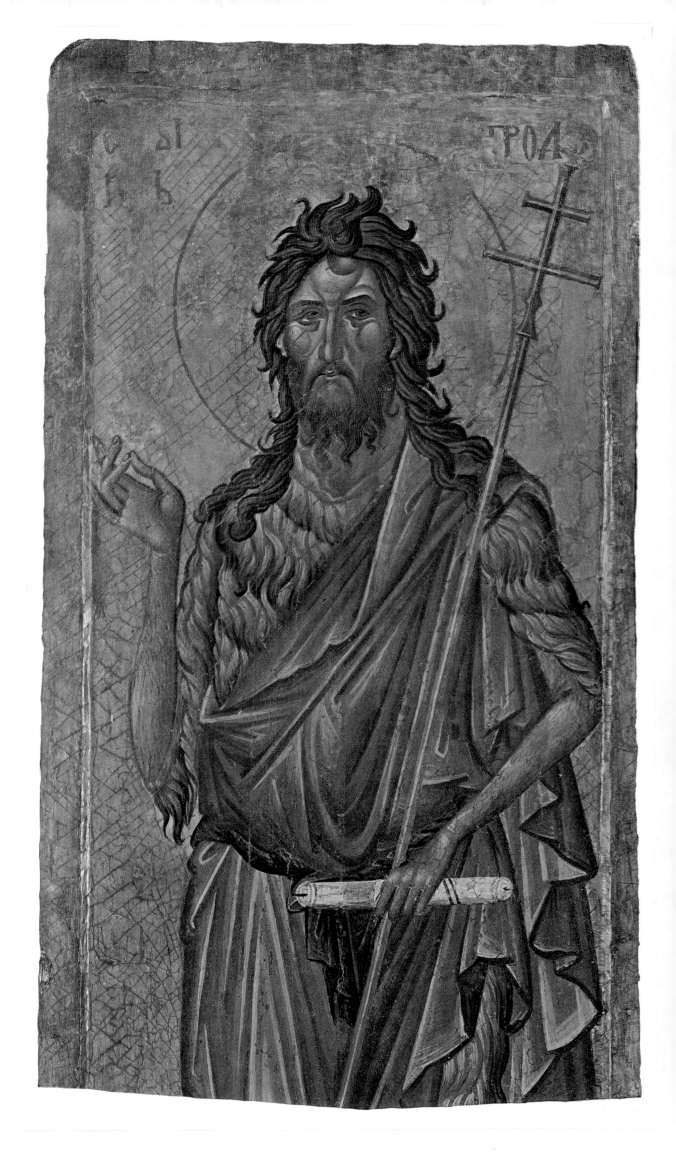

Annunciation on center door of an iconostasis (see plate 198). Dimensions of entire icon, 46 1/8 x 22". Church of Saint Tryphon, Monastery of Chilandar, Mount Athos.

200 LAMENTATION OVER THE DEAD CHRIST. 17th century. Double-faced icon. 16 3/4 x 21 5/8". Treasure of the Patriarchate, Pec.

201 SAINT JOHN THE BAPTIST. 1644. 24 7/8 x 16 3/4". Museum of the Serbian Orthodox Church, Belgrade.

203 CONSECRATION OF SAINT SAVA. 1645. Painted by Cosmas. Detail from an icon of Saints Simeon Nemanja and Sava, with scenes from their lives. Monastery of Moraca.

204,205 SAINT GEORGE WITH SCENES FROM HIS LIFE. 17th century. 47 1/4 x 31 7/8". Treasure of the Patriarchate, Pec.

206 THE SERBIAN PATRIARCH PAJSIJE. 1663. Painted by John of Chilandar. 13 3/8 x 9 1/2". National Museum, Ravenna.

207 SAINT NAHUM OF OHRID. 17th century. 19 5/8 x 15". Gallery of Art, Skopje.

209 CHRIST THE REDEEMER. 16th century. 28 3/4 x 16 1/8". Gallery of Art, Skopje.

211 SAINT NAHUM OF OHRID. Second half of 14th century. 36 x 27 3/4". National Museum, Ohrid.

212 SAINT GEORGE. 1266-1277. 57 1/8 x 33 7/8". Church of Saint George, Struga.

213 SAINT CLEMENT OF OHRID. End of 14th or beginning of 15th century. Double-faced icon. 33 7/8 x 25 5/8". National Museum, Ohrid.

215 SAINT JOHN THE BAPTIST. c. 1350. Detail. From the same iconostasis as plate 187. 64 3/4 x 22". Monastery of Decani.

16, 18, 19

VIRGIN ENTHRONED BETWEEN SAINT NICHOLAS AND SAINT GEORGE. 6th century. Encaustic. 27 x 18 7/8". Monastery of Saint Catherine, Sinai.

The Virgin sits on a jewel-studded throne of simple form; she is wearing a purple garment and red shoes, both of which were the prerogative of the Byzantine Empress. In her lap sits the Christ Child, who is blessing and holding a scroll, the symbol of wisdom. His brown garment is so heavily highlighted with gold that it appears to be entirely that color; gold is above purple in the Byzantine hierarchy of colors, and at the same time it has the effect of abstraction. The two soldier-saints, in the dress of high officials of the Imperial household, wear luxurious, richly patterned mantles (chlamys) with a purple rectangular inset, the tablion. In the second plane of the picture, two angels gaze up at the hand of God. They are crammed rather tightly into a high niche with a golden cornice that leaves little space for the sky behind, painted in two shades of blue. The painterly tradition of classical antiquity is evident in almost every detail, above all in the shadows cast by the soldier-saints and in the transparency of the angels' nimbi. The combination of stylistic elements from the classical tradition with iconographical elements from imperial Byzantium is typical of the art of Constantinople.

21, 26

THE THREE HEBREWS IN THE FIERY FURNACE. c. 7th century. Encaustic. 13 1/4 x 19 1/2". Monastery of Saint Catherine, Sinai.

Lined up in a row in frontal position are the three youths. The two at left and center are identified in inscriptions as Ananias and Azarias, but the name of Misael, on the right, is no longer legible. Dressed in the traditional Persian Costumes with long trousers, and cloaks (lacerna) clasped across the chest by a large brooch, they stand in hieratic position with their hands raised in prayer, in the midst of a sea of flames. There is no indication of a furnace, and one almost has the impression, unintended of course, that the comforting angel also stands in the flames. A small strip at the top with the upper parts of the nimbi has been lost, but the old frame survives (not fully illustrated here); on it is written in capital letters an excerpt from the third chapter of Daniel. The Canticle of the Three Hebrews has become one of the odes incorporated into the Psalter, lending the image a liturgical significance. In the early Christian period, particularly in the art of the catacombs, this scene was immensely popular. Its basic meaning was interpreted as the deliverance of the soul, with none of the liturgical overtones it later acquired in icons.

25

VIRGIN AND TWO SCENES FROM THE LIFE OF SAINT NICHOLAS. c. 11th century. Fragment of a wing of a triptych. 8 5/8 x 4 3/4". Monastery of Saint Catherine, Sinai.

The enthroned Virgin, busily spinning the purple thread from which the curtain of the Temple is to be woven, turns her head to the side in awareness of the approaching Angel of the Annunciation, which was depicted on a corresponding panel that is now lost. The two panels once formed the wings of a triptych of which only this right wing survives. Unfortunately it has been sawed horizontally into two parts. The upper part shows the ordinations of Saint Nicholas, first as priest and then as bishop. In the somewhat standardized narrative cycle of his life that is usually placed on icon frames, the two ordination scenes are generally preceded by representations of his birth and education; these must certainly have been depicted on the lost left wing, below the angel. There can be scarcely any doubt that the lost central panel was filled by a bust of Saint Nicholas. In the lower parts of the triptych, extending across the central panel and the wings, the narrative cycle continued with sixteen more scenes. Four of these have been preserved that make up the lower half of the right wing, ending, as might be expected, with the burial of this most popular of all Eastern saints.

31

THE APOSTLE THADDEUS. 10th century. Wing of a triptych. Height of the whole wing, 11" (this figure occupies little more than half); width 3 3/4". Monastery of Saint Catherine, Sinai.

Thaddeus, the apostle of the Edessenes, occupies the upper part of the left wing of a triptych; in the upper part of the right wing is depicted Abgarus, king of Edessa, to whom was brought the mandilion, the cloth with the imprint of Christ's face. This image of Christ "not made by human hands" was one of the most venerated relics. In the middle of the tenth century it was bought for a high price from the Emir of Edessa, at the instigation of the Byzantine emperor Constantine VII Porphyrogenitus, and brought in a triumphal procession to the capital. The Emperor, here portrayed in the person of Abgarus, is supposed to have written an encomium recounting the story of the relic. The great popularity of the cloth in the tenth century was certainly responsible for this icon whose central panel, now lost, presumably contained a large image of the mandilion. In the lower sections of the two wings are the monastic saints Paul of Thebes, Anthony, Basil, and Ephraim the Syrian; this suggests that the triptych was probably made for a monastery. Restored by Carroll Walles in 1960.

33

SAINT PETER. 7th century. Encaustic. 36 1/2 x 21". Monastery of Saint Catherine, Sinai.
Compared with other early Christian representations of the apostle Peter, he is depicted at half-length in this icon as an intellectual prince of the Church. In his left hand he holds a cross-staff, in his right the number three keys — whether the number has here a symbolic, trinitarian meaning is not certain. Like the Virgin in plate 16, he is placed in a niche that in this case terminates in a more elaborate cornice, thereby emphasizing the decorative character of this architectural detail. Of the three medallion heads above the niche, the center one represents Christ and the one at the right the Virgin, but the identification of the third is not certain. Some believe him to be Moses, who is often depicted as a youth in Byzantine art. In our opinion, he more probably represents John the Evangelist, but this must remain an open question. Restored by T. Margaritoff, 1962.

34, 35

CRUCIFIXION. 8th century. 18 1/4 x 10". Monastery of Saint Catherine, Sinai.
The crucified Christ stands erect on a suppedaneum, His arms stretched out horizontally. The long purplish brown garment, the colobium, leaves a small strip free over the breast to show the wound from which issues a double stream of blood and water. Christ was originally flanked by two thieves, but the one at the right is lost except for the inscription identifying him as Demas. Gestas, at the left, is depicted with his arms pulled back over the crossbar and fettered behind his back. The Virgin holds her handkerchief, the mandilion, close to her face but otherwise betrays little emotion. The figure of John is partially destroyed. His left hand is hidden under his mantle, while his right is held in the sling of the mantle, in classical fashion. At the foot of the Cross three crouching soldiers cast dice, and above the Cross two pairs of mourning angels, seen only as busts, pay reverence to the crucified Christ (the angel at the far right has been lost). The human figures are of different heights, corresponding to the hierarchical order in the old Eastern tradition. The cuboid rocks of the background symbolize the rugged desolate wastes of Golgotha but do not convey any spatial depth.

37

SAINTS ZOSIMUS AND NICHOLAS. 10th century. 8 1/8 x 5 1/2". Monastery of Saint Catherine, Sinai.
Two immobile saints stand next to each other, facing the spectator but not looking at him. Their gaze is directed toward the right, thus creating an effect of remoteness. One has the impression that the figures were taken from one of the long rows of saints which cover the walls of churches, or make up the calendar icons in which each day of the year is represented by a saint in this same hieratic pose. To the left is Zosimus, a Palestinian monk of the fifth century, known as the author of the Life of Saint Mary of Egypt, the famous penitent. He wears the usual garb of an Orthodox monk, including the wide embroidered stole, the so-called megaloschema, the attribute of a full monk. To the right stands Saint Nicholas, the Bishop of Myra, perhaps the most popular saint of the Orthodox Church. In his left hand, which is concealed under the chasuble, he holds a Gospel richly decorated with jewels and pearls. His face is deeply serious and ascetic but is not yet as rigorously stylized as his images became after the eleventh and twelfth centuries. The names of the saints are inscribed in beautiful, rounded uncial letters typical of the tenth century.

38, 39

THE APOSTLE PHILIP. 10th-11th centuries. 12 7/8 x 8". Monastery of Saint Catherine, Sinai.
The youthful apostle faces us in a frontal position like that of Saints Zosimus and Nicholas (see plate 37) but possesses a greater degree of physical reality. In his clinging garment are traced out the lines of his body, and a clear distinction is made between his weight-bearing leg and his free-standing leg. Between these two icons, one from the early tenth century, the other from the late tenth or early eleventh, the renaissance movement had taken place which consciously attempted to recapture a greater feeling of corporeality by the study of available classical models. In the upper right corner, in a segment of sky, there is a small bust of Christ turning with a gesture of blessing toward the apostle, who seems unaware of the divine apparition. It required a further step in the development of Byzantine art before saints were depicted as being aware of the Divine Presence and as turning in its direction (compare the Saint Euthymius in plate 46).

40

SAINT NICHOLAS. 10th-11th centuries. 16 7/8 x 13". Monastery of Saint Catherine, Sinai.
Compared with the head of the standing Saint Nicholas (at the right in plate 37), this example in bust length is modeled with greater subtlety; this can be explained by its larger dimensions, but it shares with the former a painterly quality and the use of natural facial proportions. Saint Nicholas is not blessing, but simply holds his right hand before his breast. One has the impression of physical reality and human sentiment in this rather unconventional head, which is set against a nimbus that is tooled to give the effect of rotating. The small busts in the raised frame conform somewhat more to standard types and are set within medallions worked in the same way as the nimbus of Saint Nicholas. They represent holy personages grouped according to their hierarchical order: Christ in the center at the top is flanked by Peter and Paul; on the lateral frames are the four most popular soldier-saints, Demetrius and Theodore on the left and George and Procopius on the right; at the bottom are the best-known physician-saints, Panteleimon in the center and Cosmas and Damian on either side.

41

THE LADDER TO HEAVEN OF JOHN CLIMACUS. 11th-12th centuries. 16 1/8 x 11 1/2". Monastery of Saint Catherine, Sinai.
A very rare subject for icons, the Ladder to Heaven no doubt had its origin in a title miniature of the treatise written by John Climacus, abbot of Sinai, probably toward the end of the sixth century. The treatise served as a guide to the achieving of those monastic virtues which would open the gates of heaven to aspiring monks. In earlier manuscripts the ladder is only a schematic drawing accompanying the table of contents, with

each chapter heading corresponding to a rung; but in eleventh-century manuscripts the ladder became peopled with monks clambering up it. A manuscript in the Vatican Library contains a composition painstakingly worked out with many features in common with our icon, such as the devils who pull down the monks. Our icon must have been made not long after this archetype had been devised for manuscript illumination. The composition was undoubtedly inspired by some representation of Jacob's ladder to which, in fact, the text of John Climacus alludes.

43

CRUCIFIXION. 11th-12th centuries. 11 1/8 x 8 1/2". Monastery of Saint Catherine, Sinai.
Compared with the more narrative Crucifixion scenes of pre-Iconoclastic icons (see plates 34, 35), the Middle Byzantine period concentrated on a simplified harmonious composition with only the Virgin and John the Evangelist as witnesses to the death on the Cross. The focus is on those aspects of the event that have greatest significance to dogma and liturgy; as a result, this new, more essential image became one of the most effective of those done for the cycle of the great feasts. The liturgical aspect is also responsible for the hierarchical order of the saints in the medallions on the frame. The place of honor at the top is given to John the Baptist, flanked by Michael and Gabriel in Imperial costumes becoming archangels. Two apostles, Peter and Paul, stand for the entire twelve, followed by two pairs of Church Fathers, John Chrysostom and Gregory of Nazianzus on the right, Basil and Nicholas on the left, and by two pairs of soldier-saints, Theodore and Procupius on the right, George and Demetrius on the left. At the lower corners of the frame are two stylites, both named Simeon: the one to the right, inscribed "in the Mandra," is the famous fifth century stylite who lived in a lavra of that name before choosing the column as his permanent abode; the one to the left, inscribed "the miracle worker," is the younger Simeon, who lived a century later. Between them are a third monk, Barlaam, and two female martyrs, Saint Catherine and Saint Christina; both the latter were of noble birth and are dressed, therefore, like Byzantine empresses.

44, 45

NATIVITY AND INFANCY OF CHRIST. 11th century. 14 1/4 x 8 3/8". Monastery of Saint Catherine, Sinai.
The Nativity, more than any other of the images for the great feasts, continued to stress its narrative elements. It was generally customary to set the main event, the birth, in a cave and to flank it on the right by the Annunciation to the Shepherds and on the left by the Adoration of the Magi. In our icon, however, in addition to these principal scenes two choirs of angels led by archangels have been added at the top, enhancing the ceremonial and liturgical character of the work. In the lower part are the Flight into Egypt and the Massacre of the Innocents, episodes related to the readings from the lectionary for the 26th and 29th of December. For illustrations of the infancy of Jesus, elements were taken quite early from such apocryphal texts as the Gospels of Saint James and of the Pseudo-Matthew. In our icon, this influence can be seen in several details: the cave where the Nativity takes place; the insertion in the Flight into Egypt of a son of Joseph's from a previous marriage; and the introduction of an entire scene with the flight of Elizabeth and the young John into another cave.

46

SAINT EUTHYMIUS. 12th century. 24 3/4 x 16 1/8". Monastery of Saint Catherine, Sinai.

Unlike the strictly frontal pose of Philip (see plates 38, 39), Saint Euthymius is here turning to gaze at the heavenly apparition of the Virgin, who is depicted in half-length, holding the Christ Child. Although there is no chapel dedicated to Saint Euthymius in Saint Catherine's Monastery, there are many icons in Sinai of this greatly venerated monk; their presence there is not surprising, for in his early days Euthymius had been a hermit in a lavra near Pharan, once a famous bishopric in the heart of the Sinai peninsula. Euthymius can thus be considered a Sinaitic monk. Furthermore, he was an ardent defender of the dogma of the two natures of Christ, as formulated at the Council of Chalcedonia in 451, and he also had great influence over the Empress Eudocia, who had strong leanings toward the Monophysite heresy. More than anything else, his defense of that dogma must have made Euthymius popular in Saint Chalcedon in 451, and he also had great influence over the for centuries despite being surrounded by adherents of Monophysitism.

47

DESCENT INTO LIMBO. End of 12th century. On the same iconostasis beam as plates 56 and 57. 15 1/4 x 21 1/2" (panel includes two scenes). Monastery of Saint Catherine, Sinai.
The four scenes of the great feasts after the Presentation in the Temple — Baptism, Transfiguration, Raising of Lazarus, and Entry into Jerusalem — have been lost. Surviving is the following panel with the Crucifixion and the Descent into Limbo that symbolizes Easter in the Orthodox Church. For the greatest of all feasts, the chosen subject was not canonical but was based on the apocryphal Gospel of Nicodemus. The choice was made for dogmatic reasons, since the text states explicitly that Christ descended into hell "in the flesh," implying that He retained His human form even after the Crucifixion, a dogma formulated by the Council of Chalcedon in 451. This explains why the stigmata on Christ's feet are so evident. Striding over the shattered gates of hell, Christ draws Adam out of a marble sarcophagus while Eve, behind him, awaits her turn. On the right are two kings, the youthful Solomon and the bearded David, and behind them John the Baptist, who prophesied Christ's descent into hell.

49, 50, 51

RAISING OF LAZARUS. 12th century. Scene from an iconostasis beam. Width of panel containing three scenes, 16 1/8 x 44 1/2". Monastery of Saint Catherine, Sinai.
The entire iconostasis beam consists of four panels, each containing three scenes from the canonical cycle of the twelve great feasts. The third and fourth panels are now hung on the wall of a side chapel in the basilica. A place has been found for the first and second panels on the iconostasis of the tiny Chapel of Saint George, on one of the fortification towers. Unfortunately those two latter panels have since been heavily overpainted; the first, with the Annunciation, Nativity, and Presentation in the Temple is still disfigured, but the second, with the Baptism, Transfiguration, and Raising of Lazarus, was cleaned some time ago, though not thoroughly enough. As a result the colonnade, with an enamel-like pattern filling the arches, has emerged from under the later repainting. To avoid overcrowding the composition and to focus attention on the individual figures, only two disciples accompany Christ; one is clearly characterized as Peter. Christ takes no notice of Lazarus' sisters, one of whom is depicted in the typical position of proskynesis. A servant who carries away the door of the tomb and the man who loosens the dead man's mummy wrappings each hold one hand, covered by an overlong sleeve, against their faces. In early Christian art this gesture meant the holding of the nose against the stench of a corpse (as in John 11:39), but the twelfth century Byzantine painter of this icon

toned down this very realistic gesture.

52, 53

TRANSFIGURATION. 12th century. On the same iconostasis beam as plates 49-51. Monastery of Saint Catherine, Sinai.

The Transfiguration preceded the Raising of Lazarus on the iconostasis beam. In white raiment, Christ stands at the summit of Mount Tabor between the prophets Moses and Elijah. As was frequently the case in Byzantine art, Moses is depicted as youthful and beardless. Elijah wears a fur-trimmed mantle. All three are enveloped by the light shining on the mountain, an aureole made up of three concentric ovals constituting a symbol of the Trinity. Below at the right, Peter is seen kneeling and apparently struggling to rise, while, at the left, James turns away from the vision, unable to bear the glaring light. John still sprawls on the ground — "Peter and they that were with him were heavy with sleep" (Luke 9:32) — and turns only his head toward Christ; like his companions, he seems so overwhelmed by the light that he is unable to rise from his cowering position.

54

ANNUNCIATION. End of 12th century. 22 1/2 x 16 1/2". Monastery of Saint Catherine, Sinai.

When Cretan artists in the early seventeenth century carved a new iconostasis and painted icons for it, they did not prepare enough icons for the upper zone. To fill the available frames, they selected a few earlier icons from the monastery's rich collection, in particular this Annunciation from the late twelfth century. The somewhat mannered pose of the approaching angel strikes one immediately. The freely twisted movement of the body creates an impression of realism but this is in no way the result of observation of nature. Rather it is a skillfully applied formula harking back to an ancient classical model. This was the formula for a dancing maenad and seems to be the ultimate source for the angel, although the various stages of copying through which the type may have passed have perhaps transformed its original meaning. In any event, this Angel of the Annunciation demonstrates that classical art, even in periods having no special renaissance movement, never lost its power to inspire individual Byzantine artists.

55

VIRGIN IN PRAYER. c. 1200. 29 5/8 x 20 1/8". Monastery of Saint Catherine, Sinai.

This icon of the Virgin in half-length has shared the fate of the majority of paintings on wood: as the result of warping, the panel has split vertically. There is usually one big crack down the center but in this case two cracks are sufficiently far apart to leave the face intact. Like most of the Sinai icons, this one is covered by a thick coat of discoloring varnish; it has been possible to remove this from only a few of the icons. But one can still recognize the highly effective shadowing of the eyes in a dark green color which creates an effect of remoteness from reality obviously intended to emphasize the divine nature of the Virgin. Dark green was used for this purpose as early as the sixth century (see plates 16, 18, 19) and, indeed, for the Virgin exclusively; but later, especially in thirteenth century Italy, it began to be employed indiscriminately for all human faces. The nimbus, as so often seen in icons of the twelfth and thirteenth centuries, was roughened with a tool; the original effect of rotation must have given a strong impression of a disc of light, an impression which can still be sensed here in spite of the varnish obscuring it.

56

ASCENSION OF CHRIST. End of 12th or beginning of 13th century. On the same iconostasis beam as plates 47 and 57. 15

x 10 1/4". Monastery of Saint Catherine, Sinai.

Most of the pictures for the great feasts contain elements that have no basis in the canonical Biblical texts but were added later for dogmatic reasons. In this Ascension, which is on the same beam with the following plate, we see the Virgin in the center with the apostles on either side. Although her presence is not mentioned in Acts 1:6-12, she had already been introduced into the scene in early Christian art. She takes no part in the event and does not look up at the ascending Christ, but stands immobile, facing the viewer. She is present as a witness to the Incarnation of Christ, who had become man through her. The artist succeeded well in contrasting her immobility with the exaggerated movements of the apostles, who crane their necks to see and mill about agitatedly. The technique of tooling nimbi is extended here to the mandorla behind Christ, which is not the usual oval but a large rotating disk intersected by the rotating nimbi of Christ and the two angels.

57

DORMITION OF THE VIRGIN. End of 12th or beginning of 13th century. On the same iconostasis beam as plates 56 and 47. 15 1/8 x 10 1/8". Monastery of Saint Catherine, Sinai.

The death of the Virgin, another scene from the same beam, shows her lying on a bier as if asleep while Christ holds her soul in the form of an infant wrapped in swaddling clothes. In more elaborate representations of this subject, angels swoop down to take the soul and bear it aloft into heaven. According to the apocryphal text of the Dormition of the Virgin, all twelve apostles were miraculously brought to her deathbed by angels. Here, four apostles are individualized: Peter stands at the head of the bier and Paul at the foot, while John, the best beloved, bends down over the couch and Andrew, with his unkempt hair, is recognizable behind Paul. There are also fourteen mourners present, and one of the two supernumeraries, the figure who rises at the head of the bier, is characterized by his pallium as a bishop. Correspondingly, the tallest bearded man in the group on the right can also be presumed to be a bishop, since there was an old tradition that three bishops joined the twelve apostles as mourners: Dionysius the Areopagite, Timotheus, and Hierotheus; only two of them are represented here.

59

VIRGIN AND CHILD. c. 1200. Mosaic. 17 1/2 x 13". Monastery of Saint Catherine, Sinai.

This special type of the Virgin can be traced back to one of the most famous icons of Constantinople, the so-called Odegitria Virgin, named after the Monastery of Odegon, where it had long been enshrined. According to tradition, it had been painted by Saint Luke himself and in the fifth century was sent to the capital from Jerusalem by Empress Eudocia, the wife of Theodosius II. The innumerable copies of that popular and deeply revered icon vary considerably. In some the Virgin is depicted at full-length, which may have been the original form; in others, as in the icon here, she is shown as a half-figure. She usually holds the Christ Child on her left arm with her right arm before her breast; the reversal of these positions in our example must be considered a variant. Nevertheless, in spite of these deviations, Orthodox worshipers would immediately recognize the Sinai icon as a copy of the Odegitria icon that played such a great role as the protective image of Constantinople in the various phases of the city's history.

65

RAISING OF LAZARUS. 12th-13th centuries. 8 1/2 x 9 1/2". Private collection, Athens.

Christ dominates the other figures by His larger scale. In His left hand He holds a rolled-up scroll; with His right He reaches out to Lazarus standing in the entrance to the tomb. At Lazarus' side a man holds the end of one of the winding bands and puts his covered right hand near to his face to shield his nose against the odor of corruption. The heads of three other figures are behind him. The two sisters of Lazarus crouch at Christ's feet. On the left there are two men, presumably the apostles Andrew and Peter. Restored by P. Zachariou in 1958.

67
SAINT JAMES. 13th century. 35 7/8 x 25 5/8". Monastery of Saint John the Evangelist, Patmos.
The half-length saint is shown in full face, holding a scroll. In the upper right corner is Christ, also half-length but very much smaller, holding a chalice as the symbol of His consecration of the future first archbishop of Jerusalem. Restored by P. Zachariou in 1963.

70
SAINT GEORGE. 13th century. Double-faced icon in painted relief. 42 7/8 x 28 3/8". Byzantine Museum, Athens.
On one face of this icon are two female saints, Marina and, probably, Irene; they look up in prayer to Christ, who is shown as a miniature bust in the upper part of the icon, in frontal position and blessing with both His hands. On the other face of the icon is this full-length figure of Saint George dressed as a warrior and in an attitude of prayer. In the upper right-hand corner a tiny half-length figure of Christ leans forward to bless the saint. In the lower left corner, an equally tiny figure of a female donor kneels in prayer. The margins of the icon are taken up on both sides with twelve small scenes of the saint's life and martyrdom, and, at the center top, there are two angels with scepters, who hold a square of cloth between them. Saint George, his shield, and his halo are in relief; also in relief are the frame surrounding the entire icon, and the small arc of a circle which separates the figure of Christ from the rest of the picture. There are traces of an inscription on either side of the saint. Restored by T. Margaritof in 1961.

76
VIRGIN AND CHILD. 14th century. 32 5/8 x 22 7/8". Collection of the Refugees from Asia Minor, Byzantine Museum, Athens.
The Virgin is presented frontally in half-length holding the Child on her left arm, as is characteristic of the Odegitria type. The icon was originally rectangular, but it was later cut down to fit a new frame. Restored by S. Baltoyannis in 1964.

77
VIRGIN "EPISKEPSIS." 14th century. Mosaic. 37 3/8 x 24 3/8". Collection of the Refugees from Asia Minor, Byzantine Museum, Athens.
The Virgin holds the Child on her right arm, in the type known as Glykophilousa (the Virgin of the Sweet Embrace). The flesh is made of white and rose mosaic cubes, the outlines of red, and the shadows of green cubes. The garments of both figures are streaked in gold; the Virgin's veil (the maphorion) is dark blue, the Child's tunic green, and His overmantle (the himation) brownish-green. Above on the right, there is the inscription in red mosaic: Mother of God, The Protectress. Restored by P. Zachariou in 1959.

79
CRUCIFIXION. 14th century. Double-faced icon 40 1/2 x 33 1/8". Byzantine Museum, Athens.
The crucified Christ forms the axis of the composition. His body, naked except for a loincloth, curves slightly and His head sinks down over His shoulder. On the Cross there is an inscription: The Crucified. To the right and left above the Cross are small busts of angels. The Virgin and Saint John stand on either side of the Cross with their hands to their faces in gestures of grief. Both faces have been badly damaged. A conventionalized representation of Jerusalem stretches like a narrow band across the lower part of the icon. Restoration has disclosed a fine Odegitria Virgin on the reverse of the icon. Restored by T. Margaritoff in 1961.

81
VIRGIN ENTHRONED BETWEEN TWO ANGELS. End of 15th or beginning of 16th century. 34 1/4 x 25 5/8". Benaki Museum, Athens.
The Virgin is seated on a backless throne, flanked by two archangels in Imperial costume who lean slightly toward her. On the upper border are depicted an Annunciation, the Crucifixion, the Descent from the Cross, and the Resurrection. On the left border are busts of saints: John the Baptist, Peter, George and Catherine. The other side has John the Evangelist, Paul, Demetrius and Anthony. Below are four bishop saints: Gregory the Theologian, John Chrysostom, Basil, and Nicholas; on the other side are the saints Constantine and Helena. This perfectly executed icon is somewhat stylized in the Cretan manner, according to the trends of the second half of the fifteenth century. There were excellent artists of this school, such as Andrew Ritzos (1421-1497). The scenes which are featured represent the types of icons that were perpetuated during the sixteenth and seventeenth centuries in Crete and in Mount Athos, both in mural painting and in icons. It is due not only to the stylistic values but to some particular techniques of Ritzos that we date this work at the end of the 1500's.

85
VIRGIN AND CHILD. 14th century. 33 1/2 x 25 5/8". Byzantine Museum, Athens.
The Virgin is presented as a bust slightly turned to the left. She cradles the Child on her left arm and supports it with both hands. The Child leans back a little in a three-quarter pose. He blesses with His right hand and holds a scroll in the other. Restored by T. Margaritof in 1959.

87
VIRGIN "KARDIOTISSA." End of 16th or beginning of 17th century. Signed by Angelos. 47 5/8 x 38". Byzantine Museum, Athens.
This large and beautiful icon is a rather rare type whose model dates back to the thirteenth century or earlier. The Infant, who is seen from the back, extends His arms towards the Virgin, while turning His head around in order to see the two angels on either side of Her. On the base is written in large red letters the word Kardiotissa, the name of a miracle-performing icon which was located in a Cretan monastery until 1420, when it was stolen. It turned up in 1498 in the Church of Saint Alphonso in Rome. It is among the best of Cretan paintings from the sixteenth and seventeenth centuries, but we do not know to whom we should attribute the calm and majesty of this composition, the later artist or the painter of the prototype. The delicacy of the modeling, however, particularly the long fingers, the careful craftsmanship of the draperies, and finally, the elegance of the melancholy Virgin can be credited to Angelos.

89
SAINT PETER. 12th century. The Protaton, Mount Athos.
The apostle is depicted full-length, in a frontal position. The figure is tall and slender, but of considerable dignity. The head is rather small in relation to the body. Restored by P. Zachariou in 1958.

90

SAINT PANTELEIMON. 12th century. 15 1/8 x 10". Monastery of Lavra, Mount Athos.

The saint is presented as a bust and full face, holding a medical instrument in his hand. Restored by P. Zachariou in 1958.

91

CHRIST PANTOCRATOR. 12th century. Detail of an icon on the architrave of an iconostasis. Dimensions of entire panel, 27 1/8 x 83 7/8". Monastery of Vatopedi, Mount Athos.

Christ Pantocrator is enthroned in the center of the architrave. To either side of Him, under arcades in low relief, are pairs of full-length figures that together with Christ, make up a Great Deësis. These comprise the Virgin and an archangel, Saint John the Baptist with another archangel, and the four Evangelists. The remainder of the architrave is devoted to icons of the Raising of Lazarus, Entry into Jerusalem, Crucifixion, Descent from the Cross, Presentation of the Virgin in the Temple, and Betrothal of the Virgin.

92, 93

CRUCIFIXION. 13th century. Double-faced icon. 34 1/4 x 24 1/4". Byzantine Museum, Athens.

During a recent cleaning, this Crucifixion was discovered on the back of a sixteenth century icon of the Odegitria Virgin. The Crucifixion itself belongs to three different periods: to the first may be ascribed the Cross and the body of Christ, the archangels, and the small hand which can be discerned to the left of the figure of Saint John; to the second period belong the star-strewn yellow background and the inscriptions; to the third belong the head of Christ, and the figures of the Virgin and Saint John. In the original version, the head of Christ was less inclined and the eyes were open; the figures of the Virgin and Saint John were smaller than that of Christ and above the Virgin there was, apparently, an angel who held a vessel to catch the blood spurting from Christ's side. The representation of archangels with birds' claws is unique; and they usually gather up a fold of their garments rather than holding up a veil, as seen here. Mme. M. Sotiriou proposes that the earliest period of the painting dates from the eleventh century, but for our part we propose, instead, the ninth. Restored by T. Margaritof in 1959.

94

VIRGIN. 13th century. Detail of a Crucifixion, on a double-faced icon. Dimensions of entire icon, 38 1/4 x 31 7/8". Palace of the Archbishop, Nicosia, Cyprus.

The Crucifixion of which this is a detail is on the back of an icon of the Odegitria Virgin. To the left of the Crucifix stands the Virgin reproduced here, with two female figures behind her. To the right is Saint John, and a fragment survives of the figure of the centurion who stands behind him. Two angels are poised above the horizontal bar of the Cross. Restored by the Byzantine Museum in 1964.

95

SAINT NICHOLAS. Beginning of 14th century. Mosaic. 16 3/4 x 13 3/8". Monastery of Stavronikita, Mount Athos.

The saint in archbishop's vestments is presented as a bust in frontal position with his right hand raised in benediction. According to legend, this icon was fished out of the sea with a mussel stuck to the saint's brow, which is said to explain the break at that place and the epithet "Oysterman" applied to the icon. Restored by P. Zachariou.

96, 97

THE ARCHANGEL MICHAEL. 14th century. 43 1/4 x 32 1/8". Byzantine Museum, Athens.

This bust of the archangel includes his symbolic attributes: the messenger's staff, and the transparent orb surmounted by a cross. To either side of the head is the inscription: The Archangel Michael, the Great Leader of the Cellestial Cohorts.

99

CRUCIFIXION. 14th century. 13 1/4 x 10 1/2". Chapel of the Annunciation, Patmos.

The crucified Christ, with head sunk down, body bowed, and blood flowing from His wounds, occupies the upper part of the icon. Two angels, now almost indistinguishable, mourn His death. On the left, the Virgin reaches out her right hand toward her Son and presses her left against her cheek. In front of her, on a higher level, Saint John bends forward, his hand also against his cheek as a sign of grief, and clutching a fold of his mantle with his left hand. Behind the Virgin are four women. The centurion on the opposite side of the Cross, surrounded by a group of Jews, young and old, raises his right arm toward the Cross. At the foot of the Cross is the scene of the Division of the Garment. In the deepest plane of the picture rise the walls and towers of Jerusalem against a gold background. Gold highlights are used chiefly on the garments of the centurion and of the soldier below at the right. This type of depiction of the Crucifixion must have enjoyed wide popularity; we find it again on an icon from 1550, which is probably Cretan (according to N. Kondakov), as well as in a mural painting by Frangos Katelanos in 1548 in the Monastery of Barlaam at Meteora. Restored by P. Zachariou in 1960.

101

WARRIOR-SAINT. 13th-14th centuries. Detail. Dimensions of entire panel, 36 3/4 x 28 1/2". Palace of the Archbishop, Mytilene.

The saint, dressed in rich military costume, is presented as a bust-length figure. He carries a lance and a sword, and a shield hangs from his left shoulder. Abundant curly hair surrounds the delicate face, which has a slender nose and small mouth.

102

SAINT DEMETRIUS. 14th century. 34 5/8 x 20 1/2". Monastery of Vatopedi, Mount Athos.

The saint is shown as a frontal half-length figure holding a lance and shield.

103

SAINT GEORGE. 14th century. 28 1/2 x 18 7/8". Monastery of Lavra, Mount Athos.

The saint is in a bust-length, frontal pose, wearing a martyr's crown. Restored by P. Zachariou in 1958.

104

MATER DOLOROSA. End of 14th century. Wing of a diptych (see plate 105). 10 5/8 x 8 1/4". Monastery of the Transfiguration, Meteora.

On the left wing of this diptych, the Virgin is turned to the right, toward the dead Christ on the right wing. With her left hand, on which her chin rests, she holds the edge of her veil, while her right hand is stretched out in prayer. Restored by P. Zachariou in 1962.

105

THE CRUCIFIED CHRIST. End of 14th century. Wing of a diptych (see plate 104). 8 5/8 x 7 1/2". Monastery of the Transfiguration, Meteora.

The right wing of this diptych shows the dead Christ in bust-length, nude, with closed eyes and head sunk down as in depictions of the Pietà. His hair flows down loosely over His shoulders. Behind Him the horizontal bar of the Cross stands out against the gold background. Restored by P. Zachariou.

106
MIRACLE AT CHONAI. 14th century. 16 3/4 x 14 1/8". Greek Patriarchate, Jerusalem.
On the left side the Archangel Michael drives his lance into the ground, opening up a funnel to catch the waters of a river rushing down between two steep cliffs. The unbelievers above try to divert the stream with their picks in order to destroy the church and the monk Archippos, priest of the Church of Saint Michael at Chonai in Phrygia. On the right side the monk himself, in front of a high-domed cruciform church, falls to his knees in terror at the apparition and miraculous intervention of the archangel. Restored by S. Baltoyannis in 1964.

107
SAINT DEMETRIUS. 14th century. Mosaic. Dimensions with frame, 9 1/2 x 4 3/8". Museo Civico, Sassoferrato.
The warrior-saint stands frontally, holding a lance in his right hand and in his left a shield on which a lion is depicted. His halo is ornamented with small crosses forming squares, and his name is written in the double lozenges at either side of his head. The icon has a wide frame covered with repoussé silver leaves (one of which recently disappeared) on which are two crosses united with four B's (the emblem of the Palaeologue family), two double-headed eagles, and lozenges with vertically arranged inscriptions. Of these inscriptions, the one in Greek implores the intervention of the saint for the victory of the Emperor Justinian (which is, of course, an anachronism); the other describes in scarcely Byzantine language the contents of a phial, embedded in the center of the upper part of the frame, as "myrrh drawn from the fountain (?) in which the body of Saint Demetrius lies." The phial which is there today is of lead, and on it a clumsy sketch of a female saint with a fragmentary inscription in Greek. An old photograph, however, shows us that the original phial was of silver and bore a different inscription. Curiously enough, the letters of this inscription are entirely the same as those in the usual inscriptions, showing that even the silver phial was not the original one from Salonica, but belonged to the silver casing.

108
PRINCESS MARIA PALAEOLOGINA AND HER HUSBAND TOMA PRELJUBOVIĆ. c. 1372-1383. Detail from an icon depicting The Incredulity of Thomas. Dimensions of entire icon, 15 3/8 x 11 5/8". Monastery of the Transfiguration, Meteora.
To the right of Christ, who is the central figure, are six apostles and two other persons who, according to Xyngopoulos, must be Toma Preljubović, despot of Jannina (1361-1384), and his wife, Maria Angelina Comnena Ducena Palaeologina, sister of the second founder of the Monastery of the Transfiguration, Jovan Joasaph Uros Palaeologue. Maria wears the ceremonial costume with diadem and veil. Of Toma we see only the head, one shoulder, and one foot. He is looking out of the picture at the viewer; the apostles are all watching the scene or conversing among themselves. This scene is reproduced in a fresco from 1548 in the Monastery of Barlaam in Meteora, but the figure of the despot Toma does not appear. Restored by P. Zachariou in 1962.

109
THE ARCHANGEL MICHAEL WEIGHING SOULS. 14th century. 12 7/8 x 9 5/8". Museo Civico, Pisa.
The archangel is presented almost frontally against a gold background, his great wings fully unfurled and his feet planted on a rose-colored cushion. In his left hand he carries a medallion of Christ Emmanuel and the scales of justice. With his right, he brandishes a spear with which he transfixes a tiny black devil attempting to snatch away one of the two souls on the pans of the scales. The Latin inscription has almost entirely disappeared.

110, 111
HOSPITALITY OF ABRAHAM. End of 14th century. 13 x 23 5/8". Benaki Museum, Athens.
Three angels seated around a long oval table are being served by Abraham and Sarah (Genesis 18:1-15). A line of buildings rises behind, against a gold background. The iconographic elements here belong to a type probably developed in Constantinople in the fourteenth century.

113
BAPTISM OF CHRIST. End of 14th century. 19 7/8 x 14 5/8". Greek Patriarchate, Jerusalem.
Christ stands nude in mid-stream, immersed to the neck in the water, and turned almost imperceptibly to His right. The Holy Ghost comes down toward Him. On the rocks to the left, John the Baptist leans forward in the pose that is conventional in this scene, while on the right, three angels disposed one above the other bow in reverence before Christ. The steep, rocky banks of the stream, the few trees, and the personifications of the Jordan and the sea pouring water from vases complete this scene, which is dogmatic yet conceived in a painterly manner. Restored by S. Baltoyannis in 1964.

115
SAINT MARINA. 15th century. 45 1/2 x 30 3/4". Collection of the Refugees from Asia Minor, Byzantine Museum, Athens.
In this half-length figure, the saint holds a cross in her right hand and raises her left in the gesture of adoration typical of representations of martyrs. Restored by T. Margaritof in 1959.

117
SAINT GEORGE. 14th century. 40 1/2 x 26". Church of the Virgin of Trypiti, Aighion.
The warrior-saint is shown frontally in half-length. His right hand holds a javelin, forming a diagonal across the picture, and his left hand rests lightly on his shield. His head, with its short brown hair, is surrounded by a halo in relief. The upper left-hand part of the picture is damaged. Restored by the Byzantine Museum.

118, 119
MAGNIFICAT WITH GOSPEL SCENES. 15th century. 29 3/4 x 24 7/8". Collection of the Refugees from Asia Minor, Byzantine Museum, Athens.
In the central field, which is slightly sunken, a large medallion represents an assembly of angels and saints around the Virgin, who is enthroned within a circular mandorla. Above the mandorla is the Temple of the Heavenly Jerusalem depicted as a five-domed church. The inscription explains that the rather unusual iconography refers to the Magnificat hymn. In the lower portion of the central field are two medallions, one with the Hospitality of Abraham, the other with a bust of Saint Nicholas. In the border around the central field are the Forty Martyrs. On the wide outer frame there are twenty-four scenes: the Twelve Feasts above and below, plus ten scenes of the Passion, and two others.

120
RAISING OF LAZARUS. Middle of 16th century. 14 5/8 x 10". Benaki Museum, Athens.
The icon must have been part of a group of images which appeared on an iconostasis as part of the Dodecaorton. The arch that frames the scene confirms this. The scene evokes John 11:32-44. Christ, followed by the apostles, approaches the corpse of Lazarus, which is upright at the entrance to the tomb. As is the custom for kings, he receives homage from the sisters of the deceased. Between the two large rocks one can see a crowd of people coming through the door in the wall of Bethany. The Jew who finds himself closest to the tomb covers his nose discreetly to protect himself from the stench, proof

that Lazarus is really dead. The others indicate their astonishment before the accomplished miracle. The only figures that remain separated from the solemnity of the moment are the two workers who are occupied with carting stones and applying the bands of burial cloth to the body. The composition is inspired by the style that was in vogue during the Palaeologue period, but has traits which foreshadow Cretan art of the seventeenth century. Strong and well-balanced, the work is simplified in the design of its elements, with serenely posed silhouettes situated in a space that was rather symbolically designed by the crossing of planes. Icons that are analogous to this work in subject, style, and quality are attributed to eminent painters such as Theophanes. This permits us to date this painting along with Cretan artwork of the mid-sixteenth century.

121
DESCENT FROM THE CROSS. 16th century. From the border of an icon depicting the Virgin enthroned between two angels. Dimensions of entire icon, 34 x 26 5/8". Benaki Museum, Athens.
The Virgin standing on a platform holds the limp body of the dead Christ under the arms while Joseph of Arimathaea, poised on a ladder, supports the corpse around the waist. Saint John and a woman each kiss one of Christ's hands and the kneeling Nicodemus tries to remove a nail from the left foot. Three other weeping women are present. The well-balanced composition is typical of sixteenth century painting in Crete, where a tradition of the fourteenth century was carried on.

122, 123
DESCENT INTO LIMBO. 16th century. Signed by Michael Damaskinos. 14 3/8 x 25 5/8". Benaki Museum, Athens.
Christ strides over the two crossed panels of the broken gates of hell to pull Adam, kneeling within a tomb, up by the hand. Behind the resurrected Adam are Eve and the Righteous. On the left side of the picture, John the Baptist and the prophet kings arise from their tombs. Behind the two mountains appear two cantors, and two small angels hover over the scene, which symbolizes the Resurrection according to the apocryphal Gospel of Nicodemus. In iconography and style, this icon follows beyond doubt some fourteenth century model. Restored by G. Stratigos in 1944.

124
SAINT JOHN THE EVANGELIST. Middle of 16th century. 38 x 23 5/8". Monastery of Saint John the Evangelist, Patmos.
The upper edge of this icon is arched. The saint is turned slightly to his left; he holds in both hands a book which appears closed, and which is inscribed with the traditional first words of the Gospel according to Saint John. Under his right arm the saint clasps an inkhorn and a sheaf of quills to his breast. The bushy eyebrows and heavy beard also belong to the traditional iconography of this saint. Restored by P. Zachariou in 1964.

125
RELIQUARY OF CARDINAL BESSARION. 14th century. Wooden reliquary with sliding lid. 18 1/2 x 12 5/8". Galleria dell'Accademia, Venice.
The lid shows the Crucifixion; the frame is decorated on the outside with the following painted scenes: the Betrayal of Judas, the Mocking of Christ, the Scourging, the Bearing of the Cross, the Nailing to the Cross, the Deposition, and the Entombment. The interior of the reliquary is of dark blue enamel with gold stars, and is divided into five compartments, of which the central one is in the form of a cross with three cross-bars. It contains a gilded silver cross with the crucified Christ on the front and at either side, of the same height, are Saint Constantine and Saint Helena; above, in relief, are busts

of two angels. The Irene mentioned in an inscription must be the niece of Michael IX Palaeologue (1295-1320). According to another inscription, the cross belonged a century later to Gregory Pneumatikos who is presumed to be the Patriarch Gregory III (1443-1459). Finally, the reliquary was presented in 1463 by Cardinal Bessarion (1403-1472) to the Scuola della Carità in Venice. Many questions remain unanswered as to the origin and date of this work which is, in every respect, truly exceptional.

126
DORMITION OF THE VIRGIN. 15th century. 12 5/8 x 9 5/8". Monastery of Saint John the Evangelist, Patmos.
The tall elongated figure of Christ standing against a mandorla dominates the entire composition. He holds the soul of the Virgin in the guise of a newborn infant. At the head and foot of the Virgin's bier stand apostles and archbishop-saints. The bier itself is covered with a cloth decorated with pseudo-cufic designs. In the foreground a candle is burning; to the rear, the composition is closed off by two buildings. Restored by P. Zachariou in 1964.

127
SAINT JOHN THE EVANGELIST. 14th-15th centuries. Double-faced icon. 42 1/8 x 27 3/8". Church of Saint Therapon, Mytilene.
On one face of the icon is a Christ Pantocrator; on the other, illustrated here, is the bust of Saint John turning slightly to the left and holding in both hands an open volume on which one can read the first words of John's Gospel. Restored by P. Zachariou in 1960. The two faces of the icon have been mounted on separate panels for better preservation.

128
NATIVITY. Middle of 16th century. Dimensions without frame, 22 1/2 x 18 3/4". Hellenic Institute, Venice.
In the center, the Virgin lies alongside the manger where the newborn Christ is laid. All around are scenes related to the central theme: angels singing praises, the annunciation to the shepherds, Joseph speaking with two shepherds, the bathing of the Infant, and the approach of the three Magi in the distance. The rocky landscape consists of the grotto, three mountain peaks one behind the other, and trees and shrubs. The inscriptions read "The Birth of Christ" plus the well-known passage from the Gospel according to Saint Luke (2:14). This icon has retained its original wooden frame carved in sixteenth century Italian style. Restored by Mme. A. Kessanlis in 1959.

129
VIRGIN AND CHILD WITH SAINT PAUL OF XEROPATAMOU (?) AND SAINT ELEUTHERIUS. 15th century. Triptych. 11 1/4 x 17". Benaki Museum, Athens.
On the central panel are the Virgin and Child and the inscription "Portaïtissa". Blood flows from a wound on her cheek, undoubtedly referring to the miracle of a famous icon known as the Virgin of Portaitissa in the Monastery of Iviron on Mount Athos. On the wings are Saint Paul of Xeropatamou (?) and Saint Eleutherius.

131
SAINT ANNE AND THE VIRGIN. 1637. Signed and dated by Emmanuel Tzane. 41 3/4 x 29 7/8". Benaki Museum, Athens.
Saint Anne as a half-length figure holds the Virgin, who holds a flower as a symbolic prefiguration of Christ.

132
THE ANNUNCIATION OF ZACHARY. End of 16th century. 25 1/4 x 24 3/8". Benaki Museum, Athens.
The subject, which is rarely treated in small icons, follows the text of Luke 1:9-21. Zachary, after entering the sanctuary to

burn incense, meets an angel who tells him that his wife is going to give birth to a child named John. The crowd of people in the Temple are anxious to see what detains Zachary. The composition of this scene must be influenced by the more expansive Presentation of the Virgin, which would explain the two separate parts of the Temple, each covered with a canopy, as well as the charming angel at the summit of the sanctuary. One can see in this painting the merits of sixteenth century Cretan art. It succeeded in creating new compositions of an austere, geometric nature. This geometry underlies the structure of each figure, the fall of the drapery, and even the modeling of the forms. All of these elements, as well as the range of colors, are vigorously traditional. However, the spirit of the times gives freshness to the image.

133

THE DISCOVERY AND ELEVATION OF THE HOLY CROSS. End of 16th century. Signed by George Klotzas. 12 x 5 7/8". Monastery of Saint John the Theologian, Patmos.
The scene covers the back of a triptych, on which may be read an inscription located in the lower left hand corner: "Painted by the hand of George Klotzas and you who receive it, may you think favorably of me." George Klotzas, a well-educated man, a writer, calligrapher and painter (active from 1564 to 1609), translated traditional models in a rather personal manner, enriching them with a crowd of secondary subjects to create a somewhat animated composition. Below, Judas, the Jew who knows the location of the Cross, digs beneath the earth and finds it while under the watchful eye of Saint Helena, who presides over the small group assisting the patriarch Macaire. Above, the patriarch, mounted on the deacon's pulpit, lifts the Cross in full view of his assistants. The background architecture is of Franco-Byzantine style. One sees that Klotzas, while remaining faithful to pictorial norms, knew how to create a mystical atmosphere.

141

ODEGITRIA VIRGIN. c. 1198. Mosaic. 15 x 22 1/2". Museum, Monastery of Chilandar, Mount Athos.
The half-figure portrait has a gilded background. The Virgin is dressed in a blue maphorion of richly graduated values; the border and floral crucifixion ornaments, the stars of chastity, are executed in gold and arranged on the forehead, shoulders, and arms. The Virgin's face is framed by the bonnet worn beneath her maphorion. The hands, which are almost totally destroyed, were created with even smaller stones, which permitted a more careful rendering and change in tonal quality. The plump face of the Infant has a softer expression than His mother's, but it is treated in the same manner — very subtle use is made of color, along with black and white for the extreme accents. Christ's robe, the color of coffee, is flecked with golden highlights that underline some of the shadow effects. On the shoulder two clavus bands are rendered with rose-colored stones; in the left hand, which no longer exists, the Infant held a scroll. Preserved by P. Zachariou.

143

CHRIST THE REDEEMER. 13th century. 47 1/4 x 35 3/8". Museum, Monastery of Chilandar, Mount Athos.
The large portrait of Christ on a gilded background is marked with red letters: ICXC. Christ, dressed in a somber green himation, leans a bit to the left, exposing a mauve chiton with a deep red clavus. He gives blessing with his right hand and holds a Gospel, richly adorned with pearls and gems, in His left hand.

147

VIRGIN THE SAVIOR OF SOULS. Beginning of 14th century. Double-faced icon (see plates 149, 171, 178). 37 1/4 x 31 5/8".

National Museum, Ohrid.
The Virgin is represented facing front in half-figure, the Infant on her left arm. Her maphorion is bordered with gold braid, and on her head she wears a grey headdress. The right part of the sleeve is adorned with a green and ocher border, accented in gold. The garments of Christ are ocher with gold and red accents on the folds and a blue clavus on the shoulders. He holds a red phylactery in His left hand. His hair is blond. In the upper corners are small busts of angels: to the left, Michael, and to the right, Gabriel. The background is covered in a rich coating of silver on which there are remains of a coat of enamel. Surrounding the Virgin's head is the inscription "Mother of God, Help for Souls." Preserved by Z. Blazić.

149

CRUCIFIXION. Beginning of 14th century. Double-faced icon (see plates 147, 171, 178). 37 1/4 x 27 3/4". National Museum, Ohrid.
The Crucifixion is represented with the Cross in the center, the Virgin to the left and Saint John to the right. The Cross has two gilded inscriptions, in Greek: "The King of Glory," and "The Crucifixion." It stands among ocher-colored rocks highlighted with white. The skull inside the hill is that of Adam. Christ, dressed in a loincloth, is painted entirely in grey, green and olive tones. The Virgin wears a purple maphorion and red shoes while John has a blue tunic with a himation of ocher and grey. Above the Cross, two angels, dressed in grey-ocher, weep. In the background, on the lower half of the icon, is a green wall; it is partially gilded and has red and gold inscriptions

153

BAPTISM OF CHRIST. 14th century. 15 3/4 x 12 5/8". National Museum, Belgrade.
A steep and rocky landscape on a gold background is divided in the middle by a dark green stream. The figure of Christ occupies the major part of the painting. Above, two angels open the door to heaven, from whence comes the hand of God, surrounded by angels. Below that the Holy Ghost, in the form of a dove, is carried by a ray of light. Standing on the left bank, Saint John the Baptist rests his hand on the head of Jesus. The saint is dressed in animal skins and a green himation. On the opposite side of the river three angels, each holding a linen, are ready to receive the baptised Christ. Small boys swim nude in the river, as well as fish. In the lower portion of the painting are personifications of the Jordon river and the sea. Two other allegorical figures stand on the rocky summit: Jor and Dan, whose inverted shores let two waves flow together to form the Jordan River. A bit lower, on the left, is Jesus, accompanied by three apostles, speaking to John. The hatchet at the Baptist's feet is in reference to a New Testament parable. it cuts the tree that bears no fruit. Below, on either side of the river, are two groups of men and women; each group holds a nude infant. Their multi-colored clothing augments a picturesque scene already rich in details.

155

JESUS CHRIST. 1262-1263. 53 1/8 x 28 3/4". National Museum, Ohrid.
The half-length figure of Christ stands against a gold background, on which is inscribed ICXC. Christ is dressed in a purple tunic with gold highlights and a himation of blue which covers only the left shoulder. He gives blessing with His right hand, while carrying a scroll in His left. The halo is ornamented with gilded patterns and a deep red cross which bears a Greek inscription. The date of the icon is given on its reverse side — five circles contain a text which refers to the time of Archbishop Constantine Kavassila.

158
THE ARCHANGEL GABRIEL, FROM THE ANNUNCIATION. Beginning of 12th century. Offering of the donor Leon. 43 7/8 x 26 3/4". National Museum, Ohrid.
The archangel, right hand extended, is dressed in a long blue robe underneath an ocher cape, both of which are richly colored. The wings are painted in red with white highlights. The whole background of the painting, with the exception of the lower portion encased in silver, is decorated with floral patterns. On the border is a succession of figurative representations. The remains of a medallion are visible above; it showed a throne supported by angels.

159
VIRGIN, FROM THE ANNUNCIATION. Beginning of 12th century. Offering of the donor Leon. 43 7/8 x 26 3/4". National Museum, Ohrid.
The Virgin is seated on an ocher-colored throne with gold highlights. She holds a spindle in one hand and the thread in the other. The folds of her blue robe are richly accented and almost white in certain areas. Her purple veil is decorated with fine fringes and the stars of chastity in front. The face under this maphorion is framed by a darker headdress. The cushions of the throne and the shoes are of deep red. The majority of the icon is covered with silver plaques, which contain plant motifs. On the top of the encasing is a series of small busts in relief; the center is occupies by a Deësis the Virgin, Christ, and John the Baptist; these figures are flanked by Saint Joachim and Saint Anne. On the sides of the icon are figures from the Old Testament, standing five to each side. The portraits at the bottom are of Saints Andrew and Basil.

163
VIRGIN OF PELAGONIA. 1421-1422. Painted by the priest-monk Makarios. 52 3/4 x 36 3/4". Gallery of Art, Skopje.
The Virgin is turned toward the left, with the Infant on her right arm. She is clothed in a blue headdress and a purple maphorion; the latter is in gold with stars on the shoulders and above the forehead and fringes on the sleeves. The animated Christ Child is dressed in a greyish-white gown covered with red and blue flowers. His belt is blue enhanced with gold. One end of His orange cape is wrapped around His left leg; the other falls into the Virgin's arms. The skin tones are rendered in burnt ocher, with massive olive shadows, a bit of red on the cheeks, and white highlights. The background is of gold. Around the head of the Virgin there is an inscription in Greek: "Mother of God, the Pelagonitissa," and above the Infant's head, "Jesus Christ." The historical inscriptions stand out in red from the top and bottom borders of the icon. Restored by Z. Blazic.

165
THE APOSTLE LUKE. End of 14th century. From a Deësis of the large iconostasis of the principal church of the monastery (see plate 197). 38 3/4 x 28 3/4". Museum, Monastery of Chilandar, Mount Athos.
The Evangelist is shown in half-figure holding a closed book. The himation is grey-violet, the tunic of dark green with a clavus of gold. Restored by P. Zachariou.

167, 169, 171
ANNUNCIATION. Beginning of 14th century. Double-faced icon (see plates 147, 149, 178). 37 1/4 x 31 5/8". National Museum, Ohrid.
The Virgin, seated to the right under a baldacchino, is dressed in a purple maphorion, a somber green dress and deep red shoes. The Archangel Gabriel wears a himation of greyish-rose color. His wings are brown striped with gold below, and of blue striped with grey above. His platform is grey-blue. The gold background bears inscriptions in red. Preserved by Z. Blazic.

172
SAINT PANTELEIMON. Beginning of 14th century. 16 1/8 x 13 3/8". Museum, Monastery of Chilandar, Mount Athos.
In this half-figure portrait of the young martyr and warrior, Saint Panteleimon wears a deep red robe adorned with applications of gold. He holds a scalpel in his right hand and a box of medications in the other. There is a Greek signature. The background is of gold.

173
CRUCIFIXION. 13th century. Double-faced icon (see plate 184). 38 1/4 x 26 3/4". National Museum, Ohrid.
Christ is shown crucified between the Virgin and Saint John. Across the top are two angels in flight. The Cross is grey and black, and carries a gilded Greek inscription: "The King of Glory, Jesus Christ, the Crucified." Christ is dressed in a red loincloth, the Virgin in a dress and bonnet of light green. Saint John's robe is mauve. The angel on the left, which is better preserved, wears a robe of the same color as the apostle's. The floor is deep green; the rocks at the foot of the Cross are ocher with white highlights; the background is of gold. The border of the icons and the inscriptions are in red. On the edge of the painted area is a border of gilded lozenges on a black background. The skull of Adam lies in the hole beneath the Cross. Preserved by Z. Blazic.

174, 175
THE EVANGELIST MATTHEW. End of 13th or beginning of 14th century. 41 3/4 x 22 1/4". National Museum, Ohrid.
Saint Matthew moves toward the right holding an open Gospel in his hands. He is dressed in a blue tunic with a grey-ocher himation. On the background, near his left leg, is an inscription in Greek that has not yet been deciphered, but which is perhaps the painter's signature. The flesh tones are ocher with olive shadows, a touch of red on the cheeks and white highlights accenting the prominent features. The background is pale ocher, the halo gilded, and the lettering black. Preserved by Z. Blazic.

177
DESCENT INTO LIMBO. 14th century. 17 7/8 x 15". National Museum, Ohrid.
Christ is depicted on a blue-green mandorla decorated with gold. He wears a robe of ocher, emphasized by white highlights with greyish shadows. Standing above the orange doors of hell, the Redeemer extends His right hand to Adam, who looks up from a violet colored sarcophagus. Adam wears olive green, also accented with white highlights and grey shadows. Next to Adam is Eve, in a maphorion of deep red. The figures above Eve wear either violet or green robes, depending on their age. Of the four figures to the right, the two in front are recognizable: David, in a deep red tunic and dark green cape, and Solomon, in a green tunic and purple cape. The rock formations are grey. Above the mandorla of Christ is a group of angels which have been painted in grey-green. The gold haloes and gilded background have Greek inscriptions. Preserved by Z. Blazic.

178
CHRIST THE SAVIOR OF SOULS. Beginning of 14th century. Double-faced icon (see plates 147, 149, 171). 37 1/4 x 27 3/4". National Museum, Ohrid.
The Redeemer holds a closed Gospel in His left hand. The half-length portrait is encased in its original silver and has Greek inscriptions on its face. The lower right hand corner of the encasing, however, is destroyed. The frame has sculpted, gilded busts of apostles.

179
CHRIST THE GIVER OF LIFE. 1393-1394. Painted by Bishop Jovan. 51 5/8 x 34 7/8". Gallery of Art, Skopje.

The half-length figure of Christ, facing to the front, gives a blessing with His right hand while His left holds a closed Gospel covered with red and blue stones. He is dressed in a purple robe with a himation of blue; on the shoulder is a golden clavus adorned with gold. Christ's hair is brown with green outlines around the tresses. The skin is golden with olive shadows and white highlights on the prominent areas. The background of the painting is gold. Around the head of Christ is an inscription: "Christ the Savior and Source of Life," while on the upper vermilion border are Greek letters inscribed in lead. Restored by Z. Blazić.

181
VIRGIN OF PERIBLEPTOS. Beginning of 14th century. Double-faced icon. 32 5/8 x 25 3/4". National Museum, Ohrid.
The Virgin holds the Infant on her left arm. Her golden veil drapes over her shoulders, leaving a dark green garment exposed on her right shoulder. The folds of Christ's clothing are marked in black shadows. The faces are painted in ocher with green shadows, reddened cheeks and white highlights on the background. The haloes are of silver inlay worked into a leaf pattern. Around the Virgin's head is an inscription in Greek, "Admirable Mother," and above the head of the Child, "Jesus Christ".

183
BAPTISM OF CHRIST. 14th century. Double-faced icon. 18 1/2 x 15". National Museum, Ohrid.
Christ in a red loincloth is standing in the blue-grey waters of the Jordan. To the left, on the river, stands John the Baptist, and on the right, four angels in robes of olive, green, red and purple. Their wings are brown with gold accents at the bottom and rose and light green on the upper portion. In the water, the personification of the river, an old man, has wings of blue and wears a red loincloth. He rests his hand on a golden urn. At the feet of Christ is a fantastic turtle in green and gold. The sky is made up of blue and green rays which fall on the golden halo of Christ; the lower portion of the background is of gold; the rocks are grey-violet in hue, with white accents. The red inscriptions in Greek read: "The Baptism" in the center, "Saint John the Baptist" above John, and "Jesus Christ" above Christ. Restored by Z. Blazic.

184
ODEGITRIA VIRGIN. 13th century. Double-faced icon (see plate 173). 38 1/4 x 26 3/4". National Museum, Ohrid.
The icon is covered with small plaques of sculptured silver whose subjects include the twelve feasts, busts of saints, the prepared throne for the second coming of Christ, the Last Judgement and in the center, near the bottom, the Virgin Episkepsis. All of the plaques are made by stamping. The haloes and inscriptions, however, are worked by hand. The signatures are Greek. Restored by Z. Blazic.

185
SAINTS SIMEON AND SAVA. 15th century. 12 3/4 x 10 1/4". National Museum, Belgrade.
The two saints are represented standing in a frontal pose. Saint Sava wears white episcopal clothing: a polystaurion with a red border and gold crosses, and an omophorion with crosses of black and gold. He gives a blessing with his right hand, and in his left holds a Gospel. Saint Simeon is in a ceremonial habit: orange frock, purple cape, and a blue and gold scarf with a blue hood. He has in his right hand a gilded cross and in the left a phylactery, which is unrolled and shows a Serbian text in black letters. Sava has brown hair and beard; Simeon is greying. The flesh tones are rendered in golds, olive shading, and red in the cheeks, whose color seems screened in the deepest shadows. The inscriptions are in red, and the background is of gold.

187
OUR LADY OF MERCY. c. 1350. Detail. From the same iconostasis as plate 215. Dimensions of entire icon, 64 3/4 x 22". Monastery of Decani.
The Virgin, seated on a red cushion, wears a green dress. Her headdress has a purple veil and braided gold border. Christ is wearing a small blue gown with a red waist band and a cape of gilded ocher. The flesh is worked with green shadows and ocher accented with white on the lighter areas. The cheeks, lips, and nose are accented with deep red. The outlines of the faces and hands are drawn in brown or carmine. The background is yellow; the contour of the haloes and the inscriptions are in red. Restored by Z. Blazic.

188, 189
DIPTYCH OF TOMA PRELJUBOVIC. 1367-1384. 15 1/8 x 10 7/8". Cathedral, Cuenca, Spain.
The icon is encased in silver encrusted with pearls. On the right wing are Christ and the despot Toma, who prostrates himself before the Redeemer. On the left wing is Maria Preljubovic on her knees at the feet of the Virgin and Infant.

190
PRESENTATION OF THE VIRGIN. 14th century. 43 x 34 1/4". The principal church, Monastery of Chilandar, Mount Athos.
A group of young girls follows the Virgin, wearing light dresses with collars of braided gold. The girls have veils on their heads and carry candles. They protect the flames with their hands.

191
SAINT DEMETRIUS OF SALONICA. End of 14th or beginning of 15th century. 13 1/2 x 10 3/8". Museum of Applied Arts, Belgrade.
Saint Demetrius is presented in full-figure in a frontal pose. He holds a brown lance in the right hand and a sword with a golden guard in the left. He is dressed in a red tunic, blue armored pants, a dark red and gold breastplate. The breastplate is enhanced with gold and blue and is gilded. A cape of dark blue is thrown over the saint's shoulder. He wears a belt, an arrow-holder, a gilded shield, and a headdress of blue with red and gold highlights. The flesh is ocher with green shadows — these colors are accented by the reddish cheeks and lips. There are white touches on the forehead, nose, and around the eyes. The background is yellow with red inscriptions.

193
PRESENTATION OF THE VIRGIN. 14th century. Double-faced icon. 39 x 29 1/8". The principal church, Monastery of Chilandar, Mount Athos.
On the left, the Virgin at three years old, led by a young woman, approaches the High Priest standing before the doors of the Temple. In the foreground are Anne and Joachim, in the background, the followers. The upper left-hand corner shows a miniature of the Virgin receiving bread from the Archangel Gabriel.

194, 195
THE FIVE MARTYRS. (SAINTS AUXENTIOS, EUGENIOS, EUSTRATIOS, MARDARIOS, and ORESTES). End of 14th or beginning of 15th century. 13 x 16 3/4". Museum, Monastery of Chilandar, Mount Athos.
The martyrs, facing front, carry crosses in their right hands. They wear oriental clothing in vivid colors — the reds and greens stand out against a background of gold. The inscriptions are in Greek. The feast day of the Five Martyrs is December 13th.

196
ECUMENICAL COUNCIL. 17th century. Double-faced icon. 12 3/4 x 8 3/4". National Museum, Belgrade.

On the upper half of the icon, in the middle, is the tsar on his throne. To the right and left are two bishops. Behind the seat are pairs of guards and deacons. On the lower half is a group of Orthodox believers with haloes, and a group of heretics without them. The colors are somber, with a predominance of dark red, brown, and green. The modeling is achieved with touches of white. The inscriptions are Serbian.

197

THE EVANGELIST JOHN. End of 14th century. From the Deësis of the large iconostasis in the principal church of the monastery (see plate 165). 39 3/8 x 29 1/8". Museum, Monastery of Chilandar, Mount Athos.
The half-figure shows the Evangelist with white hair holding a closed Gospel. His himation is mauve and marked with highlights of a lighter shade.

198, 199

ANNUNCIATION. 1621. Painted by George Mitrofanovic. Center door of an iconostasis. Dimensions of entire icon, 46 1/8 x 22". Church of Saint Tryphon, Monastery of Chilandar, Mount Athos.
On the left wing, the Archangel Gabriel, in a light-colored himation with a dark tunic, holds a messenger's staff in the form of a cross. To the right, the Virgin, standing in a violet veil with golden stars and fringes, is in the midst of spinning yarn.

200

LAMENTATION OVER THE DEAD CHRIST. 17th century. Double-faced icon. 16 3/4 x 21 5/8". Treasure of the Patriarchate, Peć.
In the center, the body of Christ lies in a sarcophagus — Saint John kisses His hand; to the left, the Virgin sits on a low throne. These central figures are surrounded by grieving women. Nicodemus and Joseph of Arimathaea stand off to the right. Golgotha, the walls of Jerusalem and the Cross are visible in the background. In the sky, four angels weep. The inscriptions are Serbian.

201

SAINT JOHN THE BAPTIST. 1644. 24 7/8 x 16 3/4". Museum of the Serbian Orthodox Church, Belgrade.
John the Baptist is represented with wings, in a sculpted, gilded frame. He gives a blessing with his right hand and in his left holds a blue shield, on which rests his haloed head. He wears a rough blue tunic. The other elements of the composition — John's hair, beard, wings, and cape — are almost exclusively brown and gold. Behind the saint there is an inscription in red letters. On the lower portion of the icon, an unrolled phylactery carries the text of the litany for the Vespers of the Decollation. Under the phylactery is found an inscription concerning the donor and production of the icon.

203

CONSECRATION OF SAINT SAVA. 1645. Painted by Cosmas. Detail from an icon of Saints Simeon Nemanja and Sava, with scenes from their lives. Monastery of Moraca.
The scene represents the consecration of Saint Sava as a bishop. The inscriptions are Serbian.

204, 205

SAINT GEORGE WITH SCENES FROM HIS LIFE. 17th century. 47 1/4 x 31 7/8". Treasure of the Patriarchate, Pec.
In the central portion of the painting, a redheaded Saint George is seated upon a throne of red and gold, which is gilded and adorned with pearls. The sword he holds in his hands has a black handle with a gold motif. His garments include: a green tunic with an armature of reddish brown gilded and accented with green; a red cape; and shoes of red and gold. On the borders of the icon are seventeen scenes from the saint's life. Nearly all of the figures are clothed in red and green; the sun is green; the landscape, green, blue or grey, and the architecture is green or blue with red roofs. The icon has a gold background, red inscriptions and ornaments of sculpted, gilded wood.

206

THE SERBIAN PATRIARCH PAJSIJE. 1663. Painted by Jovan of Chilandar. 13 3/8 x 9 1/2". National Museum, Ravenna.
With a mature head of grey hair, the crowned Pajsije is portrayed standing, dressed as a patriarch. He turns in a gesture of prayer towards Christ, who appears in the sky. The background is inlaid in gold, and has Serbian inscriptions.

207

SAINT NAHUM OF OHRID. 17th century. 19 5/8 x 15". Gallery of Art, Skopje.
The hermit saint gives a blessing with his right hand while his left holds a banner. He wears a grey robe with a black hood. The painting has a gold background with Greek inscriptions.

209

CHRIST THE REDEEMER. 16th century. 28 3/4 x 16 1/8". Gallery of Art, Skopje.
The portrait, an elongated bust on a vermilion background, carries an inscription in white Greek letters. The golden halo is inscribed in brown. Christ gives a blessing with His right hand, while the left holds an open Gospel. The himation covers His left shoulder and part of His chest, exposing a red tunic with a golden collar.

211

SAINT NAHUM OF OHRID. Second half of 14th century. 36 x 27 3/4". National Museum, Ohrid.
The large half-figure portrait has a blue-grey background. The saint is dressed in a green tunic, which appears from under his robes of deep mauve. He gives a blessing with his right hand and holds a scroll in his left, the inscription of which has nearly disappeared.

212

SAINT GEORGE. 1266-1277. 57 1/8 x 33 7/8". Church of Saint George, Struga.
The warrior-saint holds a sword and leans toward the left, supported by his shield. The background is golden. George is dressed in a dark green tunic fringed in red, with a suit of armor on the forearms and thighs. The orange armor has auburn highlights and an ornament in the form of a cross. A long red cape falls from George's shoulders to the bottom of the painting, breaking up the somber uniformity of the colors.

213

SAINT CLEMENT OF OHRID. End of 14th or beginning of 15th century. Double-faced icon. 33 7/8 x 25 5/8". National Museum, Ohrid.
Saint Clement, with greying hair and beard, is dressed in a purple phelonion, decorated with crosses of black and gold. The fringes on the sleeves are gilded and decorated. A book, held in the left hand, has a golden cover dotted with vermilion stones. The flesh is rendered in rose color with olive green shadows and touches of white on the forehead, nose, and eyes. The lips are red and the eyelids, nose, and cheeks are accented with the same. The inscriptions are in Greek.

215

SAINT JOHN THE BAPTIST. c. 1350. From the same iconostasis as plate 187. 64 3/4 x 22". Monastery of Decani.
Saint John turns slightly toward the left in this portrait. He wears a garment of grey camel skins, a reddish-brown cape and a green belt. He makes a blessing with his right hand, and in his left holds a white phylactery and a blue staff. The staff has a dark green cross at the end of it. His hair and beard are brown; the shadows of his face are green, with yellowish highlights on the nose, forehead, and cheeks.

Acheiropoiete:
An image that supposedly has not been made by any human hand.

Anastasis:
Resurrection, symbolized by the Descent into Limbo.

Ban:
A commanding officer in a southern Slavic province.

Catholicon:
The main church of a monastery.

Chiton:
A type of tunic; from the second century on, they typically had sleeves.

Chlamys:
A lightweight cape worn by cavaliers and dignitaries of the Byzantine Empire.

Christ Pantocrator:
Christ the All-Powerful.

Cinnabar:
A vermilion red, the color of mercury.

Clavus:
A long decorative band on a tunic, of a different color than the tunic.

Deësis:
A composition whose format includes the figure of Christ flanked by the Virgin and John the Baptist, who together act as intercedents for humanity. Such a composition is, in effect, a symbolic representation of the Last Judgement.

Despot:
Master, in Greek. From the twelfth century on, it was a title given to important individuals by the Byzantine emperor.

Dodecaorton:
A group of icons which depict the twelve great feasts of the year.

Epistyle:
The part of an iconostasis which rests directly on the columns.

Herminia:
A manual of models which was used as reference by painters.

Himation:
A cloth garment which is draped over one shoulder and wrapped around the body.

Iconostasis:
A structure of wood or marble which is decorated with icons.

Lavra:
A collective of pious individuals, in some cases a monastery.

Mandilion:
A word of Arabic origin, designating the image of Christ.

Maphorion:
A long veil covering the head and shoulders, serving as a cape for women.

Menologue:
A book describing the lives of the saints, sometimes illustrated with miniature paintings.

Myron:
Oil or essence of perfume.

Pareclession:
A side chapel.

Proskynesis:
An act of prostration.

Proskynitarion:
A pedestal upon which one places an especially venerated icon.

Protospatharius:
A commander of the Spatharian Guard in Constantinople.

Stauroteque:
A reliquary which contains a piece of the Holy Cross.

Suppedaneum:
The platform on the Cross which supports the feet of Christ.

Tablion:
A square of cloth sewn onto the capes of dignitaries.

Trope:
An embellishment of the text or melody of liturgical songs.

Typicon:
A book of rules for the yearly religious services of the Orthodox Church.

Orthodox Vestments

Analabos:
A cloak decorated with crosses worn by monks of the Orthodox Church.

Epitrachelion:
An embroidered bond of cloth worn by bishops and archbishops.

Omophorion:
A woolen scarf, embroidered with crosses, which is worn by bishops. It is looped around the neck, under the arm, and over the shoulder.

Phelonion:
A sleeveless vest, similar to a chasuble.

Polystaurion:
A vest covered with crosses.

Qualities expressed in the various types of icons of the Virgin.

Eleousa:
Mercy

Episkepsis:
Protection and help.

Glykophilousa:
The soft kiss, tenderness.

Hagiosoritissa:
Of the saintly sash.

Odegitria:
The guide of voyagers.

Pelagonitissa:
Represents an icon of a Virgin from Macedonia.

Peribleptos:
Literally, celebrated.

ANTHONY is celebrated on January 17th by Orthodox and Latin observers. Born in the year 250 in upper Egypt, he returned to the desert at the age of twenty. Anthony founded several monasteries before his death at age 106. His biography was written by Saint Athanasius, patriarch of Alexandria, who knew him well.

BARLAAM; celebrated on November 19th, is the hero of a religious novel composed toward the end of the tenth century by a monk from Palestine or Sinai. The author, who knew the Greek Fathers and neo-Platonists, was also well informed of Buddhist philosophy. His uplifting story of Barlaam and Josaphat, which exalts the life of meditation, became so popular that its heroes were immortalized.

BASIL was born around 329 in Caesaria of Cappadocia, the son of a public official. A brilliant student, he founded a monastery in Pontus, where he developed a code for life in the religious orders of the East that remains in use today. Involved in the religious controversies of his time, Basil became a bishop in 370 and died on January 1st, 379.

CATHERINE is celebrated on November 25th. Her story, of no particular historical authenticity, was formulated in the ninth century. Daughter of a king living in Alexandria, Egypt, her beauty equaled her intelligence and poise. During a persecution, she presented herself before the Roman emperor and reproached him for his action. The confrontation led to the emperor sending philosophers and writers to argue with her, but she outwitted them and the angry emperor had them burned. Catherine was decapitated but angels carried her body to the summit of Mount Sinai. It remained there for three centuries until brought down to the Monastery of Saint Catherine, which was constructed in her name by Justinian.

CHRISTINE, celebrated on July 24th, was a martyr from Tyre. Highly popular in the East, her story has been known since the fifth century but has little historic value. Her father wanted to have her consecrated by a pagan cult and enclosed in a tower, but wanting to be baptised, Christine destroyed the gold and silver statues to whom she was supposed to offer incense. Her father had her beaten. After extensive torture, she died, pierced by two arrows.

FIVE ARMENIAN MARTYRS (fourth century). The five are Auxentios, Eugenios, Eustratios, Mardarios, and Orestes. Victims of the Diocletian persecution, they are known to us by an apocryphal story which is known in Greek, Georgian, Armenian and Latin. Their cult, which expanded throughout the Byzantine Empire, was also known in Rome. They are celebrated on December 13th.

CLEMENT OF OHRID (died July 27, 916). A disciple of Saint Methodius and a Slavic apostle, he was one of the first five bishops ordained in the country.

COSMAS AND DAMIAN are celebrated on July 1st and November 1st by the Orthodox. They are revered in the West as well as in the East. These saints, who received no money for their services to worshipers, were transformed by legend into doctors and twin brothers. During the fifth century, the center of their cult was in Tyre. Their basilica was reconstructed by Justinian during the sixth century. That century saw their following spread throughout the Byzantine Empire, Egypt, Rome and the rest of the Western world.

DEMETRIUS, celebrated on October 26th by the Orthodox, is the patron saint of Salonica. His story, written at about the time his magnificent basilica was constructed (fifth century), tells of a nobleman who became an ardent promoter of faith in Christ. He was arrested by the emperor and imprisoned in the baths near the stadium, where through his prayers he aided his friend Nestor in killing a gladiator preferred by the emperor. He was then stabbed to death and buried in that location, where the basilica was later constructed in his name.

EPHRAIM THE SYRIAN is celebrated on January 28th in the East. He was born in 306 at Nisibis in Mesopotamia and went to the desert to become a monk. The battles between the Empire and the Persians brought him to Nisibis, where he was named deacon. When the city fell to the Persians in 363, he went to Edessa. He died in 373.

EPIPHANIUS, celebrated May 12th, was born in Palestine. After studying Hebrew, Egyptian, Syrian and Greek, he founded a monastery in his homeland. Thereafter Epiphanius was escalated to the position of bishop of Cyprus. He died in 403.

EUTHYMIUS is celebrated January 20th by Orthodox and Latin followers. He was born in Armenia in 377 and became a priest at the end of his studies. At the age of thirty he left on a pilgrimage to Jerusalem and then retired to a life of solitude. Being in contact with the Bedouins, he miraculously saved the son of a sheik and then became the spiritual leader of the nomads, of whom the sheik, baptised, became the bishop. Euthymius died after 68 years in the desert. The Orthodox attribute to Saint Euthymius and his disciples, including Saint Sava, a good part of their liturgy.

GEORGE, celebrated April 23rd and November 3rd, is called "the Great Martyr" by the Greeks. A victim of the last persecution at the beginning of the fourth century, he died at

233

Lydda in Palestine. During the fourth century a basilica containing his remains was dedicated to him. George's legend, known by a manuscript from the fifth century, contains many tales, of which the story of the dragon is most popular. As a military tribune stationed in Libya, the saint encountered an adolescent girl in tears. There appeared a hideous dragon which George then brought to the ground with the sign of the Cross. In a later version, George wounded the dragon with his lance and then saved him with his staff.

GREGORY OF NAZIANZUS, celebrated January 30th by the Orthodox, was born in Cappadocia. His father, also named Gregory, was the bishop of Nazianzus and sent his sons to study in Palestine and Alexandria. Gregory continued to travel, first to Athens and finally to Constantinople in 356. Recalled to Nazianzus by his father, he was ordained as a priest and assistant to the bishop. When Theodosius became emperor of the East, the younger Gregory was sent to Constantinople to preach against the Arians, and soon became a bishop himself. He retired to Nazianzus and died in 389 or 390.

JOHN CHRYSOSTOM received his surname from his talent as an engraver. He was born in 344 in Antioch, where he studied well and entered the clergy. After a period of solitude, John returned to Antioch, where he became renowned as a speaker. He was made bishop of Constantinople in 398 and thus was involved in religious disputes and the politics of the Empire. He lost favor with the Empress Eudocia, wife of Arcadius, who exiled him to Asia Minor. He died there on September 14th, 407. His body was returned to Constantinople in 438, on January 27th, his feast day.

JOHN CLIMACUS, so-named because of his work "The Ladder to Heaven", was born in 579, and entered the Monastery of Saint Catherine at Sinai at sixteen years of age. After nineteen years of communal living, he retired to the desert. He returned briefly to the monastery to write "The Ladder to Heaven" and after having chosen his successor, returned to the desert. He died in 649. His feast day is celebrated March 30th in both East and West.

JOHN OF DAMASCUS, whose feast day is December 4th for those of the Orthodox Faith, was born in 676 in the city whose name he bears. He received extensive instruction and became a great minister. For protesting the attempted ban on religious images in 730, John was denounced by the emperor. The saint had his right hand cut off, but the Virgin miraculously reattached it to his wrist — an episode that is the inspiration of the icons of the Virgin with three hands. One of these icons, in the Monastery of Chilandar on Mount Athos, is from the fourteenth century. John retired to the Monastery of Saint Sava as a priest, and died in 750.

MARINA is celebrated on July 17th in the East. Her story, without historic basis, was very popular among the Orthodox as well as the Latins. Daughter of a pagan priest, she embraced Christianity and was denounced by her father. She sought shelter with her nurse, but her beauty drew the attention of the prefect Olybius, who wished to marry the girl. Marina refused, and for this was imprisoned, tortured, and finally decapitated.

MERCURIUS, a military saint, is honored on November 25th. His story goes back to the fourth century. According to legend, Mercurius was recalled to earth by Christ in 363 to fight the emperor Julian, enemy of the Christians.

NAHUM, a disciple of Saint Methodius, is honored on December 25th and June 20th. He was a missionary in Macedonia at the end of the ninth century.

NICHOLAS, celebrated on December 6th, was a bishop of Myra in Lycia, Asia Minor. His cult is well known. The legend of Saint Nicholas, which dates back to the sixth century, is above all a tale of miracles. The oldest story is an episode in which Nicholas received a pardon from the emperor for three condemned men. Another tells of his calming the sea, for which he became the patron saint of mariners. During the eleventh century the Corsicans transported his body to Bari after the inhabitants of Myra fled from the Turks.

PANTELEIMON is celebrated on July 27th. He was a doctor and also a martyr — his name signifies suffering. Honored in Cologne and around Naples, Panteleimon is also very popular in the East. After publicly declaring his religion, the saint was tortured and decapitated. He shares the same reputation as Cosmas and Damian of refusing rewards for the treatment that he gave his followers.

PAUL OF THEBES, celebrated January 15th, retired to the desert after a series of persecutions in the third century and remained there until his death.

THE FORTY MARTYRS are celebrated on March 9th. During the last persecution, forty soldiers in Sebaste, Asia Minor, who originated from different countries but were all Christians, refused to worship idols. They were punished by being forced to spend the night laying in a frozen stream with their bodies exposed. The group was saved the next day. Their cult expanded throughout the East and Saint Basil mentioned them in his writings.

SAVA is celebrated January 27th. He was born in 1174, the son of Etienne Nemanja. Christened Rastko, he took the name Sava upon entering the monastery at Mount Athos as a boy. With his father, Sava founded the monastery at Chilandar, which still exists. He was the first archbishop of the autonomous Serbian Church. Saint Sava died in 1235.

SIMEON, celebrated on February 26th, founded the Serbian dynasty known by the name of the Nemanjas.

SIMEON STYLITES THE ELDER, celebrated by the Orthodox on September 1st, was born in Asia Minor. At first he was a shepherd, like his father, but later entered into the monastery. After being sent away from the order, he ceased to be a monk and hid himself in a small cell near Antioch for three years. Simeon eventually came out of seclusion to end his life as a preacher. He died at the age of 68

SIMEON STYLITES THE YOUNGER, celebrated on May 24th, was born in Antioch sixty years after the death of the elder Simeon, and based his life on that of his namesake. Many

miracles are attributed to him. Simeon the Younger died in 592.

THEODORE, celebrated on February 7th, was born a Christian in Asia Minor. Enrolled in a legion that wintered in Cappadocia at the beginning of the Diocletian persecution, he perished when the temple of the city was set fire to. The center of his cult was Euchaita, which was called the City of Theodore during the fifth century. His fame spread to Syria, Constantinople, and through the West.

THEODORE THE STUDITE, celebrated on November 11th, was a superior of the monastery in Constantinople called Studios.

He was born in 759, the son of a high Imperial functionary. Theodore entered the monastery and later succeeded his uncle as its director. Under the saint's tutelage the Studites distinguished themselves in the fight against Iconoclasm. Theodore was arrested and deported to Asia Minor in 815, which is where he wrote his treaty in defense of religious images. He died there in 826.

ZOSIMUS, celebrated on April 4th, was a monk in Palestine during the fifth century. He is best known as the confidant of Saint Mary of Egypt, whose story was popular during the Middle Ages.

DR. KURT WEITZMANN, Professor of Art History at the University of Princeton.

Born in 1904 in Germany. Studied from 1923 to 1929 at the Universities of Munster, Würzburg, Vienna and Berlin. Received a doctorate from the University of Berlin in 1929. Sabbatical in Greece in 1931. From 1932 to 1934 a corresponding member of the Institute of Archeology in Berlin. From 1935 to 1972 a member of the Institute for Advanced Studies at Princeton. In 1950 became a professor of Art History at Princeton and in 1972 was made professor emeritus. Also served as a temporary professor at the following: Yale University (1954-55), Alexandria (1960), and Bonn (1962). Traveled to Sinai for research in 1956, 1960, 1963, 1965. A member of: the Board of Scholars at Dumbarton Oaks Center of Byzantine Studies at Harvard; the Institute of Archeology in Berlin; the Medieval Academy of America; the American Philosophical Society of Philadelphia; the Academy of Sciences, Heidelberg; the British Academy; and the Pontificia Accademia Romana di Archeologie.

Publications: In collaboration with Adolph Goldschmidt: Die Byzantinischen Elfenbeinskulpturen des X.-XIII. Jahrhunderts; vol. I: Kästen, Berlin 1930; vol. II: Reliefs, Berlin 1934; Die Armenische Buchmalerei des 10. und beginnenden 11. Jahrhunderts. Istanbuler Forschungen vol. 4, Bamberg 1933; Die Byzantinische Buchmalerei des 9, und 10. Jahrhunderts, Berlin 1935; Illustrations in Roll and Codex, A Study of the Origin and Method of Text Illustration, Princeton 1947; The Joshua Roll, A Work of the Macedonian Renaissance, Princeton 1948; Greek Mythology in Byzantine Art, Princeton 1951; The Fresco Cycle of S. Maria di Castelseprio, Princeton 1951; Ancient Book Illumination (Martin Classical Lectures), vol. XVI, Cambridge 1959; Geistige Grundlagen und Wesen der Makedonischen Renaissance (Arbeitsgemeinschaft für Forschung des Landes Nordrhein-Westfalen), Geisteswissenschaften No. 107, Cologne 1963; Aus den Bibliotheken des Athos, Illustrierte Handschriften aus Mittel- und Spätbyzantinischer Zeit, Hamburg 1963.
STUDIES IN CLASSICAL AND BYZANTINE MANUSCRIPT ILLUMINATION (ed. H. L. Kessler), Chicago 1971: IVORIES AND STEATITES. CATALOGUE DUMBARTON OAKS COLLECTION, Vol. III, Washington 1972; (with G. H. Forsyth). THE MONASTERY OF SAINT CATHERINE AT MOUNT SINAI: THE CHURCH AND FORTRESS OF JUSTINIAN, Ann Arbor 1973: THE MONASTERY OF SAINT CATHERINE AT MOUNT SINAI. THE ICONS. VOL. I. FROM THE SIXTH TO THE TENTH CENTURY, Princeton 1976.

DR. MANOLIS CHATZIDAKIS, Director of the Byzantine Museum and the Benaki Museum of Athens.

Born in Crete in 1909. Studied in Athens, Paris (G. Millet, A. Grabar) and Berlin (Rodenwaldt, E. Kuhnel). Doctorate from the University of Athens in 1942. From 1934 to 1939, Assistant to Director, and from 1940, Director of the Benaki Museum. Became Curator of Byzantine Antiquities in 1943 and Director of the Byzantine Museum in 1960. Member of: the Committee of the International History of Art; the Association of International Art Critics; the Institute of Archeology in Berlin. Secretary of the Society of Christian Archeology in Athens. Received the Herder Prize, Vienna, 1965.

PUBLICATIONS: Mistra, second edition 1956 (in Greek); The Monuments of Byzantine Attica and Boeotia, 1956 (in four languages); with A. Grabar: The Byzantine Mosaics in Greece, UNESCO editions, 1958. Icons of St. George of the Greeks and the Collection of the Hellenic Institute of Venice, Venice 1962. Byzantine painting, from: M. Chatzidakis - A. Grabar, Byzantine Painting and the Height of the Middle Ages, Paris, (1965). There are other articles on Byzantine and post-Byzantine art in scientific reviews.

DR. SVETOZAR RADOJCIC, Professor at the Faculty of Letters, University of Belgrade.

Born in 1909 in Yugoslavia. Studied in Ljubljana, Zagreb, Vienna and Prague. Received a doctorate from the University of Ljubljana in 1924. In 1935 began his personal scientific research at Skopje in the area of archeology and the history of medieval art. A professor at the Faculty of Letters, University of Belgrade since 1945. A member since 1952 and a permanent member since 1963 of the Serbian Academy of Arts and Sciences. Specializes in the history of Byzantine and Medieval Serbian art.

PUBLICATIONS: The Portraits of Serbian Sovereigns of the Middle Ages, Skopje 1934; The Antiquities of the Religious Museum of Skopje, Skopje 1941; Early Serbian Miniatures, Belgrade 1950; Masters of Early Serbian Painting, Belgrade 1955; Yugoslavia, Medieval Frescoes (preface by David Talbot Rice), New York 1955; Icons of Serbia and Macedonia, Belgrade 1962; Mileseva, Belgrade 1963. The majority of studies concerning the archeology and the history of art have appeared in Glasnik skopskog naucnog drustva, Starinar, Bulletin of the Institute of Byzantine Studies, Belgrade.

Table of contents